Exhibiting Photography

Displaying Your Work

Second Edition

Shirley Read

D1438526

f Focal Press
Taylor & Francis Group
NEW YORK AND LONDON

Second edition published 2014
by Focal Press
70 Blanchard Road, Suite 402, Burlington, MA 01803

Simultaneously published in the UK
by Focal Press
2 Park Square, Milton Park, Abingdon, Oxon OX14 4RN

Focal Press is an imprint of the Taylor & Francis Group, an informa business

Notices
Knowledge and best practice in this field are constantly changing. As new research and experience broaden our understanding, changes in research methods, professional practices, or medical treatment may become necessary.

Practitioners and researchers must always rely on their own experience and knowledge in evaluating and using any information, methods, compounds, or experiments described herein. In using such information or methods they should be mindful of their own safety and the safety of others, including parties for whom they have a professional responsibility.

Product or corporate names may be trademarks or registered trademarks, and are used only for identification and explanation without intent to infringe.

First edition published by Focal Press, an imprint of Elsevier 2007

Library of Congress Cataloging in Publication Data
Read, Shirley.
 Exhibiting photography : a practical guide to displaying your work / Shirley Read.
 p. cm.
 Includes bibliographical references and index.
 ISBN 978-0-240-82061-3 (alk. paper)
1. Photography—Exhibitions. 2. Art—Exhibition techniques.
3. Museum exhibits. I. Title.
 TR6.A1R43 2013
 779.074'421—dc23
 2012019691

ISBN: 978-0-240-82061-3 (pbk)
ISBN: 978-0-240-82062-0 (ebk)

Typeset in Times New Roman
Project Managed and Typeset by: diacriTech

Printed in China by Everbest Printing Co.Ltd

Contents

Acknowledgements

The source of quotations not made directly to the author or acknowledged in the text are listed here:

Ed Barber (*Design Week,* July 2007); Tina Barney (*Image Makers, Image Takers*: Jaeger 2007); Victor Burgin ("Looking at Photographs," 1982); Rineke Dijkstra (*Image Makers, Image Takers*: Jaeger 2007); William Eggleston (*Image Makers, Image Takers*: Jaeger 2007); Colin Ford (*PLUK* no. 10, Jan/Feb 2003); Ori Gersht: (*PLUK* no. 28, Jan/Feb 2006); Dr Inka Graeve Ingelmann (*Image Makers, Image Takers:* Jaeger 2007); Reesa Greenberg (*Thinking about Exhibitions*, 1996); Mark Haworth Booth (*Photography: An Independent Art*, 1997); Katherine Hinds (*Image Makers, Image Takers:* Jaeger 2007); Rudolf Kicken (*Image Makers, Image Takers:* Jaeger 2007); David LaChapelle (*Image Makers, Image Takers:* Jaeger 2007); Kay Larson (*Thinking about Exhibitions:* Greenberg et al. 1996); Michael Mack: (*PLUK* no. 31, autumn 2006); Mary Warner Marien (*Photography: A Cultural History*, 2002); Mary Ellen Mark (*Image Makers, Image Takers:* Jaeger 2007); Jeremy Millar (*PLUK* no.14, Sept/Oct 2003, p. 39); Brian O'Doherty (*Inside the White Cube*, 1986); Mari Carmen Ramirez (*Thinking about Exhibitions:* Greenberg et al. 1996); Sebastiao Salgado (*Image Makers, Image Takers:* Jaeger 2007); Stephen Shore (*Image Makers, Image Takers:* Jaeger 2007); John Stathatos (exposed 02 January–April 1998); Thomas Weski, (*PLUK* no. 12, May/June 2003); Max Wigram (*PLUK* no. 9, Nov/Dec 2002).

Regarding Carole Evan's installation image in Chapter 9: I would like to acknowledge the help of the Collyer Bristow Gallery, which is a unique gallery space with a dynamic exhibition program. Collyer Bristow LLP is a leading UK law firm with offices in London and Geneva. The firm provides business and personal legal advice to a wide range of clients both in the UK and internationally. Collyer Bristow has been championing emerging talent in contemporary art for over fifteen years.

Thanks

I am very grateful indeed to Georgina McNamara, who volunteered to take on picture research just when I needed someone. She showed exactly the qualities of initiative, resourcefulness, and resilience that she told me she had been taught were necessary for a successful career as an artist.

Thanks to Tony Gale for his very helpful technical edit and special thanks, too, to Stacey Walker at Focal Press who is a great editor; both thorough and supportive.

And thanks to:

Martin Argles, Murray Ballard, Karin Bareman, Mandy Barker, Myka Baum, Sian Bonnell, Deborah Bright, Susan Bright, Caroline Brown, Nadia Burns, Mac Campeanu, Paul Carter, Sarah Cave, Sarah Chapman (Peninsula Arts), Zelda Cheatle, Jane Clark, Bridget Coaker (Troika Editions), Marcella Colaneri, Hannah Collins, Mike Crawford, Arno Denis, Andrew Dewdney (London South Bank University), Malcolm Dickson (Street Level Photoworks), Willie Doherty, Jo Dorrell, Mark Dumbrell (Margate Photo Festival), Christina Dunhill, Joanna Empson (The Photographers' Gallery), Helen Esmonde (Hoopers Gallery), Brandei Estes (Brancolini Grimaldi) Jennifer Eudicone, Carole Evans and the Collyer Bristow Gallery, Graham Evans, Maria Falconer, Mary Familiant, Ruth Fuller, Philippe Garner, John Gill, Gina Glover, Joy Gregory, Brian Griffin, Dominic Harris, Paul Herrmann (Redeye, the Photography Network), Paul Hill, Dan Holdsworth, Giles Huxley-Parlour (Chris Beetles Fine Photographs), Elizabeth Ikin, Mike Ingleheart (Frame Factory, Islington), Natalia Janula, Astrid Kruse Jensen, John Kelly, Peter Kennard, John Kippin, Robin Klassnik (Matt's Gallery), Grace Lau, Zoë Leonard, Jenny Lomax (Camden Arts Centre), Alison Marchant, Michael Marten, Jenny Matthews, Georgina McNamara, Anne McNeill (Impressions Gallery), Roy Mehta, Harriet Merry, George Meyrick, Leila Miller, Renee Mussai (Autograph ABP), John Myers, Simon Norfolk, Anstice Oakeshott (The Photographers' Gallery), Pippa Oldfield (Impressions Gallery), Matthias Olmeta, Todd Pacey, Nicole Polonski, Mary Pritchard, Carole Rawlinson, Tim Roberts, Brett Rogers (The Photographers' Gallery), Paul and Esther Rowley, Mark Sealy (Autograph ABP), Michelle Sank, Valentine Schmidt, Anne Kathrin Schuhmann, David Scull (Hoopers Gallery), Mira Shapur, Mike Simmons (De Montfort University), Katrina Sluis (London South Bank University), Helene Sorensen, Cherry Taylor, Roma Tearne, Esther Teichmann, Jim Thorp, Anna Tjan & Mauro Saccardo (Oaksmith Studio Fine Art Picture Framers), James Tye, Tim Walsh (Camden Arts Centre), Simon Warner, Liz Wells, Jason Wilde, Peter White (FXP Photography), Gary Woods, Tim Youles.

And thanks, too, to all my students who have shaped this work and reminded me of how hard it can be to start exhibiting.

Introduction

This book originated in workshops taught at the University of Westminster, Photofusion, and the City Lit. The aim of the workshops was to empower students, both photographers and would-be curators, by opening up the processes and practices of exhibiting. What the workshops taught me was that, although students are increasingly working with a career aim of exhibiting their work, they frequently leave college unprepared to start showing their work professionally.

My aim, then, has been to write a book that can be used as a guide to each stage of exhibiting so that any potential exhibitor or curator can take some control of the process. The chapters therefore follow a chronology from thinking about exhibiting to the tasks undertaken during the period when the exhibition is open to the public. Providing an overview of this kind invariably means that the process can be oversimplified; there's a danger of suggesting that there is a right and wrong way to approach exhibiting, that all exhibiting photographers will follow the same route and that all photographs are part of a single discipline with standard methods of presentation. Of course none of this is true, and I have attempted to include enough diverging and contradictory views to make it clear that photographers and artists have to make the choices that suit them, their work and their showing circumstances if they are to sustain a long-term and personally rewarding exhibiting career.

Thinking about Exhibiting

The Salon Photo Prize at Matt Roberts Project Space, Vyner Street, East London. Image © Georgina McNamara www.georginamcnamara.com.

Exhibitions have become the medium through which most art becomes known. Not only have the number and range of exhibitions increased dramatically in recent years but museums and art galleries such as the Tate in London and the Whitney in New York now display their permanent collections as a series of temporary exhibitions. Exhibitions are the primary site of exchange in the political economy of art, where signification is constructed, maintained and occasionally deconstructed. Part spectacle, part socio-historical event, part structuring device, exhibitions—especially exhibitions of contemporary art—establish and administer the cultural meanings of art.

From *Thinking about Exhibitions* (Greenberg et al., 1996)

In the 1970s, the photography world began to evolve quickly: major museum exhibitions, the teaching of the history of photography, the incorporation of photography into art historical texts and general art periodicals, and the success of the international auction houses all enhanced and contributed to the interest in collecting photography.

From *Inside the Photograph* (Bunnell, 2006)

In 1950 a professional photograph was typically a 10 × 8 in (25 × 20 cm) black and white print that was passed to a designer and then a printer to appear in a magazine. It was then discarded, filed, or forgotten. In 1980 a professional photograph might also be a handsome work of graphic art, generally twice the size of its predecessor. It might be made by hand, in one of a variety of craft processes, expressly for exhibition in and preservation by museums. It was usually made to last: printing was to archival standards. Quite frequently it was issued in a signed and strictly limited edition.

Mark Haworth-Booth, from *Photography: An Independent Art*

I have never been interested in exhibitions because I think in a way you tend to be preaching to the converted. And I've always really been interested in the printed page because that way you get to more people with what you're trying to say and the sort of photography I do is trying to say something about people to other people that might just influence them—I'm not trying to change the world but it might affect the way they're thinking. But because of the downturn in the mag market if you want to be seen and get assignments one of the few ways now of having people see your work is to have exhibitions because who sees anything in the magazines?

Ian Berry, Magnum photographer, National Sound Archive interview

My biggest advice would be to take the pictures you want to take. Don't think about the marketplace, what sells or what an editor might say. And don't think about style. It's all bullshit and surface stuff. Style happens.

David LaChapelle, photographer

While historically the importance of exhibiting for photographers has shifted and changed, over the years exhibition has, arguably, never been more crucial to the medium than it is today. Many photographers leave college with their sights fixed firmly on an exhibiting career and for many photographers an exhibition is the desired outcome of any piece of work. But it is worth considering what this might mean, when and how photography belongs in the gallery and museum, how it can adapt itself to these institutions, what alternatives there might be and what role the photographer plays in bringing their work to its audience. In making

work the photographer may or may not think about exhibiting but the very chameleon qualities of photography makes it crucial that the photographer consider the context in which their work is shown. So we start by thinking about what it means to exhibit photography.

What is an exhibition?

There are very many situations in which photographs are viewed that can come under the term exhibition. In this I include:

- any conventional exhibition space (which can include commercial and publicly and privately funded galleries and museums)
- a variety of other spaces where work is sometimes shown (such as community centers, open studios, cafes, bars, restaurants, libraries, cinema and theater foyers, schools, colleges, churches, and streets)
- commissioned public art (which can be permanent pieces commissioned especially for public buildings such as hospitals and government offices or more temporary sites and situations such as hoardings, projections, performances)

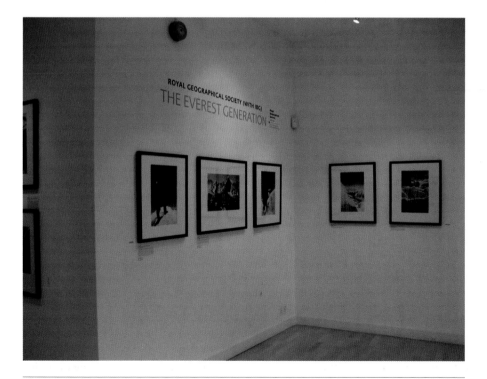

The Royal Geographic Society show mountaineering photographs from their archives at Hoopers Gallery, 2011. Image © David Scull, courtesy of Hoopers Gallery.

Fotomuseum Den Haag, Nederlands. Image © Karin Bareman.

- people's homes (through sales and loans)
- online galleries, social networking, and websites
- temporary spaces or events (such as photo fairs and festivals, talks, workshops, and conferences)
- photographic commissions and competitions, which result in an exhibition
- printed exhibition—related materials (such as catalogues and gallery guides, self-published books, and press images)
- CDs

It may seem surprising that this list includes such outlets as speaking engagements and sending out press prints or CDs, but it is useful to recognize that these are exhibition opportunities of a particular kind. They are a time when, just as in a gallery, the photographer's work is being seen by a new audience and quite possibly without the photographer's presence and input to the viewing process. So the work has to stand by itself and will be assessed accordingly.

The important thing for the photographer is that he or she needs to be sure that their work can be presented well in any context, that appropriate information is available, and that the work will be treated with respect in any situation. Press photos and CDs, for example, should always have detailed information attached and include the name and contact details of the photographer and the title and date of the work. Contact information should be included in the metadata on all digital files. If the photographer sells work or gives or exchanges it with friends

or colleagues, it should have the same information and substandard prints should never go out of the work space even as press prints or gifts.

The myths of exhibiting

I completed a major piece of work and then sent out the usual promotional information to curators and editors. Much to my dismay I heard nothing for over a year—then out of the blue, in the space of a fortnight, I received exhibition offers from two curators. My advice to photographers is not to give up or lose confidence in the work. Don't put it away and forget it!

Grace Lau, photographer

So what do we expect from an exhibition? It is useful to think about this before starting out on what can be an all consuming process. First-time exhibitors in particular tend to have several, sometimes contradictory, preconceptions about the process of exhibiting their work. These can be misleading and can lead the exhibitor to build up unrealistic expectations of an exhibition with the inevitable disappointing result.

The first of these misconceptions is that exhibiting is either a simple and straightforward or a mysterious and bewildering process. Neither is true. Organizing an exhibition does require specialized skills but most of the skills involved can be understood and learned by any photographer. Acquiring some experience and skill in exhibiting will make the process more rewarding and mean the photographer is not overwhelmed by the numerous, and sometimes unexpected, deadlines and tasks. It can also mean that working with a curator becomes a sharing of ideas and decisions rather than a process in which the curator has always to take the lead throughout.

The second misconception is that the rewards of exhibiting will be instantaneous and exciting. Photographers frequently hope that their first show will make them a star overnight or, at the very least, bring them a great deal of critical attention. Perhaps because the private view or artist's reception is an absolute deadline—which feels similar in its drama to an opening night at the theater—photographers expect the same sort of applause and critical response. Unfortunately, although the build-up and the tension may feel the same as in the theatre, the response may be very much slower in coming. New plays are often reviewed overnight, whereas new exhibitions may be reviewed only weeks later or even after the exhibition has finished. As a result, the photographer may be disappointed by what seems a tepid response to his or her work.

It helps, then, to be realistic about expectations and to recognize that an exhibition is a rewarding process in a number of very different ways, which may take time to come to fruition. It is equally useful to understand that the process, especially for first-time exhibitors, can be adrenaline-fueled and that exhibitors may feel exhausted and deflated for a few days or weeks until their creative energy kicks in again. The experienced exhibitor may either get used to this creative low or may need to make a habit of arranging a break from work immediately after an exhibition opening.

The third myth is that exhibition sales are a verdict on the work's intrinsic merit. As a colleague said to me, 'It was difficult to ignore the presence—or worse, absence—of those red dots and not feel competitive angst.' Over the last decade, as photography has become more popular and as sales through galleries and auction houses have boomed, selling has come to be seen as a marker of photographic excellence and students encouraged to develop a signature style, in part to make the work more marketable. This goes hand in hand with a celebrity culture in which the press is often as interested in the artist as the work. In fact, of course, people buy photographs for many reasons—from their investment value to coordinating an image with a domestic colour scheme—and the artist is well advised to keep a level of detachment from the opinions of the marketplace. 'Difficult,' experimental, or very personal work may not sell at all. At the end of the day, a real sense of the success or failure of the work can only come from the artist themself and from a trusted group of colleagues, critics, and curators.

Reasons to exhibit

Most photographers take it for granted that an exhibition is a desirable outcome for a photographic project, without examining their reasons in any depth. There are, however, a number of quite different reasons to exhibit. Not all of them will be true of every exhibition prospect, and it is useful to be able to recognize which ones apply in order to evaluate what each exhibition does or does not offer and to be realistic about the rewards of exhibiting.

Reasons to exhibit include:

* getting the work seen

 This is the most obvious reason to exhibit. Photographs are taken to communicate, and they cannot do so if they never leave the photographer's work space.

* selling photographs

 This is important for more reasons than the obvious one. Selling work is one way of ensuring that the photographs are in circulation and continue to be seen after the period of the exhibition. An exhibition in which a photographer sells work will also tell the photographer what sort of images people buy and which are popular. There can be a danger in this: if a photographer lets the knowledge of what sells drive his or her work, it can make it hard to take risks, to experiment, or develop new ideas. Some galleries will also, and for obvious reasons, encourage their artists to focus on making work which sells and lack interest in other areas of their work. So it is useful for most photographers to keep a level of detachment from the selling process and recognise when the work is starting to feel stale and when they need to develop in a new direction rather than produce more of the same—showing work which does not sell can be just as important as showing work which does.

* it's a career marking point—that is, photographers need to be seen to be showing their work

Sian Bonnell in *Domestic Interiors: Regency Town House*, in Hove, England. Image © George Meyrick.

An exhibition shows that a photographer is a professional and serious about his or her work. It is, perhaps, the equivalent of producing an annual report or taking an exam and demonstrates, both to the exhibitor and to the worlds of photography and business that the photographer is on track.

The exhibition also appears on the photographer's c.v. or résumé, and in some ways this can be as important as the exhibition itself. A good track record of exhibiting is crucial to the photographer who wants to build an exhibiting career and is a pedigree that guarantees the work. When looking at a portfolio, any major gallery director or curator will probably also want to see the photographer's exhibiting c.v. or résumé and the strength or weakness of this may well influence the decision to offer an exhibition.

• to get feedback about the work

This does not mean just waiting for reviews in the photographic press. An exhibition is a major opportunity for the photographer to get informed feedback from friends and colleagues, other photographers, and professionals in the field of photography. The audience at the private view will let the photographer know how they receive the work, if they understand it, and whether it succeeds in doing what the photographer intends. The photographer, however, must be ready to ask for responses to the work and to listen carefully to what is being said about it. Many galleries will arrange a talk by the photographer for exactly this reason. During the hours when the gallery is open to the

public, the gallery staff can actively seek feedback, and it is a good idea to ask them in advance to make sure they pass this on.

It is useful for photographers to know whose comments they want to hear and will value and to be ready to seek those out. They should also be prepared for unhelpful or even positively destructive comments though, on the whole, other people's insights can be liberating. Very occasionally, a life-changing insight will be offered, and the photographer needs to be aware that a complete stranger could understand and appreciate his or her work better than anyone they have worked with to date.

- it's good practice

Every exhibition is a learning opportunity. Each is different, and every time photographers exhibit their work they will learn something new about exhibiting, about how to show work, what works and what does not and how it will be received. Much of what a photographer learns is practical—for example, how long to allow for each stage of the process, which frames best suit their images, or how to write about their work. Over time it gets easier to do and becomes more rewarding, more creative, and more enjoyable as a result. Becoming more confident about exhibiting and building up a store of knowledge and ideas about presenting images is also one of the things that can progress the work itself. Not exhibiting, even occasionally, makes it much harder to start doing so at a later stage in the photographer's career.

- it marks the completion of the work

An exhibition usually marks the end of a particular piece of work. It is the moment at which the photographer can stand back from the photographs, assess the work, listen to other peoples' assessments, understand the successes and failures of the work, and draw a line under it. Having learned the lessons and evaluated the project, the photographer can then let the work go and move on to a new theme or project. It is very easy for a photographer to become overly attached to a particular piece of work, subject, or style of photographing, and an exhibition is a good way of making sure not to get stuck in this way. Even if the photographer expects to pursue a single subject matter for their whole working life the process of exhibiting it will mean that it can be subdivided in ways which should help the photographer to move the entire body of work forward.

- to build up connections and a mailing list

An exhibition is one of the times when a photographer learns who is genuinely interested in his or her work and will support them and the work. This could be buyers, curators, galleries, critics, other photographers, friends, or acquaintances. It can be surprising and unexpectedly rewarding.

A photographer will need to build his or her own mailing list and not rely on a gallery mail out (which may not be specifically appropriate to their work), and this is a good moment to add names to it. Most photographers are helped by having an informal support group of people who they know understand their work well and who are invited to every exhibition; it often only becomes clear who these people are when the work is being exhibited and they show their interest in it. A visitor's book can also be a useful

starting point for this. If exhibition visitors show interest in the work, the photographer should always be prepared to ask if they would like to receive future mailings and ask for a business card, e-mail, or address.

• it'll lead to something else

No one can predict what an exhibition will bring the exhibitor, or who will see it. It might not be a major review or a huge sale, but it could well lead to an offer of some teaching, a commission, a magazine spread, a further exhibition, or new colleagues whose insights into the work will enrich it in the future or who will support the exhibitor in other ways.

POSSIBLE OUTCOMES include:

• Sales

• Reviews and useful promotional material

• A catalogue that can be distributed widely and will outlast the exhibition

• New contacts including new working groups

• An approach by another gallery

• An exhibition tour

• A publishing proposal

• Related work; invitation to show all or some of the work in a different context (a group show, for example); teaching, talks, commissions, residency

• Feedback (positive or negative)

• Strengthened relationship with a curator

• c.v./résumé entry

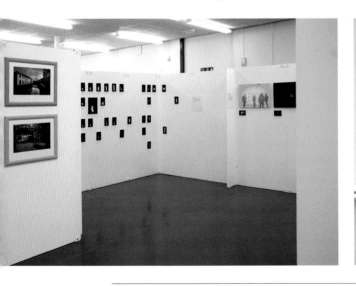
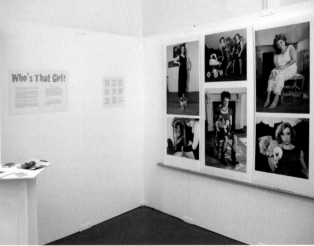

MA photography show De Montfort University, Leicester, England. Image © Mike Simmons.

When not to exhibit

It is worth remembering that there are times when one should turn down an opportunity to exhibit. Exhibiting can be stressful, time consuming, expensive, and unproductive and, although it is always flattering and exciting to be asked to exhibit, it is a good idea to be able to recognize and avoid situations that will be damaging to the work itself or to the reputation or confidence of a would-be exhibitor.

Before entering into a contract, even a verbal one, with a gallery or a curator, the would-be exhibitor should be asking a lot of questions, both personal and practical. It is useful to be able to recognize potentially difficult situations early in the negotiations for a show rather than later. Declining an invitation to exhibit or withdrawing early on from an exhibition, for whatever reason, is acceptable practice, and the situation can be handled politely by both artist and gallery. Once an exhibition plan is well advanced, however, it may be impossible or damaging to withdraw, and the exhibitor may well be letting friends or colleagues down or gaining a reputation as an unprofessional or uncooperative artist.

Two examples of this from my own experience illustrate how artists can handle this situation in exactly the right or exactly the wrong way. I once asked an artist who had just started on a major commission to show in a group exhibition planned for several months in the future. We had never met but spoke on the telephone. She said she would like time to think about it and would get back to me within two weeks. When she phoned back, she said she felt she would have to decline the opportunity because she needed time to let her work develop at its own pace without thinking about the completed project and did not want to put that kind of pressure on herself when she was just starting new work. Although I was sorry to lose her input, I was very pleased that she had not risked the show, and I retained a great deal of respect for her as an artist who was able to make a clearly difficult decision.

Almost the opposite situation developed when I was co-curating a small group show with a short deadline with a colleague from another gallery. My colleague had an agreement from an artist he'd worked with before to take part in the show but, when we tried to arrange collection of the photographs, we were told that the artist was out of the country and had left no instructions. When contacted he denied the arrangement had been made, and a flurry of correspondence failed to sort this out in time for him to show. The exhibition went ahead without him, although it was too late to change the publicity material that included his name. We had the documentation to prove the arrangement had been made and afterwards realized that he had simply been too pressured to deal with making the arrangements but his denial of responsibility and the embarrassment that ensued left us both resolved never to work with him again.

An exhibition can go wrong for many more reasons than these and so the would-be exhibitor needs to look at each exhibition opportunity before making a commitment and ask a very simple set of questions about whether the reasons for exhibiting outweigh any possible reasons against. Some basic questions to consider are:

• Is this a gallery with a reliable curator and staff?

• Is this a good space? Will the work fit it and look as it should?

- What is the gallery's reputation? Will the work be shown well and professionally? Will showing enhance my reputation or might it damage it?

- Might the work be physically at risk (of damage or theft for example)?

- Will it be well publicized?

- How much of the work for the exhibition will be done by the gallery and how much by the exhibiting artist? Has this been made clear at the beginning of the process or might there be unvoiced expectations by the gallery?

- Who pays for what, and what financial deal is on offer?

- If this is a group show who else is showing and how will the photographs work together? Could one body of work dominate to the detriment of others? If the group is organising the show itself is there enough experience and organisational skill to do it well or might the group members squabble?

- Is there enough time to do this well? Is the proposed deadline realistic? Can I assess the amount of work involved and fit it in with my other commitments?

Each exhibiting opportunity has its own particular circumstances. Only the would-be exhibitor can assess the opportunities and risks involved and decide what will be worth doing.

Although every situation differs, some to be wary of are:

1. When the curator or venue is disorganized or unprofessional. This may seem obvious, but sometimes it is difficult to recognize when a gallery will fail to take good care of its artists. Things to check include whether the gallery is properly insured and staffed so the work itself is not at risk of being damaged or stolen; that the gallery is offering a decent financial return on work sold; that the gallery looks good and can display the work well and it will do so for the whole period of the exhibition. It is worth visiting a gallery mid-exhibition to check; I have done this and discovered the gallery, which had been immaculate for the opening night, was dirty and untidy and the temporary invigilating staff unwelcoming three weeks after the opening. I have also made the long journey to an out of the way gallery only to discover it was closed, for no very good reason, during the hours it was advertised as being open. Most important of all is to check the gallery's reputation with other photographers. A gallery that consistently fails to support its artists will soon gain a bad reputation among artists.

2. When the work is not ready or it is the wrong time for the artist. This can be difficult to judge. It could simply be that the deadline is too close and the work incomplete. Or the work may not be ready in a way that is harder to define but means that the artist needs time to continue to think about it. These sorts of decision have a great deal to do with the way an artist works, and only the prospective exhibitors can decide what is right for them. Some people, of course, thrive on pressure, so a tight deadline means they produce great work while others need to take it slowly and so flounder and fail when stressed. Exhibiting is a creative process in itself, which can engage the exhibitor as

fully as making the work did and can leave the artist exhausted and drained if he or she is too busy to give the exhibition the level of thought it demands.

3. When the showing situation cannot be negotiated and work could be shown unsympathetically. You want your work to look its best and represent you in the best possible way every time it is shown. If the work is hung when the exhibitor is not there the photographer needs to know that it will be shown well. No exhibitor wants his or her work to be shown unsympathetically, in a poorly lit corridor next to the lavatories or juxtaposed with work which overpowers it or is by much stronger or weaker photographers. Exhibitors also need to be aware of the way other artists' work impacts on theirs—it might seem attractive to be the strongest artist in a show, but the context will reflect badly on all the work if is not of a consistent caliber.

4. When the exhibition venue is in an organization that does not understand or respect the exhibition process, usually because it is not their primary purpose to exhibit. This can mean that the venue will be unreliable. I have, for example, booked an exhibition into the exhibiting space of a central London college where I taught. Although I booked this well in advance, the exhibition was cancelled at the last minute by the department head who had decided to use the space for something else. After some difficult negotiation and a great deal of additional work, the exhibition was shown later in the year. For the students, who were all first-time exhibitors, it was a tough lesson on the perils of exhibiting. For me, it was an example of unprofessional practice and not untypical of venues like town halls or hospitals which like the idea of exhibiting but leave the organising to a committee or to someone who has other priorities. Other examples include venues which close an exhibition without warning during its run; allow work to be removed from an exhibition when sold and move or block the work from view. A professional gallery will announce its program and stick with it; be absolutely rigorous about opening as announced and do nothing to undermine the work on the wall.

5. When the financial burden of showing could be too great. Exhibiting has become increasingly expensive over the years as standards of presentation rise and rise. Transport, printing, mounting, and framing work, as well as the time involved, can make it uneconomic for the artist if the exhibition is unlikely to sell, be widely seen, or reviewed. For instance, if an exhibition period is very short or in a gallery with few visitors, it may well not be worth the costs incurred. If the work can go on to be shown elsewhere, using the same mounts and frames, then the investment is more likely to be rewarded.

6. When the work has already been shown a number of times. Many galleries anyway prefer to show work that has not yet been seen. It is also possible to show work too often. Although it can be difficult to recognize when your work has been overexposed, and though it may be tempting to accept yet another invitation to show, sometimes the artist is the only person who can see that it is time to disengage with this piece of work and move on. With luck the work can be shown again at some point in the future.

Making an exhibition plan

For most photographers who are just starting out, the most difficult period is usually the few years after leaving college. This can be when no one seems interested in looking at or showing the work, and the practical, emotional, and technical support systems provided by the college are no longer there to keep the photographer focused on his or her work.

This is the time for the photographer to think about:

1. making a short-term exhibition plan
2. making an individual exhibition plan
3. ways of promoting work to support and back up exhibiting (see Chapter 2)
4. how to find or create good support systems (see Chapter 2)
5. learning how the exhibition system works (see from Chapter 4)

My colleague, Mary Familiant, suggests that you should identify your goals. 'Ask yourself these questions: What kind of artist do I want to be? What are my goals and values? Who is my target audience and market? Your answers to these questions will enable you to make choices that define and direct your career. When you have the answers to these 'goal' questions, you can 'reverse-engineer' the steps it will take to get there. Write your life history from the future to the present, rather than the other way around!'

Making a short-term exhibition plan

Over the years it has become harder for photographers who are just starting out to get a foot on the exhibition ladder. However, although chance and opportunity play a part in an exhibiting career, there is more than one possible route to follow. Why wait until a gallery approaches you? Photographers usually need to be proactive about exhibiting but never more so than when they are first starting out. Many galleries will be booked up, many have more applicants for exhibition than they can deal with, and increasing numbers of galleries no longer look at applications and only show exhibitions by invitation. This is the time to look at alternatives and, in the short term, to prioritize getting the work seen as part of a strategy of learning to exhibit professionally and of finding a gallery with which to establish an ongoing, long-term relationship.

Some possible exhibition strategies for a group or individual to consider include:

- hiring a private gallery for a regular exhibition at the same time every year
- holding a regular 'open studio' weekend
- looking for smaller, informal commercial spaces (cafes, restaurants, clubs, offices, cinema and theater foyers, for example) that will show photographs
- setting up a small group of photographers with similar concerns to show regularly together—a group can share or rotate the tasks of finding exhibitions or setting up an exhibiting website or can employ someone to do it for the group

- entering exhibition-based competitions on a regular basis, especially when juried by influential gallerists or curators

- keeping in touch with one or more supportive curators who may remember the work when planning a show or mention it to other curators

- when working in a particular genre or on a theme or issue recognizing that there are interested groups with related magazines, venues, or other outlets who may be interested in showing or promoting the work and researching and approaching those. For example, there are specialist magazines for skateboarding, dance, landscape, music, and so on, all of which may well lead to exhibition opportunities for photographers who share that particular area of interest.

If a photographer wants to focus on producing new work rather than exhibiting, then it may well be useful to plan to show the work at some point before the project is finished rather than to wait till the work is complete. Showing informally once or twice a year is a useful practice

Part of the installation of Hannah Collin's *Drawing on the City* at Caixa Forum, Barcelona. Image courtesy Hannah Collins.

that keeps photographers alert to how their work is progressing. Work in progress can be shown fairly informally in the photographer's studio or work space where the presence of the photographer is an incentive for visitors to talk and to buy work, and the inclusion of a portfolio can be an invitation to browse. An audience can be invited through the photographer's own mailing list of professional contacts, colleagues, friends, and family and, because for most people seeing work in the artist's own work space is fascinating, attendance is usually good, and the afternoon or evening can become an important event in the social calendar. If the photographer is not showing elsewhere, this is a particularly good way of making sure that their work does not disappear from the public gaze and that one does not lose the skill of talking about one's work. It's also useful to make a 'work in progress' show a regular event so that both photographer and audience expect it at certain points in the year.

Making an individual exhibition plan

If photographers look at what suits their work pattern and their circumstances and think about making an exhibiting program that will suit their individual needs in the long term, they can then work to make sure that exhibiting fits into their working life rather than disrupts it. It is usually useful for photographers to be able to identify, by trial and error or by looking at the way they work, how much and how often they want to exhibit and what sort of priority to give to exhibiting.

Over a period of time, most artists and photographers develop a work pattern that is specific to them. Although some are prolific, consistently turning out new ideas and images, others may take years to complete a particular piece of work. Some photographers like to keep their focus on a single project, while others may combine working on both short- and long-term projects.

Exhibiting has a similar sort of internal dynamic, and it is useful to realize that there is no single model here, no 'right' way to make an exhibiting career. Nor is there a standard number of times to exhibit over a particular period. Different photographers have very different exhibiting careers and exhibit their work for different reasons, and it helps to be aware of what suits each person and their work. For some photographers, exhibiting regularly and accepting every exhibition opportunity is their main aim, whereas for others an exhibition is an occasional event, a time when they have completed a long-term project or want to bring together and exhibit work which has not been seen in its entirety before.

For most photographers, a good starting point for assessing the impact that exhibiting will have on their working life and deciding how large a part they want exhibiting to play in their work is to look at the amount of personal input and work an exhibition requires. Finding a balance between exhibiting too often and too little can be a personal decision or it can relate to practical issues like how difficult it will be to frame, transport and install the work. For some artists the exhibition is everything and the work designed with exhibition in mind so the process is straightforward, whereas for others it is secondary to the making of the work and needs to be considered only when the work itself is complete.

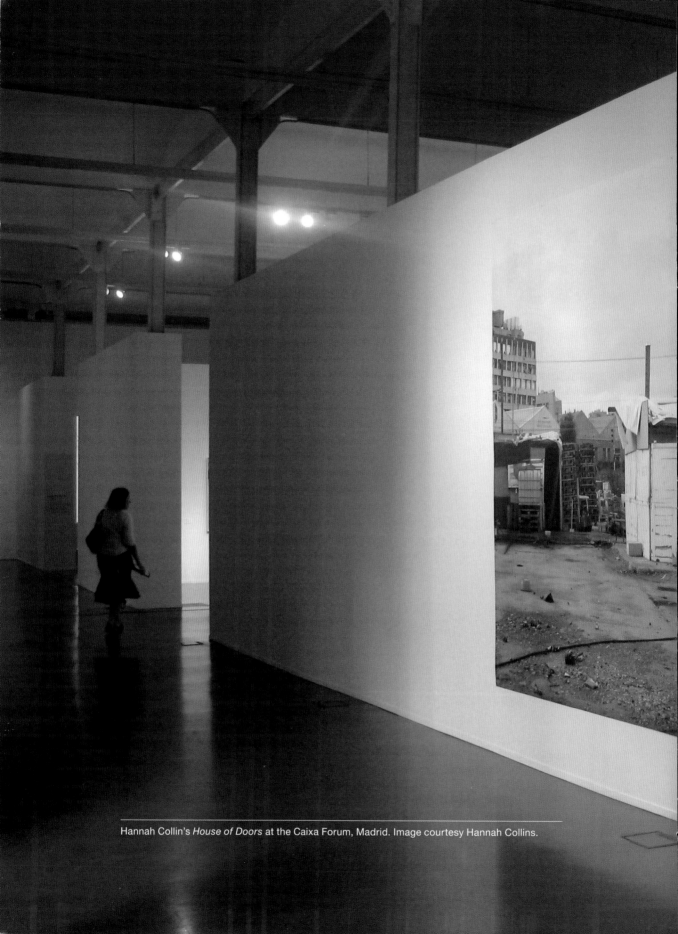

Hannah Collin's *House of Doors* at the Caixa Forum, Madrid. Image courtesy Hannah Collins.

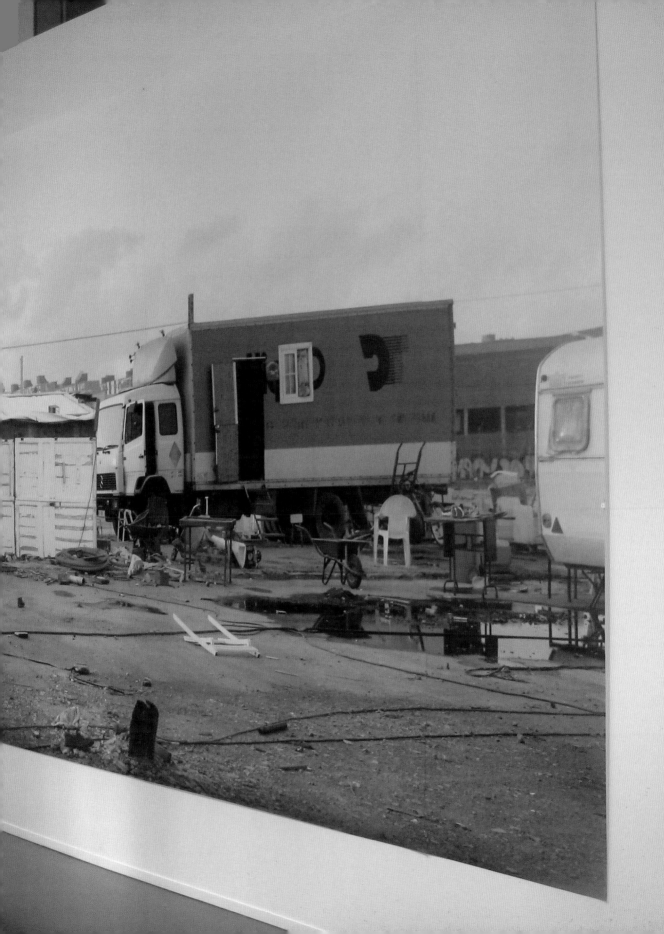

Another factor to think about is how the photographer reacts to feedback. Photographers who finds it hard to take unthinking or adverse criticism or to let go of their work might consider waiting until that work is absolutely complete, or until they have a sense of having let go of it, before exhibiting and finding out how the work will be received. But sometimes the decision one makes about exhibiting is simply about whether one enjoys exhibiting and finds it a process that advances the work or not.

Planning an individual exhibition program is about taking some control of the exhibiting process. This means that the photographer can decide to work on the aspects of it he or she can arrange for him or herself, like deciding to show regularly with a local group of photographers or holding an annual open studio show. At the same time, he or she might be negotiating with a gallery elsewhere or regularly entering work into competitions. A photographer may decide to start out by showing as much and as often as they can for a time and then settle into a routine which suits them and the way they make work. A strategy should be varied and adaptable, have both long- and short-term projects in it, as well as challenges and certainties; but above all it should suit the way the photographer works.

Creating Support Systems

Your resources file

A good starting point for the would-be exhibitor thinking about ways of promoting their work and finding or creating good support systems for themselves is to start a resources file (see checklist in Appendix). Having a personal list or file of photographic and exhibition resources and suppliers is very useful, and even doing the preliminary research for this will be helpful in thinking through the tasks of exhibiting and should save time when you come to exhibit.

It should be specific to you rather than general. Most of the resources also need to be fairly local to you. It will take time to build up and need to be regularly updated—as your work develops you may need to find a different type of framer, for instance, and you should add names and contact details to your mailing list with every exhibition. Asking other photographers is one of the best ways to start to find out which are the most reputable and reliable shops and firms; finding out which ones best suit your needs will take longer.

It can also usefully include funding information. In Britain, this is likely to be the Arts Council and regional arts boards as well as charitable foundations, businesses, and arts-related opportunities such as residencies, competitions, and commissions. In the current recession new funding opportunities are being created online. For example, kickstarter is an online platform for funding creative projects (kickstarter.com). In America, grant information can be found on the New York Foundation for the Arts (NYFA), the Society of Photographic Education (SPE), or the Chicago Artist Resource (CAR) websites.

Promotional tools

A photographer can choose to use a number of promotional tools that have different and complementary uses. These include business cards, postcards, e-mailed images, CDs, portfolios, and websites. All of these have application beyond the gallery system and are useful ways for photographers both to keep a record of their ongoing work and to reach a wider audience.

Business cards including a card display box which can be used when the work is exhibited. Image ©
Georgina McNamara.

Business cards

A standard sized (3½ × 2 inches/9 × 5 cm) business card can be easily kept in the photog-
rapher's wallet or purse and is generally useful when making new contacts. It should be simple
and clear and needs no more description than 'artist' or 'photographer' after the name.
Photographers who work from home can use a box number on the card, available at the local
post office, if they move frequently or want to keep their address private.

The card does not need to have a photograph on it, unless the photographer intends to
keep reprinting cards, as the image will quickly date and could be too small or poorly repro-
duced to read well. It can also be a mistake to select a single image to represent a photogra-
pher's body of work, since one image can rarely do this adequately. Using a single image
can prove counterproductive because it may well be taken as suggesting that the photographer
has only one particular style or set of interests when in fact their range is much broader and
more varied.

Postcards

Postcards are a good way for photographers to promote their work whenever they are in touch
with anyone. Postcards have all sorts of uses: as a record of the work, they can be a reminder
for potential clients and curators and as a compliment slip when sending out information.
Most people enjoy postcards, and they are a good way to circulate an image. Think, for
example, of how many are picked up if they are provided at opening views and receptions

'The Old Fire Engine House in Ely, Cambridgeshire is primarily a restaurant with lots of pictures on the walls and a gallery upstairs. For their shows you write your own press material, design your pv card yourself and your poster too if you want to. I found the exhibition very useful as a springboard for contacting other galleries and promoting my work and will continue to use this card to do this long after the exhibition has closed.' Image River Great Ouse 10,13 & 16 © Elizabeth Ikin wwwelizabeth-ikin.co.uk.

or how visitors buy them as a record of an exhibition they have enjoyed. I can remember the pleasure of walking into the London office of Magnum and seeing a colleague's card pinned prominently above a desk. I also keep a large index file of postcards by contemporary photographers, filed alphabetically, as an aide memoire and as a teaching tool. If a photographer has not been published, this may well be my only visual reminder of his or her work.

However, postcards can have a short shelf life if the image is going to date. Printers usually print in runs of 500 (although some will do short runs of 100) or more, so the photographer needs to feel confident that he or she can distribute a large number of postcards over a period of about a year, lest he or she end up with a lot of redundant cards. Choosing an image that makes a good postcard needs to be done thoughtfully, since the image must work well as a single, strong, standalone image that will represent the whole of the photographer's work and will not need additional information or date quickly.

CDs

CDs are very useful in that they can be posted or left with a potential client or curator as a reference, record, or reminder. However, in my experience, they are not always an adequate substitute for a print, as most curators prefer to see prints when making decisions about an exhibition. This is in part at least because the CD may not accurately represent the image.

CDs should be simple and easy to access. It is not necessary to add graphics or design elements to enhance the information. The sleeve should include the photographer's name and contact details, the title of the work, the date, and a subtitle or brief description of the project

if it needs some explanation. On the CD itself, the images should be sequenced, titled, and captioned. Numbering them will help if the work should be seen in sequence.

This advice may seem obvious, but it is something that photographers frequently get wrong because they are too busy to be meticulous about labelling information or to think through tailoring a CD for a particular situation. If you have made several copies of the same CD for use in a variety of situations, you need to be aware that there is nothing more disheartening for a curator than skimming through what appears to be a random collection of images in search of the one or two that might fit with the theme of the exhibition. The photographer needs to ensure that the CD labelling and/or file names and arrangement make it clear to the curator (or other recipient) which images are being offered for consideration; a covering letter can also help to clarify the photographer's intention.

Here is an example of how this can go wrong: I recently asked a photographer to send me a specific set of about six images for an exhibition proposal I was making on behalf of four photographers all working on the same theme. I know his work well, explained the proposal to him in some detail, and was clear about which images I wanted. He sent me a CD that included twenty images from about five different projects. Some of the images did not relate to the project I had talked to him about, the captions clearly were for his reference alone and were a sort of shorthand I did not understand, and there were no contact details on the CD. I spent some time labelling the sleeve and providing backup information related to the exhibition proposal. I knew that without this, the CD would not have been considered by the gallery director I was sending it to—but the photographer should not have let this happen. He could, and should, have made sure that the CD related directly to the exhibition application he was being asked to make. If the images had been numbered or captioned well originally, this would have taken less than five minutes; but unfortunately they were not, so it took much longer than it need have to make it clear which ones were relevant to the proposed exhibition.

The photographer must also be certain that the image accurately represents the colours that can be replicated in an exhibition print. At the same time, he or she needs to make sure that the image resolution is such that the image can be read from the CD but not reproduced or the work may be used without their permission.

Portfolios

One of the most useful things any photographer can do before approaching a gallery is to take their work to a portfolio review session at an event like the Houston FotoFest or Rhubarb-Rhubarb. The reviewers have a range of different expertise and their comments will be invaluable in shaping a project and in giving the photographer confidence in their work.

Zelda Cheatle, WMG Photography Fund Portfolio Manager

One of the best vehicles I've found for getting work in front of over 200 curators, editors and collectors is Photolucida's Critical Mass. This annual call for portfolios is a two-stage review that culminates in the selection of the top fifty photographers and one finalist.

Mary Familiant, photographer

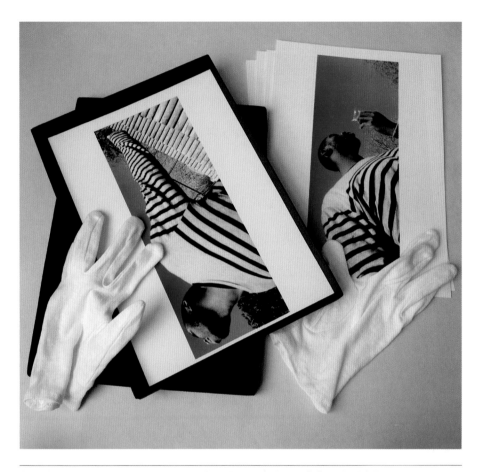

A portfolio box and cotton gloves used for handling prints. Image © Georgina McNamara.

Artists who present their work at portfolio sessions for critical comment and advice should recognise that it's their responsibility to prepare in advance and to know what it is they want to gain from the experience.

John Gill, Director, Brighton Photo Biennal

A portfolio is still an essential tool for a photographer who wants to exhibit his or her work, even though some of the work done by portfolios can now be done on the web or using CDs. A portfolio is usually needed for meetings with curators and galleries both when initially selecting work and at a later stage when considering an exhibition hang. This is because deciding on which prints to use and what sequence to use them in is best done when one can see actual print quality and physically move images around to see how they work when juxtaposed.

A portfolio should be small and flexible to use; small both in its dimensions and in the number of prints the box will hold and flexible enough to arrange so that it can be used on one occasion for a meeting with a curator and then rearranged as necessary for other meetings. Two good alternatives are a bound book and a smart box of prints; both of these need to use archival-standard materials. At one time many photographers used large folios and carried exhibition-standard prints in the folio. This is no longer current practice, and a 10×12 or 12×16 inch folio or box is more usual. A book or box this size is easy to handle and show whereas it is not always possible or appropriate to take a very large exhibition print to show in what may be quite a small or cluttered space.

Choosing between a box and a book is largely a personal preference. Both allow the photographer to rearrange the images for different occasions. The advantage of a box of prints over the more traditional portfolio is that it looks contemporary and is easier to arrange and rearrange and it makes it easy to hand around prints if several people are looking at the work. It can also be used to store a large number of prints between appointments or the photographer can store each completed project in its own box. The boxes should be specialist boxes of acid-free board, and prints should be stored in archival-standard clear envelopes to protect them from careless handling. Such boxes can be bought from specialist photographic or graphic design suppliers. However, many people still prefer traditional book portfolios, particularly when photographs need to be kept in sequence. Book portfolios also help ensure that photographs will not go missing, as they are unlikely to be taken out of the folio during a showing.

The purpose of a portfolio is to show a curator a potential show rather than to display all of a photographer's strongest images. So, the first rule of making a portfolio for this purpose is to put together a single set of strong photographs that work together. Most people make the mistake of including too many images in their portfolio. Twenty photographs is usually a good maximum number to show anyone unless they have specifically asked for a larger selection. Photographers should be prepared to edit their work ruthlessly and exclude repetition. It is better to have a set of ten interesting photos than twenty or thirty that include several versions of the same thing and dull or poorly printed images.

Most curators look at a large number of portfolios on a regular basis and will know within the first minute whether the work interests them or not so, however hard it is to do, the photographer's task is to pare the work down. Additional images can be included as sheets of reference thumbnail prints, a small self-published book or a CD to be left with the curator who expresses interest in seeing more or a second meeting can be arranged.

It is also always, as in every showing situation, important to put the photographs in a good sequence. The order of the images should be carefully considered so that they flow well from one image to the next. The skills of editing and sequencing work can take time to acquire, and many photographers find it hard to edit their own work (see Chapter 4 for a description of the process). If this is the case for you, it is worth inviting a trusted colleague to help, as other people sometimes see our work more clearly than we do. A second opinion is always useful, too, in that it encourages us to question our assumptions about what does and does not work.

Keep the design of the portfolio or box simple and clear. It does not need elaborate graphics. Remember, most people you'll be showing it to will probably give it about fifteen minutes of their time, and you do not want to distract their attention from the images with graphics or too much information. It may be tempting to try out some very contemporary presentational methods, but unless you are really skilled, you may well end up looking amateurish rather than slick. This is a moment to play it safe.

Everything in a folio or box should be presented in a consistent way so that nothing distracts from the photographs themselves. For ease of viewing, to keep a sense of the flow of the images, and to avoid breaking the viewer's concentration, prints should be consistent in size, color, contrast range, paper type, and finish, as far as is possible. This may well mean reprinting an entire set of images simply because they may not look like a set if they have been printed at different times and are all slightly different sizes or paper types. For the same reason, when you have a mix of landscape (horizontal) and portrait (vertical) photographs, both should be printed so they can be viewed without having to rotate the folio—either all the landscape photographs should be printed across a portrait page if most of the photographs are portraits, or vice versa. All the photographs should be in the same position on each page with the same amount of border all around. If the pictures are almost but not quite the same size, it is possible to make the whole look consistent by making all one set of borders, either above or below the image, the same depth.

Images in a folio or box do not usually need to be mounted on card. However, if they are to be presented on card and with the card visible, the image should be trimmed to its edge and mounted without a white border on the print, i.e., there should not be two different borders with one border on the print and one border of card mount. (Trust me; your image will look better this way). If the image is unmounted, the border can remain. Black or dramatic, dark colors of card are often a favorite of photographers but should be avoided, even for black-and-white prints, because dark colors usually overwhelm the photographs and tend to be considered as unprofessional. Most neutral greys and beiges are good as background. White card should be carefully considered; it may look dirty or dull with some colors, and contrast unpleasantly with different shades of white in black-and-white photographs. But it is never ill judged to use white card, whereas some colors can be a mistake. When buying card, it is a good idea to buy slightly more than needed in case pieces are spoiled, as it may be impossible to buy more of the exact same shade at a later date (batches of anything produced at different times may differ marginally in their color). Different colors, weight, or finishes of card will be distracting. Don't mix background colors of card unless you are really convinced that your photos need to be presented in a different way. As a general rule, too many stylistic changes will distract from the photographs rather than enhancing them.

All text and picture captions should also be consistent. Captions are best underneath the photograph, on either side or in the middle. This means deciding where they should be placed before starting the task of mounting images. Captioning is easier to do with computer-generated prints than when a print is to be separately mounted. If images are individually mounted, it may be preferable either to put the captions on the back or to number all the images and put captions on a single, separate sheet rather than attaching small slips of paper to each piece of cardboard, since there is always a danger that they will move or become detached from the image.

Text in a folio should be kept to a minimum. It is useful to include a c.v./résumé and an artist's statement, although the gallery may not look at them. Keep any artist's statement simple, short, and factual. Three paragraphs are usually enough. Do not make elaborate or grandiose claims for the work. Remember that other people may well not know even the basic facts about the work, so a statement that says when and why the photographs were taken is useful.

When the work is being considered for exhibition the photographer may be asked to be present to introduce the portfolio and talk about the work, but this will not always be the case. The portfolio may have to speak for itself, so it has to be strong enough and straightforward enough to be looked at just as it is, with only a small amount of additional written information available as reference.

A folio should have the photographer's address on or in it. Portfolios were once designed to be left with prospective galleries or clients. This has always been a risky thing to do, since there is a real danger that the work can be lost or damaged. New technology makes it unnecessary to do this, and a good CD can be left instead of original prints.

It is always a good idea to give people something to keep as a reminder when you have shown them the work: a small print or postcard or a copy of your c.v. or artist's statement which also has your contact details on it. It may also a good idea to follow up a visit or portfolio review with a personal note of thanks.

Websites

A website is useful but not a substitute for a portfolio, as most galleries still rely on seeing prints and meeting photographers face to face. However, it is a useful reference, selling, and promotional tool, in particular because it can be larger than a folio and hold a broader range of work. It is also important as a way of reaching a wider or geographically distant audience or as a quick reference in lieu of a meeting for someone who is already familiar with the work.

The crucial thing here is to make the site accessible and easy to use. In doing this, a careful choice about categorizing the work needs to be made. For a documentary photographer, this is likely to be subject matter. For a photographer whose main aim is exhibition, it is more useful to divide the work into particular projects or exhibitions and select themes or keywords.

Commercial photographer Paul Carter provides a good example of how a website can be useful:

> *I get work in several different ways now but it's very rare that I'm asked to bring a hard copy portfolio. For me being on the grapevine is crucial. It is still the best way of getting new work because you establish a reputation. Only a very small amount of work comes from people browsing the Internet looking for a photographer. But the difference it does make is that even before I get a phone call the person has checked the website and knows I might be the right photographer for the job. I have had a website for about eight or nine years. It has gone through at least three major permutations and I've been learning each time. I taught myself web design so can manage the site. Because we manage our own website we have the means of delivery behind it. It is not designed as a very sophisticated site but a fast loading, easily accessible site seems to work well. I think it is really inappropriate to make a site for still photography which jumps around*

all over the place. I've found over the years that my portfolio was too general because I do such a wide range of work and people have tended to want to see work which is very specific to their area of interest—they don't say, 'Oh I like your style. I would like you to apply that to my commission.' Over the years I have actually increased my portfolio areas, which is often considered bad practice, and I now have twenty-five portfolios with twenty images in each but they are all very quick to access. People look at their area of interest and then tend to browse through other areas on the site. We also have a dedicated server with a forty GB hard drive which is never compromised for speed in loading the site because we are never sharing it with anyone else.

Interview by the author with Paul Carter January 2007 for the *Oral History of British Photography*. All OHBP interviews are part of the National Life Stories Archive and held at the British Library, London. Most of them are available on line to students and academics at www.bl.uk/sounds

A website needs to be kept up to date, both to appeal to regular visitors and because it is curiously disheartening to access a website only to find that all the images on it are several years old. There is no very good reason for this—images in a portfolio do not have to be very recent for instance—but perhaps it is an aspect of the way new technology works in always seeming to promise something new. Still, this is a second good reason to keep the design fairly simple. Setting up and maintaining your own website can be complex and time consuming and doing it for yourself, or hiring someone else to create a website for you, is not the only option. Organizations like bigblackbag.com; photobiz.com; photoshelter.com; LayerSpace; Dripbook or Aphotofolio and some artists' websites will act as a web host and are a good option for photographers who don't want to devote too much time or money to their website. They offer a choice of site designs for photographers, are not expensive and, crucially, allow you to update the website on a regular basis. They will also assist you in selling work and will promote their sites at markets and fairs.

My colleague Mary Familiant suggests that you develop a web presence.

Be visible. Every artist must have a website. An artist website is your digital business card that allows access to your work, your philosophy, and your resume and biography. Expand your web presence by exhibiting your work via online artist registries and online galleries. It's best to research the ones that fit your artistic concerns and goals as some may not work for you. Some online galleries include: saatchionline.com, retitle. com, wooloo.com, fotovisura.com, and socialdocumentary.net.

Webzines and blogs are another way of expanding your online presence. J. M. Colberg's website Conscientious features insightful reviews of photographers, exhibitions, interviews, and books. Some other websites that I enjoy include: Daylight Magazine, Lenswork, Artslant, Fraction Magazine, Humble Arts, and Lenscratch and Flak Photo. Check each site for details in how to send your images for review.

Keep your professional Facebook presence separate from your personal page. Open up a second Facebook account solely for your artwork and be strategic about who is invited to join. LinkedIn, the professional networking site that connects you to professionals in your field, can also be used to post updates about projects and announcements of exhibitions.

Sending out monthly announcements and examples of new work to those people on your contact list will keep you fresh in their mind. There are many different e-mail marketing services. Constant Contact, Mad Mimi, Mail Chimp, and Patronmail are just a few that are available. You can also have a list of your accomplishments as part of your e-mail signature.

She also suggests developing an online presence by the creation of a video recording discussing your art.

You can host this on YouTube or Vimeo with a link from your website. Hire a writer to interview you and write an essay about you and your work. This description can be used on your website, in promotional materials, grant proposals and gallery submissions.

Mary Familiant

Support systems: working groups, volunteering, networking, and mentoring

Photography is often seen as a solitary and competitive practice, but it is a rare person who does not need a variety of different sorts of help and advice. It is up to the photographer to work out what sort of support he or she needs and where to find it but there is a great deal of support available.

Four useful ways in which the photographer works with others and keeps in touch with the world of photography is through creating or joining working groups, volunteering, networking, and in finding a mentor.

Working groups

My associates, people like Lee Friedlander, Garry Winogrand, Diane Arbus, we all knew each other. We felt like a secret society that believed in each other. We never criticized each other's work, although we took extremely different kinds of pictures, we would just look at each other's work. I guess we all learnt and borrowed from each other—only with the best intentions of course. It wasn't copying.

William Eggleston, photographer

If artists can pick their own shows, they will reserve for themselves some of the power to determine the way history is written, because exhibitions help define and shape that history; in showing the artists that they feel are important, they will partially deflect the power of critics and curators who have traditionally told artists what is good and not good.

Kay Larson

Politicians are now more prescriptive about gallery and museum exhibition policies than ever before and this limits the artist's options. Now more than ever artists should be setting up their own exhibition spaces and nowadays there are more exhibition options than just the gallery.

John Gill, Director, Brighton Photo Biennal

One of the best ways to start exhibiting is either to join a group that exhibits regularly or to set one up. Many people find this a good way to deal with the transition between college and a regular exhibiting career. It is also very helpful for any photographer to know other photographers with the same interests or at the same career stage who can form a fairly informal support group. In a group of this kind, photographers share information about resources (such as where to buy good, inexpensive materials or who will loan out exhibition-quality frames), swap skills, exchange information and ideas, loan equipment, and use group members as unpaid helpers in return for similar help when it is needed.

Groups often meet on a regular basis at exhibitions or in someone's home or studio to look at ongoing work or simply to socialize. This may be for the length of a particular shared project or may have a longer life. This sort of group can form the basis for an exhibition project and make it very much easier for an individual to start exhibiting.

A group like this works best if it has a clear aim and its members have a great deal in common and less well if it is divided by differences in attitudes and interests. The group should not be very large, unless it is one in which not all members show in every exhibition or is one in which subgroups are formed around areas of particular interest or exhibition. The administrative time of dealing with a group of more than about ten photographers can be overwhelming, especially if the group communicates by e-mail and vast amounts of information are passed around, although some larger groups exist which can rotate administrative roles or appoint a paid administrator.

A group can be essentially practical and problem solving or it can take on looking at, and giving feedback on, members' work. In many ways this can be a much more challenging role for a group, especially if the members have different approaches or areas of interest and varying levels of expertise. Most photographers are highly sensitive to negative feedback and it is worth agreeing on some basic ground rules before setting out to discuss members work (see, for example, the checklist in Appendix). Because trust is an important element in feedback (trusting both the motives and the judgement of the person giving feedback) it can be a good idea to close a group to new members so that, over time, group members can develop an increasingly intimate understanding of each others work and feel able to give tough and critical feedback when necessary. In a feedback group with a fluctuating membership the feedback will probably need to focus on supportive comments since it is difficult to judge the right level of criticism to offer to people who you don't know well.

When a group works well, it supports all its members, shares the workload, includes a range of different skills and experience, and can act as a forum for creative ideas and brainstorming. When a group works badly, it can be taken over by individual egos, can include members who contribute very little, and can get bogged down in battles or minutiae. Russell Miller's book (1997) on the Magnum photo agency, the most famous photographic cooperative now over sixty years old, well illustrates both aspects of being part of a group. He points out that Magnum 'has reeled from crisis to crisis, usually financial, sometimes emotional, occasionally personal and often potentially terminal.' But he also says, 'Setting aside the bickering, membership of Magnum provides photographers with a rare opportunity to give and receive frank criticism of their work and sharpen each other's eyes by the constant interchange of superlative images.'

So finding a group also means finding the right group. Exhibiting as a group means deciding how to organize it right at the start of the process rather than waiting until the last minute because some tasks are best done collaboratively and some individually. Group discussion of images is usually insightful and rewarding, whereas group curation can result in an unfocused show. This is because working consensually is slow and often means that the transition from seeing sets of individual images to working them into a coherent exhibition whole is not made. Appointing a curator, even if not everyone agrees on their 'take' on the work, should make for a stronger exhibition. I would also advise any group showing together to appoint members to do or oversee specific tasks such as administration, publicity, curation, and hanging, rather than trying to do everything as a group (see checklist 'Organizing Teams' in the Appendix).

Volunteering and internships

Photography students often work in galleries, both before and after graduation, as part of an intern or work experience program and can gain useful experience and contacts this way. Many galleries are permanently understaffed and will welcome volunteers who can work on a regular basis to help hang shows, serve on committees, and invigilate the gallery as well as appointing interns who will usually be given a more regular role. Working as an intern or volunteer on a short-term basis can be a useful way of acquiring exhibition skills and keeping in touch with the photographic world. It can also be a way into permanent gallery work.

However, it is important to find a gallery that is friendly and inclusive and is genuinely prepared to train volunteers and interns rather than exploit them. As Nadia Burns points out: 'Volunteering is a good way to get a foot in the door and learn how galleries work. When I left college I volunteered at three different places and the best was the one which had a specific program for interns—a volunteer or intern needs to find a place which gives something back. It's easy to panic when you've just left college and jump at the first opportunity but it's really not fair to land a volunteer with only the dull jobs like photocopying. In the end I got a gallery job by volunteering—it was just good luck really, being there when they needed someone.' (In conversation with the author, May 2007. Nadia Burns was then Gallery Manager for the Getty Images Gallery London.)

Networking

One of the ways the art world works is through a system of connecting institutions, organizations, and individuals. Many exhibition opportunities come about fairly informally by word of mouth and through conversation among curators or photographers. If photographers want to exhibit, then it is useful for them to be in touch with people in the world of exhibiting, to attend artists' receptions, festivals, and private views, to keep in touch with gallery staff they know, and show their work or talk about their work to them. Visiting galleries and attending private views can be a terrific way to meet like-minded people. Short educational courses and workshops on different aspects of photography are also a good way of meeting like-minded photographers.

A colleague gave me this example of the way networking can be useful. At a private view I introduced her to another photographer with whom I thought she shared interests and a similar photographic style. They enjoyed a long conversation about their current work and exchanged cards. Almost a year later she got a call from the photographer, telling her that someone had dropped out of a group exhibition she was in and inviting her to replace the original photographer.

Organizations like Slideluck Potshow (SLPS) are a useful way of meeting like minded photographers. Slideluck Potshow is a 'non-profit organization dedicated to building and strengthening community through food and art.' They host multimedia slideshows in forty cities around the world. The price of admission is a dish to share with other attendees (http://slideluckpotshow.com/).

Mentoring

Mentors are quite interesting you know. They're a good thing to have. People don't really have them enough.... I haven't had them enough in my life.

Max Wigram, art dealer and curator

Every museum is perforce a political institution, no matter whether it is privately run or maintained and supervised by government agencies. Whether museums contend with governments, power trips of individuals or the corporate steamroller, they are in the business of molding and challenging consciousness. Even though they may not agree with the system of beliefs dominant at the time, their options not to subscribe to them and instead to promote an alternative consciousness are limited. Survival of the institution, personal careers are at stake.

Hans Haacke, *Museums: Managers of Consciousness*, 1984

There is a wide variety of possible mentoring situations. They can be short or long term, formal or informal, free or paid for. Mentors can be photographers, curators, arts administrators, or lecturers with differing sorts of expertise. In Britain some mentoring schemes are paid for by the funding bodies in order to support and professionalize the practice of younger and mid-career artists.

In essence, a mentor will do some or all of the following:

- talk to the artist about issues of theory and practice around their work and help resolve or edit the work as necessary
- identify appropriate opportunities for exhibition and commissions
- explore contacts who may help in any of a number of ways—including buying, selling, helping make, critique, commission, exhibit, or write about the work
- set up meetings to help the artist
- work on specific projects
- help the artist develop business skills and find funding or financial support

In my experience photographers can think that they don't need this sort of help because they think they should be able to acquire all the relevant knowledge themselves. They can also

believe that it is in their interests to maintain their independence and their artistic integrity by keeping close control of their work. In fact one of the key roles of a mentor is that they can approach the work from a different perspective—that of the art world and/or that of the audience—and this should help the photographer see how their work will be received. As well as being able to offer an informed critical appraisal of the work, the useful mentor will have an in-depth knowledge of the workings of the gallery system, one which can only be acquired by someone who works in that system, and knows where and how to move the work into the world of the gallery.

So, the photographer is well advised to work with a mentor who is a more experienced photographer or someone who comes from a background of working with galleries or arts organizations and has a broad and detailed knowledge of the visual arts sector at national and international level, who has worked closely with a number of artists, who understands the financial and funding opportunities available and can make introductions and arrange meetings for that artist. The photographer or artist may do better to focus all their attention on making work and use the help of mentors and/or curators to progress the finished, or almost finished, work. They may find they rely on one mentor to progress their work and someone else to help them approach a gallery.

Gina Glover, who holds regular mentoring sessions for photographers, offers the following comment:

> I hold regular mentoring sessions once a month at Photofusion of approximately one hour per photographer, and I usually see three photographers in an evening. Over a year I probably see about thirty-six photographers, and I may see them only once or they may continue to come back over several years. Each photographer makes an arrangement which suits them.
>
> The mentoring came about because Photofusion holds regular portfolio viewings and I recognised that some people who attend these sessions need a different sort of feedback and to have more than one session if they are to take their work in a direction which is right for them.
>
> What I do is offer a mix of practical and personal advice. It's entirely up to the photographer whether they take it or not. People don't come back again if I'm not being useful to them. My aim is to help them move their work on to the next stage and that varies a great deal with each photographer. It may simply mean suggesting they show their work to a particular gallery or curator. It may mean wrestling with an issue in the work which they can't see or can't deal with. I sometimes spend a whole session working my way towards asking the most poignant question which will allow them to understand their work more clearly. For some people just talking about their work to someone who is a photographer and understands the issues is enough. It's not psychotherapy but it is about giving photographers the confidence and skill to achieve their photographic goals.

<div align="right">E-mail to the author, February 2007, from Gina Glover, a photographer
and a director of Photofusion</div>

Some curators will provide this sort of support, fairly informally, to a few artists whose work they are interested in. Curators may mentor because they find it personally rewarding and because it keeps them in touch with the day-to-day issues affecting artists and in tune with younger artists as they develop. An important point for the artist is to treat this situation with respect and acknowledge the significance of the mentor's help. If I mentor three people, and one gives my contact details to all her friends who then demand my unpaid help; one only gets in touch when he needs a reference; and one thanks me by giving me a print then it is obvious which one I will be most disposed toward continuing to help.

Galleries and photographic organizations may also have membership schemes that sometimes host events that provide short-term or one-off mentoring, such as portfolio sessions in which curators look at folios and offer constructive criticism, advice, and suggestions to photographers about their work and about which galleries they might approach for an exhibition. These usually provide useful feedback, although photographers should be aware that they will receive a range of different, and sometimes conflicting, opinion and not all of it will be useful to them. When going to portfolio sessions it's a good idea for the photographer to select the curator or reviewer whose interests are most appropriate to their work by researching them beforehand when this is possible.

For most photographers just starting out, finding a community of peers is important and useful. Joining membership organizations that act as centers for information and education, and provide services to members in the form of lectures, portfolio review days, members' juried exhibitions, conferences, bookstores, and libraries provide opportunities for networking and mentoring. The Society for Photographic Education (SPE) and galleries such as The Photographic Resource Center in Boston, The International Center of Photography in New York, San Francisco Camerawork, CEPA Gallery in Buffalo, and The Photographers' Gallery in London all have useful events programs as do many smaller galleries and artists' organizations.

Stimulating personal and creative development

Yorkshire based photographer Simon Warner comments on how attending photography events can influence practice:

> Starting out as a landscape photographer in the early 1970s I always felt on the fringes on the UK creative photography movement. I was briefly a member of Co-Optic, a small London group, and then a similar group in Leeds after I moved to Yorkshire. I attended a couple of Paul Hill's inspirational workshop weekends at The Photographers Place in Derbyshire, but could never wholly commit to that aesthetic adventure.
>
> Twenty years later I was illustrating books, running my own stock library and working for a range of editorial clients including the 'Telegraph Magazine' and 'Country Life.' Perhaps I'd spent too much time in pristine national parks walking along beautifully

River Aire Castleford Weir. Image © Simon Warner.

maintained national trails, but by 1995 I was beginning to think the heritage landscapes didn't really need me any more. Fully engaged and less commercial photographers than me have often been interested in marginal countryside and the urban fringe, and my moment of realization came when I noticed that pit closures and the collapse of the textile trade were changing the face of the unprotected, un-conserved West Riding land-scape near where I lived. Places that had been defined by huge industrial structures were—sometimes overnight—becoming blank spaces on the map, up for grabs by com-peting interests.

I conceived the idea of an exhibition project about the Aire Valley, tracing the course of the 97-mile River Aire from its source in the Yorkshire Dales through Keighley, Shipley and Leeds out to the Yorkshire coalfield and past three huge coal-fired power stations to the Ouse estuary. For much of its length the river is accompanied by canals, first the Leeds & Liverpool, then the Aire & Calder, adding substantially to the watery theme. I had found a subject, but was in a turmoil of creative doubt. How could I create meaning out of such disparate visual material?

In this sensitized state I picked up an advertisement for a conference on landscape photography taking place in Ambleside in September 1996. It sounded sufficiently unusual for me to book at once. Changing Views of the Landscape was the first of two

residential conferences on this theme (the second was at Ilkley in 1998) and to begin with I really didn't like it. I had no prior understanding of the new ways photography was being used by conceptual artists and theorized by academics like John Taylor. The results seemed strange. I had expected to see more traditional landscape photographers like Fay Godwin (who did indeed take part) but there was an emphasis on change, and it felt uncomfortable.

However half the point of conferences is what happens between sessions. There were representatives putting together what was to become Photo '98, the Year of Photography (based in Yorkshire & Humberside). In conversation it became clear that funding might be available for a project like mine, and so I started to take part in the conference proceedings with more confidence. And in the evenings delegates gave informal showings of their current work: I saw Kate Mellor's Island series for the first time, as well as Gordon McWilliams' extended panoramas of the Manchester Ship Canal. Everyone's work had an element of pushing boundaries, and there was much talk of books I hadn't read.

One of these, Roland Barthes' Camera Lucida, became a foundation for my later explorations of early photography. I still find the analogy he makes between photography and the theater absolutely spellbinding, but the whole book is packed with wisdom and questioning. Having grown up with writers who were always making claims for the uniqueness of photography, I liked the fact that he situates it in a broad psychological and art-historical context, rather as Geoff Dyer has done more recently in The Ongoing Moment.

So for me Changing Views… really did change my views. I started going to contemporary art shows as well as photographic ones, discovered video art at the Turner Prize, saw video and photography being used in performative contexts. My exhibition did get funded by Photo '98 (via Bradford Museums & Art Galleries) and toured for nearly two years. At the second Landscape conference I ran a workshop on panoramic photography, and my work continued to evolve and to branch: towards the moving image as a primary medium for exploring landscape, and towards live appearance, magic lanterns and the camera obscura.

Simon Warner
www.simonwarner.co.uk

Case Study One

Leila Miller: The M.A. Show

When I heard that the boarding school I attended in my teens was closing and most of the buildings would be demolished, I knew I wanted to photograph it. I arranged access to the buildings and started to photograph how it had felt when I had lived there. Gradually I realized that the methods and styles I was using to photograph the building and the process of its changing, reflected my own personal journey. It wasn't a representation of a linear narrative but a collection of perspectives. I didn't plan how to show the work when I started, I just knew it was a project I wanted to do. Some projects I have done are very focused and carefully organized, and others happen in a more organic way. Now the photographing is finished I would really like it to be shown as a book and an exhibition. All images © Leila Miller.

In 2006 I completed a part-time, two-year MA program in Photographic Studies at the University of Westminster. The academic year began in September and ended with a final show in September two years later. Although we had the option to write a thesis, all twenty-four full- and part-time students in my year decided to do a visual project as their final work for exhibition in September. The work was marked/graded as it was presented in the exhibition space, along with statements and research books.

As a part-timer doing the course in two years, I had seen the previous year's students organizing their show and had noticed a few issues and difficulties. Because starting late was something they had complained about, I felt it was very important to start at the beginning of the new academic year, my second year. So in October I arranged for us to meet each week to discuss organizing the show. As a group we identified all the areas that we needed to work on: website, finance, venue, sponsorship and press, and curation. But soon it was apparent that our meetings were poorly attended, there was a lack of motivation, and nothing seemed to be getting done. There were many issues I had overlooked that made starting at the beginning of the year difficult.

By the end of the year, once the exhibition was over, I was able to look back and realize so many things that, had we known and thought about them in advance, would have been really helpful. But I think the first time you organize a group show it's always going be a big learning experience.

There were quite a few factors that affected students in the early part of the year:

At the beginning of the final year some students had already been on the course for a year and others were just starting, because half of the students were full-time and half were part-time. In many cases this meant a big difference in the workload; and in the early days full-timers were just finding their way around the campus and figuring out what was expected of them on the course. Many students had moved to London for the first time and had to deal with living in a new city as well. Some were new to the country and a few had additional struggles with the language. In the early days, if a student was very quiet it might have been because he or she didn't wish to comment—or he or she might have had problems understanding other students and so didn't want to say anything.

Also although there were some full-timers who had a lot of relevant experience, in the early days it felt like the part-time, two-year students needed to wait until the full-timers could adjust and catch up and understand all the factors that affect putting on an exhibition. It's a tough choice to decide whether to organize the exhibition anyway and let others catch up when they're able, or wait until they have settled in and have more experience and a consensus can be achieved. On one hand, it is a communal exhibition and must be inclusive; on the other, there comes a point where if someone doesn't start organizing something the show might not be so good.

On our course the final project is begun in the second year, so one issue that affected almost all students was the stress of deciding what their project should be about. Some students found it took a long time to decide, and some changed their minds on subject matter and treatment a few times. It felt difficult to organize an exhibition without knowing what work would be shown in it. I think this affected motivation in the early months, with

priority and time being put towards individual projects. However, it should be possible and is good practice to start early when planning an exhibition even though you don't know the types of images to be included or the methods of presentation.

It's important to remember that every person involved has had different experiences and will have different ideas and ways of doing things. This is really what you have to cope with when you're organizing a group exhibition. There are times when it can seem frustrating, but there's a lot to learn from it: others have different ways of doing things that you might find useful, and they may have solutions to problems you had never even thought of.

Another factor to remember is that each student wants something slightly different from the exhibition and from the process of organizing the exhibition. This affects students' decisions (for example, what kind of venue, in what part of town) and how much time they put into organizing the exhibition and what they are prepared to work on. You're only going to be disappointed if you allocate a task to someone who has no interest in or benefit from doing that task. In the main, people only offered to work in areas they wanted to gain experience in, such as curating or marketing, so that there remained other jobs that just had to be done by people who hadn't contributed already, such as invigilating or staffing the exhibition. Some students had heavy work and home commitments, which affected how much they could contribute, and some students contributed considerably nonetheless.

I've been told recently that, no matter the size of the group, generally a quarter of the students do the vast majority of the work and about 10 percent turn up on the day of the exhibition just to hang their work, having not contributed at all. If you are someone who wants the exhibition to succeed, you have to get together with other interested students and make it happen.

Initially group discussions revolved around finance. We knew the university gave money toward the final show, which often went toward hiring the exhibition space, but we didn't know how much. I think we made a big mistake here: we wanted to be told by the university what funds we could expect so we could then see what venues we could afford. I have since been told that it is advisable for students to do their research, put together a proposal, and pitch it to the university. It should outline what the plan is and how much it will cost and should emphasize why it's such a good idea. Universities have limited resources, but if you put together an inspiring plan, which will be good for the reputation of the university, they may find additional funds to support the plan. This is generally what has to be done in the 'real world' after university, when looking for funding for an exhibition. It is a good idea to complete this proposal by about three months into the year, so that there's time for debate and you can make alternative plans if you haven't got the funds for your first choice. In London, available gallery spaces often get booked eight months ahead, which is another factor to remember.

We kept asking for a budget figure and then we waited. Finally we realized that if we didn't book a space we might have problems getting one we liked, so in the new year we started looking at venues and based our budget on what the previous year's students

had been allocated. We still had little or no idea of what the photographic work in the exhibition would be.

Finance in general was a contentious subject. On many courses the students have to contribute toward some of the exhibition costs, including venue, invitations, opening night costs, and catalogue, but students have different financial situations. In our group the majority wanted the costs for the venue to be entirely met by the university's funds. Many had tight financial situations and couldn't risk footing the bill if sponsorship wasn't forthcoming. But it felt difficult to promote our exhibition to sponsors when we had no idea of what the show would be like.

Once it was agreed by the students that university funds would cover the venue costs, there were other costs to consider: invitations, website, catalogue, and so on. How much people were able to contribute varied, but we had to find a figure for individual contributions that everyone could agree to. The amount debated ranged from about £25 to £100 per student; the higher figure was considered unacceptable by many. We agreed that everyone would pay £25 to get us started.

Putting on a show is an expensive business. In addition to group costs, students have to find the money to pay for their own production costs, such as printing, mounting, framing and projector hire, which can be very expensive (from a minimal several hundred pounds to an average thousand pounds and occasionally several thousand pounds) while still paying tuition fees and living costs.

When looking at venues for the exhibition, we decided we wanted a space where everyone could show a reasonable amount of work—say, six or eight in a series rather than just one image each—so people could represent their projects more fully. Eventually we found a really amazing big space with about a dozen separate rooms so work could be shown thematically. It was in central London, which would be good in terms of attracting visitors, but with our budget we could only keep the show up for a week. It was such a good space that getting everyone to agree on it was relatively easy (that is, once everyone got around to going and visiting it). We reserved the venue for the dates we needed. In March the university budget was confirmed, so then we started to organize the contract and paperwork required to book the space (which included a risk assessment for every student's work).

We made decisions by voting, usually online through a Yahoo! Group, as we couldn't get everyone together at the same time. We had set deadlines for casting our votes, and decisions were made by majority rule on that date. There were times when we made decisions in meetings, but because this was not the norm, there were sometimes arguments about these decisions later. It's important that it be made clear well beforehand that such-and-such a meeting is when a particular decision will be made (and if you don't turn up you don't have a say). Decision making and debates usually raged on for ages, took up a fair amount of time, and could be very frustrating, but I don't see how they can be avoided altogether—they are how you gain a consensus.

Encouraged by the course leader, we picked a title for the exhibition in mid-March. Of course, this had to be fairly all-encompassing, as student's work was far from settled.

With five months to go and only the title and venue chosen, we lacked focus for organizing everything. Eventually some students offered to organize the group. If they hadn't done this, things would have been tricky. At this point several people realized that something had to be done, because if we didn't get started, nothing would happen.

Around April we started work on the invitation. The invitation design caused some arguments because several people said they had friends who would probably design it for free, and then someone else said we could probably find them a bit of money for it, and this was taken to mean that a particular person would be paid. In the end the first design was not popular, and it was redesigned by someone else, for free. But arguments about whether the first person should be paid went on for months. Ideally we should have made it clear that no money would be committed unless it was put in writing.

The appearance of the invitation was relatively straightforward: we just had to agree on an image and the design. This took a bit of time but wasn't difficult. The invitations were delivered three weeks before the show opened. They were sent out by the students to the university's list and to whomever the students chose to invite.

We began to organize the website in late April. It was designed and set up by one of us, so we just had to pay for the address/server. Initially we paid for just one year, but later changed to another company and a much longer period: the website can continue as a reference point long after the exhibition and course is over.

Getting everyone to submit a statement and an image for the website was excruciating, partly owing to students not getting around to it, but also because most didn't have final images yet and some hadn't even finalized what their project would be about. In fact, though, the website worked as a catalyst, focusing everyone: images and text were uploaded as they came in, and a blank web page with their name on it seemed to encourage many to submit material, even it if would be changed later on. From this time until the show opened, student changed their images and text on the website repeatedly; I thought the people handling the website were saints. But today a system could much more easily be set up so that the students can upload their content when they want to.

Looking back, the website could and should really have been set up at the beginning of the year. Although students don't know what their final project will be, they can still have their own page with images from previous projects and a link to their personal website or blog if they have one. An early website would be useful for showing to potential sponsors (a kind of proof of existence), is good promotion for all the students, and can be adapted with new material as projects develop.

We started looking for sponsors very late, with less than four months to go many avenues were already closed. A press release on the website was an efficient way to inform potential sponsors. We started off by contacting a list of banks and similar institutions, but they were only interested in giving to their own designated charities. We then approached companies that were in the vicinity of the exhibition venue, and in a couple of cases were just a bit too late as the company had already committed its charity

budget for the year. We then concentrated on companies associated with the photographic industry and drinks/alcohol suppliers.

Despite many protests that students couldn't afford to contribute toward the exhibition costs, very few found sponsorship instead. It's worth noting that sponsorship was normally gained through students' own personal contacts or employers, the only exception to this was a sponsor that was a large supplier to the university. Two students found financial sponsorship, one gained sponsorship in kind for projectors for showing digital work, and one arranged for food for the private view.

As we didn't get any sponsorship for drinks for the private view, we paid for them ourselves: around £300. We planned to cover the cost by asking for donations on opening night, and in the end we did cover our costs. We were lucky that the private view was very well attended.

Another feature we had to work on was a catalogue to go with the exhibition. From the beginning there had been a lot of debate on whether or not to have one, particularly as it would be costly. Some felt that the catalogue would be all that remained after the show had finished and it would be a permanent record; others didn't mind having one as long as they didn't have to pay or do anything for it.

There were about six students who really wanted a catalogue, and eventually enough others were persuaded and some student contribution was agreed to. Initially we paid £40 each, though after the catalogue sales at the exhibition, everyone got £12 back. We covered the rest of the costs through the financial sponsorship, in exchange for advertisements in the catalogue and on the website. But without the university supplier's very generous contribution, we would not have been able to have had one at all. Our choices of cover and paper type were entirely dependent on cost. We printed 1,000 copies of 60 full-color pages for £1,802. However, with printing technologies changing all the time, cheaper deals may now be found.

The production of the catalogue was very hard work, and throughout the process students changed their minds about their images and text. One of the students designed and produced the catalogue with a great deal of assistance from one of the course tutors. The course tutor must have spent about five working days on it, and the student probably spent at least three full weeks on it. It was sent to the printer two weeks before the exhibition opened. The layout had been completed earlier, but printing was delayed while we tried to find more money.

The catalogues were delivered the day before the exhibition opened.

In May it was agreed that three students would oversee the curation of the exhibition. They did a brilliant job. We had a massive space with eleven different rooms and twenty-four students with very different kinds of work. Because the work was so varied we decided that a key aspect of each student's project would be for them to research and decide on the best method of presentation for their own work rather than try for a uniform method of presentation. Exhibition plans were initiated by making floor plans of the space and the curators asked each student what they thought they would want in terms of space by deciding on numbers and sizes of prints and created a plan knowing

that they might need to make changes nearer the time. There was little point in pressing for final details when students were often still very unsure about what the project would be about. Some students projected their work, one had backlit large format transparencies, several chose mounting on aluminum or diasec and there were many different frame types and sizes. Almost everyone was happy with the space they got. Slight adjustments for technical reasons had to be made on the day the show was put up, so a flexible attitude was important. In the end, the show looked amazing.

About a month before the exhibition opened we organized press for the show, which should have been started at least a month earlier—or three months earlier if we had hoped to get in monthly publications. We were lucky that the gallery had a press list, and we were put in all the major listings guides. We also sent press information to all the London photographic galleries and e-mailed all the different arts sections of the various newspapers. I e-mailed press information three weeks beforehand, one week beforehand, and on the private view day, as a reminder. Not surprisingly, there were no reviews, but it was still worth trying.

It's important to remember to invite representatives from your industry. For us, we mainly needed to encourage gallery owners and curators. I hadn't realized that besides e-mailing them, you need to contact them individually to remind or persuade them to see your show. A tutor suggested this the night of the private view, and as our show was only open Thursday evening, Friday, Saturday, and Sunday, it led to some fairly frantic telephone calls. It was short notice, but in the end we managed to get an extra six or so gallery owners to see the show by delaying the takedown until Monday. This is definitely something to start work on at the beginning of the year. If there are students who are serious about what they're doing, they should make contact with industry representatives much earlier, with the aim of creating a relationship and getting them to attend the show. You'll need these contacts for the future.

The exhibition was due to open on Thursday evening, and we had from Tuesday morning to hang the show. We began by bringing in a large number of flats to create extra surfaces to hang work on, and students worked together to carry them in. Everyone had an allotted space according to the curators' floor plan, and with the exception of a few particularly helpful people, generally people arrived in their own time, put up their own work and left. Ideally everyone would have helped each other far more. We had a huge amount of support from two technicians from the university, who did a fantastic job. They were excellent at carpentry, electrics, hanging work, and much more; without them, we'd have been in real trouble.

We had one major problem in hanging the show, which can be attributed to miscommunication. A student had been assigned a 'distressed' wall although he insisted he wanted his work to be on a white wall. So, without checking first, he painted this 'distressed' wall with a strip of white. The gallery was furious, and a lot of arguments ensued about how much it would cost to return the wall to its former condition and who should pay for it. It's a good idea to make clear to all students in advance what they can and can't do with their space, and if they do something without checking first, they may well have to pay for it.

There are many things that need to be done just before and during the time of the exhibition. This is hopefully when people who haven't contributed earlier will come forward to help out. In our case, for example, the drinks and food for the show had to be collected, work from the university campus transported, gallery information sheets photocopied, posters put up, and leaflets handed out in the local area. The exhibition must be staffed whenever it's open with at least two people at any one time, probably more if you have more than one room or floor. Ideally those on floor duty will hand out information, keep a note of attendance numbers, and be friendly to visitors—you never know when an industry representative might turn up. During our opening night, we had someone at the entrance and three people helping on the bar. We had ex-students and friends doing this to take the pressure off us.

But after all the angst, the show came together and looked good and completely professional. The private view was packed and went very well. It was a great way to celebrate the end of the course and invite friends and family and anyone else who had helped or contributed to the work. When considering numbers to invite, it's sometimes important to bear in mind that overseas students may not have many family and friends visiting.

The next day, one of the students photographed the exhibition so that there would be a record for everyone. This is definitely worthwhile, as it's the only evidence you have to show how your work was presented.

Throughout Friday and over the weekend, we had a very good walk-in rate. There was a festival in the area of the exhibition; without this it might have been pretty quiet.

After a few gallery owners came around on Monday morning, we all took our work down, which seemed very quick compared with putting it up. Normally you have to make sure the space is returned to its previous condition when you leave, but we had done quite a bit of cleaning, tidying, and painting, so it was in pretty good shape.

It really varied as to what students got from the show besides the great satisfaction of seeing, and having others see, their final work on display. For many it was simply the new experience of producing work and presenting it publicly. For others having their work up meant they got useful feedback from a wider audience, encouraging them to continue their practice. Many of those who helped organize the exhibition got useful experience for future events. Some students did get some work and interest from galleries because of the show, and some got noticed by their future employers. Although this is unusual it is worth preparing just in case—make sure you have enough cards next to your work with your contact details on, and try to spend time next to your work at the private view, so you can talk about it. However, if you want to get noticed in a show, it really is up to you to get to know and invite people who could be important to your future. After the show's over, you'll have some great experience, but you'll have to go straight out and start organising what you want to be doing for yourself.

The show was a few years ago now and there has plenty of time to reflect, and become rather misty eyed about it. It was an incredible amount of hard work and stress at the time, but the show will be with me forever. It was a great experience, and one

that I'm still proud of. I keep in touch with quite a few of my former colleagues—we formed a group to meet up and talk about our post-MA projects. Many continue to show their work, mostly at group exhibitions so far with a couple of exceptions of students that have done very well in the intervening years.

I think the show was an excellent experience of what happens when you organize a large show, with a large number of people in a reasonably democratic way. For an emerging artist starting an exhibiting career, and therefore very likely to be in many other group shows, this is highly relevant. It can feel tough, and I did sometimes think how much easier it would be if I was doing a show on my own, but I learned so much more by working within a group. Its experience that has been incredibly valuable and I know I'll continue to draw on in the future as I organize and participate in other exhibitions.

Leila Miller

CHAPTER 3

Storage & Archiving

Prime Minister Gordon Brown and his family in No 10 Downing St shortly before handing in his resignation. One of a series of pictures taken behind the scenes during the British 2010 election campaign. The pictures have historic significance as being the first to show the inside of Downing St on the day a UK government changes. It is a news picture aimed at the following day's paper and websites. Although it was not taken primarily with a thought to exhibition if properly stored (something which many newspapers do not do) it is likely to be of interest to exhibition curators in the future. Image © Martin Argles.

For the working photographer and exhibiting artist, the problem of printing, storing, and presenting archivally sound prints can be a potential minefield. The key issues are storage and the use of archivally sound materials. As the market for sales of photographs grows, so too does the demand that prints be produced and presented to high archival standards. Major corporations such as Corbis may be able to store analogue prints in a deep, secure, environmentally controlled vault, but most people have to make do with much less costly solutions and with advice which changes as this area of knowledge expands.

Archivally processed and washed prints, properly stored, should last at least thirty years before showing signs of deterioration. Any print which is to be sold should be produced to archival standards. Continuing improvements in the permanence of digitally generated images, such as the use of pigment-based inks and nonplastic archival papers, now make it possible (as was not the case ten or so years ago) to produce prints which can be expected to last. A great deal of testing has been done by Wilhem Imaging Research and many people now accept properly made and cared for inkjet prints as equal to, or better than, traditional color processes.

Having said this, it might be useful to add that I spent some years working in an archive where black-and-white press prints, which were up to fifty-five years old, had been roughly handled and stored, upright, in ordinary cardboard boxes in a large loft where the temperature and humidity were not controlled. It was hot in summer and sometimes damp in winter. As I worked through the storage boxes the worst deterioration I found was almost always from inadequate fixing or washing of the print when it was made and sometimes from rough handling since then. However, color prints are much more vulnerable than black and white.

In the Victoria and Albert Museum's Print Room in London vintage prints are available to the public for study purposes. They are stored in shallow print boxes which hold between ten and twenty mounted prints. Each photograph is mounted in a hinged, window-matted mount with a sheet of acid-free paper held between the two layers of the mount. Although the prints are different sizes all the mounts are the same size, usually considerably larger than the print, and sized to fit the boxes exactly in order to limit movement in the boxes. Typed sheets of extended captions and information about the images are stored separately in clear archival envelopes. Students can study these without using gloves (under the very watchful eye of an on-duty staff member) because they are only handling the mounts. To anyone who is thinking about print storage, I would recommend that you visit a museum which offers comparable study facilities and study the storage systems as well as the prints.

However, although this is a sound storage method for study purposes it is a slow way to look at prints because the mounts can be unwieldy and the paper needs to be removed before the print can be studied. A quicker method is used for sales purposes by the Print Room of The Photographers' Gallery in London which, at an event such as a photo fair, shows contemporary prints unmounted in clear acid-free sleeves stored in boxes. This means that no one has to wear gloves, that anyone looking through the box can handle the prints in their sleeves and that the prints are immediately visible and can be seen at their best. They use more than one size of box and a box may contain up to about thirty prints. Each print is on paper, which fits the box exactly, so one set may have no borders and others have borders of

varying sizes. Each set is printed and oriented in such a way that the images can be viewed without turning the box.

Storage

Most papers, cardboards, plastics, and woods contain pollutants, which can seriously damage or degrade emulsions over time. Fabrics, paints, glues, and all sorts of everyday products can also be damaging as can damp, salt air, humidity (high or very low though high is the worse danger), heat, dramatic temperature change, and airborne pollutants.

The perfect storage environment is to be found in museums where controlled air conditioning keeps temperature and humidity consistent. For most people, this is not a viable approach and so the best option is to take the following precautions:

- consider investing in a single storage system, buy supplies in bulk to set it up and stick to that system rather than dealing with the issue piecemeal

- select a permanent site for storage which is not damp or subject to extreme temperature change—try to ensure that it is cool, well ventilated and dry and keep prints away from direct sunlight

- If possible test for humidity with a relative percentage humidity thermometer—if the humidity is higher than 60 percent either store work elsewhere or buy a dehumidifier

- make sure that everything you put into storage is clean and dry

- if necessary, clean dust from images gently with a well washed soft lint-free cloth (old silk scarves or print handling gloves work well) or, if mold is beginning to appear, use a film cleaner before storing them

- store negatives in specialist envelopes, which may be made from uncoated polypropylene, polyethylene, or archivally processed paper

- store prints in specialist boxes made from archivally processed cardboard with corners, which are either folded or held by metal rather than glue

- make sure these prints are not in contact with each other either by keeping them in archivally sound clear envelopes/sleeves such as Secol or by interleaving them with acid-free paper

- don't mix sizes of print or mounted and unmounted prints in a storage box because when the box is moved a print or mount may shift and so damage another print

- ventilate stored materials regularly by opening boxes and files for a few hours a week

- at the same time check for insect damage—moth and beetle like to eat emulsions—the best deterrents are cleanliness and good ventilation which discourage them. Chemical insect repellents should never come into contact with photographic materials but may be used to scent the air. Lavender oil can be used in the same way

- wear specialist white cotton gloves when handling prints unless they are already protected in mounts or acid-free envelopes

- old metal storage cabinets are better than either wood or modern metal cabinets because modern paints may emit gases. Old cardboard and leather boxes and cases are to be avoided. Wood can be sealed with water-based polyurethane varnish but this needs to be carefully done if plans chests are used
- consider making a digital backup copy of both analogue and digital material using memory card, CDs, and/or hard drive disc storage

Handling

Prints should be handled as little as possible because of the grease and other contaminants carried on even the cleanest pair of hands. Alternatives are to use specialist gloves, to store prints in clear acid-free conservation envelopes or to keep prints in window matted mounts. None of these is perfect. The gloves are usually fairly crudely made so may make the handler feel uncomfortable and clumsy, conservation envelopes and window-matted mounts look good but are probably too expensive for most photographers to use for all their prints. One answer is to store prints between sheets of acid-free paper and to wear gloves to move them to clear sleeves on a temporary basis when they are being considered for exhibition or publication.

Damage

If you already have damp or damaged prints put them into a cool, dry, dust-free and well-ventilated space for several months to dry before risking causing further damage by handling them. If they are important, then consult a specialist.

Captions

Including conservation and archiving information in a picture caption has now become a norm. At Photo Paris in November 2006, few of the galleries included this information, by May–June 2007 at Photo London all the exhibiting galleries included it and even small noncommercial galleries may well include this information.

To sum up:
- prints should be processed to archival standards
- prints should be handled as little as possible and with gloves or clean hands
- prints should be kept out of contact with other prints, papers, woods, and so on which means protecting them with acid-free papers or conservation sleeves
- prints should be stored in acid-free boxes in a controlled environment
- prints should be mounted on acid-free or rag board

Hannah Cullwick (1833-1906) was a maid-of-all-work and self-declared slave to her upper middle class lover Arthur Munby. Cullwick was proud of her work and position in life and presented herself to the camera in guises from lady to servant. Artist Alison Marchant searched the Cullwick/Munby archive and, using Cullwick's words and images, created an installation that pinpoints the way Cullwick's tableaux foreshadow and are echoed by the works of many contemporary women artists. Marchant's reinterpretation of this archive speaks volumes about women's labor, social, and class barriers, and the use of photography in creating a multifaceted portrait of one woman. 'Relicta' Image © Alison Marchant. Shown at Cambridge Darkroom UK 1998; Ffotogallery, Cardiff, Wales 1999; Kulturhuset, Stockholm/ MOMA, Copenhagen 2004; Fox Talbot Museum, Lacock, UK 2009. 'Relicta' Image © Alison Marchant.

CHAPTER 4

Preparation

Image © Valentine Schmidt.

Transposition is the first stage in a series of images where I position structures built using my father's Anchor Building Blocks in sites representative of my father and his history.

In this image the German educational toy has Birkenau as its setting. This place of unimaginable horror now also flourishes as an undisturbed site for nature; strangely, it has an unexpected and disturbing tranquility and beauty. Here symbols of innocence are married with the structures and memory of the Holocaust. This exploration of fate and the burden of the past offers many questions with very few answers.

My father (Peter Schmidt) left Berlin for England when he was seven. His likely destiny, had he not left, would have been Auschwitz. He brought his Anchor Blocks with him and later used them in his work as an artist. He died in 1980 and I inherited his Anchor Building Blocks.

The second stage and the final stages of the work place the arch in the landscape of Madeira and then in Scotland and Iceland, representing the landscapes of Peter's painting. Because of the intensely personal nature of this work considering an appropriate method of presentation is important. At this stage I think that showing one of Peter's paintings will be central to an exhibition.

There are a number of useful steps the photographer can take before either approaching a gallery or considering alternative ways to show their work. These are: for the photographer to start to make the practical and emotional transition from making photographs to showing them, to start editing and shaping the work into a possible exhibition proposal and/or exhibition, to look at exhibitions to consider and learn from the ways other photographers present their images, and to show a completed portfolio to curators and gallerists before taking it to a gallery.

The Transition from Making Work to Showing It

In terms of young art students, I think they need to develop a point of view and then fully work through that idea. Sometimes we look at work by young artists and they are all over the map, so to speak. It's a disparate body of work. What we're interested in when looking at young work, is that a photographer has taken an idea and really explored it.

Katherine Hinds, Curator of Photography, Margulies Collection
at the Warehouse, Miami

I make the work, I offer the work, and I think once you give the work to a public, it's not yours any more. It's left your territory. It's in the public domain. Everyone is free to think of the work as they wish. You have no control over the work any more. It's important to do this. It inspires new work.

Marie Jo Lafontaine (p. 89, *A Fruitful Incoherence: Dialogues with Artists on Internationalism*, Institute of International Visual Arts, London 1998)

The world of art has always had the ambition of having the work completed by the viewer, and part of what comes from that is that no one person brings the same thing to the same work.

Philip-Lorca Dicorcia, *British Journal of Photography,*
May 2011 (p. 37, Vol. 158, issue 7788)

So, having completed a project or piece of work, where does a photographer start with the complex business of looking for an exhibition? It may seem like a contradiction in terms but the best way to start thinking about exhibiting is often to stop thinking about it for a time. The pressure can be on photographers to exhibit but hurtling quickly from making photographs to trying to exhibit them is not always the best approach. It is often useful to allow some time between making work and presenting it to others.

One reason for this is that the progress from making work to showing it is rarely seamless. For the photographer making the work is the first stage in a process in which the exhibition is the second stage. For the curator the photographer's completed work is their starting point and the completed set of photographs provides the raw material from which an exhibition is shaped. As a result they may have little awareness or interest in what has gone into the making of the work. So, by the time the work reaches a curator, the photographer needs to know their own work well enough to be absolutely certain that it is finished and that they have no doubts, untaken images or desire to take the work in a new direction. This is because an exhibition cannot usually be shaped from incomplete work and most curators will be reluctant to start until the entire project is complete and prints available to them.

The shift from the work of making images to shaping an exhibition can also be a difficult transition for the photographer. Of course photographers differ a great deal in the way they make work and for some an exhibition outcome is intrinsic to the way the work develops from its inception but as many, if not more, photographers set out with aims that shift and change as the work makes its own demands. For most photographers concentrating on an outcome, whether in the shape of an exhibition or a finished piece of work, can be inhibiting. So the importance of taking time is to ensure that this stage of making the work has been completed and that the photographer understands their own work fully before he or she sets out to make an exhibition. Even though a curator may well bring fresh readings of the work to the process the photographer has to be clear in their own reading of the work at this stage.

Ori Gersht describes the way many photographers make work: 'With my photographic work I don't make too many plans, I just have a framework; and then I want my intuition to inspire the work. If you take an overly intellectual approach I feel the work becomes too illustrative and didactic.' An artist has to feel free to trust his or her instinct and follow where it leads even if it takes them away from the original idea which motivated the work. In the same way he or she may not see what exactly it is that they have been doing until a project is finished, or nearly so, and they can stand back and look at it with a level of detachment—almost as if someone else made the work.

This is a step which many less experienced photographers miss out and it can be a mistake. Until relatively recently most photographers had good darkroom skills and simply by spending many hours making prints came to know their work intimately in a way that is not duplicated by contemporary technology. Photographers need to understand their own work for themselves rather than rely on how other people interpret it, even though other people's interpretations can be very useful. The only way to do this is by spending time with the work studying it, whether consciously or unconsciously. When making work, Diane Arbus did this by covering her walls with photographs, by other people as well as her own work: 'I like to put things up

around my bed all the time, pictures of mine that I like and other things and I change it every month or so. There's some funny subliminal thing that happens. It isn't just looking at it. It's looking at it when you're not looking at it. It really begins to act on you.'

William Eggleston's approach is to avoid looking at other people's images, probably for exactly the reason that Arbus did look at them. Her desire was to absorb them because it fed her work while his is, quite possibly, to avoid doing so because it might influence his image making. 'I don't look at other photographs much at all. I don't know why. I study my own a lot. I'm just not drawn to wanting to look at other people's images.'

So, whether or not the photographer uses others' work to understand their own the important thing is to find ways to do it. There are very many possibilities here and most photographers arrive at a method that suits their way of working. I would suggest that the simplest and most efficient is for the photographer to devise a hanging system in their home or studio, which will mean that they live with the work for as long as it takes. Different ways I have seen this done include stringing lines of prints across the room or attaching battens to the wall from which photographs can be hung using photo-clips or bulldog clips. My preference is for using a wall so that, as Arbus suggested, you are always looking at the work but some photographers work with small prints in books, like an artist's sketch book or one of the self publish books available on the internet. Some photographers make a set of 4 × 6 prints, which can be laid out on a floor or table and are a simple way to look at and rearrange work. Others use clear-leaved books, designed for family snapshots, in which small prints can be ordered and then reordered. I would always advise working with actual prints rather than on a computer as colors and tones on a computer can be misleading and difficult to match to final prints. Just living with prints, and studying them in whatever way suits the photographer, makes it easier to see the work again, understand which images are successful, which are the key images and which could or should be discarded, where there are repetitions and how different photographs or combinations of images work together.

This next step usually takes time. It is about making that transition which transforms the work from a collection of images into a coherent exhibition proposal. It may be a quick and easy process because the photographer has been so close to the work for so long that by the time it is complete there is little to do to make it into an exhibition. Or it may take longer for the photographer to make the leap of the imagination which will transform the work. It may require the intervention of a close colleague or curator who can bring fresh insights to the work. Sometimes it means going back to make additional images that are necessary to complete the work for an exhibition. But it is crucial that the photographer has actually finished the photographic project and done most of the work to shape an exhibition concept or proposal before approaching a gallery because a curator or gallerist can't begin to start work until they know exactly what material they have to work with.

So, whatever method the photographer uses to look at their work again once it is finished taking time can allow two things to happen: the photographer can step back from the intense engagement of making work and achieve a level of detachment from it and can also learn to understand the work all over again—from the perspective of an audience—a process that will help an exhibition concept take final shape. When this understanding is complete, the photographer can start to edit the work for exhibition.

Editing work

Photography for me is all about editing. When you edit you retell stories and create new stories.

Zwelethu Mthethwa, photographer (from the exhibition *Figures & Fictions* at the V&A Museum, London 2011)

Photographers who can edit their own work well are rare, and they also tend to be the best image-makers. A clear understanding of why images are being included is imperative. Too often photographers include images because of some anecdotal reference.

Michael Mack, Managing Director of Steidl and Co-publisher of SteidlMACK

Editing is extremely difficult. It's taken me a long time to learn how to edit. Teaching has helped me a lot with editing. One of the ways I teach is to assign my students work and then edit their contact sheets with them every day.

Mary Ellen Mark, photographer

If someone says they can't edit their images, I normally refuse to see them. I also prefer to see images from a project the artist is actually working on, rather than images from ten different projects.

Dr Inka Graeve Ingelmann, Head of the Department of Photography and New Media, Pinakothek der Moderne, Munich

I do a first choice from contact sheets and then do many, many work prints. From that I then choose an average of six images per film. Then I reduce it down to whatever is needed.

Sebastiao Salgado, photographer

There are often several stages involved in editing a piece of photographic work and the first is usually an edit made before an exhibition idea or portfolio is presented to a curator or gallery. On an initial meeting a gallery will expect to see a portfolio of around twenty images rather than an entire proposed exhibition. This edit means reducing the number of images to be presented and usually also sequencing them. Many photographers find it difficult to do this or to accept that work will look stronger, rather than weaker, when fewer images are presented. But it is an essential skill for an exhibiting photographer to acquire if they want to retain control of their work since, if the photographer doesn't edit their own work, someone else is likely to do it and they may not understand the work as well as the photographer does. The process of editing should also deepen the photographer's ability to understand and therefore to speak and write about their work.

However, editing work is a skill usually learned over time and through practice. It's a difficult skill to teach because each body of work will require its own edit and there are few guidelines. Editing necessitates developing and trusting one's own visual sense of how images work together. It is often best learned by working with other people—especially people like curators or picture editors who understand how images are received by an audience and have developed

Pages from Georgina McNamara's sketchbooks. Images © Georgina McNamara www.georginamcnamara.com.

these skills over years—or as part of a photography group's discussion of the photographs, of their possible readings and of what does and does not work. Other people's readings of their photographs can be startling to the photographer, who may well be too close to the work to see how it will be perceived, but it will educate the photographer in their understanding of how a gallery audience may receive the work.

Looking at exhibition and magazine selection may also help sharpen this skill though some people will find doing this no help at all because the exhibition or magazine is evidence of what has been kept in rather than of the whole 'before' and 'after' process of editing. An exercise in editing can also be devised by, for example, cutting out all the images in a magazine and then editing them into a sequence or story (or several different sequences and stories). Research notebooks or sketchbooks are not only a useful way to keep a record of ideas and decisions but a useful tool when editing the work because they can be used to 'rehearse' different editing decisions.

Many photographers find it much easier to edit other people's photographs than their own because they have less emotional attachment to particular photographs and can see the way a set of images will work when edited. Photographers can find that they are more attached to some images than to others and reluctant to lose their favorites from an exhibition selection. Unfortunately, this attachment often has more to do with the circumstances in which the photographs were taken than because of the way the image works. If one image has taken a day of very hard work to produce or has strong personal associations, while another is almost accidental,

an afterthought or the product of an inattentive moment the photographer is likely to prefer the first, regardless of the fact that the second may be more interesting to other people or more relevant to the planned exhibition. I was once in an editing group when a photographer described to everyone an event in the photograph—no one could see this even with a magnifying glass— but for the photographer the image had, somehow, captured the event and she had to be persuaded that the photograph didn't work without her presence to tell the story before it could be edited out. When this happens the photographer must be prepared to listen to other people's opinions and lose their favourite photographs from an edit; a 'good' (i.e., tough and realistic) curator will not let the photographer's sentiments get in the way of an exhibition edit.

Working with a group of photographers is one of the best ways to edit work because most photographers enjoy the process and are prepared to discuss and analyze photographs in great detail and to persist with an edit until something satisfactory emerges. The photographer can learn through this discussion but will also need to learn to stand up for their ideas and preferences because there can be a danger that the edit will be too simplistic or, occasionally, unsympathetic to the photographer's intentions—although most groups are very good at taking their lead from the photographer.

The best starting point is usually to put all the photographs out on a very large table or on the floor or wall, if that offers more space. If the images have a sequence, either of the order in which they were taken or in which a narrative is intended to develop, then they should be put in that sequence as a starting point.

It can also be useful to number them (in pencil on the back), simply in order to be able to keep a record if necessary. Most people can remember sequences and juxtapositions visually for a short time only.

The next step is to look at the images slowly and carefully until you know each quite well. Look first for the things that hold a set of pictures together that may be a narrative, a chronology, an aesthetic, technical or stylistic thread. Then look at how the images might fall into sequence, how images repeat each other and which, if any, are the weaker images. Effectively you are looking for the things that hold a set of pictures together and editing out images that don't fit or are repetitious. This may mean losing individual compelling images that do not work with the rest of the set for any reason, technical, aesthetic, or in terms of meaning.

Once you are familiar with all the images there are different ways to start editing and personal preference will dictate which one you choose. The choices are to start by 'playing' with the images, to group the images, to start editing images out of the selection, or to start by editing images in to the selection.

My personal preference is to start by grouping images by subject matter, by aesthetic or technical similarities so, for example, in a body of work about the coast the images might divide into beach furniture, picnic items, different types of beach umbrella and shade provision and views out to sea. I might make a group simply because the horizon is in the same place in each image. In a body of work about light falling across leaves the work might fall into groups with large or small leaves, different patterns of light or background colours. Look at the images for a few moments and points of similarity will start to appear and once you start to move the images into groups other possible sub divisions usually appear.

Just 'playing' with images is also a good place to start, especially if no clear groupings are obvious. Experimenting by moving them around and putting images together, making pairs and small sets will help determine which images work together and which don't. Gradually through doing this a sense of the shape of the overall edit should emerge.

Editing is sometimes best done by taking photographs out of a selection rather than by selecting photographs in to a selection. Images can be removed because they don't hold the attention, repeat other images, are technically weak or don't quite fit, visually or as part of a narrative, with the set that is emerging. Each time an image is removed, the set should be checked to make sure that the right decision has been made and that the set looks stronger by its removal. If at the end this doesn't seem to have provided a good edit then the process starts again from a different point.

Another way to do this is by selecting a small number of key images. These will probably be the strongest images visually and together hold the message or theme of the exhibition (they may later be chosen as press images). This can then be built up slowly with the addition of images to the set of key images. Once again each time an image is added the set should be checked to make sure that the right decision has been made. In a set the key images are usually kept separate and distributed through the set—if they are kept together there is a risk that they overwhelm the other images. So, for instance, in sequencing work the sequence starts and finishes with a strong image and other strong or key images are more or less evenly spread through the sequence—as fence posts support a fence so these images support a sequence.

There are many ways to approach sequencing work. An obvious way is to follow a chronology—this need not be true to the original order in which the images were shot but simply a device so that, for instance, the set of images appears to start in the morning and end in the afternoon. Or a narrative thread may emerge when, for instance, the first image sets the scene or is an establishing shot, the next moves in closer, the story unfolds and then a final shot seems to sum up or end the narrative. The work may fall into groupings resembling chapters in a novel with each new 'chapter' marked by a statement image. Color, graphics, or composition may suggest a sequence—a subtle shift from dark to light images for instance. Or something as simple and obvious as height in a set of portraits or distance in a set of landscapes mean that the portraits can be placed from small person through to tall or alternating short and tall people and landscapes from distance to close. Often what makes a sequence work is something very simple.

For someone who is an inexperienced editor it may be necessary to leave the process and return to it later if it suddenly stops making sense and you become aware that tiredness is affecting the decision making. The crucial thing to do at the end of this process, even if the edit is not finally resolved, is to make a record (using the numbers on the photographs, a photograph or drawing). When an edit is achieved it may feel entirely 'right' and as if the photographs can only be in that one sequence but, unless it is recorded, the photographer may find that they have to start all over again later. I once worked with a student for hours to find the best combination of a set of very similar images which were to be shown in a grid of three by three. It took a long time but finally we had the perfect selection. Several days later I heard from her that she hadn't remembered it; I didn't have time to repeat the exercise and neither of us ever felt certain that the final exhibition was the best possible showing of her work as a result.

We will return to the subject of editing again because, although the photographer will need to do a preliminary edit before approaching a gallery, the work will most probably be re-edited later. A curator, who brings an entirely fresh vision to an edit, may later want to re-edit the work to make it fit an exhibition concept or to shape it to the constraints of a particular space and may start again from the beginning of this process. They may also want to see images that have already been edited out of a portfolio or set. However, the photographer not only needs to present an initial edit to a gallery but will be in a much stronger position to discuss the work and contribute to the process if they have been through an edit already.

Self-publishing and editing

In recent years with the fall in the price of publishing and the increased availability of self-publishing the popularity of photographic books has grown tremendously. These can be both a substitute for exhibiting and a supplement to it. A self-published book can be widely distributed and also used as a portfolio with the advantage that the book can be given to an appropriate curator or gallery.

The process of assembling a book can also be useful to the photographer. Mandy Barker, a recent graduate of De Montfort University, working on issues raised by the mass accumulation of plastic debris in the North Pacific Ocean, writes about her experience in making a blurb book (see blurb.com):

Ingredients; all plastics partially burnt. *SOUP*: burnt. Image © Mandy Barker.

Working on a blurb book has affected both my photographic practice and my approach to presentation. I set out on two recent book projects with different intentions for each and both were nominated for the Blurb Peoples Choice Award with Soup being awarded First Runner-Up in the 2011 Blurb Photography Book Now, Student Category.

From the outset I intended to present images from my project, Indefinite, in book form and to use it as a mini-portfolio. However, experimenting with the layout and the sequencing of images and text also made a stronger body of work as attempting to create a seamless flow from page to page meant I had to rethink the sequence and the way that some images didn't follow on or sit properly together. This experimentation and editing process meant that I scrutinized the work in much more detail than I would have had the images gone straight into an exhibition or been presented individually in a portfolio. In this particular project being able to be self-indulgent in the use of a whole page for a minimal caption also gave greater emphasis to the meaning of each image, something that ultimately maximized the impact of my work.

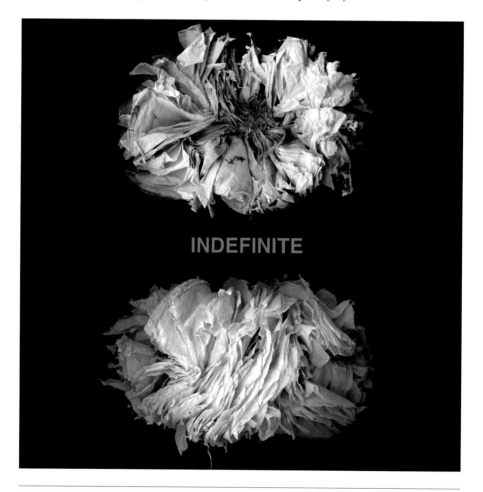

INDEFINITE (book cover). Image © Mandy Barker.

Initially, the intention for the second project, Soup, was for the images to be exhibited only at a large scale, and not as small images in a book. But, although the work was finished, I felt the prints alone did not seem to capture the whole story so I chose to make a book as a way of discovering the relationship between the individual images and of experimenting with the way the work could look exhibited. The connection between image, page, and text helped me develop a more compelling story. Using a single page to make an obvious break in the sequence provided a clear distinction and natural pause for thought between the first part of the series, and the final image. Including ideas from sketchbooks as image spreads at the back of the book helped pull the project together. The feedback I received from the judges at Blurb confirmed my feeling that the sketchbook images enhanced the overall project by giving supporting evidence which helped the viewer identify with the story at another level. This was something that only happened through the process of creating the book, but is something that I can now take into account before pursuing other areas of presentation or exhibition.

When I met my fellow prize winners in New York I discovered that some used books as a way of sending bodies of work to prospective galleries or clients as an initial introduction. Some publish multiple copies and sell their work online, which increases the accessibility of their work and brings responses from a wider, global audience. All of the winners I spoke to agreed that the most important reason for making their book was to enhance communication and to create a strong visual narrative or storytelling concept.

In my experience creating both books has reminded me of the importance of taking the time to consider my work in detail and from different perspectives. Creating the books provided me with a certain pause for reflection, with time to think and revise, and for the option of early feedback or comments. Whilst I feel that work can only be truly appreciated through exhibition a book is an early form of self-curation, a way of communicating quite unlike other methods of presentation and can play a significant part in both photographic practice and in the process prior to exhibiting work.

Mandy Barker
www.mandy-barker.com

Looking at presentation and curation

Of course it should go without saying that a photographer should keep in touch with the world of photography by regular exhibition visiting. However, photographers vary in their attitudes toward looking at other photographers' work; some find it rewarding and sustaining for their own work, while others feel that it deflects them from their own creative vision and that they need to avoid being overly influenced by images made by other photographers. So why is it particularly useful to look at exhibitions by other photographers? Do the same issues apply? I don't think they do. It is useful to look at exhibitions because a practical way to start thinking about exhibiting is to analyze how other photographers exhibit and promote their work. On the whole, it is easier for photographers to avoid being overly influenced by exhibiting styles

because the aim is to research and analyze possible options which will then be considered by others, such as curator and framer, as well as the photographer.

In practice, however, this can be quite a difficult and time-consuming thing to do. It can often take an act of conscious will to go into a gallery and look at the way the work is being shown rather than at the work itself. This is partly because our usual job as viewer is to start by doing the opposite: by being passive and wandering (apparently) aimlessly, postponing critical thought and letting the work 'speak' to us rather than analyzing the presentational methods and curatorial intent of the exhibit. In part, too, it feels like insisting on looking behind the scenes at the theater rather than at the performance itself.

However, an analytical look at a series of exhibitions can help prospective exhibitors approach making exhibiting decisions by themselves or to develop the knowledge and confidence to negotiate with gallery directors and curators over how to show their work to the best advantage.

The aim is for the would-be exhibitor to:

- see and understand what is current in the world of exhibiting photography with the intention of making a place for him/herself within that world
- learn how an exhibition concept can be shaped to make a body of photographs cohere and communicate with the audience
- learn how other photographers present their work (for instance, in series or as a narrative) in order to acquire the same skill
- look at the practical issues of framing and matting as well as the key issue of how the gallery space has been used
- look at problem solving by photographers who are dealing with the same issues as the would-be exhibitor (this might include, for example, the use of scale, text, captions, or a light box)
- see which exhibition styles do and do not work and understand the possible pitfalls of exhibiting (for example, when too many images are shown, the frames distract from the images or an installation is too complex)

In analyzing exhibitions it is useful to take a colleague to discuss it and a notebook in which to make a record and draw diagrams of the exhibition layout. Gallery staff may also be very helpful and share information and insights about the exhibition. There are three main tasks in this process:

1. Description. Essentially this is to look carefully at every detail of the exhibition presentation and record or describe it. The description should be as detailed as possible.

 First look at and—crudely—categorize the type of photographs shown. Are they journalism, documentary, landscapes, portraits, architecture or urban landscapes, abstract or graphic, autobiographical or personal work? Then (and I hate to suggest this) forget the photographs and look instead at the size of the images, the matting and framing of the images, the size and color of the mat in the frame around each photograph, the amount of wall space between photographs, the sequence and flow of images, and their layout in

the gallery. Also look at the lighting, the captions, and text used. What information is provided about the photographer? What information is provided about buying photographs? Are there leaflets or other information to take away? Look at the audience: How have they made the journey into the gallery? Is the door open and welcoming? Is there clear signage outside? Is the audience engaged with the work and following the flow of the exhibition? Make notes if necessary, and write down anything that seems particular to that exhibition or gallery space. For this list, the most crucial thing for the would-be exhibitor to note is the way the work is displayed and whether the audience is looking at it in any particular way. (Is their attention held? Do they move around the gallery in a direction clearly dictated by the layout?)

2. Interpretation. The task here is to look at the reasons behind the choices the curator made in showing the work in the way it is done. So, why are the photographs printed at that particular size? Could they have been shown in a different order? How do they fill the space? Do these particular frames complement the images, and can you imagine them in different frames or mats? Could the exhibition have been lit differently? How do these choices, all of which will probably have been made by the curator, influence the way you, as audience, look at and understand the exhibition?

3. Assessment. The task here is to decide whether the various curatorial choices made help the photographs and the exhibition or not. Are there perhaps alternative or better choices that could have been made? In trying to understand how the work has made the transition from a set of photographs to an exhibition the photographer should see why these choices have been made and how this has helped the work (or not).

An example can be taken from *In The Face of History,* a major exhibition of twentieth-century European photography shown at the Barbican Gallery in London. As part of two different sections of the exhibition, Ukrainian photographer Boris Mikhailov and the German Wolfgang Tillmans each showed a single wall of photographs. The two installations could not have been more dissimilar, and a comparison gives us a way to understand the curatorial choices made. Mikhailov's sixty-six photographs were shown in a very formal grid which formed a solid block of images that filled the wall. Inside the block the photographs were subdivided into further blocks of two, three, or four photographs. Looked at from a distance, or seen diagrammatically, the display had a look of military precision, everything lined up precisely, and the grid looked both formal and regimented, almost like a diagram of an army drawn up before one of the great battles of history.

On the other hand, Tillmans's thirty-six photographs appeared to be placed on the wall at random, almost as if a high wind had blown them there by chance (although they were straight rather than at angles) and the placing was accidental. Some of the photographs were almost too high to be seen, others were so low that the viewer had to bend down, some were closely grouped together, while others just seemed to float in solitary space. Many were taped to the wall, apparently haphazardly.

A comparison of the works themselves, and particularly of their historical background, provides us with an explanation for these contrasting methods of display. Mikhailov's work,

'Red' (1968–1975), is a satirical response to Soviet power in the Ukraine, so the layout echoes a sense of military discipline and rigid bureaucracy while the content of the images undermines and pokes fun at this formal arrangement. The message for the viewer, given in a way that will usually be perceived unconsciously, thus echoes the subversive view of the photographer.

Tillmans, on the other hand, started the work 'Markt' (1989–2005) at the point that the Berlin Wall came down and the Cold War ended. The work as well as the installation, which is characteristic of the way much of his work is displayed, echoes the sense of new-found freedom of that period and, perhaps, of the freedom of his role as photographer.

An entirely different sort of exhibition design decision was made by my colleagues and I at the Tom Blau Gallery where we showed vintage press prints, most of which had been in circulation for many years. Some of the photographs were up to fifty years old and fairly battered. They were journalistic images intended for newspapers and magazines rather than exhibition, but over time they became interesting as art works in themselves (in part because of the quality of the images and in part because they were reportage photographs by photographers who were subsequently recognised for their contribution to photography). To make it clear that we were offering these erstwhile press prints for reconsideration as art, despite their sometimes much-used appearance, we displayed them in the most formal and conventional way possible, with wide mats in simple and immaculate large frames rather than in the less formal and more immediate way that we would have shown contemporary photojournalism.

Thus an interpretation of the work and the context in which each work or piece of work was made helps us see that each installation design is specific and appropriate to the work and, although the audience may not be consciously aware of this, their appreciation will have been assisted and enhanced by the way the installation reinforced the understanding of the photographs.

In his useful book *Criticizing Photographs*, Terry Barrett points out that in looking at photographs and photographic exhibitions from a critical perspective, there are four main activities: describing, interpreting, evaluating, and theorizing. A would-be exhibitor can use the first three activities to develop a sense of what does and does not work in an exhibition. (Barrett's fourth category, theorizing, which he subtitled 'Is it Art?' is less relevant here since, by and large, the gallery itself, as an art gallery or a photography gallery, will make that statement on behalf of the work shown.)

It is worth noting that this method will not suit everyone. Some photographers find they need to ignore what everyone else is doing if they are to focus on and develop their own work without either imitating other photographers or becoming intimidated or self-conscious. But for most photographers, looking at how photographs are presented to an audience and carefully examining the decisions behind the presentation is a useful exercise which broadens their understanding of how an audience might see their images. Over time, this becomes automatic and the photographer keeps himself or herself in touch with developments in presentation as well as understanding how best to show their own work.

Showing a portfolio

Before going to see a gallery it is very useful for the photographer to test the response to their work by showing it to curators and gallerists at a portfolio session. These sessions are usually available at local events at galleries and photography festivals and at major international events such as Rhubarb Rhubarb, Paris Photo, the Huston FotoFest, Review Santa Fe, or the Palm Springs Photo Festival.

There are two good reasons to attend a portfolio session. It's both a way to, as it were, test the portfolio by seeing if experienced curators will understand and like the work in the way the photographer intends. This gives the photographer the chance to reshape the portfolio in line with their comments before taking it to a gallery if necessary. The curators at these events also usually give very useful advice about who might be interested in showing the work, galleries who might be approached and may well have helpful advice about how the images should be shown. And sometimes, of course, the photographer will be offered a show at one of these sessions or be asked to bring the work to the curator's colleagues or gallery.

Different organizations organize and offer portfolio sessions in their own way but sessions tend to be about thirty minutes long and visitors see more than one curator, who will be either allocated by the organizers or chosen by the photographer. If the photographer gets a choice of curator or gallerist they should, obviously, do their research first to see which ones might represent a gallery with a track record of showing the sort of work the photographer makes. The photographer should be very organized before they go, have their portfolio and questions ready, and be efficient about fitting into the schedule. It will be worth considering how to present the work in a way which will be easy for the reviewer to look at because there will be a time pressure. These sessions can be tough for the inexperienced and the photographer is probably well advised to go with friends or colleagues and arrange some sort of informal debrief afterward as a way of celebrating or commiserating.

Case Study Two
Esther Teichmann: Working Collaboratively

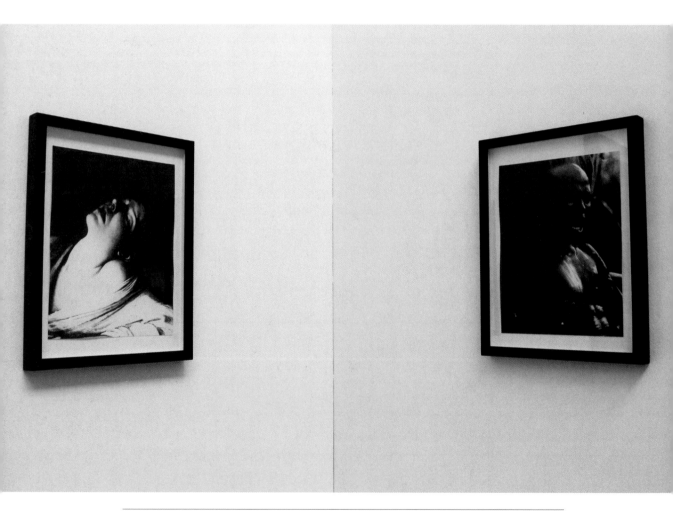

Diptych from *Mythologies*, 2011, fiber based, 10 x 8 inch each, image © Esther Teichmann.

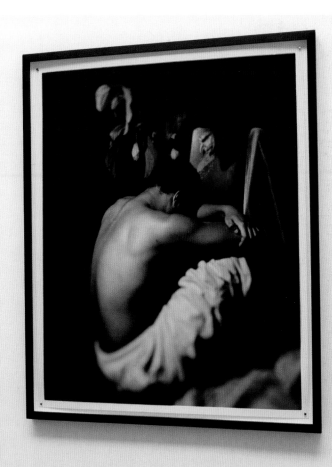

'Untitled' from *Mythologies*, 2011, fiber-based print, 20 x 24 inch and 'Untitled' from *Mythologies*, 2009, C-type, 30 x 40 inch, image © Esther Teichmann.

Dialogue needs community and creativity thrives upon dialogue. This triangular relationship between creativity, dialogue, and community, which is the foundation of all fine art education, is perhaps what is most vital to sustaining a practice, but is also difficult to maintain outside the framework of the academy.

At various stages of my practice it has been crucial to both the development of the work as well as the dissemination thereof to in part work collaboratively. This has taken the form of founding and joining more formalized collectives and research groups, as well as working together with other artists on joint exhibition and curatorial projects, and collaborating with writers on publication projects. This continually expanding network of likeminded friends and colleagues who inspire and support one another, is, I believe, vital to most creative practices.

After my undergraduate degree in 2002, myself and many other classmates moved to London and began internships and assistant jobs, trying to make sense of the multiple facets of the photography and art world. Within this initially daunting environment it can be difficult to not only try and keep one's head above water financially, while also continuing to actively develop one's practice without the framework of art school's dialogue and group feedback based teaching.

One of the first creative networks I was a part of, was a collective, *Photodebut* (2002–2010, www.photodebut.org), founded by myself and Jan von Holleben, a fellow recent graduate from another photography degree course, whom I met during our neighboring final shows in a warehouse district in London.

After several months of discussion about what it was we wanted and needed from trying to create a new community of emerging photographers, Jan was given the opportunity to use a gallery space in Shoreditch to coincide with *PhotoMonth* in autumn 2003. Rather than curating an exhibition we invited a large selection of likeminded emerging artists to participate in a salon-style show, in a call for entry format. Over 400 people jostled their way through the space, images cluttering every wall. Suddenly a dialogue was taking place, which was self-propelling and exhilarating. A possible form of collaboration among artists made itself apparent and thus we decided to structure and shape it into a collective of photographers.

The initial members were selected photographers from the Shoreditch exhibition, who had expressly voiced their desire and need for such collaboration. Beginning with our initial mission statement to promote, support, and connect emerging photographers, we would draft and redraft our aims and ideas as a united group. These conversations took place within monthly crit meetings and while looking at and critiquing each other's work. It soon became evident that one of *Photodebut's* strengths was the variety of backgrounds and experience amongst its members—alongside developing and working on our own practice, most of us were also working within another aspect of the industry, as picture editors, agents, art buyers, critics, lecturers, producers, photographic assistants, and within galleries (to name but a few areas). By pooling and sharing this knowledge and resource *Photodebut* soon developed into a professional network whilst maintaining its founding principle of collaborative project and educational work. On a

purely practical level this expertise allowed for a professional management of projects such as the exhibitions held. We were also able to get extensive media coverage from leading journals and papers and raise sponsorship for private views. An independent collective combining elements such as self-promotion, exhibiting, and publishing with a wider reaching educational and support ethos, was met with encouragement and generosity. A list of impressive trustees who wholeheartedly embraced the concept added credibility to a group tentatively maneuvering their way through new terrain.

After eight years, in 2010, most of us within *Photodebut* were following such active career paths that we were no longer able to sustain the momentum and time input necessary for the initial formality of the group structure. At the same time the group had expanded immensely over the years, and the network functioned in exciting and unforeseen ways. In 2010 we decided to maintain the website as an information page only and publish a small book as a case study to archive all our projects, which included photographic workshops for the public in conjunction with other organizations, moving exhibitions comprised of lightboxes on the back of huge trucks, to name a few. The close relationships forged among members continue to be vital to us every day, both professionally and personally.

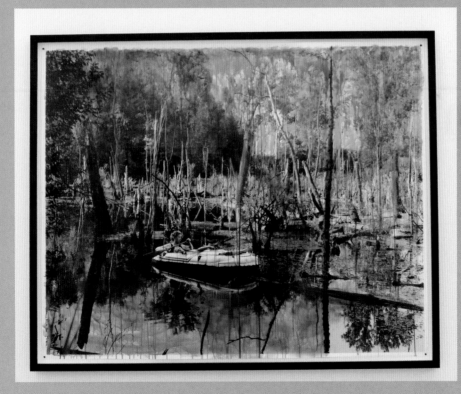

'Untitled' from *Mythologies*, 2009, C-type, acrylic, ink, 40 x 50 inch, framed image © Esther Teichmann.

A recent research group I am part of, which in some ways follows a similar structure of monthly critique meetings and an online forum for archiving the shared material as well as opening up the discussions beyond the meeting space, is *The Postgraduate Photography Research Network*, www.ph-research.co.uk (founded by Benedict Burbridge, PhD Courtauld, and editor of *Photoworks* magazine, and Olga Smith, PhD Cambridge University). Established as a research forum for doctoral students and early career academics working in the field of photography, this network also grew out of the frustration felt by a number of emerging scholars faced with a lack of opportunities to meet and discuss their work. *Ph* is above all a collaborative venture, unattached to any single organization, with members from institutions across the UK, all working in very differing ways on ideas of the photographic, both within theoretical research projects and in studio based ones such as myself. At the heart of the initiative lies the conviction that photography can provide a point of contact between different disciplines, discourses, periods, and approaches and that, by opening a dialogue between them, we might better understand the positions it occupies in society and culture.

Besides these more formalized networks of discussions set up independently of any one institution, other forms of collaborations have been key to my practice.

In 2007, a collaborative show with the artist Spartacus Chetwynd (*Fantasie Fotostudio—The Esthacus Teichwynd Photographs* shown at Giti Nourbakhsch Galerie, Berlin), saw us give up individual authorship, making joint images during a week's self imposed residency prior to the opening. This very different mode and pace of working opened up my own practice in exciting and dynamic ways.

In 2009 I worked on another two person show and publication with the artist Henrietta Simson, very different in nature and approach. In the run up to *Lulled into Believing* (Man&Eve, London, 2009), we spent week days working alongside one another in dialogue in each other's studios, making work contingently in response to the other's work, unfolding these shared interests and reference points, while infusing our practices with new learned processes and references from the other's. From this initial show and catalogue (which functioned as an exquisite scrapbook-like documentation of our process—another collaboration with the designer Matilda Saxow with whom I have worked on print material over several years), we are continuing to expand our ideas and are in the midst of proposing an exhibition and program of events (such as artist talks, symposia with invited artist, writers, and curators, and screening event around the subjects and influences our works draw and touch upon), which expands upon and develops both the ongoing bodies of work and the conversations and dynamics between these.

Current collaborative projects and dialogues include the very beginnings of a curatorial project with artist Steffi Klenz in which we are thinking about how early German Romanticism influences certain contemporary artist's practices working in the still and moving image. Expanding from a talks series around *Affect and the Photographic* I was invited to program for The Photographers' Gallery at the start of the year, I am working on a two-person show proposal with the artist Wiebke Leister. One of the most influential dialogues in the past years has been with writer, Carol Mavor, with whom any

shared time is one of exhilarating exchange in which, as in all the examples discussed earlier, each practice is invigorated and opened up by that of the other.

Currently, I balance part-time lecturing with my practice, and this community based on an exchange of ideas and knowledge is one I feel particularly fortunate to be part of. Whether in the UK or on visiting artist guest lectureships in other countries, such as recent trips to Melbourne and San Francisco, each art college emphasizes and is founded upon the notions of dialogue, exchange, and collaboration between students, but also of course between staff and students and among staff, which allows for a unique non-hierarchical space of mutual learning and making. In career paths and fields, which have perhaps some very solitary and insular aspects to their nature, this sustaining of a network of critical feedback and support is crucial and necessary to most practices.

Esther Teichmann

www.estherteichmann.com

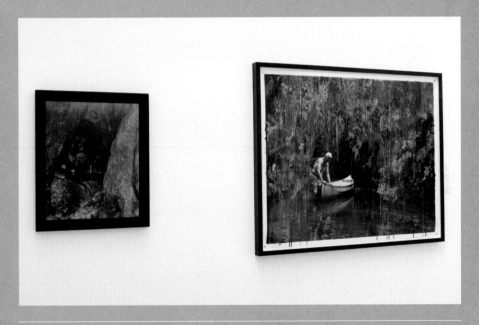

'Untitled' from *Mythologies*, 2011, C-type, 16 x 20 inch, and 'Untitled' from *Mythologies*, 2011, C-type, acrylic, ink, 30 x 40 inch. Image © Esther Teichmann.

Alternative Routes

Installation shot of the Crypt Gallery, St Pancras Church, Euston Rd, London showing C-type photographs by Ewa Kazmierczak from the project "Look into my Eyes" (www.ewaphoto.com) in the exhibition: *Tracing the Photograph*, 2009. This was a group show of seventeen of the Super Monday photography collective (who had studied together at Central St Martin's School of Art).

"The hang alignment was extremely difficult as the Crypt's regulations stipulated that we were not allowed to drill any holes into the brick walls and had to use existing holes from previous shows."

Image © Georgina McNamara.

Indeed much of the art of the late sixties and the seventies had this theme: how does the artist find another audience or a context in which his or her minority view will not be forced to witness its own co-optation? The answers offered—site specific, temporary, nonpurchasable, outside the museum directed towards a nonart audience, retreating from object to body to idea, even to invisibility—have not proved impervious to the gallery's assimilative appetite.

Brian O'Doherty (*Inside the White Cube*, 1986)

One of the most difficult tasks for any photographer just starting out is to find that all-important first show. Most galleries receive many more applications than they can take on. Most will also prefer to take on photographers with some exhibition experience. It can be disheartening for the photographer to be regularly rejected and to have work that is ready for exhibition but be unable to find a suitable gallery. It can also be a disincentive to starting new work. The answer is usually to look outside the gallery system for an alternative. By choosing this route, the photographer can keep the work in the public eye, acquire a breadth of experience and contacts in exhibiting, and gain confidence and a sense of independence. Each of the possible alternatives will have its own specific advantages and disadvantages, which will need to be carefully assessed in advance, but this is one of the best routes into exhibiting and the photographer can choose one of the many options that best suit them.

Finding a space

There are several good alternatives to finding a gallery that will show your work. These include hiring a gallery, showing in schools and colleges, showing in places that are not galleries but will show photographs, and converting a space to act as a temporary gallery. There are also all sorts of unusual spaces available to show work. These include cooperative spaces run by artists, people's homes, and galleries in cinemas, theaters, cafés, bars, local libraries, community centers, hospitals, shops, factories, decommissioned churches, and offices. There are also all kinds of markets, specialist fairs, and festivals where you can hire a space or stall. Some of these venues will regularly exhibit photographs, while others will be available only in the short term, for a single exhibition or one-off event.

Open studio shows, whether the studio is in the photographer's home or in a shared, designated studio building are a different kind of exhibition in that the work can be displayed informally and be a 'work in progress' show rather than a show of finished work. It can also include both finished and unfinished projects. A studio show can be a way of testing work and a good informal bridge between making the work and a finished exhibition piece.

Any of these options can bring a new audience to your work and be an enjoyable experience. It is often a good opportunity for a photographer to be experimental and innovative in his or her presentation. It may also be a challenge and can be stressful, but it is one of the fastest ways for any photographer to learn exhibiting skills. Equally importantly, these sorts of venues are usually carefully watched by most curators and galleries looking for exciting new work and may be as direct a route to exhibiting as the more traditional one of presenting a folio to a gallery.

The potential downside is that most of these spaces will lack the support systems that exist in the regular gallery so the photographer will have to do more work than they would in a

Photographs by Sophie Michael *'Intra-spectral,'* a one-month exhibition at The Ideas Store, Whitechapel, East London. Tower Hamlets 'flagship library, learning, and information service' the gallery @Ideas Store Whitechapel is billed as 'an exciting new space for local artists to exhibit their work.' The gallery is situated on the art books floor within a study area for students. It consists of a wall on the fourth floor of the building (which is also where the café is) with stark strip lighting and reflections from the huge windows on each side. www.sophiemichael.co.uk. Image © Georgina McNamara.

conventional gallery. Many will have no permanent staff or regular audience, no publicity system, inadequate hanging, heating, lighting, and security systems, and little money or experience in dealing with exhibiting. They may require extensive and expensive refurbishment. These sorts of opportunities are probably best explored as a group or by an individual who already has a good support system, as they are generally more labor-intensive and require a wider range of skills than showing in a conventional space.

There are several ways to find such a space. As a starting point, try your local council particularly if they have an arts office. Once again, it means looking at 'what's on' or 'around town' magazines, gallery guides of every type, specialist photography magazines, websites, and, of course, talking to other photographers. However, the simplest solution may be simply to walk around an area of town and look for possibilities. Several cafés and restaurants in my locality either show work or could perhaps be persuaded to do so. In the main shopping street near where I live, a computer shop had recently closed down. There was about six

months left on the lease, and the leaseholder loaned the premises to a young curator. She held a series of interesting temporary exhibitions in the vacated premises before the lease expired and the premises were handed back. She relied on her own mailing list and on attracting an audience of passers-by in a street with no other galleries; she had no costs to set up the gallery and very low running costs. Opportunities like this are there if you look for them.

Approaching a venue will be made a great deal easier if the venue already has a track record of showing and is sympathetic to it; in which case they will have some sort of system in place. If the venue has not been used in this way before then the crucial factor will be the attitude of the person in charge—if their immediate response is interest you have a chance of making it work; if not I would be tempted to give up at once. You, as potential exhibitor, should be ready with a realistic list of the practicalities (e.g., you would need to drill into their walls but will repair them after the exhibition) and advantages (e.g., that it will bring a new clientele into their establishment) and disadvantages (e.g., they would have to open the building for a private view, which might be a nuisance for them). Be prepared to discuss issues of security and insurance and be realistic. Don't attempt to make hosting an exhibition sound easier than it is or promise things you can't deliver, you need the wholehearted support of the building's owner or manager and you should be prepared to give them something of a starring role in publicity or at the private view because they will most probably be doing this out of interest rather than self-interest!

Hiring a gallery

Although each situation will differ, hiring a gallery brings with it all the advantages of having a space specifically designed for showing artwork. The gallery should also have systems in place for promoting the work and attracting visitors. It may also be a gallery that can be hired on a regular basis, so, for example, it could be hired every year for a summer show. However, many such galleries are expensive propositions, as they rely on hiring out their space to support their regular exhibition budget over the rest of the year and charge a high rate to cover possible damage and disruption.

In this situation, a great deal depends on the suitability of the space itself and on the attitude of the gallery owner or staff. If they are enthusiastic and supportive, hiring a gallery could be worthwhile, and it might be worth considering hiring the same gallery on a regular basis. On the other hand, some galleries are available to hire only because the owner doesn't quite know what to do with the space, and so the place gets gradually shabbier over time and has a dispirited atmosphere. Such spaces should be avoided.

One important consideration is usually that a gallery that hires out may well not have the regular audience that most regular galleries will have and the exhibitor will have to pay attention to bringing in their own guests. One of the other key things to remember when you do hire a gallery is that, as far as the gallery is concerned, taking down the show is as important as putting it up. If you leave the gallery in a mess, that particular gallery won't hire it to you again and may bill you for cleaning, damage, and redecoration.

Cafés, wine bars, and restaurants

These are often good places to show and sell work. Any environment where people relax and enjoy themselves can provide a good selling opportunity. Someone who has spent a pleasant evening looking at a photograph they like may well feel that the image will work just as well in a particular corner of their home.

However, owners and managers can vary a lot in their attitudes to displaying artworks, so an opportunity like this needs to be carefully explored. Some café owners like showing work because, as one of them said, 'I could have bought the art I wanted but we'd still be looking at the same stuff two years later, and when you're serving food one hundred hours a week, it's great to have a changing environment. We generally use local artists and I take 10 percent of sales revenue.'

However, other café owners take the opposite view, fearing that arranging a program of changing shows will be too time-consuming and that they will lose regular customers if they close for a private view or artist's reception.

It is important to find out what is actually being offered before arranging such a show. Some years ago a student of mine arranged to show his work in a wine bar in a fashionable area of Chelsea. We were all impressed until we arrived for the evening opening and found a dark bar with a poorly hung display. He had been so pleased to have persuaded the bar owner to show his work that he had not asked any questions of him. When he arrived to install his exhibition, he was told that he could only use the existing hanging system, which had been designed for large paintings. His small, irregularly spaced photographs almost disappeared on the dark walls of the bar.

This type of venue is likely to want to keep their walls undamaged and so will limit the possible places for installing photographs. This can be awkward and may make the venue unsuitable if, for example, the photographer wants to show small works and hanging spaces are only behind tables. No viewer wants to lean across other people's food or drink to examine a photograph! The downside of cafés, wine bars, and restaurants is that the work might be difficult to hang and even more difficult to light. Work might get damaged or stolen and be uninsured. The upside is that the work may well be shown for several months rather than several weeks, and the chances of selling work are usually good.

Using a nongallery space

Another alternative is to use a space that is not usually a gallery. Spaces I have seen used as a temporary gallery include disused factories and empty shops and offices.

This can be exciting and challenging. Most audiences like the sense of discovery that a different sort of space promises. However, it does pose a different set of curatorial issues. Few people are likely to invest in the space itself if it is going to have only a single use as a gallery, and painting the space or installing special lighting may be too costly to consider. Security of the premises, if not of the work, may necessitate hiring a security guard at night, particularly

if computer or video equipment is part of the exhibition. Some of the most interesting uses of this sort of space are those that emphasize and utilize the temporary nature of the place or its abandoned condition. Fragile works on paper, or work with a subject matter like urban landscapes, may be well suited to this type of space, whereas traditionally framed photographs may sit uncomfortably on crumbling walls.

A crucial part of curating in this sort of space is that a great deal of consideration be given to the way the audience will react to the building and move around it—signage is important and a strong street presence can be essential to persuade people to enter the building in the first place. There can be an uneasy compromise between treating the space as if it were traditional gallery space and being realistic about its temporary nature—so, for instance, decisions about whether to bring in specialist lighting or repaint the venue are central. An audience needs to be encouraged to concentrate on the work rather than on the real estate; it's all too easy to find oneself speculating on the previous use and inhabitants of the building if the curator hasn't addressed this issue.

Fairs, markets, and festivals

Fairs, markets, and festivals can be enjoyable and rewarding occasions. Hiring a stall at a fair or market, either as an individual or as a group, may or may not bring sales, but it is usually informal enough to bring feedback, informed and uninformed comment, and networking opportunities.

At major art fairs and festivals, especially those organized by or for commercial galleries, conventional subjects and styles with wide popular appeal are the norm and the most likely to find favor. Even major international events such as Paris Photo are often not the venues for experimental or socially critical work and exhibiting is usually by invitation.

However, smaller and more local festivals can be very different in their approach with open submission exhibitions and opportunities for the photographer to show new work or work in progress and to experiment with styles of exhibition and presentation. With luck and good planning these are also the venues where photographers can engage in direct debate with their audience and coexhibitors and take part in an event that might well start off small but, once established, will grow and increase in popularity and audience year on year.

I have been doing photography since 1981 and for the last seven years have concentrated my work on producing ambrotypes: direct positive on acrylic glass and all unique pieces. When I first started working on ambrotypes I spent three years in my studio, making my living by selling to a small network of collectors that had been following my work over the years.

However, if you don't exhibit or publish your work, it's as if you don't exist. By collaborating with agnes b.'s 'La Galerie du Jour', I was able to get some visibility in fairs like Paris Photo and galleries in Paris, London, and New York.

Indeed, photo fairs give the opportunity to show your work internationally to a wide variety of curators and collectors and are a good place for selling. Exhibiting in a gallery is, more often than not, restricted to a local public.

I have very few exhibitions a year as each piece is unique, and when I choose to exhibit without the backing of a gallery (as I did recently in a chapel in the Cathedral at Cavaillon, France), I have to be present as the pieces are fragile and need to be handled with care. My ideal would be to have one solo exhibition a year in order to have the time to concentrate more fully on my work and make the most of my life.

Matthias Olmeta
www.olmeta.com

KELIT, *The mystics of immanence*, 2010, 33 × 31 cm. Ambrotype, wet collodion on altuglass, unique piece, private collection. Image © Matthias Olmeta.

Studio shows

The first major open studio show in London was Space Open Studios in 1975, organized by artists Alexis Hunter and Robin Klassnik. It included some fourteen large studio buildings that opened across London for three weeks. In a 'Letter of Intent' in the catalogue artists'

representative, Jeff Instone, wrote of the development of the open studio movement by artists' unions and collective workshops across Europe as being an alternative to gallery representation. He suggested that 'The exhibition itself is a pilot scheme, a significant beginning which may well replace traditional methods of display.'

Since then, the open studio movement has grown year on year and expanded to include a wider range of studio space including studios in the home. Open studio shows are usually held over a week or weekend and bring in enthusiastic audiences who enjoy the informal nature of a studio show and the opportunity to see a wide range of contemporary art. However, far from replacing traditional methods of display, they tend to replicate the gallery system and studios are often turned into mini-galleries for the period of the show instead of opening a door onto a genuine working space. If the original intention of open studios was to challenge the power of the galleries then it has failed but the shows do bring new audiences into direct contact with artists and photographers, encourage debate and discussion and provide direct selling opportunities for the artist.

Website galleries

For most photographers, running one's own website is primarily a useful tool for reaching a wider audience. Most galleries now use a website to promote their exhibitions and to bring in new clients. Some see them as an educational tool. For galleries, however, there is also the possibility of selling online. This is a relatively new way to market work and one that is developing quickly.

In the early days of these new technologies, a number of companies, including Sotheby's and Eyestorm, set up websites for selling photographs. The two had different approaches. Sotheby's brought together existing US and UK galleries that were interested in marketing internationally and sold both contemporary and vintage prints. The galleries guaranteed the authenticity of the work they were offering for sale. Eyestorm commissioned editions of contemporary photographs from artists and stored them to sell.

Neither site was initially very successful, for a number of reasons: start-up costs were high and buyers were slow to start buying. In part this was because it took time for buyers to trust the new systems. In particular, it was difficult to convey the quality and feel of an image online and to guarantee provenance. Trust in the attributed provenance often depends on a close examination of the actual photograph. Experienced collectors know what they are handling and can rely on their own senses, so it took time for people to start buying without actually handling the work themselves. In 2002, Sotheby's linked their site with popular Internet auctioneer eBay (www.eBay.com).

Established galleries see websites as a means to reach clients who are searching for specific works. This is particularly useful for opening up the international market for photography. Howard Greenberg Gallery gives an example of a client from Los Angeles who had been searching for a 1990 set of Roy DeCarava photogravures; another example cited is of Catherine Edelman of Chicago selling a Joel Peter Witkin work to a London dealer via their websites.

Tony Theodore/Jason Wilde's Free Portrait Studio

Bill Wiltshire/Jason Wilde's Free Portrait Studio

John Batt/Jason Wilde's Free Portrait Studio

Amerigo Crolla/Jason Wilde's Free Portrait Studio

All images © Jason Wilde.

For Jason Wilde, who is working on a long-term photographic portrait project, making work takes priority over exhibiting. He sees the eventual outcome of this work as more suited to an interactive website and a range of d.i.y. books, which will be available from the website, than to exhibition.

This is because he finds he can best focus on making the work without the pressure of exhibition deadlines and because his interaction with the people he photographs is in itself a kind of exhibition event. Talking to possible participants about his work and what photography means to them and the public making of the images are as much about display as it would be to show more conventionally. Because he works mostly in nongallery venues he can also hope to reach out to an audience which does not necessarily visit exhibitions.

He began work on *A Snapshot of Britain* travelling along the south coast with his camper van and working in the open air. However, he found that the constraints of wrestling with a 6 × 9 foot backdrop in changing light and wind direction made unexpected problems. He now sets up his free portrait studio in a variety of venues which have included a doctor's surgery, a library, a tea dance, and a pop up shop and gallery space and invites visitors to have their portrait made. When space is available he displays A3 prints and a portfolio from previous portrait sessions.

He now has about 750 portraits, some of which are available to view on his website. http://www.jasonwilde.com

In general, the problem of setting up a selling website remains one of guaranteeing provenance. Only a reputable dealer or gallery can provide this. If websites are to be successful as art venues they have to be easy to find, fast to upload, and regularly updated.

What an exhibition space does or does not offer

So, what are the differences and the advantages and disadvantages of showing in a gallery that can be hired rather than with an established gallery? Or in a place like a cinema foyer or café? Or of turning a nongallery space into a temporary gallery? How does the potential exhibitor decide whether to show in a particular venue or not and what issues should they take into account?

Every exhibition is a balancing act in terms of the time, cost, and effort put into it by the exhibitor. Each option needs to be considered in terms of the specifics of that situation. Each one will be different. No two galleries are likely to offer the exhibitor the same amount or kind of practical or financial support. Where one gallery may not involve the photographer in anything more than providing prints, another will expect them to be hands-on in every aspect of the exhibition, from framing to writing text and publicity material.

Using a space outside the gallery system usually means that the photographer has to put more time and effort into exhibiting than he or she would in a more conventional gallery situation. However, this should not be a disincentive to putting on an exhibition in a temporary space. On the contrary. Working in a nongallery space can be an enormously enriching experience that will give the photographer a much deeper understanding of his or her audience and how to show his or her work and a confidence in his or her own exhibition skills which will stand him or her in good stead in every future exhibiting situation. Because it often means working with a group, it can forge strong friendships and working relationships that will continue to support the photographer over time. Most important of all, it can be fun.

Exhibiting in difficult or unusual circumstances can be richly rewarding if the photographer can be creative about the process and ignore the conventions of the traditional gallery space when

necessary. I have never forgotten an exhibition I saw in an unused shop where the electricity had failed shortly before the exhibition was due to open. The audience was met at the door by someone who solemnly handed each of us a torch and ushered us into the space two at a time. We had, literally, to find the works in the dark. The visual impact was stunning. The black-and-white photographs loomed up out of the darkness like treasures being discovered. We were forced to explore each image individually as we came across it in the dark because the torches were not powerful enough to illuminate the entire photograph at once. I felt as if I were discovering photography for the first time. Afterward we were escorted down the street to another empty shop illuminated only by candles for an opening party, which was enlivened by our shared experience of near-disaster.

No exhibition opportunity is likely to be perfect—each space will probably have some advantages and disadvantages. Postponing a decision to book a gallery until the perfect space can be found is usually a mistake, one that may leave the exhibitor with reduced options and deadlines that are too short. To be successful in selecting any of the different available options,

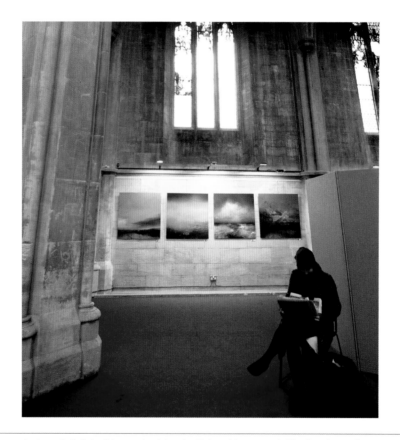

Photography based digital prints on aluminium by Robert Youngson in The Landmark Show 2012. An exhibition of digital and new media art working in collaboration with the Landmark's gothic interior. The Landmark Arts Centre is housed in the former church of St Albans in Teddington, southwest London. It holds a range of artistic events and is available for hire. Details about the church: http://www.landmarkartscentre.org/about-us/more-about-our-history.html. Image © Georgina McNamara.

a photographer must consider carefully what sort of financial, practical, and time commitments are involved in each, before choosing one. None of the factors listed below should pose insurmountable problems, but the exhibitor needs to recognize in advance what the particular costs and workload are likely to be and to adjust to the particular situation as required.

This means considering some, or all, of the following:

1. The space itself and how it can be used

In an established gallery, a great deal of work has already been invested in making the space work as a gallery. It will probably be smart, well lit, and secure. The gallery staff will have long experience of using the space to show the work to its best advantage. And the gallery will most probably have a regular audience accustomed to the way that particular gallery looks and works.

At first sight, other spaces may look just as appealing, but careful consideration needs to be given to how the space will work both for the photographs and for an audience. The size and condition of the space need to be checked. The space may need painting, decorating, and signage. Heating and lighting might be a problem, and the electrical circuit inadequate for the necessary additional lighting. Access may be poor and staircases a safety hazard. It will take time to make sure that the exhibition works in the available space. None of these things need be a disincentive to showing but the exhibitor does have to spend time, and usually money, carefully working out how to circumvent problems and make the best use of the space. If the space is not a gallery there is no real need to try and emulate the look of a gallery or hang the work as it would be hung in a traditional showing space. In my view a non gallery space forces the exhibitor to think about different methods of display and to look for creative solutions to the issues of using unusual spaces.

Timing is also an issue here. It takes time to put a show up and take it down again. This time needs to be built into the schedule. Some spaces hire out with very little changeover time, and this needs to be carefully assessed.

2. Control over the work and the availability of curatorial help

Most galleries show work the way they want it shown. This can be frustrating for the photographer who has his or her own vision and ideas about how the work should be shown. Hiring a space or putting work in a non gallery space usually gives the photographer much more freedom to experiment or to show their work as he or she has dreamed it should be seen. However, for the inexperienced photographer it may mean either hiring in some curatorial help or allowing him or herself enough time to learn by trial and error what will best suit the work.

3. What practical help is available

Most galleries have staff with expertise in every aspect of exhibiting, from framing and hanging work to producing exhibition texts and publicity material. They will either take responsibility for doing these things or help the exhibitor to do them. An exhibitor who hires a gallery space or uses a non gallery space will probably have to hire help or rely on friends, family, and colleagues to work jointly on the exhibition. These spaces do tend to differ in what they provide so it essential to be very clear about who does what right at the beginning of the process. Once again, this is only a problem if an exhibitor fails to allow enough time to plan ahead, experiment or acquire the necessary skills.

4. The possibilities for publicity and a regular audience

Most galleries also have a regular audience and a good publicity machine. Many galleries have an audience who visit regularly, even without knowing in advance what is being shown. It is often considerably harder to attract an audience to a space that has never been used as a gallery. Publicity needs to be sent out early and, since many exhibitions achieve success through word of mouth or reviews, it is worth extending the exhibition period because audiences may build up slowly. On the other hand, the real advantage of showing in spaces such as a cinema or café is that there will be a captive audience of movie-goers or lunchtime regulars and the exhibitor should be able to interest them in the work.

5. The building opening times/days

When a space is open or closed is a factor in deciding whether a space is appropriate or not. A public building, such as a library, will probably have much longer opening hours than most galleries whereas a theatre may only be open in the evening. Some venues may be closed over the weekend which is often the most popular time for gallery visits.

6. Keeping the space staffed and the possible need for additional security

Staffing the exhibition and keeping the work secure can be the biggest problem in using a non gallery space. Most galleries make sure that a member of the staff is in the gallery at all times. Some will welcome the presence of the exhibitor or ask him or her to spend time in the gallery, but this is usually an informal arrangement made to suit the exhibitor.

However, one of the real problems of the non gallery space is arranging for it to be secure and staffed. Staff in a library or café will not be able to make it a priority to look after work and some part of an exhibition may be in a space without a staff presence. Sometimes, if the gallery is in an isolated place, two people need to be present. Overnight security can also be a particular problem in this kind of space, depending on where it is, and exhibitors should consider either hiring a guard or removing equipment or artwork at night. Opening up and staffing the gallery can be a big commitment in terms of time, and first-time exhibitors are notoriously bad at turning up on time (or at all!) and at keeping the gallery clean, quiet, and tidy and answering visitors' queries adequately. I have been at an exhibition staffed by students who could not tell me anything about a fellow student's work, how to contact the student, or when she would be in the gallery. I was considering including the work in an exhibition I was curating, but the complete indifference of the students to questions by a member of their audience put me off. I decided I was not interested enough in the work to persist and left.

7. Possible unforeseen or additional costs

Costs are the most important item that every exhibitor must check carefully before entering into any agreement, as this is the most likely source of misunderstanding. Most galleries will meet certain costs but not necessarily all of them. This varies from gallery to gallery. Galleries available for hire may, for example, have their own mailing list and produce publicity material but expect the exhibitor to pay a portion of the costs and help with the mailing. An exhibitor should make sure all aspects of the financial arrangements, particularly who pays for which expenses, are discussed before an agreement to exhibit is reached. If this is not done, the

exhibitor runs the risk of incurring entirely unexpected bills at a stage in the exhibition process when it is too late to do anything but pay the bills or cancel the exhibition.

8. The possibility of follow-through

It is in a gallery's best interests to continue to promote 'their' artists and program. They may take on handling sales for the photographer. They will keep visual and other records for many years, and the exhibition may well be on a website. All of this is very useful. If the exhibitor uses a temporary gallery space, this follow-up will not be done, and since the space no longer exists, there is no site to act as a reference point in the same way as a gallery does.

Showing work means getting started, choosing a gallery situation that may well not be perfect but will allow the photographer to get the work out and into the world. Exhibiting gets easier with practice.

Darkroom c-type photographic installation from the series *Growing Red* by Chloe Sells www.chloesells.com from the The New Pretenders, Jan 2011, an Interim Show by Central St Martins students. The show was held at the Bargehouse in Oxo Tower Wharf on the South Bank in London. The Bargehouse is a warehouse, ideally suited for large group shows, part of London's old Docklands which became redundant in the 1960s and 1970s and today provide spaces which can be hired for art exhibitions. Image © Georgina McNamara.

D.I.Y. Alternatives

The studio at home. Image © Mary Pritchard.

As we will see in this chapter, there are an increasing number of possible d.i.y. options for getting one's work seen. All of them vary in costs, time input, and the possibility for critical attention and sales. The key criteria for deciding whether or how to follow this route are that it should suit the photographer's working life and be a choice which can be developed over time.

The open studio

Having an open studio event in your home is not something to take on lightly as it is hard work and takes a great deal of planning and preparation. However, it can be rewarding in many different ways.

A home-based event differs from an opening in a shared studio or studio building in a number of respects (mainly potential access to a wider public, advertising and publicity, sharing of tasks, possibly restricted showing space and competition with other artists).

The easiest way of doing it is to be part of a wider 'Open Studios' neighborhood event that will organize publicity and ensure visitors. These have proliferated in many parts of the country over the past few years. In my area of northwest London, an open gardens/ studios event is held on one day in June every two years. I have participated in that several times so had experience of what was involved in opening my studio but, because I wanted to open it more often, I decided to hold my own independent event.

One of the main issues about having an open studio at home, when it is not part of a neighborhood event, is footfall. It is essential to invite everybody you know and encourage them to bring along their friends, as well as contacts you have made at other art-related events. It is useful to be confident about publicising your event and inviting people, even if you do not know them well, as only a small percentage of the people you invite are likely to make it through the front door. It is also vital to invite new people every time, as your friends and relations can start to feel that you expect them to buy something. However, most people are curious about artist's studios and happy to be invited. Having the work on display in a domestic environment is also a good selling strategy as it is easy for someone to imagine the work in their own home.

I do not advertise my event other than to e-mail invitations and, because I have lived in the same area for a long time and taken part in the open gardens/studios, I have a large database of local people to invite. The wording of the invitation needs careful attention and it is important to use eye-catching images. In fact I have sold work just from the photographs attached to the invitation. A website reference should also be included.

I have had several Christmas open studios that have proved very successful. One advantage is that it can be a social occasion so a welcoming atmosphere and good refreshments are important; at Christmas mulled wine and mince pies are very popular. I usually hold the event over two weekends as people get very busy in the run up to Christmas.

It is vital to have help for setting up and especially for when you are open. What tends to happen is that nobody comes for hours and then everybody arrives at once. It is a bonus if your helpers are sociable and friendly and will create a convivial atmosphere.

In terms of selling, I have found that it is useful to have a wide range of items priced from very low to high. Hand-made artist cards are always popular. A Christmas open studio is hopefully a source of presents so I generally produce work with this in mind although it is sometimes difficult to predict what will appeal to people. Although I do show my more obviously commercial work, I do not exclude less accessible work or work in development as some visitors will be very interested in talking about your work generally. Buyers of art are often artists themselves so I never underestimate the knowledge and experience of my visitors. One great advantage of showing your work is to get feedback.

It has also been my experience that it is important not to stop inviting people who do not at first show any interest as I have had people who have come to several events without buying anything, but then surprised me by making a purchase.

The display and pricing of the work is usually very time-consuming but important to get right. It can be hard to make most domestic environments look minimal enough to show the work well. It means clearing rooms of furniture, artifacts, books, and so on, and storing all these things temporarily. Another disadvantage is that you may not be able to use rooms as you usually do—for example, to use my kitchen/dining room as a gallery, I take out my kitchen table so have to manage without. After the show everything has to go back in its original place. One way of making this easier is to show with another person and share these tasks.

I have now installed a gallery hanging system in my kitchen/dining room so that I do not have to drill new holes in my wall every time. I have also converted one of my downstairs rooms into a studio and display area so I can show work more easily.

In terms of finances, one should take out third party liability insurance and preferably insurance for damages. There is obviously the cost of refreshments and presentation of the work but at least there is no rental cost. I have found the outlay is usually more than covered by sales, although this does not necessarily take my own time into account.

Mary Pritchard
http://www.marypritchard.net/

Exhibiting in a hospital

I've had three hospital-based exhibitions, all of them commissioned by the hospital. As venues, hospitals are very different from most galleries. The audience for your images will not be self-selecting; most will just be passing by on their way to somewhere else. The exhibition space will generally not be at all secure. It will probably be in a corridor close to the main entrance, will be accessible twenty-four hours a day, seven days a

week, and many hundreds of people may pass it in the course of the day. So your images need protection from theft and from vandalism and from overenthusiastic attention. If they are framed, they need to be fixed to the walls. If they are large panels of photos, people may be less likely to walk off with them, but they will still need to have a heat-sealed protective covering to protect them from handling. I had been warned of these dangers, but in fact it wasn't a problem.

It's difficult to get much direct feedback from the public passing through, as a visitors' book is likely to disappear. The best way is probably to be there at busy times and to talk to anyone who stops to look at your work. To collect feedback from hospital staff, it's useful if your exhibition provides a hospital contact name as well as your own. They may well receive a lot of informal feedback from other staff members.

You may have to negotiate to move some of the hospital clutter that tends to end up in corridors and will certainly need to revisit your exhibition regularly to check that is not obscured or damaged in any way. Your work can also be vulnerable because people in very large organization don't necessarily communicate with each other, nor have much respect for the exhibition itself. One of my exhibitions consisted of ten very large exhibition panels displayed continuously across a large atrium area in a new children's hospital. It had been up for several weeks and was due to remain for several more. Imagine my shock and horror when I took a friend to see it one day and as we rose up in the glass-fronted lift to the atrium area, it was all too clear that the whole exhibition had disappeared! No one seemed to have any idea who had taken it down or where it had gone, and it took some considerable detective work to finally reveal that the contractors had decided to give the wall the exhibition was on another coat of paint, so they just took it down, locked it in an empty office, and didn't tell anybody!

Nonetheless, exhibiting in hospitals can be a very rewarding experience. If your work is well received and particularly if it's of direct relevance to the hospital itself or its local community, your exhibition may well open up other opportunities. Your work might be used in hospital publicity material, in more permanent displays, or might even be published in book form.

Carole Rawlinson
www.carolerawlinson.co.uk

Exhibiting in a cinema

The Metro was an art house repertory cinema in Rupert Street, Soho. I found out about the space by seeing others' work up when I went to see films there.

Like many places with free exhibition space in London, it had a booking system—where different work was generally up for one month at a time. When I finally asked the manager how it worked, he said there was a nine-month waiting list. I had to show some work in an initial meeting but I then had plenty of time to get the main body of work done.

Hanging work sounded easy, but in a cool, Brutalist, concrete-walled corridor, it actually involved buying specialist diamond-tipped drill bits to make more than a scratch on the walls to put the rawl plugs in. Visually, I had to ignore the scattering of red, yellow, and brown plugs in the wall that hadn't been removed by previous exhibitors. Unpainted concrete can't be easily filled with polyfiller and repainted.

The hardest thing with showing your work is the high expectations leading up to the private view. You hope that something miraculous will happen where someone famous or rich turns up and buys every piece on the wall. What tends to happen is your friends turn up because they like and support you, but mainly come for the free booze. They don't, necessarily, wish to live with your artistic efforts. In this case, some friends of mine arrived early from Paris and did actually buy three out of the fifteen one-off photos and a couple of editioned prints. It did make for amusing Chinese whispers when I heard later in the evening, from another guest, that someone important had bought lots of work. They were, however, the only pieces I did sell there, except for one sold to an agony aunt who lived in Soho and obviously felt sorry for me.

Five years later, the venue had changed name (to the Other Cinema) and now had lovely clean, white boards covering the concrete. Unfortunately, you couldn't screw into them. When I realized that you had to use their very ugly and obtrusive metal hanging devices or find an ingenious invisible hanging method from the top bars, it was the day of hanging and a Sunday morning. It limited the possibilities of where to find heavy-duty fishing line to support the heavy framed prints I had. Worse was to come, though. The private view was a great success (although nothing sold) but then five days later, at a private screening party at the cinema, a piece of work was stolen. Of course, their insurance didn't cover it and I had not taken out my own. The party was for a major bank, which did, finally, pay for the work, but not for a long while and after a lot of insistence.

The Other Cinema, like many art repertory cinemas in London, is now closed.

A few years later, I toured a solo show in some well-known photography exhibition spaces in the UK. The process of submission and exhibiting was very similar although the notice period is normally much longer and they always fill in the holes.

Dominic Harris
www.dominicharris.co.uk

Exhibiting in a library

A local library is a good venue for the individual photographer who wishes to display his or her own work. One great advantage that libraries have over other venues is that many devote a lot of space to information panels, equally suitable for print display.

Most libraries charge for the use of display panels though, in my experience, these charges are fairly reasonable. For exhibitions connected with charities, you may be able to exhibit for free. In my local branch I am able to rent hessian covered wall boards

measuring 8 feet × 8 feet for £10 each per week. I recently put up an exhibition of forty-five 12 × 16-inch prints using three display boards, and for three weeks the total cost amounted to £90.

Try to work out in advance your themes, juxtapositions, and so on, but accept that you may need to do some tweaking on the day to ensure the series of display panels works as a whole, as well as individually. You may have to book space many months in advance to get exactly the panels you want, which gives you time to try out specimen prints to test for attachment methods and decide on foamboard or card mounts, print size in relation to viewing distances, spacing between prints, and so on. Avoid a mish-mash of mount colors and sizes and overcrowding the prints.

Assuming you have set up a website, all inquiries and potential sales can be dealt with through that, which is probably a better solution than involving the library staff. Flyers can be easily produced on an inkjet printer and put up in likely locations some two weeks before the start of your exhibition. It is also common sense to produce an information sheet giving details on your photographic background and philosophy, as well as notes concerning the images themselves and your contact details. A pile of these should be close to your display, as also should a comments book, preferably with a ballpoint pen attached to a chain! Quite apart from the glow of satisfaction you will (hopefully) feel reading other peoples' views, you will be better able to judge the success or otherwise of your venture from an aesthetic point of view. You may also find you sell more prints than you expect, and receive a good many follow-up enquiries. Compared with a prestigious private gallery where an established photographer may be attempting to sell signed limited edition prints for considerable sums, in a library situation you have to be more realistic. Your potential customer is unlikely to be a committed buyer of fine photographs and will have a much smaller budget.

Security is an issue that has to be considered. Library books may be tagged, but your beloved, expensively mounted photos are not, and the staff cannot be expected to oversee your display. There is no simple solution to this, and whether your prints are attached by Velcro or by my preferred method of pushpins, the risk is always present. I can only say that after several exhibitions in different locations, I have yet to lose anything through theft. However, it perhaps adds weight to the view that to show expensive signed prints could be a mistake.

As with any exhibition, the more free publicity you can gather the better, and local newspapers are the obvious choice here. If your photographs concern local issues, so much the better. Unfortunately I have yet to come across a public library that will allow a private view outside normal library hours. You will, however, be guaranteed a wide cross section of visitors in a large central library, but remember that many regulars visit only once every three weeks, the usual book-borrowing period, and I suggest that this be regarded as the minimum length of time to show your work.

Jim Thorp
www.jimthorpimages.co.uk

The Salon Photo Prize at Matt Roberts Project Space. Image © Georgina McNamara (her work is top right).

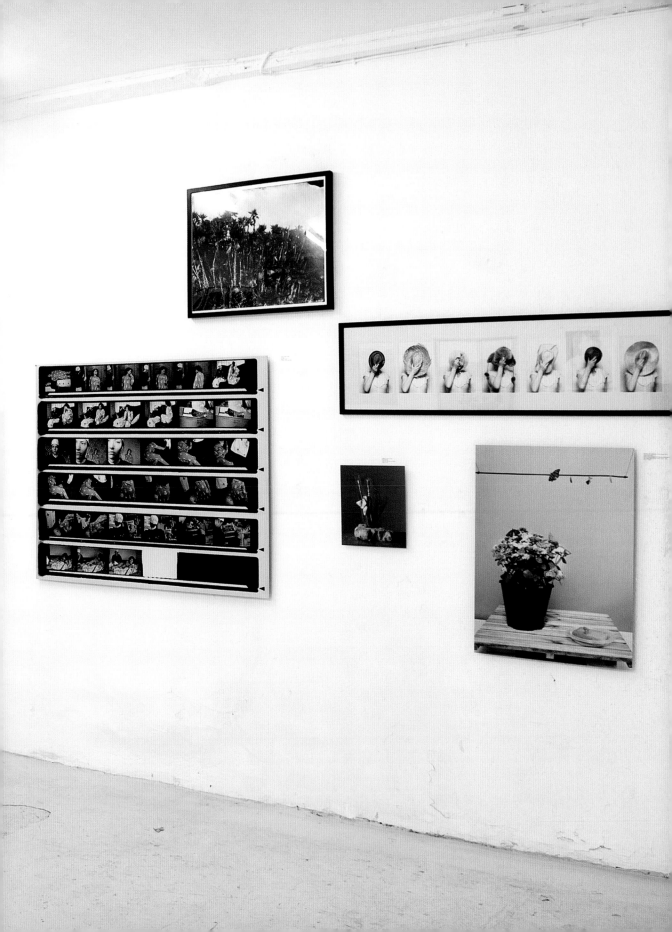

The usefulness of entering competitions

In February 2011 I was one of thirty-nine photographers selected for the inaugural Salon Photo Prize, held at the Matt Roberts Project Space in East London's Vyner Street which opened as part of the 'First Thursday' event that month.

Run by Time Out magazine and the Whitechapel Gallery, 'First Thursdays' take place on the first Thursday of each month with many galleries and museums in east London keeping their doors open late to give visitors a chance to see art and cultural events after hours. With over one hundred galleries and museums taking part and open until 9:00 p.m., this is a chance for people to get together socially to wander around several private views in one evening. With many galleries no bigger than front rooms, visiting shows in a compact gallery area can be a good way to see a lot of new work effortlessly and in a relaxed way. Like a cultural pub crawl, it's a hugely popular and busy initiative which often spills over into surrounding streets creating a real excitement and a great street party atmosphere even in the coldest of winter months.

Matt Roberts Arts, which was founded in 2006, is a not-for-profit organization, which creates a variety of opportunities for artists including annual Open Salon competitions for art, video and, more recently, photography. I first heard about the organization a few years ago from a friend, who had had an internship there and spoke highly of them. I showed pieces in Matt Roberts Art Salons in 2008 and 2009 and so knew that their exhibition would be professionally curated and the standard of work high.

One of my reasons for applying for the competition was the impressive selection panel which included curators from the Tate and The Photographers' Gallery, a magazine editor and an author, all from contemporary photographic backgrounds. Other factors encouraging me to apply ranged from the good reputation of previous exhibitions in the project space, the duration of the month-long show and the nominal submission fee. This last criterion has less to do with financial concerns than my suspicion of any organization charging a high administration fee for an open submission show.

Another draw of entering work into a competition is the knowledge that the curation, hanging, private view, invigilation, and publicity will all be dealt with by the organizers. With only the transportation of the work to and from the venue to worry about, this makes a refreshing change from the time and money invested in being part of an artist-run show. Having stocked up on hand warmers to do my share of invigilation duties over the years, I must admit to being relieved not to be faced by the prospect of spending days invigilating in a drafty space in the middle of winter!

With all the Vyner Street galleries open to the public for the February 'First Thursday' event, the Salon Photo private view was extremely busy. Rather than gathering inside the two small rooms of the project space, visitors were encouraged to purchase drinks from the pub opposite, enabling those patiently queuing outside to enter the show. After the quiet 'hibernation' period of January, many of my friends came along and it was a

really enjoyable evening. I subsequently returned to properly look at and photograph the exhibition and was pleased to see that there was a steady stream of visitors to the space during the hour or so I was there.

Whilst not primarily a selling show, enquiries could be directed to the organization and work was sold with a 50 percent gallery commission. Although the exhibited photographs were unpriced, a full list of works (with the artist's name, title, size, price, and edition number) was made available for interested visitors and the online exhibition catalogue, is still available on the website (http://www.mattroberts.org.uk/mra) long after the show itself ended.

Open for a month, the exhibition attracted a record number of visitors to the space. As the venue is open for only three days a week, ensuring that a show is on view for more than just a few days is an important consideration in getting the work seen by as many visitors as possible. I was pleased with the positive feedback I received, with many people commenting how strong and varied a show it was. Making a refreshing change to exclusively wall-based photography shows, I especially liked the fact that certain pieces were displayed on monitors, on the floor in piles and propped up against the wall.

In the year since the Salon show, the scene at Vyner Street has changed. Matt Roberts Arts and some of the other galleries have moved on and other areas of the capital are regenerating into new cultural hotspots more popular for the showcasing of new and emerging talent. As these kinds of shifts are common, when applying for competitions, it is important to keep one's focus on the gallery or project space itself without being over-influenced by the current reputation of a particular street or area.

With incentives ranging from cash prizes to related goods and services or the promise of a solo show for the winner, I see applying for competitions as a good way of challenging myself creatively, critically, and academically. I have learned from past mistakes to select only the competitions which are really relevant to my practice and generally choose those which do not involve large transportation costs or other inconveniences. I also avoid those related to brand advertising or which appear to be unprofessionally managed, making the decision about submitting work on a case-by-case basis.

I have found that without deadlines, it can be all too easy to drift along making work in a comfortable rut without any useful peer comparison, research or risk taking. As a kind of 'background noise' activity to my practice, regularly entering competitions is an essential way of getting my work seen. By seeing how my pieces fit alongside other photography or fine art, I also learn how to contextualize and place work which can otherwise feel as if it exists in a vacuum. Showing alongside others helps to develop a context for, and a critical understanding of my own work, invaluable for my creative development and growth.

Building up a good track record of exhibiting, in the form of my c.v., is also important for future applications to other shows. I find that by always having a few submissions

in mind or on the go, applications feel less precious and are easier to make. They are important in keeping my writing skills up to date and, whilst I am continually considering new directions in my work, the practice of applications, with their inherent deadlines, adds structure and variety to my practice. I view each exhibition submission as an opportunity to get my work seen by the selectors so even if I am unsuccessful in an application, visiting the subsequent show can be a very useful exercise in understanding the thinking behind the show's concept. By entering work which feels finished rather than work in progress I see competitions primarily as a way of getting my work seen by a wide audience of curators, selectors, galleries, critics, and other artists.

At times when I least expect it, it is often the surprise invitation to be part of a exhibition which I had long ago forgotten that I had even entered, which reminds me how important it is to continue with those deadlines for competition applications. In the words of Paulo Coelho, 'A warrior of light often loses heart. … Then when he least expects it, a new door opens.' (Manual of the Warrior of Light by Paul Coelho, p. 85.)

Georgina McNamara
www.georginamcnamara.com

A residency in the Norwegian fjords

In June 2010, I was preparing to attend Les Rencontres D'Arles Photographie, when an invitation arrived from a museum asking for applications for photographic residencies at a monastery in Norway. Halsnøy Kloster is the site of a medieval Augustine monastery, established in 1163, situated in a spectacular setting in the heart of the Norwegian fjords and mountains. As a landscape photographer, interested in the layering of history and culture, I was immediately hooked and expressed an interest in applying.

The museum curator asked for a project proposal and a portfolio of my recent photographic work. My portfolio was ready for review at Arles and included a series evoking sense of place in coastal Suffolk. That series looked into history, nature, and dark secrets in the landscape and was the Major Project from my MA at the University of Westminster. This seemed to seal my application and I was awarded the residency over mid-summer 2011. In retrospect, I was in the right place at the right time with the right preparation behind me.

Nine months elapsed between the award and the residency. I researched landscape art in Norway, networked with curators at the National Gallery in London and with Norwegian friends. Acquired maps, books, and new photographic equipment and researched logistics and made travel plans. Bergman, Dahl, Eco, Munch, and Tolkein all started to become very familiar.

Halsnøy Kloster, Norway. Image © Caroline Brown.

The Sunnhordland museum specializes in cultural history, it seeks to attract visitors to the museum properties throughout the region and to foster Halsnøy Kloster as a local center for the arts. The residency invitation was to live and work at Halsnøy Kloster for three weeks over midsummer; to practice photography during the residency; and, to exhibit at the monastery gallery within six months. The commissioning aspect of the residency was very flexible. In the event, my carefully laid logistical plans were totally disrupted by an unexpected 10,000-mile round trip to Los Angeles the week the residency started. Nevertheless, I was still able to be at Halsnøy for the majority of the residency period.

Living and sleeping in a setting inhabited for over 800 years is an immersive experience. The layering of history of church and state, ancient Norse myths, the practicalities of living in medieval and reformation times, were all evident in physical form. The residency produced a geographically focused project: a portrait of a medieval monastery. It's not practical to commit to travel to Norway during the winter, which I would have had to do to mount, frame, and install a hung exhibition, so I decided to show the work as an artist's book, itself a new departure for my practice.

Some ideas were carried over from previous work, including the magnetic power of huts and the concept of landschaft: a collection of dwellings within an area of cultivated land that, in turn, is surrounded by an unknown—and unknowable—wilderness. The fleeting nature of the Norwegian summer, haunting medieval setting, and the vast natural forces in the Norwegian landscape were new themes. Guides at the

museum, local people, shopkeepers, and fishermen all contributed to sense of place. The use of digital equipment, and the ability to review and refine images on location, was invaluable for a residency in a remote location where return trips are impractical.

The process of review and evaluation of the images, the forming of the body or work and preparation for exhibiting the work are ongoing. New contacts were made: Japanese, Danish, and Norwegian photographers; museum curators in Norway and London; and local gallery owners and other Norwegian artists. In addition to the artist's book to be exhibited at Halsnøy, the museum director is discussing a centenary exhibition of photography at Sord, in Oslo or in Arles in 2013.

For the past few years, I have used the rigour and defined timelines of photographic courses, to develop my work. Attending photographic festivals and folio forums has also been part of this building block process. Going forward, photographic residencies are the ideal way to progress my photographic practice and add a sense of adventure to my journey as an artist. This works for me given my desire to travel, landscape orientation, and time constraints. By definition, residencies are well anchored in place and time and thereby help to defend my photographic practice from other pressures. They allow a focused body of personal work to be created in highly time-efficient manner and to explore new worlds in visually spectacular settings. Residencies are flexible and unique individual experiences, inspiring new photographic ideas. Halsnøy proved to be all this and more.

Caroline Brown

The margatephotofest: a contemporary photography festival over an august weekend

I began MargatePhotoFest in 2010 after finishing my second year at university in London. On moving back to Margate I was struck by the sudden seismic shift in culture from the country's capital to this small seaside, ex-resort town. What little photography there was on show in Margate was devoted to the very predictable sunset/beach imagery that you'd expect to see at any coastal town in the country. This seemed a shame given the striking uniqueness of the area and the growing artistic energy that was beginning to build with the large scale regeneration projects that were looming in the distance. The opportunity was there for a project like MPF and we took it.

The intentions for the event were initially small. I hoped to set up a single exhibition to bring a group of local photography students together as a springboard for further projects. As it turned out we ended up with four galleries, who were all eager to help the project get started, and almost no response from students. It very quickly became clear that for the festival to begin we were going to have to focus on professional photographers to build our name. Once we'd realized this the job became much simpler. Instead of asking universities to e-mail students we asked the tutors to show work

Margate Photo Festival, curator: *Vanishing Point*. Image © Natalia Janula.

themselves. Getting a tutor involved proved beneficial in two ways as not only did it get us a body of work to show but it connected us to the photographic scene in the area, and further afield, which got us word of mouth promotion and lists of other artists who might be interested in contributing. We also asked local galleries to suggest photographers and spent a lot of time going to meetings and exhibitions to build an understanding and presence in the area. By speaking to people and getting involved in a variety of other projects we managed to set up an event showing the work of over twenty artists, some of significant standing, from around the country in just two months.

The second year was a completely different affair; the major difference being the introduction of a theme. Whereas in our first year we focused on merely showing contemporary photography where previously there was none to be seen we felt the second year needed to be an evolution of this, putting in the groundwork for a festival with a national profile. We eventually chose the theme 'Organic,' with a core focus on audience engagement and social responsibility within photography, to show that photography can be used to bring people together, make connections and create new themes and ideas within a community. Choosing a clear theme has been an important moment in the festival's progression in defining the work we select and distinguishing us from other festivals.

In the first year MPF ran all four spaces, which was just too much work and left us under incredible pressures throughout the week before the opening. As we had nine spaces in the second year we had to approach the organization of the event differently. We decided the best way to get the most out of the festival was to bring in people with similar ideals to be responsible for some of the spaces, taking the pressure off us, and allowing a mix of approaches to the theme which we hoped would keep each space fresh and exciting. We settled on choosing a mix of curators we knew would be interested and we opened

up a curatorial submission section where curators would send in proposals for a space based on the 'Organic' theme to allow anyone the opportunity to be part of MPF. We also began planning the event much earlier choosing the theme about nine months before the festival, giving us time to plan the event. We then opened competitions about four months before, finalised curators two months before, and chose our individual artists winners about one month before. These were all behind schedule! You get used to it.

In its second year we had over 1,000 visitors to the festival during the weekend, as well as showing works by prominent artists such as Peter Kennard we were helped by mentions in The Guardian, an article in the British Journal of Photography online and in-depth articles in the local press. All of this gives us a strong platform on which to build a very exciting and competitive national event.

Seeing it written out like this it may seem that putting on something similar can be quite straightforward but low-budget exhibitions live balanced on the raggedy edge. In order to cover the lack of money you, as the organizer, have to pay for this with your time, whether it is looking for sponsors, solving problems, or just constantly making sure everyone is doing what they're supposed to. It is your responsibility to make sure your curators and artists are organized and get what they need to put on a show. You'll need to learn very early on how to make important decisions on the spot and how to solve problems that could potentially break the event on a near daily basis. You will constantly walk around with fifty things that need to be done at that precise moment and you'll have to prioritize these into a workable order. Twenty hours days towards the end will not be uncommon and you'll be endlessly answering e-mails and phone calls from people who want you to solve any manner of problems. Also with independent projects of this scale you need to allow a significant time for the completely unexpected. Things will come at you sideways. Yet it is in this that you realise what an incredibly exciting thing it is to do. You'll also find that, despite the long, empty days where everything goes wrong, they always give way to moments of euphoria when the totally impossible changes to the booked and ready. This is what will keep you motivated through the difficult times.

In its most basic terms there are only two things that are worth knowing when attempting such a project. Firstly, know what it is you are trying to say. You need to know and understand it completely, feel it in your bones, and have the drive to follow it through; otherwise it won't be worth the effort that is needed. Secondly, once you have worked out what to say, jump in head first and don't waver. Lots of people will tell you what you should be doing, that it's not worth it, that you're doing too much, and even that you're wasting your time. This is criticism, not advice. Do not listen to these people under any circumstances. As soon as you start to compromise and begin to doubt you'll lose confidence completely and either end up in the grey middle ground or give up completely.

Basically the only real advice I can offer you is: keep going!!

<div align="right">
Mark Dumbrell

Director, Margate PhotoFest

http://www.margatephotofest.co.uk/
</div>

Work by the Wandering Bears collective at the Margate Photo Festival. Image © Natalia Janula.

Case Study Three
Sian Bonnell: TRACE

TRACE is an artist-led curation and publishing project

We moved as a family to Dorset from London in 1991. The experience of living in such a rural environment had quite an effect on us. We felt quite cut off culturally; there seemed to be no venues showing the kind of work we wanted to see, most of the exhibitions were fairly routine and unchallenging. We did feel as if we were in the middle of (a very beautiful) cultural desert.

TRACE was established in 1999. The thinking behind the choice of name, was to suggest the idea of something left behind, an after-experience, which hopefully might stimulate further thought or activity. Our aims are to develop projects and events that promote new visual and literary work. The first shows took place in the converted shop area of our new home in 2000 and we just did two exhibitions that year. Work was selected over the first two years from artists whose work I admired and knew already and who were finding it difficult to get this work exhibited. Exhibition, postage, printing, and private view costs were all covered by the artists and TRACE sharing these costs equally. Since then, an average of four exhibitions a year of primarily photographic work were held in the house by artists of international standing as well as newer emerging names. More recently, TRACE has begun publishing books under the imprint TRACE Editions.

We ran the gallery for seven years before a university teaching post demanded a move further west to Cornwall. The result of this caused an enforced break while relocating, so that for three years TRACE was dormant. In hindsight, this pause was actually of huge benefit, necessitating a complete appraisal of our situation that changed due not just to the move but to the changes wrought by the economic climate on small not-for-profit projects such as TRACE.

Priorities

Promotion and support of artists

TRACE offers artists the space and freedom to develop new ideas, away from other constraints and pressures in the marketplace, by directly addressing their needs and concerns, giving them thinking time and space to develop projects that they might otherwise not have had the opportunity to develop. It is an experimental and research-based initiative, in which concentration is on the work, in new forms and in new formats.

One way TRACE helps artists is to offer them an opportunity to show work that might be at an experimental stage to test it, see if it works; the overall intention being that everyone who attends a TRACE event will undergo some form of transformation from the experience, not least the artist.

Prior to our move we had developed a package that was offered to every artist showing with us: private view with accompanying talk event, documentation in the form

of a CD with installation photographs of the exhibition, a copy of the talk event on video, a set of postcards ordered at the time that the invitation postcard was printed for promoting their work and a fee of £200. We still offer this but without the fee or the postcards.

It is important to us that the exhibition itself is presented in the best way possible. This does not mean that we spend vast amounts on production, often the work is pinned or clipped to the wall unframed. Each show is very tightly edited and maximum space is allowed around each exhibit. For many photographers this is quite challenging as they are very keen always to display their complete life's work but we are very firm about retaining a concept for each show and veer always towards less rather than more. For instance, we never label (i.e., with titles, captions, or longer texts) the works in our exhibitions; instead, we have a plan of the space with the work titles on the plan, which the audience can carry with them whilst viewing.

We don't just show work in the house and have regularly curated exhibitions for other spaces. The most recent of which was *Elusive*, a collaboration with Camberwell College of Art in London in 2011. I was invited to put together an exhibition showcasing current trends in fine art photography as well as demonstrating the diversity and strengths of the BA (Hons) Photography course in that institution. All the pieces were presented in a variety of ways and not framed uniformly. We asked the artists to bring their work to the gallery ready to hang, so there were a variety of presentation approaches from straightforward frames to flush mounting on aluminum and in one case under Plexiglas.

Because our budget was limited we could not afford to ship framed pieces from outside London so we asked these artists to send us image files with a small print (to match the new print to) which we then printed ourselves. We returned all the files and other materials to the artists afterward. Some of these images were then pinned to the wall with sequin pins (these are like dressmaking pins but half the length, so they don't stick out of the wall so far and look extremely neat in presentation). We framed some of these works with cheap ready-made frames, which we painted white (which made the frames look much more expensive). The work was hung with scrupulous attention to detail and spaced very carefully. There was no labelling but we provided a plan of the exhibition. A few people did comment on our lack of text and labelling with the visual work. I have a particular aversion to it as I feel that it actually discourages an engagement with the art work by the viewer. I find I do it myself; the minute text is on the wall I am drawn first to that and not to the imagery. The same is true of audio guides; if I had my way, I should have the audio guide and just bare walls! Obviously there are times when text is a key component of an exhibition and can't be omitted. I think text can be used in quite imaginative ways and I do notice that audiences really seem to like to be made to do some work when they are visiting an exhibition. I see this as a way to get the audience to engage with the work and to change their role from passive to more active participation.

I wanted the show to be as diverse as possible so the work was not just presented on the wall in frames. There were two installation pieces that involved painting the walls

Elusive exhibition image © George Meyrick.

specific colours. In one of these, a piece by Anthony Luvera, his wall was painted photo grey and his large print was attached to this with masking tape, in the other by Juneau Projects, the wall had to be painted very untidily in orange and then a series of A4 inkjet prints could be attached to it in no particular order along with a video which played on an old monitor. Verdi Yahooda presented her work in two small cardboard drawer file boxes, which we placed side by side on a plinth and Laura Guy presented her book-work on a shelf, which we made especially for it. The diversity of work presented was very important; the exhibition was timed to coincide with college open days so a variety of new prospective students as well as existing ones would see it. On the opening night Tansy Spinks gave a sound performance in the lift, relating to photography and sound, which she repeated two weeks later at the one-day symposium we held as an event to support the exhibition.

I was keen that the students should see and experience a variety of ways to make a strong exhibition and the feedback we received confirmed the success of this strategy.

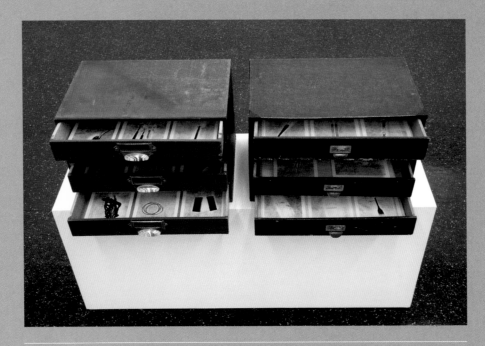

Elusive exhibition image © George Meyrick.

In addition, we made a catalogue with an essay by Martin Newth, Head of Photography and Art at Camberwell, and an interview with myself as curator. This was printed in house in an edition of 300 with an ISBN number. The plan now is to tour the show on to other venues and at present we are in conversation with a couple of galleries who are keen to have it.

Throughout its existence, TRACE has been mentoring photographers in addition to which we regularly look at portfolios and offer guidance on editing, presentation, and new directions. Another form of mentoring comes through our internship program. We began the internships in 2006 when we began receiving funding for the program. Despite being inundated by students and graduates wanting to work as interns with us before, until we had funds with which to pay them, we would always refuse and have a policy always to pay our interns. Last summer we worked with two interns and were able to pay them through the Creative Enterprise Cornwall scheme (CEC). This scheme was set up to promote graduate opportunities in Cornwall, run by University College Falmouth and part-funded by the European Social Fund. It meant that we were able to offer training to two new graduates for five weeks and who were each paid £1,000 by CEC.

I wanted to make each internship meaningful for the two graduates as well as useful for TRACE and, through negotiation, each of the interns gained valuable experience and new skills in running a curation and publishing project. We badly needed our website rebuilt to reflect our new position and philosophies and we also needed to have an exhibition with which to launch. I asked Tom to work with me on the website, allowing

him a lot of freedom to build something completely different in feel to the old one and I asked Rebecca to curate our opening show for me. I felt it was important to give them both real experience as well as training so they would have transferable skills that they can draw on in their future careers. It involved a lot of trust but it paid off as they were incredibly dedicated and I know that they continue to be strong and fervent ambassadors for TRACE. Rebecca sourced the work for the show through the internet and asked people to send us images or files which we were able to print. The show was timed to coincide with the launch of the revamped TRACE website. Rebecca and Tom together hung the show, marketed it and organized the opening. It was hugely successful and very well attended, drawing in a new and lively young audience. I could have given them both data entry to do (which is desperately needed) but I didn't feel it was fair on them just to use them as assistants rather than giving them real experience and in the end we all gained so much from the experience.

Learning curve

Funding

We made a conscious decision when we started out, not to apply for funding. The thinking being, that if we could prove initially what could be achieved without funding, then there would be a much better chance of obtaining funds with a good track record later. It was also important to remain autonomous; we really did not want to be coerced into running workshops for children or go through any of the other hoops one is expected to when in receipt of public funds. One solution was a brilliant idea by two of the artists we showed in 2001; Siebe Hansma and Mirjam Veldhuis. Siebe and Mirjam are sculptors from Holland, they suggested that we sell art multiples at a low price and take some commission on sales, the revenue from which should help cover exhibition costs. This turned into the TRACE Edition, more of which later.

In 2002 we received a small Production Grant from the Arts Council. This was meant to pay TRACE for four exhibitions over a twelve month period. We were able to make these funds last for thirty months with the help of the growing TRACE Edition and by not paying ourselves. This meant that all the funds were used to cover TRACE project costs. In April 2007 TRACE was awarded three-year funding by the Arts Council. This was revolutionary for TRACE in that for the first time there were funds in place for a small salary for the director. Having managed without proper funding for eight years the main learning curve had been to sit down and work out exactly what TRACE's strengths and weaknesses were and to put systems in place, which allowed for growth but not to the detriment of my own art practice.

The change in our circumstances along with a new government with different priorities, such as the 2012 Olympics, all had a bearing on local decisions regarding the arts in the southwest; many dedicated arts officers all over the country lost their jobs in the shake-up and our ACE funding, which had been kept aside for us while we were inactive, was also in the end closed.

Although it would have been helpful to have had some funding when we were planning the relaunch, the relief of having the freedom to plan what we wanted rather than having to fit the ACE criteria outweighed the disadvantage of having no funds. It was necessary once again to weigh up what was working and what could be abandoned and again, this was a creative benefit. We are busy at present looking into other more innovative ways to raise funds; the TRACE Edition got a little too unwieldy and we are working on reducing the number and concentrating more on publications and multiples that we know sell.

Pitfalls

Southwest trains

We have experienced a number of pitfalls since TRACE began. Most of them have been largely through lack of experience in running a project of this kind.

Now we face larger problems in attracting audiences brought about by a slow collapse in infrastructure, particularly the rail system and the growing creep of apathy in this part of the world. We used to have closing events on a Sunday afternoon; this guaranteed our potential audience a pleasant day out by the sea as well as an afternoon at TRACE knowing that there would be a reasonably fast train service to get

Elusive exhibition image © George Meyrick.

back to London at the end of the day. Gradually over the last two years the train system was affected by weekend repair work and very much extended journey times of up to four hours each way with interrupted service onto buses. We moved the closing events then to Saturdays but then the rail repairs began happening on Saturdays as well as Sundays. This began to cause huge problems in scheduling exhibitions and forced us to question whether to continue with exhibitions in the house. In the end the decision was made for us by the move. Interestingly, the audiences in Cornwall are still problematic in that it feels a bit like trying to break into something which is already quite exclusive. The audiences we have been getting over the last year have been mainly undergraduate and postgraduate students from both University College Falmouth and Plymouth University and we are pleased that we can attract young and vibrant audiences.

How work is selected

TRACE tends to show more photographic work but we do not want to limit the sort of work which interests us and we promote all kinds of fine art work from lens based through to performance. It is hard to give a list of criteria used for selection, a lot of it comes down to instinct and intuition, although it goes without saying that work which is selected has to be of the highest quality. Much of it has been selected in quite informal ways, through recommendation, through teaching, through having exhibited alongside someone or being familiar with the work. Work is also selected at formal portfolio reviews such as Fotofest, USA, and Rhubarb-Rhubarb, Birmingham. TRACE has reached an exciting point now in that we are not just selecting work for in-house exhibitions, the expansion of the website means that we now select for the online gallery, the TRACE Edition, and for publishing. The criteria for selection for all of these outlets are wider and we are able to promote more people in newer and different ways, to suit what their work requires at any given time.

Achievements

TRACE has achieved a lot since it began. We are proud that an involvement with TRACE has enhanced many artists' careers. In a time when public funding is being cut and many galleries and artist-run projects are folding, TRACE has kept going despite some hard setbacks. It is worth mentioning here that up until very recently TRACE was the only project dedicated to promoting photography in the entire southwest region. Here is an outline of some of our main achievements:

The TRACE edition

The Edition was a huge success during the first ten years of our existence. I have been loathe to change it up until now, as with its present existence largely on the website it

has served us well to date but we do need to rethink it a little to chime more with the current climate.

TRACE regularly sold to museum collections from the Edition; curators told me that TRACE had the newest emerging names at affordable prices—in purchasing from TRACE they were not only acquiring good new work for their collections but they were also supporting us.

For many years the Edition was the main source of funds for our projects. The best illustration of this is the TRACE Edition Sale, the first of which was held in May 2004 at Hirschl Contemporary Art gallery in Cork Street. Over 150 works were exhibited, all for sale at the same price of £250 each. As it was a benefit event for TRACE everyone involved agreed that TRACE should take 50 percent in commission on sales. In six days £10,000 was raised from the sale, which after commission, marketing costs, and the exhibition itself, provided TRACE a net profit of £4,000. This money went on to cover costs and expenses for our projects for the next eighteen months. It had another advantage too in that it offered support to over seventy-five artists, for some of whom it was their first exhibition in a London gallery and for many gave them their first ever sale of work. The audience for this was drawn from museums, galleries, writers, and curators who all attended. It was also extremely well attended by students from art colleges all over London, providing them with a perfect and concise overview of photography and other disciplines from the last twenty years. Work is now available for sale directly via Paypal on our secure site.

My feeling now is that the edition is too large and unwieldy. We are currently making a serious appraisal of the Edition stock and will be cutting it right down and perhaps concentrating more on smaller sales of multiples. I am also looking into other ways to generate income through activities such as the photographers' cookbook we published a year ago which was hugely successful in raising funds for University College Falmouth BA (Hons) Photography graduates' events. *Say Cheese?* was achieved through pre-sales orders. We ran it as a pilot to see if it would be a viable way to fund things and we will definitely be developing this as one of the methods to realise TRACE projects.

Publishing

Publishing is a key TRACE activity. In logical terms the amount of expenditure on production for an exhibition is similar to the printing / production costs for a publication. An exhibition especially outside London will, if a lot of time and expense is taken to market it properly, guarantee a maximum audience of possibly 250 for an exhibition lifetime of four to six weeks. A book, on the other, hand will reach an audience of, say, 500 to 1,000, and decidedly more if it is placed in libraries for an infinite lifetime. It has the prospect of being disseminated not only all over the UK but internationally, too. It is well known that a book is frequently the perfect medium for viewing photographs; it provides repeated viewings of an artist's work, and an intimate engagement with it. As a curator, I consider editing a book equivalent to putting an exhibition together, one which has a much longer life and can open many more doors for the artist.

TRACE asks the artists whose work we publish to raise the basic funds for printing and design of the book. Many of the authors have academic research requirements and are able to access these funds through their institutions as well as their regional arts boards. TRACE then gives written acknowledgment and displays their logos prominently in the publication. Everyone we have worked with in this way has been happy with this arrangement.

The first book published under the imprint of trace editions was *Wild Track*, the first book of poems by Mark Haworth-Booth. It is a book of poems and images and perfectly illustrates the TRACE philosophy. Two further monographs were published in 2006, *Imagine Finding Me* by Chino Otsuka and *Villa Mona: A Perfect Kind of House* by Marjolaine Ryley. Both books were supported by the Arts Council, with *Villa Mona* also receiving support from the University of Sunderland. Both of these have been very well received and were reviewed widely in photographic journals. In fact, both Marjolaine and Chino went on to receive prestigious fellowships and exhibitions both nationally and internationally as a result of these publications. Our fourth book, *Dark City/Light City*, a collaboration between writer Michéle Roberts and painter Carol Robertson, was published in 2007 with support from UWIC and Fivearts. Since the move we published *Say Cheese?* in 2010 and worked with Verdi Yahooda publishing her book *Romilly's Tools: An Incomplete Set*, also in 2010. Publishing is definitely an area that we know works for us and we are working on developing this more fully to include a journal in the form of a yearbook. We are extremely interested in the self publishing phenomenon which has been growing over the last few years and keen to work with young practitioners to help them with their self publishing projects. Another area is to research new publishing ideas which could incorporate the web and tablet technology, which we are hope to do in collaboration with university research groups such as BlackBox at University College Falmouth.

Research resource

Every Talk event held has been recorded on video. This provides an excellent research resource for curators, writers, and students. We are updating our website and are in process of creating an archive of all the talks and events which we will offer on the website as downloadable podcasts. The first of which, an in conversation event between Charlotte Cotton and Susan Derges in 2001, is now online and available to stream. This means that the archive will be available for worldwide interest and not limited just to this country.

The TRACE collection

TRACE has its own collection of work, which has been growing over the last six years. We acquired the complete series of *Afghanistan Chronotopia* at the time of Simon

Norfolk's exhibition with us and one of the aims of TRACE is to offer the collection for hire to university galleries to enhance student learning and research, particularly in universities outside London where access to good quality exhibitions can be limited.

The TRACE residency

In 2006 TRACE held the first artist residency. This was part of a collaboration between TRACE and independent curator Kim Dhillon, supported by the Arts Council and Visiting Arts. We placed a young Romanian painter, Adrian Ghenie, in a studio on Chesil Beach on Portland and titled it *Transylvania-on-Sea*. This arose after a Visiting Arts curators visit to Romania in 2005, undertaken by myself and Kim, where we discovered that studio space for artists was apparently almost nonexistent in that country although there was a lively gallery scene and publishing, particularly art journals. It was good to offer the placement since both Kim and I were independent and not affiliated to large institutions which moved a lot slower. We were able to fulfil the outcomes of both Visiting Arts and the Romanian Cultural Institute by introducing a young Romanian painter to the UK. Adrian has since gone on to achieve huge acclaim for his work internationally.

TRACE is planning to hold at least one residency a year for lens-based artists along with an exhibition and small publication, made possible by the generosity of Neeta

Elusive exhibition image © George Meyrick.

Madahar who has given us five unique Ilfochrome prints to raise funds for TRACE. The proceeds of the sales of these prints will fund in total at least one artist residency.

Pleasure/pain

The TRACE effect

It has been a major surprise to me that the experiment which was begun eleven years ago has survived as long as it has. I am constantly astonished by the artists I have worked with as well as new young ones and their commitment to the project, the enormous amount of goodwill that surrounds it, how it has captured everyone's imaginations as a small piece of freedom where artists are given room and space to try things out and to be allowed to fail (though no one ever has).

What do I contribute? When I think of TRACE I think of it as an artwork in itself, so that it really is another part of what I do as an artist. There have been so many times when I have thought of giving it up and doing something else but I never can allow myself to do so and realize that just as it offers help and support to other artists it also nourishes me and my own practice.

Sian Bonnell

Approaching a Gallery

This project began as a commission from the European Garden Heritage Network (EGHN) that set out to reinterpret the idea of a public garden. Following the completion of the commission I carried on with the work in collaboration with Greer Crawley (a landscape architect and academic at Buckinghamshire Chilterns University College, UK). This new work that we have developed is a representation and metaphor for surgical techniques within the manipulation of the landscape. It sets out to challenge traditional photographic approaches to gardens and has had a very positive response from curators. My starting point was to talk to curators with a strong interest in gardens and the Museum of Garden History will be exhibiting the work. www.roymehta.com. Image © Roy Mehta.

How does a photographer start looking for a gallery? Many photographers make the mistake of thinking that if they send their folio, website, e-mail, or CD details to all the galleries in town one of them will pick it up. This can be an expensive and time-consuming exercise that, in my experience, rarely works. A better plan is to spend some time shaping an exhibition proposal and researching appropriate galleries before approaching any of them.

If you are just starting out it makes little sense to apply to the major galleries who only show established figures. Look for the galleries that interest you because they show work you like, show work by your colleagues, show work which has something in common with yours or simply because, having seen exhibitions in the gallery, you can visualize your work in the space and see how it would fit into their program of exhibitions.

Depending on where you live and how much work you have to show the best place to start is usually locally or in the nearest sizeable town. To research possible galleries look at 'what's on' magazines, gallery guides of every type, read specialist photographic magazines, look at websites, and talk to other photographers. Your sources of information need to be recent because galleries can be fairly short-lived and most towns have a fluctuating number of photo galleries. If a suitable local gallery does not suggest itself then start to look further afield.

I would always suggest starting with galleries that are photography specific. In my opinion their systems are geared toward showing photographs, they will usually understand and curate your work sympathetically and knowledgeably and know where to publicize it and how to attract an audience with a strong interest in photography. However, many art galleries integrate photography into their programs and show it well so they should also be on your list of galleries to research. To some degree, your preference for which type of gallery to approach will depend on where your work sits on the photographer-artist spectrum but it is worth considering whether you will find it more rewarding to work with curators with experience in showing photography rather than curators who only work with photographs occasionally but may offer you a route into a different kind of exhibition.

If you can concentrate on local galleries it is reasonably easy to make a list of possibilities and then visit them. Actually visiting the gallery will tell you much more than any review, publicity or website can. You should be able to assess a number of things including whether the gallery shows the type of work you make, how your work would (physically) fit in the exhibition space, whether you have enough work for a one-person show and, equally importantly, whether it is a gallery you would be pleased to show in. You need to be aware also of the career stage of the photographers the gallery shows—are the exhibitors young artists, mid-career artists, or very successful, and will your work fit with this aspect of the gallery programming?

Most galleries have an exhibition policy although it may be expressed in very different ways. It is important to know what this is before approaching the gallery. The exhibiting or showing policy of a gallery is the sort of exhibition preference the gallery has. The gallery may concentrate on showing young artists or established artists; be avant-garde or more conventional; have a preference for a particular genre in photography like landscape or documentary; show themed exhibitions; mostly one person shows or always have group exhibitions. It may show local artists only or artists from one particular country. It may initiate all its exhibitions or take in a large number of touring exhibitions from elsewhere. It may show mostly contemporary work or

concentrate on vintage prints or a particular period of twentieth century photography. A policy could also have several different strands and include, for example, a regular annual exhibition of young artists in a program of major international photographers or one historical show a year in a program of contemporary work. Knowing a gallery policy saves the artist from the unnecessary time and expense of applying to galleries which are not even going to consider the work. It also helps the artist shape their proposal to fit the gallery policy and there can be no doubt that the more the artist does to show the gallery that they have understood the gallery's work the more welcome a proposal will be.

Some galleries claim not to have an exhibition policy and be open to all exhibition applications but, unless the gallery is one which is hired out, this is unlikely. Although the gallery may not articulate its policy, usually because it has an open, inclusive, and flexible attitude to what it shows, it probably has one (even if it is just to be open, inclusive, and flexible) that can be recognized by looking at what it has shown over the period of a year. Exhibition policies tend to be particular both to the gallery and also to the gallery director or curator so sometimes when a curator or director moves on a gallery policy will change, though this will probably happen fairly slowly over a period of at least a year, since they will usually have programmed well ahead before they left. If a curator or director moves on they will quite possibly take their policies and preferences with them and it is worth being aware of this when 'gallery watching.'

Once you have discovered whether a gallery is suitable for you the next step is to find out how it selects shows. This information may be on a website but, again, you will probably get a better insight into the process by visiting the gallery. The invigilator in the gallery when you visit can usually tell you a great deal and save you wasting your time. For example, they should be able to tell you if the gallery is booked up for the next few years. Most galleries are clear about their application procedure so find out what the procedure is and follow it. Pick up any available brochures and handouts and talk to the staff. They may advise you about what they want to see in terms of exhibition ideas, numbers of photographs, and supporting material. And, crucially, they should be able to tell you about the gallery exhibiting policy, whether the gallery welcomes applications for shows, and how to make that application. They may also give you additional written information, tell you of any application deadlines, or introduce you to the member of staff who deals with looking at new work.

Some galleries, usually smaller ones, like staff to spend time in the gallery as a way of observing audience reaction to the exhibitions and making the gallery a friendly place to visit. It is often difficult to tell exactly which staff member is in the gallery and you need to be aware that you could be talking either to the gallery director or to a student who is there for work experience. The role of the person in the gallery is usually both to deal with the public and give out information and also to protect the gallery director or curator from endless interruptions.

One of their tasks may well be to filter out unnecessary applications so if you are hearing a clear 'no thanks, this is not our area of interest' from them then demanding to see the gallery director will probably not be a good idea. One of my first gallery jobs included both staffing the gallery and managing a gallery committee so my role was in part as a gatekeeper for the committee. I was not a member of the committee but, after a short time working with them, knew exactly what work they were interested in. As a result when artists bought their work in

to the gallery I could recognize the ones who were likely to interest the committee and would put appropriate applications at the top of the waiting list and try to tell artists when it would be a good idea to defer or represent an application which needed rethinking. Not everyone listened and everyone's time was wasted by artists who ignored the advice and presented inappropriate exhibition proposals and portfolios. Gallerists and committees will usually work hard to find merit in an application—and will sometimes ask artists to return with more work or a revised portfolio—but the applications which set an exhibition off to a flying start are where the applicant is not only presenting exciting work but has also worked on making a thoughtful and appropriate exhibition proposal.

It should not need saying but it is important to be polite and to listen. This is not the moment to practice a heavy sales technique on gallery staff. As a general rule over promotion of work acts against it, if only because most curators want to look at work freshly for themselves without being too influenced by other people's opinion of the work beforehand. As gatekeeper I would move unnecessarily rude, bullying, and persistent artists further down the list rather than up it. I have had artists say to me that they need to see someone today because they are leaving town tomorrow and we will regret not seeing their work. My response is to think that, if the artist is so disorganized that they cannot arrange an appointment in advance, would anyone want to deal with the way they might approach an exhibition deadline? No gallery wants to work with difficult artists and staff will often pass on observations about the way the artist handled themselves when they came in to the gallery.

If the gallery is interested in looking at your application or portfolio you still have work to do to make the application relevant to that particular gallery. Remember that when you're showing work the curator will be considering not just the work but whether it will make an interesting exhibition and how it will fit into both the gallery space and the gallery program. The gallery which prioritizes sales, which not all galleries do, will also be thinking about whether your work will sell to their clients. You need to have thought through all these things before meeting. Most curators have limited time so you should expect to do considerable preparation for meeting them by shaping the work into a proposal for an exhibition which will fit their space. This means being clear both about an exhibition concept and about its size. For instance, if the space is large and you do not have enough work to fill it will help if you have in mind other photographer's work which would be relevant to show with yours or approach the gallery with those other photographers. Or if the space is small be ready to say 'this is the work I think would work best in your space' when showing a larger portfolio.

It is generally not a good idea to show a curator every picture you've ever taken. Show a body of work and show the work you think most appropriate to their gallery and exhibition program. Make it easy for them to look at the work by organizing your portfolio well and keeping it at a reasonable size. Take a c.v./résumé that includes a list of previous exhibitions and perhaps one or two (good) reviews from the exhibitions, if you have them. The gallery may not be interested in looking at them while you are there but they can be left with them as reference, along with a CD or postcard with contact details.

Never approach a gallery without doing this research to make sure that you can shape a proposal to the gallery's space and showing policy. Keep your research notes for possible future

use since a gallery which may not be suitable now may be worth approaching in a few years time when you have more work or have work which fits their showing policy.

Most gallery directors are generous with the time they give to looking at work and to supporting artists. They know what it is like to struggle and are prepared to support and help younger artists while they make their way. They are also keeping an eye out for future exhibitors, trends, and upcoming names. However, galleries are also usually inundated with inappropriate requests for exhibitions.

Some years ago I did some research into training provision for the Arts Council of England. When I talked to gallery directors most of them commented that the single thing which most annoyed them was that photographers brought portfolios to show them which demonstrated that they had not looked at either the gallery space or what the gallery showed and were then surprised or upset when they got short shrift from the director. Ten years later I discovered that photographers have still not learned not to do this.

At the same time it is useful to be aware that you may get rejected for reasons which are absolutely nothing to do with the quality of your work. A gallery may not like your work or see it fitting in their program but they are also just as likely to reject you because they have as many photographers on their books as they can deal with, they may be booked up for so long ahead that it would be unwise to take on more exhibitions or your work may be too similar (in a whole range of possible ways) to that of another photographer. An example of this is that I once said to a photographer whose pinhole camera work was complete and ready to be shown that I would talk to a particular gallery director on his behalf. The day I went to see the gallery director he had just put his new show up—which was pinhole work. Although the work was nothing like the work I was going to show him he was not interested in showing pinhole work of any kind for the foreseeable future and did not want even to think about it that day so it was primarily chance that the work was not considered by that gallery.

If a curator turns you down but suggests that you keep in touch or come back in a year or two do not interpret this as a kind way of rejecting the work and forget what they have said. In most situations the curator will mean it and will take it as a sign that you are not interested in their gallery if you do not return. They may well feel you're not ready for a show in their gallery now but might be in the future. Most galleries like to keep in touch with younger artists for this reason. However, they will most probably expect the artist to take the initiative in keeping the contact alive. Go back, the curator may say no again but they will be keeping themselves up to date on your work and keeping it in mind—you can't anticipate what might come out of this sort of contact and the curator may get in touch unexpectedly when they see an opportunity to fit your work into their program or may pass on their knowledge of your work to another curator.

Curators are often motivated by personal preference as well as gallery policy. If a curator seems to genuinely like your work take note and put them on your mailing list—if they move away see them at the new gallery. Every artist needs to have their personal support system of people who are interested in their work. Keep these people up to date by inviting them to shows and events rather than just going to see them when you are looking for an exhibition. They will appreciate it.

It is also worth showing work to a gallery or curator you are in touch with just to update them on what you are working on. This is best done when there's a substantial body of work to look at rather than at the early stages of a project. Many photographers forget that curators and gallery directors will not necessarily know all their work. It is easy for a busy curator to miss an exhibition and so not know work which might have taken several years to produce. It is worth saying to curators that you know that your current project is not yet finished or may be something they would not be interested in exhibiting but you would like them to see it anyway and maybe give you advice. As Camilla Brown, former Senior Curator of The Photographers' Gallery, London, says, 'I don't think there is any problem with showing someone you trust a body of work before it is in its final stages. I personally find it a lot more interesting as a curator.' Most curators are generous people who want to see a lot of work and help photographers when they can. But be straight about it and give them the opportunity to say no if they are not interested.

However, with the increase of interest in photography and the number of photographers looking for exhibition fewer galleries have an open submission system of application than once did so the photographer has to be ready to consider other ways of finding an established gallery to show their work.

Even if the galleries you visit do not accept direct applications it is still important to start your search for a show by identifying which galleries interest you and which you think might be interested in your work at some point. If they do not look at exhibition applications they may well offer alternative points of contact such as portfolio reviews, an annual open submission exhibition or competition, or have a curator who makes studio visits. It is well worth asking about these things and checking how an invitation to view work will be received.

A starting point with a gallery that you think might at some point be interested in your work can simply be to ask to be put on the mailing list. Attending events—from private views to talks and portfolio reviews—at a gallery that you are interested in will mean that the gallery will get to know you and appreciate your interest in their work and it will give you the chance to build up a contact that may lead to an invitation to show the gallery your work. But obviously this is only worth doing if you are genuinely interested in the gallery's program.

If you are starting out in photography and cannot find a gallery with an open submission system that you would like to show in do not despair; your strategy is to progress and publicize your work, exhibit it where you can and keep it in the public eye so that eventually a gallery will approach you or encourage you to approach them. By exhibiting, entering competitions, and going to portfolio reviews you will also be building up your contacts in the gallery system. This approach should be as focused as is possible—it is not necessary or useful to apply for everything or go to everything, the aim is to build up a reputation for yourself in the specific area of your interests. A gallery will notice you because they see your commitment to a particular area of practice and an interesting career or interesting photographer emerging rather than one who is impossible to avoid!

At portfolio reviews, for example, if you are offered a choice of reviewers, it is important to do your research (by checking out the reviewer's and gallery's programming and policies) and to select reviewers from those galleries which you think might be interested in showing your work. At these events curators often discuss the work they have seen and pass along information and recommendations to each other but you should aim to see the curator who is likely to be most helpful to you in the first place.

All galleries and curators, however busy or booked up, keep an eye out for talent, for rising stars, and for the photographers who they can see fitting into their future program. They will be reading all the photographic magazines, going to degree shows and photographic exhibitions in both conventional and new spaces, and they will be watching or judging competitions and open submission exhibitions and taking part in portfolio reviews. All of these are routes into being exhibited and taken up by a gallery that will hopefully support your work over many years.

I first met Malcolm Dickson of Street Level Gallery in Glasgow several years ago at a Rhubarb Rhubarb portfolio session in Birmingham, where he expressed an interest in showing Playgrounds of War, *a long-term project I was working on. I kept in touch with him as the work progressed. When it was almost at the point of completion Wendy Watriss, Artistic Director and Senior Curator of FotoFest International, selected it to be part of the Photo Biennale exhibition at the Guangdong Museum of Art in China and I was able to send Malcolm the catalogue which featured my work. Malcolm then offered me a commission to enable me to make additional work about World War II detritus in Scotland for an exhibition at the newly renovated Street Level gallery. It was several years between our initial meeting and the eventual exhibition and during this time we kept in touch about the progress of my work—I went to Scotland to show him the work and he came to London for the launch of my book* Objects of Colour. *I think it was important too that I was aware of the gallery's agenda; they weren't very interested in showing supporting documentation or film or video material because they are a fine art gallery and the exhibition immediately before mine was a major video installation.*

Gina Glover
www.ginaglover.com

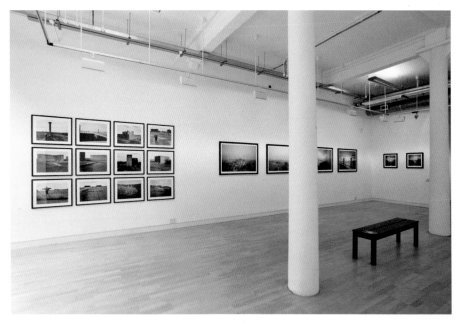

Gina Glover, *Playgrounds of War,* at Street Level, Glasgow. Image courtesy Street Level Gallery.

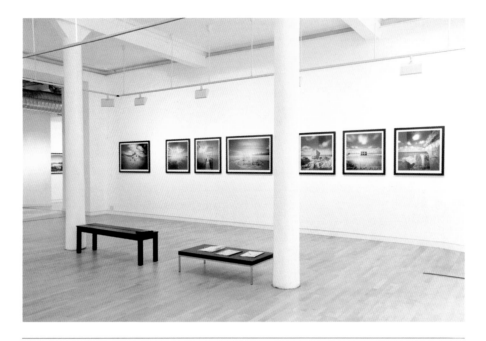

GIna Glover, *Playgrounds of War,* at Street Level, Glasgow. Image courtesy Street Level Gallery.

It is also important to recognize that different types of gallery may have completely different criteria and concerns when showing or collecting work and that, once again, an approach should be made only when the photographer has done their research.

Photography and museums

There are large numbers of photographs in museum collections. Many of them are in storage and not on permanent display and hence go largely unseen by the public. It is therefore easy to forget how important museums are as a resource for the collecting, conserving, and displaying of historical and contemporary photography.

Those museums that concern themselves with photography do so in different ways and with different aims. These can be summarized as follows: There are museums (possibly the majority) which collect photographs as an important source of documentary evidence of the past. This evidence will often serve to inform the rest of the museum's core collections. Other museums might choose to specialize in the historical development of photography as a technical and scientific pursuit. Here the photograph is collected alongside many other artefacts that constitute evidence of this development (e.g., Fox Talbot Museum). Other museums meanwhile value the photograph as art rather than artifact (V&A), emphasizing its historical and contemporary

aesthetic role. Finally there are museums that try to cut across these boundaries and present all these aspects of photographs and photography (National Media Museum, Bradford).

Within these broad tendencies, museums each have their own specific collections policy that defines exactly what they collect and why. Firstly this helps to limit what can otherwise become infinite in scope; secondly it focuses a collection within the identity and core mission of the museum. A photographer can certainly donate work to a museum, and the best way is to research a museum's collections policy so as to find the best match for the donation.

However, even within such parameters, collections in some museums can still amount to many thousands of photographs. This clearly limits how much access the public can have through display, and although some museums have made selections of photographs available online (e.g., Museum of London), this is not yet standard practice across the whole sector. Formal appointments are still frequently necessary for anyone wishing to see collections.

So how do museums display photographs? The rationale behind the collection will largely determine the approach to display. Photographs as historical evidence can be used in an infinite number of ways. Most obvious is their function to create a context for objects, or simply prove a fact. More complex is the subtle use of photography to carry forward a narrative, or touch the visitor emotionally. Whatever the intention, photography is used to its best advantage when imaginatively combined with artefacts and multimedia in the staging of an exhibition. Compare the use of photography in the following exhibitions: the Holocaust exhibition (Imperial War Museum, London), where images are blown up to create large life-size backdrops. These serve to surround the visitor with the stark realties of the political context, and also reinforce the terrible human scale of genocide. The touring exhibition Anne Frank and You (Anne Frank Trust project) where small photographs of the Frank family are laid out flat in wall recesses. This informal and self-effacing display tells us something of the Frank family story before World War II, but also allows a movingly intimate dialogue between past and present, as the visitor stands so close to these fragments that seem to have just fallen out of an album. Meanwhile other images are exploited in touch screen interactives as a learning device.

Although they deal with similar subject matter, both exhibitions use photographic images in very different ways to very different effect. One similarity however lies in the emphasis on the visual content of the photographs and not their authorship.

The authors may not be known, or if known, the fact is secondary to the photograph as documentary evidence. In a similar approach, the selection of photographs on the Museum of London website is grouped thematically according to subject matter, and not according to author, although of course full authorial details are always acknowledged and available.

There is a different emphasis at exhibitions where photography is treated as art. A case in point might be the Ché Guevara exhibition at the Victoria and Albert Museum (August 2006), where the portrait of Che by A. D. Korda took center stage, and its impact and legacy as a significant cultural icon was fully explored.

As authorship can be emphasized to varying degrees depending on the objectives of a particular museum or exhibition, so can the photograph's 'authentic' value. Museums have a certain dilemma with photographs, as they have traditionally placed higher value on 'original' artifacts and little value on the reproduction or fake. As Walter Benjamin pointed out in his essay 'The Work of Art in the Age of Mechanical Reproduction' (1936), photography challenges this notion as there is no original photograph as opposed to a reproduction. Or, to put it another way, every photograph is a reproduction. Where museums can be clear about 'original' value is in their collections of 'firsts,' for ecample, first photographic plates or first versions of new processes by early pioneers in the history of photography.

Conservation and documentation are also key to what museums do: all acquisitions have to be stored according to standards that ensure minimum deterioration of materials, and they have to be documented and catalogued in such a way that information is always up to date on what there is in a collection, and where it is. This is particularly important when museums wish to loan objects to other institutions—an activity that is encouraged by the sector to allow maximum public access to collections.

So museums are important to photography, and given the rich and complex resource that it represents, photography remains very important to museums!

Mira Shapur, Exhibition Consultant

University galleries and public art programs within the UK

Art galleries and museums, which have developed in association with higher education institutes (HEIs), are now an essential contributor to the cultural landscape within the UK. Given the range and diversity of HEIs, it is perhaps not surprising that the associated galleries and active public art programs are varied and multifarious in both their content and output. The breadth of institutional venues range from those associated with long established and historically important art collections as housed in the Ashmolean Museum of Art and Archeology, (originally founded in the seventeenth century and part of the University of Oxford), to other HEI galleries that showcase and display the latest contemporary art and design work by staff and students as, for example, regularly featured throughout the extensive college galleries at the Royal College of Art in central London.

Whilst historic galleries such as the Ashmolean and the architecturally grand nineteenth-century Fitzwilliam Museum, University of Cambridge, house specialist art and antiquity collections of international significance and are accorded museum status, other newer HEI galleries have more recently become vital contributors to local and regional cultural economies. Institutions such as Warwick Arts Centre, founded in 1970 by the University of Warwick and an anonymous benefactor, deliver a popular multifaceted public arts program featuring contemporary art, film, theater, and dance, classical and experimental forms of music. Likewise, Aberystwyth Arts Centre established by Aberystwyth University in 1972 flourishes as an important regional arts center showcasing new music, performance, comedy acts, and exhibitions.

As a key regional HEI within the southwest peninsula, Plymouth University launched Peninsula Arts in May 2005 as the provider of a wide-ranging and diverse public arts program, with the ambition to deliver exhibitions, music, film, public lectures, performance, and dance. The opening of Peninsula Arts was part of a major university reorganization in which arts and culture were seen as central assets in a renewed partnership with the city of Plymouth and the wider southwest region. From the outset the Peninsula Arts program explicitly aimed at engaging a broad public audience in addition to its own academic community within the university. The changes to the public face of the university reflected a wider political reorientation of higher education in the UK in the late 1990s and beyond, which advocated a greater emphasis on widening participation, community engagement, and increased public access. At this time there was also a greater recognition of the role that HEI's play in cultural regeneration and the potential influence that education could have in enriching the broader cultural environment. Universities were recognized as vital contributors to the creative economy, providing an interface among new research, industry, and business and have since increasingly become influential institutions within both the cultural and social infrastructure of their respective cities and regions.

In response to this wider changing cultural and political landscape university art venues such as Peninsula Arts are in a position to offer a unique and distinct program. Situated within the Faculty of Arts, Peninsula Arts is able to draw on the expertise and specialist knowledge of the academics working within the university. In this way the public arts program provides a potential interface and framework through which the latest academic research and practice can be made visible. Working at its best, the arts program provides a context for new and experimental artwork to be presented in engaging and accessible ways and a program of public talks and discussions, which are designed to extend audience interpretation and understanding, supports this approach. Each aspect of the program is supported by an advisory group, which consists of academics from relevant subject areas, who critique proposals and advise on program content. The aim is that the exhibition program reflects the breadth and diversity of art forms as represented within the Faculty, from Design and Architecture through to Fine Art, Media, and Art History subjects. Photography is strongly

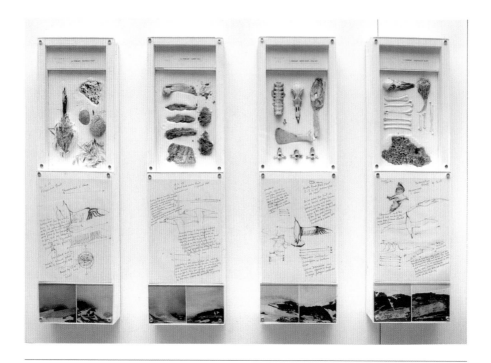

'Southern Forensics,' 2003. The work was produced from a two month residency with BAS (British Antarctic Survey), on Signy Island in the South Orkneys. It represents a daily record of life in Antarctica, using drawings, found objects, and lens-based images. Image © John Kelly.

represented within the group and we have built up a track record of hosting challenging exhibitions, which have raised important questions concerning contemporary photography and associated discourses.

As with all our exhibitions the emphasis is on the conceptual framework and a recent photography exhibition, Sightseeing, curated by Hanna Scott (September 13—October 23 2010) in the Peninsula Arts gallery, exemplifies this approach. The exhibition featured fifteen German and New Zealand artists whose work sought to explore and challenge notions of beauty, pictorialism, and nationalism as presented through the form of the photographic picture postcard. The exhibition rejected the idealized and perfected order inherent within most tourist photography and instead offered an alternative reality of border controls, building sites, fake landscapes, and even underground mines. The themes within the exhibition were further extended and explored through a series of public lunchtime and evening talks, presented by academic staff from photography and media subjects within the Faculty of Arts. These talks examined and questioned how our understanding of beauty and

landscape are constructed and further reinforced through photography and the tourist industry. These issues were further complimented by an accompanying film series, 'On Location: Representation of Place in Contemporary Cinema,' which featured a selection of independent films exploring how cinematography has influenced our perception of landscape.

A forthcoming exhibition Landscapes of Exploration (February 11—March 31 2012) curated by Liz Wells, Professor in Photographic Culture within the Faculty of Arts, brings together for the first time the work of ten visual artists, one musician, and three writers who during 2001 and 2009 were resident artists in the Antarctic as part of the British Antarctic Survey. Liz Wells writes, 'Landscapes of Exploration foregrounds the role of contemporary art in examining Antarctica. What perspectives can art offer on this terra incognita, a forbidding environment where the temperature rarely rises above freezing, yet one which for scientists offers a wealth of geological and glacial data including indicators of climate change.'[1] The visual art element within the exhibition features artists working across a range of media including painting, film, and sculpture, with two of the artists incorporating photography within their work. The artist David Wheeler creates a series of panoramic photographs printed on chart paper, which forms part of his 'Antarctic Travelogue,' while John Kelly constructs six small cabinets that display writings, objects, and photographs from his 'Southern Forensics.' A multidisciplinary exhibition of this type invariably raises questions as to the range and methods of photography used, to record and express the extreme environments of Antarctica alongside other visual mediums. Working from within a university setting Peninsula Arts is able to bring together, scientists and researchers working within fields of geology, marine and environmental science, alongside specialists from the Arts Faculty, including photography, to discuss and extend some of the issues explored within the exhibition. This is an ideal opportunity for the public to experience and gain a vivid insight into both contemporary art practice and the associated scientific fields that underpin this form of exploration and inquiry.

These two examples provide an indication of how university-based arts programs can provide distinctive public engagements which can both inform and question how our culture moves forward.

<div align="right">Sarah Chapman
Peninsula Arts, Plymouth University, United Kingdom</div>

[1]Liz Wells, *Landscapes of Exploration* exhibition touring guidelines (Plymouth University: Peninsula Arts, 2011).

The Curator's Role

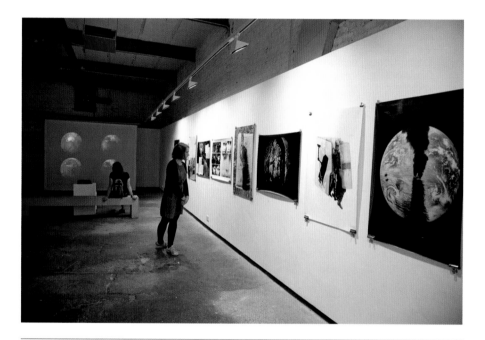

Peter Kennard *@earth* installation at Margate Photo Festival, 2011. Peter Kennard: For the MPF I took work which could be carried on the train and put on the wall in an afternoon. I always adapt my work to different contexts—the point of the work being that it should be available to everybody from being seen in the Tate to free posters given out as part of the Occupy movement. My work goes out in the form of prints, postcards, T-shirts, newspapers and is pasted up in the street as well as being in galleries. It is made in different materials adapted to those contexts—it could be a limited edition of a print as well as an unlimited print on newsprint and also made available as a free download on the Internet. To me the book is the most important visual form and in my book *@earth* (Tate 2011) I have tried to make a cheap visual pocket book which has no text so that it can be understood globally.

Shirley Read: The curator's task is to think aesthetically, strategically, and practically. I invited Peter Kennard to show at the MPF because I admire his work and think it appropriate to the very broad public audience which visits a photo festival. His book *@earth* had just been published so it was also a good moment to show the work. At the same time I knew, from working with Peter a number of times over many years, that we would be able to put the show up quickly and efficiently in an afternoon in a venue that neither of us had worked in before—and that he could adapt the work to the showing situation as circumstances dictated. Image © Natalia Janula.

Curators are, above all, the institutionally recognized experts of the artworld establishment, whether they operate inside an institution or independently. More than art critics or gallery dealers, they establish the meanings and status of contemporary art through its acquisition, exhibition, and interpretation.

Mari Carmen Ramirez, Curator of Latin American Art

The real problem in curating nowadays is that many curators are making lists of artists rather than working with the artists to make a show.

John Gill, Director, Brighton Photo Biennal

My job is to be responsive to contemporary practice, not to make trends.

Camilla Brown, Senior Curator, The Photographers' Gallery, London

Ninety percent of the business of putting exhibitions together is in the organization of it. It's not just about selecting work.

John Gill, Director, Brighton Photo Biennal

Hoopers Gallery is a commercial gallery and is profit-motivated. However, we have a strong underlying policy of support for our artists—we are there for the long term. Where we recognize real talent and originality but feel an artist needs support and encouragement to develop and focus their work, then we are prepared to work with them for a year or more until we feel they have a body of work that could form an exhibition. We had an example of this recently where a photographer is making the transition from film to stills. This level of support can only be given to a select few but it does highlight that we do not expect every portfolio to present us with an instant exhibition—both sides need to make a contribution.

Helen Esmonde, Director, Hoopers Gallery

When I curate an exhibition I have to be fascinated by the subject, it has to grab me and not let me go. With me, it's always a good sign if something actually makes me angry upon first viewing, that the art work has hit a nerve and is making me think.

Dr Inka Graeve Ingelmann, Head of the Department of Photography and New Media,
Pinakothek der Moderne, Munich

I work in an organic way. I select one or two artists and then develop the idea of the show in conversation with them and invite further artists to participate.

John Gill, Director, Brighton Photo Biennal

The way that exhibitions are always selected: works that we knew; works that were suggested; works that we could find; that were available; that we could afford; works that worked together.

Jeremy Millar, curator

What is curation? The term is a relatively recent one. One dictionary definition is that the curator is the person in charge and while this is not always the case it is useful for the photographer to be aware that it is usually the curator's vision, rather than the photographer's, that shapes an exhibition. The key curatorial tasks are to be responsible for an exhibition concept, to select the artists and the work for that exhibition, to design or oversee the design

and layout of the exhibition—possibly deciding both print size and frame type—and to write or oversee the writing of associated texts. At the same time the curator will be responsible for the overall organization and timetabling of the exhibition.

There are, however, as many different types of curator and different aspects and approaches to the curator's role as there are different types of venue for which to curate. So a museum curator has a different job from that of the curator of a commercial gallery (in that most of the work the museum curator deals with will come from the museum's collection, for instance) and both differ from an independent curator. In some galleries the gallery director is also the curator, whereas in others the roles of director and curator are sharply differentiated. Some galleries employ a different curator for every exhibition or bring in touring exhibitions curated elsewhere, while other galleries have one or more in-house curators.

As a general rule, the curator's role is narrower in large galleries, where the key tasks may be to develop an exhibition concept, bring in major artists, select the artists and the work for exhibition, and make sure that it is hung to their specification. In smaller galleries their role is likely to be both broader and more hands-on, and the curator may oversee, or be closely involved in everything the gallery does from programming and budgeting to arranging educational events. So, for example, curators in small galleries may hang shows themselves while in larger galleries this is more likely to be done by a specialist team or contracted out.

The curator's role, however, is usually both creative and organizational, and it is useful to be aware of these two aspects of the work, which can sometimes conflict. The task of developing an understanding of the work in order to shape and present an exhibition well is about being slow and thoughtful and about giving the work the sort of time and attention it demands—even though it can be difficult to predict how much time that will be. The organizational role, on the other hand, necessitates speed and efficiency, a certain ruthlessness, and keeping to a series of tight deadlines. Both creative and administrative tasks need to be done well, but under time pressure it is sometimes difficult to prioritize one over the other. An outstanding exhibition that no one sees because the invitations have been sent out too late is as much a disaster as an exhibition that has had a fantastic press campaign but is badly received because the curator had no time to think through how the work should be shown. The experienced curator knows how to balance both aspects of the work, while the photographer who is learning to curate his or her own work can find this the hardest part of their task and one which takes time to learn.

Not only do the job description and the definition of who does what tend to vary from gallery to gallery but no two curators have exactly the same approach to curation or to their understanding of their role, and an important part of the photographer's input to an exhibition is often to negotiate their role with the curator in order to be clear about what each can expect from the other. Despite this the central tasks of curation—to select, edit, and present work to an audience—remain consistent and identifiable whatever the venue. The curator is first and foremost a mediator or interpreter between photographer and audience, and his or her work starts where the photographer's work has finished. This finished work is, for the curator, simply the raw material from which he or she will shape an exhibition. Or to extend Ansel Adams's famous metaphor that 'the negative is comparable to the composer's score and the print to its performance,' if the print is the performance, the curator is the conductor of the orchestra. The curator is creating a conversation not just between artist and audience but between the artist, the audience, the space, the institution, the press, and the art world.

To do this the curator's starting point is usually the work and their aim to make a strong and coherent exhibition by making visible the ideas and connections which underpin the photographs. An insightful curator may well see meanings and connections in the work that the artist is unaware of or too close to the work to see. The curator will spend time with the images and in dialogue with the photographer to explore every aspect of the work and shape its presentation and these discussions should test and toughen the end result. A curator is not simply an enabler but has also to be capable of being ruthless with the artist—most photographers get attached to their own view of their work and to particular images, and it can be difficult for them to accept that they may have a sentimental attachment to an image simply because of the circumstance of its making. The hardest thing for a photographer to understand is often that 'less is more' and that an exhibition may not include some of their favorite images because the curator will exclude repetition, knows how to pace and shape an exhibition and how much work an audience can look at, whereas the photographer naturally wants to show all his or her work.

A curator will usually be supportive and constructive in their criticism of work so photographers have to be ready to trust the curator's knowledge, not just of their work, but of other photographers' work, of the exhibition space, of audiences, and the art world. The photographer has to be able to put aside his or her attachment to particular images or a body of work and listen carefully to what the curator says about it and in return the curator should listen to the photographer's views on the work. For the photographer this can be an essential part of understanding how their work will be received. If the curator, who is usually someone with a great deal of experience of looking at photographs, has missed something the photographer sees as being in the work, it may be that the work is too subtle and a gallery audience would, most probably, miss it too. Something that seems completely obvious to the photographer because he or she has spent many months thinking about little else will not necessarily be obvious to a curator or to an audience.

So a strong curatorial vision will usually take precedence over the photographer's understanding of his or her work (and may retrospectively change it). On this subject, curator John Gill, Director of the Brighton Photo Biennal, says to artists, 'It's your work but it's my show'— neatly summing up the relationship of artist and curator. The curator may also interpret and select work to fit with a theme of their choosing as, for example, Sian Bonnell has done by choosing work from several photographers to fit the theme of the elusive in photography—as we see in the TRACE case study.

Clearly the artist–curator negotiation can be a difficult one, particularly for the artist who has to give up some control and be prepared to accept new readings of the work. One thing which will help the photographer here is to ask the curator to be clear about the exhibition concept and to negotiate how they will work together right at the start of the process. Again, depending on the gallery and curator, it will vary. In a major gallery the curator may simply ask photographers to submit work and then select from it without any negotiation. In a smaller gallery the process is likely to include more shared discussion of the work.

This close engagement between the curator and the photographer and their work can develop into a working relationship which lasts far longer than the initial exhibition and is of great benefit to both photographer and curator. Curators often have, and have been criticized for having, strong preferences and photographic interests of their own. Although this can seem as if cliques and certain stylistic movements form around particular galleries or curators it is, in

my view, unrealistic to expect a curator to be entirely objective for the curator has to be motivated by a passion for photography and this will inevitably shape their interests. While it's a rare curator who is able to work only with artists they respect or admire, all their curation will be the better for their closer understanding of the making of the work. For the photographer this ongoing relationship is useful in that it will give them both support and an ongoing critical dialogue which will help develop their work across a range of ideas and projects and over time.

Exhibition design and image selection are often discussed at the same time or in parallel since the two tasks are interdependent—the layout of the gallery and size of print will dictate the number of images and vice versa. The gallery curator will know the way their gallery works—that is the way an audience moves round the space, where to place key images, where light falls, if there are dead spaces or areas which are difficult to light—in short, how to make best use of the space. Being able to edit and sequence work for a space, an exhibition and an audience is a skill which takes time to learn and is crucial to curation. It includes selecting key images; knowing how decide on and vary the size and framing of imagery to highlight the significance of the photographs; how to draw an audience across the space by, for instance, the placing of obviously key imagery where it is visible from a distance and how to make sure the audience doesn't take in the whole exhibition at a single glance from the door but wants to move around the space and experience the works individually.

In selecting a photographer to show and also in writing and publicizing their work a curator is both implicitly and explicitly making a statement about the significance and importance of that photographer's work and their place in the photographic world. In effect they are not only supporting the photographer on a personal level but putting their own reputation behind their choice. This is one reason curators 'gallery watch' because they read their own choices against the choices other curators make and see how their thinking is being echoed, taken up, or disputed by other curator's choices. The curator feels, for example, that their own judgement is vindicated if a photographer they show early in their career then goes on to be very successful. And a photographer's c.v.—which can be read as a history of who or which galleries have supported them—is important as evidence of this support and will ensure the interest of other curators who can see that this photographer is one who their fellow curators value.

So, to sum up, a curator is in most cases essential to an exhibition in a number of ways. For the photographer who is considering curating his or her own group or individual show, he or she needs to think carefully about how to approach it and think about asking a colleague to work with them rather than automatically curating their own work. This is also where a support or working group of photographers can be useful. By sharing these tasks and by discussing the editing and presentation of work on a regular basis, photographers acquire a set of useful skills which will stand them in good stead both in exhibiting and in making the work. But do they then still need a curator? If the photographer or artist has started out on an exhibiting career without a great deal of curatorial input and is learning to curate their own and other's work, what reason is there for them to consider working with a curator? What can a curator do for a photographer or artist that he or she can't learn to do for him or herself?

Firstly, and obviously, the curator is based in the world of showing work rather than the world of making work. Their entire focus is therefore on how best to show this particular work and what is appropriate to it and to the photographer at this stage of their career. They will

bring an extensive knowledge of the subject, an awareness of what is current, what other curators and exhibitors are doing and how to use gallery space to the task of curation. Their judgement is usually finely tuned and they can assess, for instance, what sorts of presentational risk can be taken. Most important of all they will be aware of how and where an exhibition places a photographer within the world of exhibiting. Even the photographer who sees a great number of exhibitions cannot hope to acquire this level of knowledge because it comes from working inside the gallery system and keeping a focus on exhibiting.

Because an exhibition is the end stage of the process for the photographer he or she may also feel that their priority is to get the work on the wall as quickly and simply as possible—and to let the work speak for itself—whereas the curator may well want to put much more work into the process in order to make a more powerful show. When starting to work on an exhibition the photographer can't help but feel the work is nearly complete whereas for the curator the project has just begun.

The curator also acts for the audience and will bring a fresh and independent vision to the task of selecting work. This is almost always something the photographer finds difficult to do on their own. A curator should be more useful than photographic colleagues in doing this since it is something they do constantly; they have more at stake in getting it right and more interest in reaching an audience than in indulging the photographer.

The curator will, by and large, also be better at keeping on top of the organizational tasks involved in exhibiting if only because they are less involved with the work itself and more used to exhibiting timetables. As we see from John Kippin's account below they may also be looking for new outlets and funding opportunities for the work as part of promoting it.

Crucially too the curator may well support the photographer on a long-term basis as well as for a particular exhibition. This support can take many forms: from promoting the work generally (through writing about it or putting the photographer's name up for an award, for instance), to making introductions for the photographer (to other galleries, curators, or editors, for instance), to engaging in a long-term dialogue with the photographer around the work which helps shape and direct it (through occasional or regular meetings to look at work in progress, for instance) or may offer or pass on information, suggestions, contacts, or directions. A good curator is always a teacher of sorts and the photographer should acquire insight and skill in working with them. A supportive curator will also be capable of 'tough love' in helping the photographer see when, for instance, they are simply repeating old work or heading down a creative cul-de-sac. All in all I would argue that, although photographers can bring a great deal to the curation of their own work, the input of a curator can make sure it makes a successful transition from studio to gallery.

The Prospect of Immortality: on being curated for the first time

Murray Ballard exhibited his work investigating cryonics—the practice of preserving the dead in the hope that medical technology in the future will be able to bring them back to life—at Impressions Galley, Bradford, from 10 June to 17 September 2011.

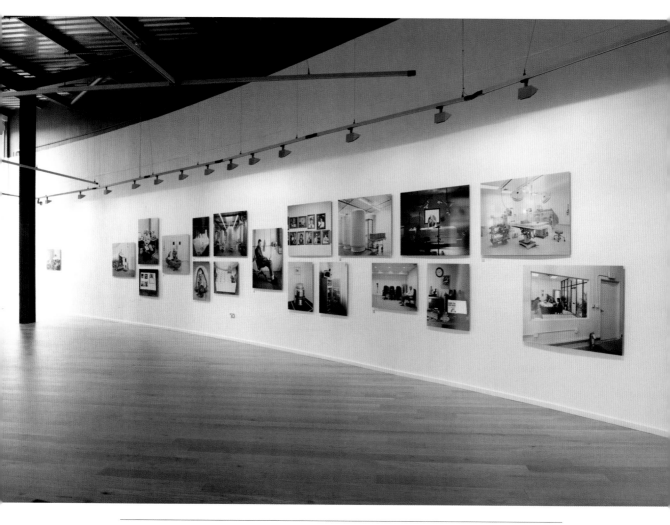

The Prospect of Immortality by Murray Ballard at Impressions Galley, Bradford, June 10—September 17 2011. Image courtesy Impressions Gallery.

When I graduated from Brighton University in 2007 I had no expectations of having a career focused on exhibiting. At Brighton there was little emphasis on this and I graduated having only contributed to a couple of internal student shows.

For many years the tradition for Brighton photography students was to take their degree show to London, but our year took the collective decision not to do this, especially after reports reached us that previous years had felt drowned amongst all the other graduate exhibitions happening in the same building.

But I was still keen to show somewhere and so I got together with six friends—also Brighton graduates—and we put on our own small group exhibition at an independent gallery in London. We funded, curated, and hung it ourselves, and it was open to the public for a couple of weeks. Although we learnt a lot in the process—mainly practical

things like how to find a venue, and how to advertise—we all felt a bit deflated afterwards. I think we were expecting it to lead directly to new opportunities. But of course it's not that easy and, looking back, I for one wasn't ready. My work still needed time to develop.

The following year, in 2008, I got together with three of those original six photographers to mount an exhibition for the Brighton Photo Fringe, part of the Biennial. Once again we did everything ourselves, but this time it was much more considered; the show was built around a central theme and we received funding from the Arts Council. The exhibition was more successful and being part of a major international festival meant we had a much bigger audience. It was at that show that Anne McNeill of Impressions Gallery saw my work; fortunately I happened to be invigilating that day and we struck up a conversation. Coincidently, I had just been selected for Redeye's exhibition workshops for emerging photographers, which were to be held in association with Impressions. So, over the period of the workshops Anne saw my project progress and afterwards she approached me with the idea of developing the work into a solo show.

The best thing about working with a curator for the first time was to have someone else—someone with a sizeable knowledge of photography—really sink their teeth into my work. The dialogue that ensued was really interesting and gave me a much better understanding of my work. That might sound strange, since you might expect that a photographer should really understand their own work, but I was often too close to it to be able to see it clearly. Anne was able to look at it quite dispassionately from a distance, and that really helped me. For three years since my graduation I had continued to work on the project with very little feedback from other people. I really missed the input I had had at university and, in hindsight, I should have been more proactive in seeking the opinions of others, but frankly that's just not in my character; I'm more inclined to keep my work close to my chest and quietly get on with it. As a consequence I think I lost some perspective on what I was doing and stopped thinking about how other people would read the work.

I've come to the conclusion that the greatest asset a photographer could have is the ability to see your own work with fresh eyes, as if you were viewing it for the first time. That, I now know, is the key role of the curator. It's almost impossible for the photographer to retain that necessary distance from their work. I remember occasions when Anne would question why I wanted to include certain pictures. To justify this I started to tell her the stories behind the images, and soon realized I was clinging to them because of the experience I'd had making them—be it difficult, or humorous, or whatever—rather than coldly looking at the strength of the results. Anne also explained the need for the pictures to stand on their own without extended captions and so, for that reason, a couple of them got dropped from the show.

I learned a lot during the process of editing the photographs for the exhibition. We began with my own edit of the work and then Anne took the time to look over a much wider selection of photographs, making her own edit, and picking out a number of photographs I had overlooked or disregarded. Then followed a rather lengthy process of discussing which pictures should make the final exhibition. We comfortably agreed on about two-thirds of the edit, but the remaining third was the subject of much debate and discussion.

In retrospect, I stand guilty of the classic photographer's desire to include as many pictures as possible. Anne referred to this as my 'editorial training' because I had a tendency to over-illustrate certain points by using several pictures, when often just one would do. She emphasized the idea that photography is about limitation, when less is definitely more.

I also had quite fixed ideas about how the photographs should be sequenced in the exhibition, which I suppose was again quite 'editorial' and probably a bit obvious. Anne introduced a number of new possibilities, seeing connections between pictures that I just hadn't noticed.

The project was photographed in three different countries: UK, USA, and Russia. I had always imagined the exhibition divided into these three distinct chapters. To an extent that's what happened, but Anne merged the 'chapters' so that relationships developed between different locations and the transition from one country to the next wasn't so marked.

I think I also held fixed ideas about how I wanted people to read the work. I had written extended captions for each photograph, with detailed explanations about the content. However, I soon understood that once work is in a gallery it's more important to leave it open to interpretation so we agreed to minimize the text in order to open the pictures up. In many cases the extended captions took something away from what was interesting about the picture.

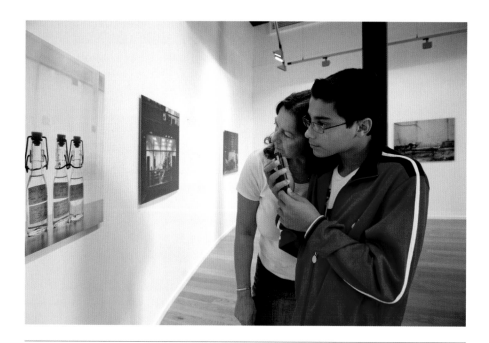

Using a mobile phone to listen to the exhibition audio. Image © Murray Ballard.

I also used audio in the exhibition. A number of pictures were accompanied by short snippets of audio, no more than two minutes in length, the subjects talking about various things that related to their pictures. These were accessed through QR tags using a mobile phone. It therefore became the viewer's choice to make that extra effort to access an additional layer of information. Although it would have been difficult for the gallery to keep an accurate tally of the number of people who used the QR tags they think that about a third of the 9,419 visitors did so.

When it came to hanging the exhibition I realized how important it was to work with someone who really knew the gallery and understood how people would move around the space. We did a lot of preparation, using small prints to work out the layout and sequencing, but a lot of those plans fell away on the day of the installation and instead it became a more intuitive process. Everything was very different in reality. For example, when the pictures were printed at a larger scale, colors become more dominant and images I thought would work well together would sometimes clash. It's a difficult thing to talk or write about because you're dealing with something almost entirely visual. But once all the work was unwrapped we spent the best part of a day moving the pictures from one place to another, trying out a number of different sequences. It's like a visual balancing act, but it's not a precise science; when you get it right you just … know.

One of the key things I learned that day is how the curation of pictures enhances the impact of the work in the gallery. Again I find this very difficult to write about, so perhaps it's better to give an example: The exhibition is about cryonics, the practice of preserving the dead in the hope that future medical technology will be able to restore life. I had made a portrait of Robert Ettinger (the so-called grandfather of cryonics because, in the mid-1960s, he gave birth to the concept) photographing him a year before his death in 2011, at the age of 92. The picture is quiet and soft in tone, with pastel colors, lit by natural light coming from the left-hand side of the frame. Ettinger is seen sitting on his sofa reading a book, apparently totally unaware of the camera; we seem to be getting a very private glimpse of this man's life. In the exhibition it was really important to find the right place for this image. Putting it next to more vibrant pictures or in a dominant space would have stifled it. Instead we wanted to find a quiet place, slightly tucked away, which would emphasize this quiet, gentle moment. In the end we put the portrait next to a window so that light fell across it in the same way the light in the photograph falls across Ettinger. For me it's these subtle touches that really add to the experience of an exhibition.

My first solo show has definitely changed my attitude toward exhibiting. Firstly the whole process has been completely demystified. I have a much better grasp of it now and realize how important it is to work with a curator. What I've come to understand is that it's their job to bridge the gap between the photographer/artist and the viewer.

It's also encouraged me to show my work to others as it develops so that I can benefit from their feedback. It's a mistake to keep the work locked away for too long. Having said that I recognize that showing people your work too soon could also be a mistake;

it's important to at least begin to investigate your idea before someone influences you to take a different course.

Murray Ballard
www.murrayballard.com

Greenham Common: on working with a curator

If there are to be exhibitions, then working with a curator is an essential element of making these happen. In certain circumstances, it is possible and perhaps desirable to become a curator oneself, but in a way this is missing the point. In an age of 'flexibility' and 'multitasking' we can all do everything up to a (frequently mediocre) level and usually professionals do it better. The putting together of an exhibition is but one aspect of being a curator, but when this (not always straightforward) enterprise is combined with initiating and developing a project together with managing it then it becomes something of an entirely different order.

I first met Ruth Charity when she was a curator at The Photographers' Gallery in London working alongside David Chandler. David and I were working on the exhibition and publication Nostalgia for the Future. *David is an insightful and singular curator and a brilliant writer and together they forged an exceptional curatorial partnership. It was however, later on that I came to work closely with Ruth on a project that was based at Greenham (and Cookham) common in Berkshire. Ruth was by this time working with ArtPoint, a public art development agency based in Oxford.*

She was responsible for developing the outline brief for the project and when I started the one-year residency we were able to sit down together and to discuss my initial thoughts and preferred approach to the commission. The outline agreement was that I would work on the common for a one-year period and that I would supply Berkshire Council with a number of photographs of the common during the process of its reversion from military to civil use. (Greenham Common had been converted to a US air base housing first-strike cruise missiles and it became the focus of a unique and effectively orchestrated women's anti-war protest movement).

The (Liberal Democrat) council at the time was anxious to complete the conversion and to reopen the common to the public in time for forthcoming elections so in some ways there were a number of different deadlines along the duration of the project. I had agreed to supply the council with images of the conversion of the common (mostly demolition work of the runways being torn up). At all other times, I was free to pursue my own approach to the project. Ruth and I met on a regular basis to discuss and review work that I had made, to discuss progress, and to plan for the future.

As is my usual practice, particularly in the early stages, I had a clear idea of my general approach, but wanted to allow for sufficient flexibility to allow the process itself to shape the project. An important part of this process became the discussions

From *Cold War Pastoral*. Image © John Kippin.

that Ruth and I had when we would look at work in progress and explore my intentions
and meanings and consider possible future developments—both to do with individual
images and also to consider potential structural possibilities considering the overall
project. We were fortunate in that we got on well and were able to freely discuss any
matters relating to the commission. It is often difficult for photographers (as opposed

say, to painters) to consider the value of process but a strong critical dialogue is an immeasurably creative contribution to focussing and refining the work. Ruth has an excellent creative and critical ability and approach that played a major role in our progress in making images whilst at the same time considering the future contextualization of the work within a broader civic and social structure. It was good to share the work and the project and to feel that we could shape something together. Although I always work alone when actually making my photographs, it can be quite isolating in some ways and working with Ruth enabled me to consider another perspective and to enjoy the results of our creative partnership.

Although in some ways, the work that I made at Greenham could be viewed as being a relatively straightforward exhibition project, the particular context and history of the location made this project more complex and politically sensitive than many others. Local views were divided and it was a great credit to Ruth that she was able to negotiate with the various interest groups surrounding the common ensuring that they understood and supported the involvement of arts practitioners. Seen from my own point of view, the important thing was to be allowed to make the most of my time on the common without unnecessary hindrance. We discussed the development of the project and it became clear that it should become a project that was able to engage the public on a broader basis than had originally been considered, and although it could not claim to be a 'public art' project in the usually understood manner, it had the potential to engage both in a national forum and at a discrete local level.

We considered the possibilities, and having agreed a strategy, Ruth set about putting together any agreements that would be negotiated and raising the necessary finance. At this stage, by this time much later in the project, I would meet with Ruth at the Imperial War Museum in London (over tea and cakes). By this time we had agreed that the initial exhibition should ideally be held at the Imperial War Museum as being the most appropriate venue as a museum that presents a mediated version of past wars so were considering how the positioning and focus of an exhibition, by now entitled Site of Special Scientific Interest, *that reflected only upon the* possibility *of 'what might be' could be successfully articulated. (The then curator at the Imperial War Museum Angela Weight was hugely supportive and my thanks are due to her). This development had allowed for the future expansion of the project by providing a national/international focus that assisted in the raising of finance for other aspects of the initiative including exhibition, poster works, and a book publication.*

Following the opening of the exhibition at the Imperial War Museum the work was adapted to be exhibited in what had been an air force vehicle workshop on Greenham Common (close to the current visitor's entrance) where many local people were able to visit the exhibition. We developed two poster works, the first of which was to inform the public of the date and location of the opening of the common and the second of which was to be (inexpensively) available to the public to celebrate the (re)opening of

the common to civilian use, hopefully laying to rest its turbulent past. Ruth also arranged a number of other well-attended local events including a workshop and discussion presentation at locations close to the common.

Clearly, by now the project had developed in scale and scope and became one that addressed a range of different audiences and had developed a momentum in terms of its ambition. Financial considerations were always a problem as we had far exceeded the original budget set aside for the project. At each stage there was a need for new finance to be generated. One interesting model that emerged was that Ruth managed to persuade the council to agree to an advance of the finance necessary to produce the initial exhibition on the basis that this would entitle them to retain a number of images for their collection. This was an excellent arrangement, as it is of far more value to me to be able to produce the work rather than to attempt to sell it after the exhibition. Such events shape what it is that we are able to accomplish and Ruth is very adept at the 'horse trading' aspect required of such negotiations.

The final stage of our collaboration was the development of the book publication Cold War Pastoral. *We carefully considered what this stand-alone publication might add to the project and its legacy. We agreed that the book should reflect a number of discursive approaches to the common reflecting its history, topography, flora and fauna, site of conflict and protest together with reflections on the nature of the pastoral and on the photographic work central to the construction of the narrative of the book. The Arts Council generously assisted with the finance, and* Cold War Pastoral *was subsequently published by Black Dog Publications in London (thanks also to Duncan McCorquodale).*

The exhibition had been slightly refocused by this time and was some time later exhibited as Cold War Pastoral *at the Side Gallery in Newcastle-upon-Tyne. It was here that I was able to catch up with Ruth when she travelled to Newcastle to negotiate the arrangements for the exhibition. One of my fond memories is of Murray Martin (sadly no longer with us) loading the exhibition into a horse trailer to move the work from my home (then in Whitley Bay) to the gallery in Newcastle.*

Ruth and I worked quite intensely on Site of Special Scientific Interest *and* Cold War Pastoral *for over two years and it grew and developed over the period. When looking at the many outcomes it is noticeable that her name seldom appears on any material relating to the project. Apart from being a reflection of her modesty this is a source of some regret to me as none of it would have happened without her energy, insight, and all round ability as a curator, commentator, and organizer. This is curiously out of tune with the cult of 'Curator as Artist' but completely consistent with Ruth's approach to being a truly innovative, creative, and supportive curator. The process of making and exhibiting the work had been an interesting and engaging experience and our creative partnership was at the center of such success as the project was to enjoy.*

John Kippin
www.johnkippin.com

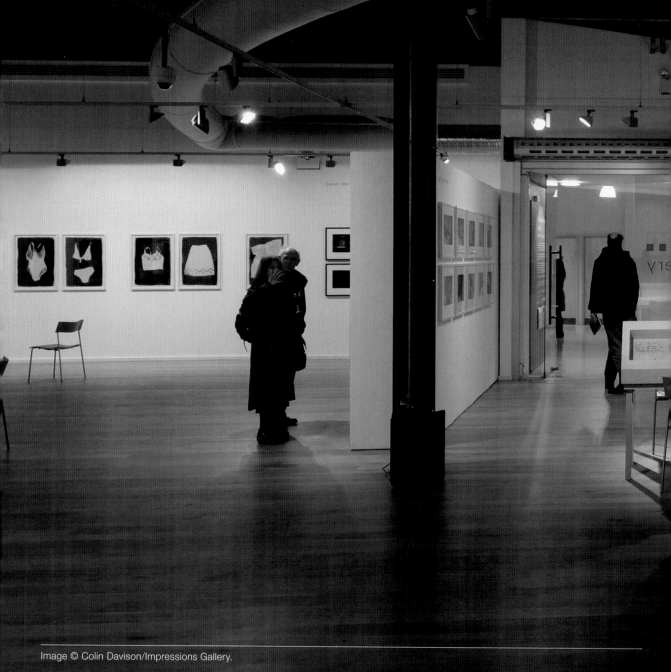

Case Study Four
Anne McNeill: A Gallery and a Curation:
Joy Gregory at Impressions Gallery

Image © Colin Davison/Impressions Gallery.

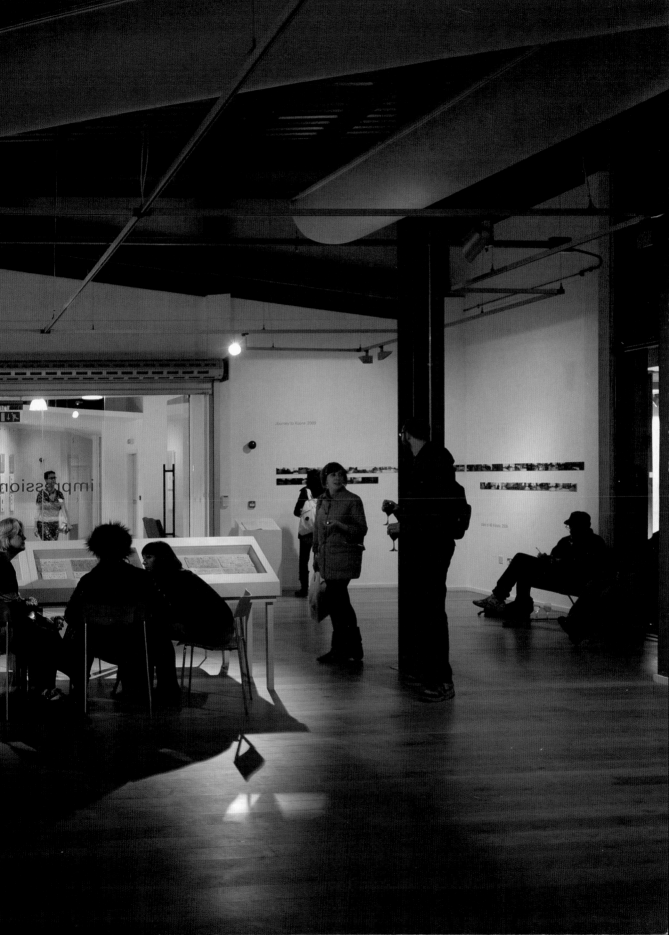

Anne McNeill, Director of Impressions Gallery, describes gallery policy and practice and her curation of Lost Languages and Other Voices *by Joy Gregory*

I think a curator brings a mix of instinct, experience, and knowledge to the task in hand. Many years ago at the Hayward Gallery, London I was wandering around a block-buster show with a 'non-art' friend and he casually remarked how at ease I was within the space. I have never forgotten this as it brought home to me that, while places and institutions such as the Hayward are my natural working environment, for many they can be daunting spaces, where fear of doing the wrong thing or appearing stupid perhaps takes precedent over the experience of the exhibition. For me, the curator has to be sensitive not only to the needs of the artist but also to those of the visitor. The manifestation of an exhibition is a dialogue between the artist, the curator and gallery. I always tell artists that it is the visitor who completes the process and as such both artist and curator need to be open to unintended consequences.

Impressions Gallery was one of the first publicly funded photography galleries in the UK and Europe when it was founded in 1972. It is a not-for-profit organization and charity, with the aim of advancing the knowledge and enjoyment of contemporary photography. In 2007 it moved from York to Bradford and into the first publicly funded bespoke photography gallery in England. The gallery is a single large space (235 sq m) with a total of 55 meters of running wall space, including a 33-meter long curved wall. It also has a dedicated education space and the leading specialist photography book-shop in the North.

Directly opposite the National Media Museum it offers a useful counterpoint to the museum's work in that it only shows contemporary work by living photographers. Impressions has a history of exhibiting photographers from culturally diverse or non-Western backgrounds, such as the iconoclastic work of Rotimi Fani-Kayode in 1989, in partnership with Autograph ABP London, and most recently the first major retrospective of work by Joy Gregory, one of the most significant artists to emerge from the Black British photography movement of the 1980s.

The gallery shows on average five, mostly one-person, exhibitions a year and plans its exhibition program two years in advance. Decisions are made at an annual meeting with its program selection panel (which includes its curators, academics, and photographers) and is attended by all the gallery staff, including front of house.

Impressions initiates most of its exhibition program and on average takes in three exhibitions from other galleries over the period of eighteen months. Exhibition proposals come from many different sources—the curators, suggestions from other galleries and curators, conversations with the staff team, portfolio reviews, and research trips to MA and graduate shows—and, although the gallery looks at every proposal it receives, it now finds that it takes very few unsolicited proposals. The ever-increasing volume of proposals also means that there is an ongoing process of short-listing before the selection panel meets.

The gallery does not shy away from work that is perceived to be difficult and has a particular interest in nurturing and supporting the creative process and career

development of emerging photographers and in supporting woman photographers. Over the last few years the gallery has also developed an interest in mid-career photographers, recognizing that, while many students are taken up by galleries straight from college and that there is a current fashion for a range of retrospectives from the 1960s and 1970s, little provision is made for photographers who have been working for about fifteen to twenty years. A mid-career retrospective is often the first time all their work can be seen together in one place.

Joy Gregory is a photographer whose work is concerned with a combination of race, history, gender, and aesthetics. She works with a full range of media from multimedia installations, video, digital and analogue photography, including Victorian print processes.

Gregory has worked internationally for many years and is regularly exhibited abroad, yet she hadn't had a solo UK show since 2005. Knowledge of her work is fragmented and people tend to know one project or another but rarely the whole story. *Lost Languages and Other Voices* is a survey show, initiated by Impressions Gallery, of twenty-five years of Gregory's work and an opportunity to bring to people's attention her significant older work alongside new work. This exhibition brought together past, recent, and new work that showed the range of her work across time and many different technologies, projects, and commissions. This helped the visitor to understand the way the history of her work and its various influences have evolved and placed it within the history of British photographic practice.

For Impressions, the curating process is about a dialogue with the maker of the work. Joy Gregory and I first discussed the idea in March 2008 and the exhibition was shown over two and half years later. During this time I spent days in Gregory's studio going though all her past work and archive. At the very beginning of this process I did not have a predetermined curatorial agenda and it was through lengthy discussion with Gregory that common threads began to emerge. These discussions narrowed down the selection to ideas of social, political, and psychological loss, alienation and journeys and went on to decide the final fourteen bodies of work that were shown in *Lost Languages and Other Voices*, in November 2010.

Some of the work had been shown before and was already framed in frames which suited our gallery space so could be reused and some images were especially made and framed for the exhibition. The design of every exhibition is dictated by the content and 'look' of the work itself. The key to Gregory's work and to the exhibition installation is the way that the discrete sets of work echo and reflect each other—while remaining firmly located in the site of their origin or the concept behind each body of work.

Anne McNeill

www.impressions-gallery.com

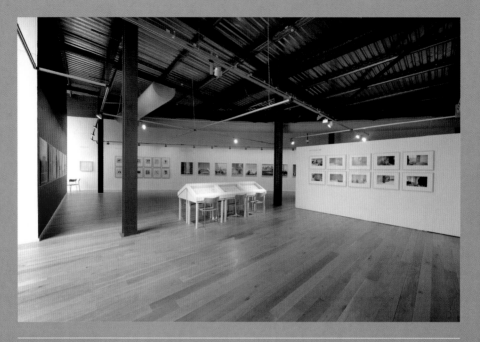

This is the view that greets the visitor as they enter the gallery. The different styles of display tell the audience that this exhibition is made up of separate bodies of work and so establishes at a glance that Joy Gregory works with a variety of ideas and techniques.

The prominent placement of the vitrines containing Six Weeks, a sequence of drawings that drew on Gregory's daily experiences in Kenya, emphasizes that this exhibition contains work that wouldn't be expected in a contemporary photography gallery. The vitrines are designed to encourage the visitor to sit down and spend time with this personal and intimate work. Image © Colin Davison/Impressions Gallery.

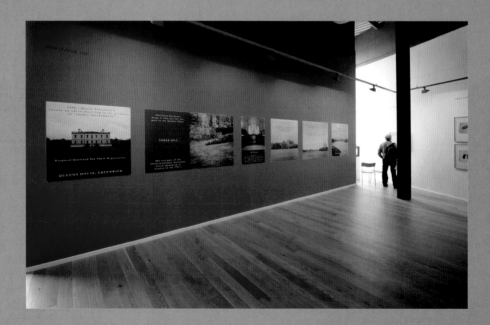

Sites of Africa 2001 (bottom left) were originally designed as outdoor billboards. Gregory and I didn't want to change the original intention or make them 'precious' by presenting them in frames. As a veteran of old style touring shows from the mid-1980s I knew that photographic work could be presented to a high professional standard laminated and map pinned to the wall. This was a simple device that enabled the images to be as large as possible (and therefore in keeping with their original purpose), since it was not possible to reproduce them as billboards.

The order of the hang was determined by the dates in the text, enabling the viewer to follow the narrative that dates a black presence in Britain back to the seventeenth century and track that presence through this time. The text challenges the common perception that Britain's black population is a relatively new phenomenon. Image © Colin Davison/Impressions Gallery.

Journey at Kuona 2009 and *46 Matatu 2009*. During summer **2009** Gregory was artist-in-residence at Kuona Trust, Kenya. She arrived in Nairobi and realized she had forgotten the charger for her camera. Ever resourceful, Gregory decided it was an opportunity to rethink her photographic practice without her digital camera.

Her mobile phone became her camera which she used to document her 45-minute walk from where she was staying to her studio and also when she was on the number 46 Matatu bus, her main mode of public transport. Freed from the constraints of a cumbersome camera Gregory was able to record the minutia of these journeys.

These are presented as small sized images mounted on Foamex (thick sturdy card) butted up together that carry on in an unbroken line around a corner. This reminds us of the continuous nature of Gregory's journeys and the narrative thread of the stories. Each individual image is enprint size to mirror the personal nature of mobile phone images and compel us to move in closer in order to look at the work. Image © Colin Davison/Impressions Gallery.

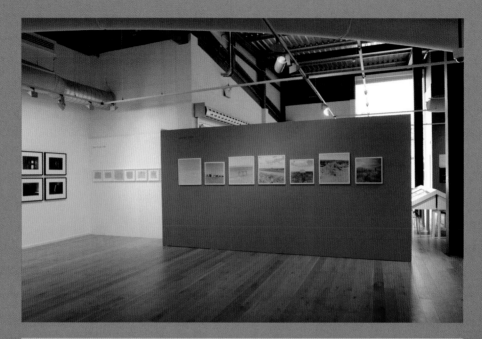

The ochre color of the walls was mixed especially for the exhibition to match the red earth of the Kalahari Desert seen in the last photograph of this sequence. This photograph was reproduced for the invite to the opening, book launch, and publicity posters. The red ochre color was used on this wall and on the large wall directly behind it to make a conceptual connection between the two bodies of work *Kalahari 2010* and *Sites of Africa 2001*. It was also an aesthetic device to bring pace and a variety of viewing that suggests a sense of travel. Image © Colin Davison/Impressions Gallery.

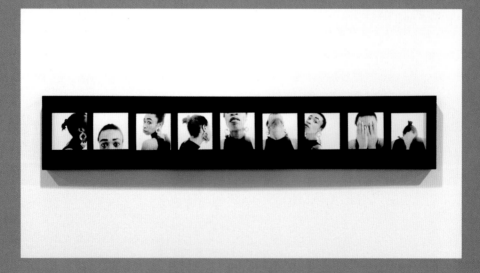

Autoportrait 1989 is a series of portraits of Gregory, all taken in a single sitting and presented sequentially in one frame. This encourages the viewer to read the images from left to right, emphasizes a sense of movement within the sequence and ends with Gregory with her back turned to the camera/viewer, which alludes to the lack of presence of black women in women's magazines in the 1970s when she was a teenager. Image © Colin Davison/Impressions Gallery

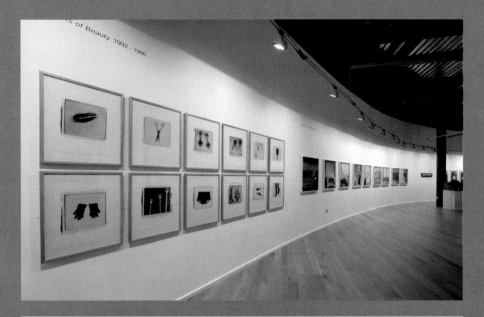

The images hung along the long curving wall at Impressions Gallery are from two different series—*Objects of Beauty 1992–1995* and *Cinderella Tours Europe 1997–2001*. Hanging them from an (invisible) central line means that the audience's eye is drawn seamlessly from one body of work to the next, while the different hanging styles and the space between the different work indicates that these are different bodies of work. Image © Colin Davison/Impressions Gallery.

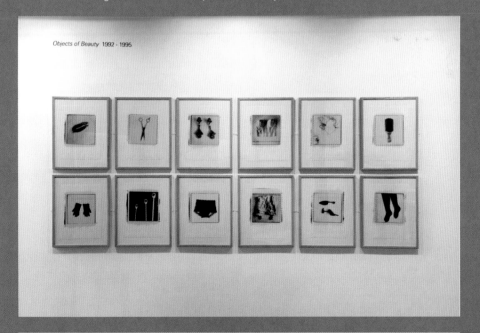

This set of twelve images is from *Objects of Beauty, 1992–1995*, and is presented in the original frames. They are calotypes, a Victorian printing process, and are double hung with equal spacing between each image to suggest a connection between all the objects in the images. Image © Colin Davison/Impressions Gallery.

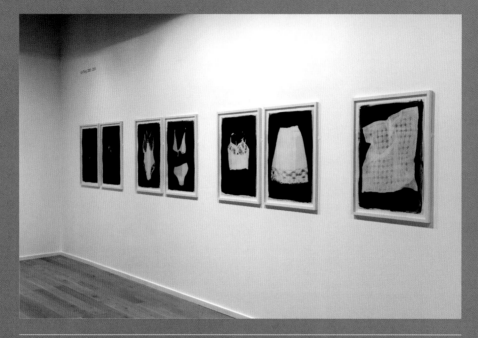

These images from *Girl Thing 2002–2004* deal with the physicality of the object, its potency, and associations with social and political issues. The stereotypical feminine clothing is presented as cyanotypes, a Victorian photographic printing process. *Girl Thing* is presented in the original frames. Three are paired up (as diptychs) to show the relationship between the garments. Image © Colin Davison/Impressions Gallery.

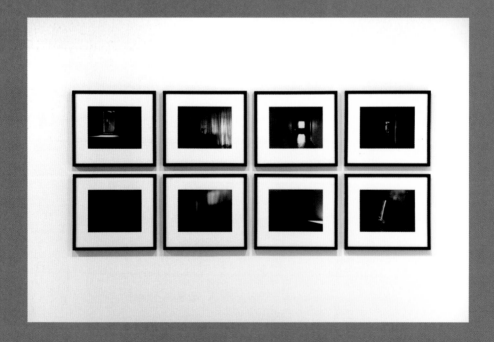

Interiors 2004 (bottom left) Shortly after the death of her father Gregory spent time at an isolated colonial country house in Sri Lanka. Despite its stunning location she was forced to spend many days inside the house due to monsoon rains and embarked on making a body of work within its confines. Gregory had taken a large number of photographs, none of which had been printed for exhibition before. We spent about two days looking through the contact sheets with me asking her, amongst other questions, what her state of mind was at this time. Having experienced the grief of losing a parent, it was obvious that the most powerful photographs were the dark interiors. Five years on from her bereavement Gregory also knew how to read what was within the images. We chose eight images that revealed her state of mind at the time—that of grief, a sense of loss and solitude.

The dark frames were chosen to emphasis this melancholia, white ones would have competed with the muted colours and given a different reading of the work. The photographs are hung close together to emphasize the underlining themes of claustrophobia and intense sadness. Image © Colin Davison/Impressions Gallery.

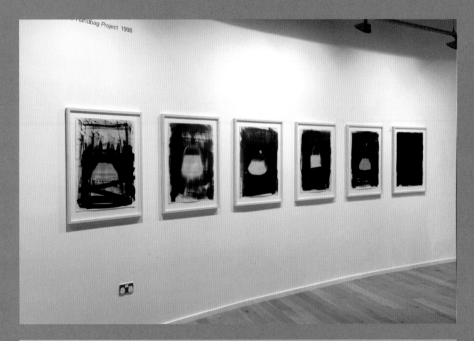

These images are from *The Handbag Project 1998*, which is a collection of one-off salt printed photo-grams. Gregory collected these luxurious handbags while working on a residency in Johannesburg, South Africa, at the time of the Truth and Reconciliation Commission. Gregory was attracted to these handbags because to her they are potent symbols of white woman's advantage and general femininity.

The images are dark and the frames are light to counteract the diffuseness of the trace of the original object. Presented like religious relics the spacing between each image allows the work to be viewed as unique prints. Image © Colin Davison/Impressions Gallery.

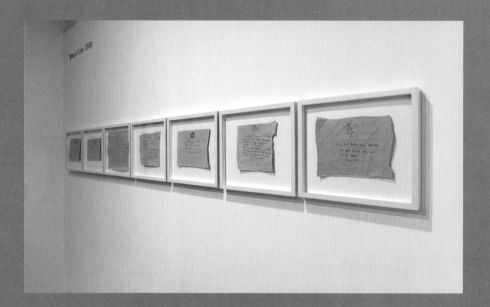

Tales of Loss: This set of seven almost childlike drawings depicts humorous events that Gregory encountered on her journey from her home in London to Orkney, Scotland. They are framed in pale frames and the drawings on paper torn from brown paper bags appear to be floating within the frame and as such emphasize the fragility and transient nature of the subject matter. Image © Colin Davison/ Impressions Gallery.

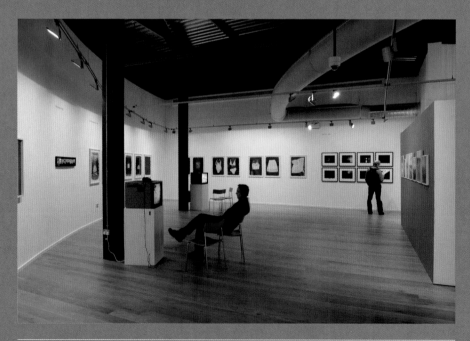

This shows seven different bodies of work including two different video works. The visitor is watching *Gomera*, a ten-minute film which looks at the complex relationship between language, the environment and survival. The second monitor is screening a ten-minute animation *Hoy/Hobart*. Headphones were supplied to provide the visitor an individual engagement with the work and on a practical level ensured that the sound didn't intrude into the exhibition space. Image © Colin Davison/Impressions Gallery.

Forward Planning: One

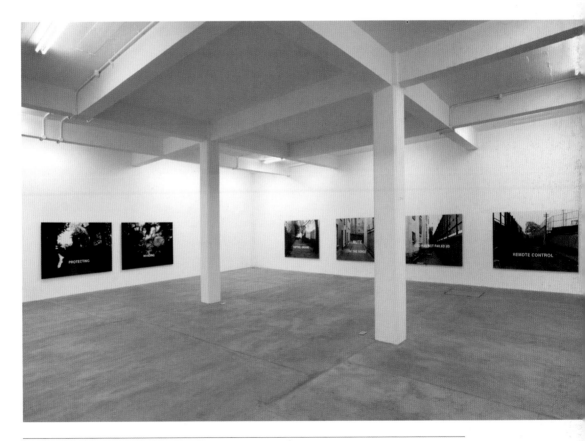

Willie Doherty: Photo/text/85/92 at Matt's Gallery, London, April–May 2012. Photograph FXP Photography, London, courtesy Willie Doherty and Matt's Gallery. www.mattsgallery.org.

Some of the most common problems around exhibiting are the result of a lack of shared understandings or misunderstandings between gallery and exhibitor, the stress which can be caused by this or by trying to do too much too quickly when there is a lack of clarity about the process of exhibition. The steepest learning curve is often for new exhibitors if their student experience has not prepared them for the tough business of professional practice.

So, before even starting to plan the exhibition itself it helps to be clear about:

* what a gallery will be looking for
* the artist's and the gallery's expectations
* understanding the different agendas of exhibitor and gallery staff
* the value of contracts
* expecting the unexpected to happen and finding ways to avoid stress

What a gallery is looking for

When approaching a gallery for an exhibition it is important to be aware that galleries differ greatly in their interests and do not necessarily share selection criteria. Looking at the gallery's financing and funding, position in the art world, programming, and personnel will help the artist determine what is likely to be important to a particular gallery. For example, some galleries will be more interested in being at the cutting edge of practice and others in showing work by acknowledged major artists.

1. **Work that fits the gallery's interests, policy, program.** So, for example, a gallery will only consider work which fits its particular interests or policy. It will also be looking at how a show might fit into and complement its program (usually planned between two and five years in advance) and want to avoid such complications as having two landscape photographers who work in the same way or in the same area show within the same year.

2. **A body of work which is themed, complete, consistent, fully realized, and ready or nearly ready for exhibition.** Essentially, the gallery will want to have a clear idea of an exhibition and confidence that the work will be completed in the time available so it should have been edited and be presented clearly with a title, captions, and rationale or artist's statement. There are occasional exceptions to this in that some curators like to play a strong part in shaping work to their interests and gallery space and so will consider work at a much earlier stage.

3. **A body of work that is appropriate to the gallery space and size** so that the curator can visualize it installed in the gallery

4. **Many galleries look for work that has a distinctive photographic style, subject matter, or approach** that can be identified with a particular photographer and means that there will be something new, remarkable, or unique about the exhibition.

5. **Work that presents a clear marketing opportunity** (e.g., it addresses a currently 'hot' topic or explores an entirely new area of technology) may well attract a gallery since considering how a show can be publicized and marketed will be important to the

gallery. A number of things make an exhibition easy to market—topical subject matter, a distinctive style or methodology, the artist's reputation. While this consideration should not influence the artist in making work it is useful to recognize that some galleries will respond to it.

6. **Good and consistent print quality is a baseline criteria,** i.e. poor-quality images will exclude the work from consideration.

7. **If the gallery is primarily a selling gallery it will choose work that it knows will interest its existing clientele.** It will also most probably be interested in considering a show which will expand that clientele or interest a new group of collectors or purchasers and an artist who brings a clientele with them will be well received.

8. **A gallery will take on new artists who fit with and complement their existing stable of artists.**

9. **Most established galleries will be looking for artists with a track record of showing work** who already have or have had some critical support.

10. **When looking for new young artists a gallery may well express initial interest then observe the artist and the work over a period of a few years,** include the work in a group show to see how it is received, and consider the direction the work will take in future to assess its sustainability over the long term before taking the artist on.

11. **Most galleries prefer artists who are professional in their approach, know how to present their work, understand the gallery system, are personable, speak well about their work and ideas, and will bring something to the gallery in terms of new ideas, critical support, audience, or sales.**

12. **Publicly funded and private galleries will usually have differing criteria for their selection.** A funded gallery may well show a wide range of work and only show an artist once in their career whereas privately owned galleries will often take on artists they expect to show at regular intervals throughout their career.

13. **Publicly funded and private galleries may also differ in their relationship to the artist.** Many privately owned galleries (often distinguishable because they are named after the owner) will be interested in artists whose work they very strongly believe in or can connect with on a personal level, can perhaps help shape, and with whom they can expect to have a close working relationship over many years. A curator in a publicly funded gallery may expect to keep more distance in the relationship.

What a gallery will expect from you

1. Clarity, considered ideas about your work and the way it should be presented and marketed combined with a willingness to negotiate over the way this is done.

2. Reliability in making arrangements and meeting deadlines.

3. An ability to work well with the gallery staff and respect their priorities and deadlines, not to be excessively demanding, not to pester the staff (with unnecessary information

and huge computer files, for example), or behave like a prima donna (emotionally, practically, or financially).

4. An ability to work quickly and to put in long hours if necessary may be an unacknowledged part of your contract.

5. That you show an appreciation of the gallery's support for your work and support the gallery's work in return by, for instance, recommending/introducing other artists to them, taking new exhibition proposals to them before approaching other galleries, and attending their exhibitions and events.

6. That you credit the gallery publicly and acknowledge their support as appropriate in published or broadcast material.

What you should expect from the gallery

1. A good understanding of your work matched with an ability to place it in the context of the art world.

2. Expertise in marketing, promoting, and/or selling the work.

3. Supportive curatorial input that may well develop, change, or expand your understanding of your own work and help shape the future direction of the work.

4. Clarity about your contract, what the gallery is and is not offering you, and what they expect from you.

5. Consultation, clarity, and negotiation about their schedules and plans and about what they expect from you throughout the exhibition period and afterward.

6. A working relationship and support beyond the period of an exhibition—continuing support for your work after the exhibition in terms of future sales, promotion, and exhibitions (by, for example, taking the work to major art fairs) although not all galleries will be able to offer this.

7. Not all galleries offer long-term support or aim to have good personal relationships with their artists but there should be some commitment to your development as an artist, thoughtfulness, and good advice about your future. It is worth asking for this if it is not offered.

The different agendas of exhibitor, gallery director, and curator

Photographers do need to realize that curators and gallery directors are not just sitting by the telephone waiting to hear from them. We have busy jobs with our own stresses and strains. In a typical work day I have to think about funding, problems with the building—toilets leaking, junkies, reports for the Arts Council, feedback to staff, and all the many other things I have to do, as well as the exhibition program.

Anne McNeill, Director Impressions Gallery

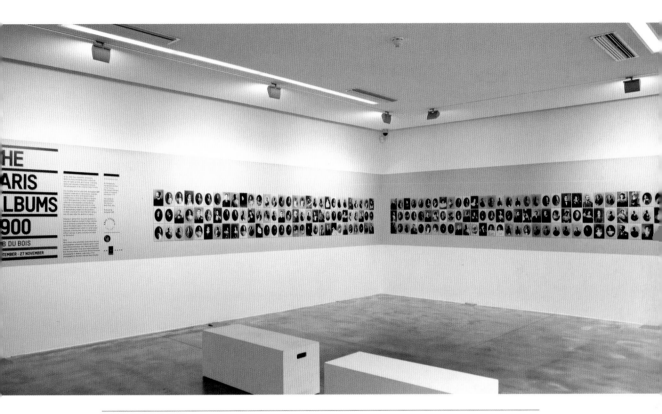

Installation photograph for *W.E.B. Du Bois: The Paris Albums 1900*, presented by Autograph ABP at Rivington Place, London, September 17—November 27, 2010. The exhibition featured over 200 unframed photographs mounted on aluminium, juxtaposed with text extracts in vinyl by W.E.B. Du Bois. Image courtesy Autograph ABP. www.autograph-abp.co.uk.

The curator is subject to numerous pressures, some of them welcome and some of them not recognized perhaps, to keep to safe zones of activity. The pressures include:

1. The desire to get along with the artist or artists.

2. The necessity to keep good relations with the artist's main dealer or dealers.

3. The necessity of maintaining collector contentment.

4. Taste expectations emanating from the trustees and director.

5. Taste expectations of other members of the curator's peer group.

Lawrence Alloway, Artforum (May 1975)

As a gallerist, if you take someone on, you have to believe in them very intensely. ... I think there has to be a personal relationship between the gallerist and the artist.

Rudolf Kicken, Founder and Co-Owner, Gallery Kicken, Berlin

Exhibiting should be an enjoyable process, but the relationship between exhibitor and gallery staff can be a delicate one and, for the exhibitor, working with a gallery can be a disappointing experience if the exhibitor does not recognize in good time that everyone involved in putting on an exhibition has a different timetable and set of priorities and that these may well conflict. If the exhibitor's previous experience has been of student exhibitions where everything has been done at the very last minute and the students create a close bond in the process, it may also be disconcerting to discover that gallery staff may keep a professional distance and insist on maintaining tight deadlines, even to the detriment of the work.

Understanding the different agendas of exhibitor and gallery staff makes it considerably easier to avoid problems and potential conflict.

The exhibitor has the priority of showing the photographic work in the best possible light. To do this, they will probably be prepared to drop most of their other work commitments, work very hard on the show and stay up all night to write captions or hang the show if necessary. The exhibition may well be the highlight of their year; it will probably be the main focus of their life for a short, intense period, and they may well feel emotional and anxious about it. They may also expect a level of emotional support that the gallery staff does not give them. However, the major part of the exhibitor's work ends on the night of the private view or artist's reception, after which they have less to do for the exhibition and may plan to relax for a few days or turn their attention to a new piece of work.

The gallery staff, on the other hand, has a completely different set of concerns. Their job is to keep a rolling program of exhibitions on track. Even if the current exhibition is a major part of their working week, they still have their daily duties to carry out, a busy telephone, and future exhibitions to prepare for.

The gallery director will be concerned with the overall financing and running of the gallery. They may spend a great deal of their time away from the gallery and looking after the gallery's interests elsewhere. Once the gallery program is decided, the gallery director's priority is to get the show installed, publicized, and open on time. Making sure that the gallery is cleared up after the private view or artist's reception, open on time the next morning, and planning to do the same for several other shows in the year can be as important as the quality of the work on show. This may well not be the most important show of the year, and they will almost certainly not stay up all night to help hang it. Unfortunately, keeping the cleaner happy may be just as important to them as keeping the artist happy.

The curator's priority is the overall show, but they may be working on other shows at the same time. They have to keep each on schedule and keep everyone working well. If the curator works freelance, keeping on good terms with the gallery, with whom they might expect to work again, could be more important than keeping on good terms with the exhibitor. If they are working freelance, their time is crucial; they cannot spend more hours on something than they have budgeted for or take time from other projects. An exhibitor who starts phoning them at midnight because of an emergency is not going to be popular. They may put up with dramas for the sake of the exhibition, but will think carefully about working with that person again.

These differences should not be a problem but can often become so when everyone is working under pressure and there is not enough time to keep channels of communication open. The

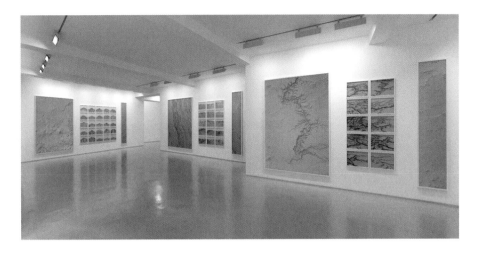

Dan Holdsworth *Transmission: New Remote Earth Views* at Brancolini Grimaldi, London April–May 2012. Image © Mike Bruce & courtesy Brancolini Grimaldi. www.brancolinigrimaldi.com.

ideal for the exhibitor is to plan well in advance, to make sure that they are clear about deadlines, about what is expected, and about who does what, so that, if misunderstandings do occur, there is time to sort them out. A good, clear contract should help to ensure that this happens.

Curiously, given that the relationship is one of mutual dependence, there is often a struggle for recognition and appreciation between artists and galleries. Artists frequently say, 'If it weren't for artists, there wouldn't be any galleries,' and gallery directors say, 'If it weren't for galleries, there wouldn't be any artists.' Both things are true of course, but in practice the artist who keeps to their agreed schedule and then thanks the gallery director for their hard work and support is much more likely to be invited to show again than the artist who has acted like a prima donna and then expects to be thanked by the gallery.

Contracts

The purpose of a contract is not to open a gateway to litigation but to establish a shared understanding of what has been agreed, what the timetable is, and who is responsible for which aspect of the exhibition.

An exhibition contract is there to protect both artist and gallery but in my view the artist is usually the more vulnerable person in this relationship and so should therefore be the one to make sure they have a contract. Artists should not be so grateful to be represented that they lose sight of the fact that art dealing is business, not philanthropy, and they should protect their interests when working with a gallery. Many artists get quite nervous when the word contract is mentioned in conjunction with the word exhibition. It may seem bureaucratic and something of a burden to add a layer of legal language to what is intended to be a creative and pleasurable event; however it is both possible and helpful to keep a contract simple.

Artists frequently fail to recognize that when they agree to show in a gallery, they are making a verbal contract. What can happen is that artist and the gallery director talk about the proposed exhibition in some detail, and then each goes away with a slightly different recollection of the agreement. Misunderstandings proliferate and later take time to sort out. The result can be a damaged relationship between the artist and gallery director.

A written contract is a safeguard against things going wrong. The most common problem in exhibiting is that misunderstandings occur around who is expected to do what, who makes which decisions and when deadlines are. A very basic contract negotiated carefully by the artist and gallery together should mean that this situation is avoided. If changes to the contract are to be made later in the process, they can be added in the form of a letter or document signed by both parties.

A contract does not need to be in complex legal language—the priority is that it should be absolutely clear and not open to misinterpretation and this usually means spelling the agreement out simply. A standard exhibition contract between a gallery and exhibitor should include the following information and be signed by both:

- the name and address of the gallery, and the name and address of the artist
- the date of the agreement
- the date of the exhibition
- the works to be exhibited
- the prices of the work and whether the price includes or excludes tax
- the amount of commission to be retained by the gallery
- who is responsible for arranging the publicity, sending out private view invitations, and how these and the costs of printing, postage, and other incidental costs are to be shared
- the arrangements regarding delivery and collection of the artworks
- who is responsible for insuring the artworks during transit and during the exhibition
- who is responsible for hanging the show
- the gallery opening hours and arrangements for invigilation or attendance of security personnel at the exhibition
- the date of the private view
- the arrangement for when and how the artist is to receive the proceeds of sale of his/her artworks and how the gallery will account to the artist
- that the artist retains copyright in all their work
- the return of unsold work
- any additional special terms and conditions as discussed and agreed to by the artist and gallery

Many galleries have a standard contract that they issue for each exhibition. It can take the form of a letter to the exhibitor. However, it should be read carefully rather than signed automatically. Exhibitors should feel free to ask for changes before signing the contract. It is quite easy for the administrator of an organization to send out a contract without checking or thinking through every aspect of it and for it to include errors.

At this stage it may not be possible to specify exactly which works have been selected for the exhibition, or the selection may change later. The contract shouldn't be delayed while the decision about which works will be shown is discussed but should go ahead and the contract should cover what has been agreed (for instance that the works will be between x and y in number and from a named series) and outline what has still to be agreed.

As part of the contractual agreement it is essential that both artist and gallery have a complete list of works held by the gallery at all times and that this is kept up to date. If the list has not been agreed by the time the contract has been drawn up, it can be written when a final selection is made and delivered to the gallery and can take the form of a delivery note. This has to be signed by a responsible member of the gallery staff (rather than a student intern, for example) and can then be attached to the contract.

In my view, it is the artist's responsibility to make sure that they always have a signed record of what work of theirs is being held by a gallery simply because they have more invested in the work than any gallery will. Keeping this up to date means making a new list every time the gallery sells, takes on, or gives back a work. It is not unusual for a gallery to lose work or close suddenly and when this happens the artists are often the last to find out. If the artist has an up-to-date record of the works the gallery have in hand, they are less likely to have to file a lawsuit to get their works returned.

Galleries sometimes hold works on consignment, whether or not they exhibit them. Sometimes they do this as a way of assessing the possible reception of an artist's work before committing to an exhibition. And, once again in this situation, as in any situation where a work is left with a gallery, a complete list of the works needs to be made and signed by both artist and gallerist.

Expecting the unexpected

When I was Director of the Tom Blau Gallery, I worked on an exhibition by the leading celebrity photographer Jason Bell. The exhibition was being used to raise awareness for a cancer relief charity, and it was decided to hold a pre-exhibition event in a fashionable Notting Hill venue, at which many of the celebrities would be present. This was to occur a few days before the exhibition opening at Tom Blau Gallery. The show consisted of some forty images, digitally printed by Epson UK, with a book produced by Dewi Lewis Publishers. The Notting Hill event was going well when I arrived, with many famous faces in attendance and a well-stocked cocktail bar proving hugely popular.

After a few hours I left to return home but sensed something was amiss when I received a telephone call from the PR agency the following morning. 'There might be a few images requiring reprinting. ...' It transpired that most of the prints had been removed from the walls by the partygoers. A panicked call to Guy Martin at Epson followed. Could he reprint the entire exhibition in time? Over that weekend Epson delivered batches of ten prints at a time. Meanwhile I was hanging empty frames in the hope that the prints would all arrive in time for the opening. Thanks to Epson's generous support the exhibition opening was a great success, and only a very few of us knew how close a call the whole thing was.

Keith Cavanagh, gallery director

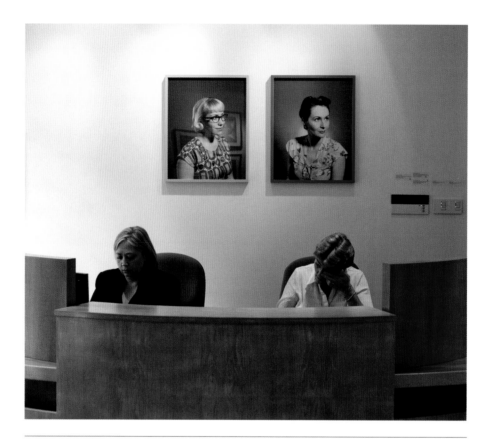

Portraits from the series *Retro Girls*, in *Fifties, Fashion and Emerging Feminism* curated by Lucy Day and Eliza Gluckman for Collyer Bristow Gallery. The gallery is on the ground floor of a law firm which has a series of curated exhibitions throughout the year, featuring photography amongst other art forms. 'I heard about the show about three weeks before it was due to start, saw how appropriate it was to my work, and contacted the curators, who managed to fit me in at the last minute.' Image © Carole Evans. www.caroleevans.co.uk.

It is useful to recognize in advance that unexpected things can and will go wrong during the exhibition process and prepare oneself for the fact that exhibiting can be stressful.

However careful and thorough one is in planning an exhibition there is a very strong likelihood that something unexpected will happen to delay things at some point—for example, it could be a piece of equipment failing, all the lights blowing, someone missing a deadline or falling ill, the work or a delivery being lost or the street outside being dug up just when you are expecting the press. Whatever it is it'll be something unpredictable. The only way to deal with it is by accepting that, however infuriating the event is, something was bound to go wrong somewhere along the line and knowing that, because you have allowed a little extra time in the timetable, you should be able to make sure the event won't impact on everything else.

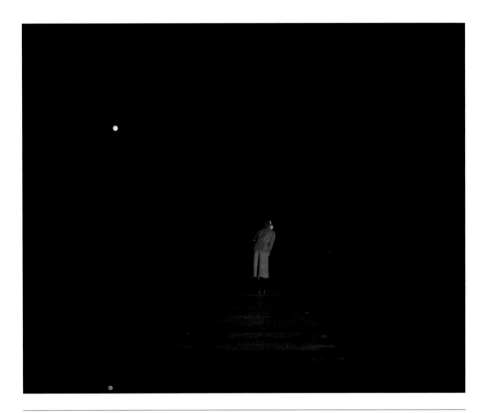

She Was Looking for Herself. 'I never really thought about an international career as a goal—but it came quite naturally after studying abroad—first in Amsterdam and then in Glasgow—where both art scenes are international. As a photo based artist I am dependent on my surroundings and locations, and through artist residencies I have been able to exhibit and work abroad for long periods.' Image © Astrid Kruse Jensen. www.astridkrusejensen.com.

Stress, on the other hand, is something which should be easier to prepare for. The pressure of exhibiting can be intense. It is stressful for many reasons. An irrevocably fixed deadline makes most people nervous. Most peoples' expectations are unrealistically high, and most exhibitions are one-off situations, and can be short on funds and time. Often the people involved are working together for the first time. There is not enough time to get to know each other, and the result is frequently communication problems with people working to different timetables and priorities, sometimes on different sites. Exhibitions inevitably bring with them small emergencies and unexpected problems and a broken piece of glass can become stressful if there is insufficient time to replace it.

No two people react to pressure in the same way. A group of students, when asked about how they reacted to exhibition stress, came up with the following list of the things they found they did with a deadline looming: panic disproportionately over small setbacks; decide to ignore the deadline; suddenly become indecisive; keep working at things which are in fact finished;

lose things; forget things; break things; get irritable; get muddled; get argumentative; lose their tempers over nothing; walk out; get a stomachache; feel ill in other ways; stop eating; eat too much; stop sleeping; sleep too much; start drinking too much; experience endless equipment and transport failures; start working on something minor and forget tomorrow's deadline; lose all sense of their normal routine; become very untidy.

There are a number of ways to prepare for the stress that an exhibition will inevitably cause:

- forward plan very thoroughly
- get as much done as early in the process as is possible (especially if you can get some large mundane tasks or small but crucial and difficult creative decisions out of the way)
- build a little extra time and some flexibility into the schedule
- expect the unexpected and for at least one small thing to go wrong for no apparent reason
- recognize your own stress points and behaviour so you see the danger signals early
- look after yourself very well indeed
- get support from friends and/or family
- be ready for other people to be stressed and behave uncharacteristically or unpredictably
- put aside a small personal contingency fund of your own which can be used for emergencies (hiring some help for a day when there is too much to be done; taking a taxi across town to save time) and for treats (like taking everyone out for a meal before or after the exhibition hang)

Good forward planning is the key to exhibiting success. If an exhibition is well planned, the exhibitor will know that he or she is on track and can work through the many tasks without feeling overwhelmed by them.

Small tasks have a way of turning into problems if left until the end of the exhibition process. Artists who fail to think about titles for their work or who should be invited to the opening are likely to find that they no longer have time or energy to do these things well when the time comes. Getting them done early on so that they're out of the way helps and may well ease the sense of overwhelming pressure an exhibition deadline can generate.

Allowing some flexibility in the timetable means that tasks that take longer than expected need not hold up the entire exhibition production. If the framed work arrives two days late but the gallery has built in an extra day or two into the hanging time, then it is not going to be a problem. If it arrives two days late and this has not been done, it may spell disaster.

Almost every exhibition I have worked on has had what I call my 'deliberate error.' This is a mistake so inexplicably stupid that it can only have been caused by a moment's inattention and is probably the result of stress. This has included miscaptioning images, misspelling names, or simply forgetting something important. For the same reason, every gallery I have worked in has at some point printed an invitation without one key piece of information—the gallery

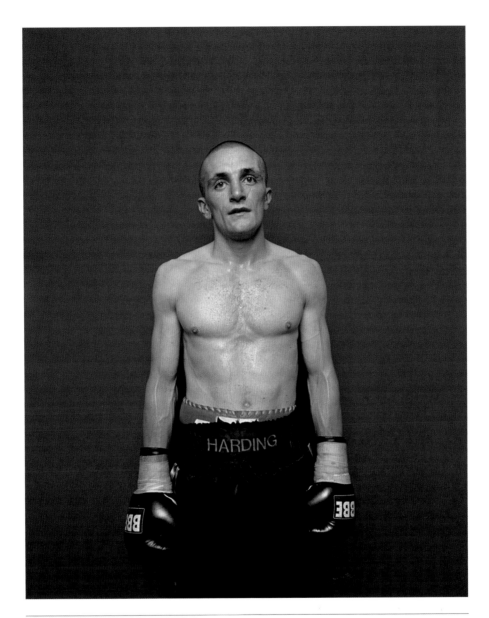

In this work I tried to show some of the extreme physical exhaustion that professional boxers experience after a fight and the state of internalised reflection that then occurs. Visually it has parallels with Christian iconography, and in mounting the work I considered pursuing this parallel with ornate frames to command reverence. I finally decided not to pursue this route but instead to show a triptych that would reference this parallel without being too overt. Still, however, I discovered that the use of a heavy plain frame, when compared with a frameless mount such as Diabond, gave them a sense of claustrophobic tension that seemed to add to the images. The boxers appeared trapped within the boundaries of the frame, as if too exhausted to escape. In this way the frame also referenced the ring in which they'd just completed their trial of endurance. Image © James Tye. www.Jamestye.com.

name, the title of the show, or the date of the private view—despite having a template that they use for every invitation. If you expect the unexpected and expect people to do something out of character, then hopefully it will not be an impossible problem when it happens. Systems of double- or triple-checking and making certain, for instance, that all text is proofread by someone who has not seen the text before will do a great deal to ensure that one person's moment of inattention is caught by someone else.

Looking after yourself means eating and sleeping well, keeping to a normal routine as far as possible, and not putting your whole life on hold while you work on an exhibition. It means seeing friends and talking about things other than your exhibition. It means arranging treats if you know that will help.

Support can be anything you can arrange that will help you through difficult moments. It will probably be temporary and short term. It may mean just having good friends to e-mail or talk to about the exhibition process. Artists know the sorts of stresses that come up when working on exhibitions and can share experiences, so an informal arrangement to see one another through can sometimes help. It may mean hiring someone to help you frame your work or hang the show. It might mean joining a creative writing group to help you sort out the tangles in writing an artist's statement.

It is also worth being aware, right from the start that curators, gallery directors and assistants, and artists and photographers can all behave in ways that are completely out of character during the process of exhibiting. Everyone is under pressure and everyone will have different priorities and deadlines. Personal clashes can be the most difficult part of an exhibition. One of the ways to prevent this from happening is to make sure that everyone's role is clear and timetabled in advance.

So the two things to remember when you want to avoid stress are:

- first, not to plan a schedule so tightly that when the unexpected happens everything falls apart

- second, to take very good care of yourself throughout the process

Forward Planning: Two Research

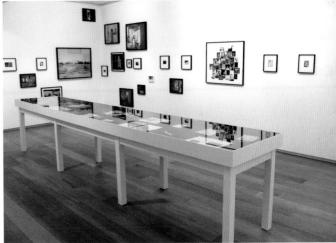

The Photographers' Gallery, London, 2009. Installation image from Jim Goldberg, *Open See*. Photo by Jason Welling.

So you have your gallery booked and the work selected. The exhibition is several months away. Time to relax, right? Wrong. All exhibitions need good planning, the earlier and more thorough the better. The very early months of an exhibition schedule are the best time to sort out the administration and production of the exhibition. This is the work that, done very thoroughly and done early, leaves the curator and exhibitor free to concentrate on the creative side of exhibiting. Good forward planning cuts the stress load of an exhibition immeasurably and whether you are working with a gallery, by yourself, or as part of a group getting as much done as early as you can will be a great boost to your confidence and your ability to deal the process.

Forward planning means working on:

1. timetabling

2. budgeting

3. fund-raising

4. arranging transportation (if necessary)

5. arranging insurance

6. planning accompanying events, educational programs, or artists' talks

7. thinking about preparing the venue

8. planning the private view (see also Chapter 20)

9. organizing gallery attendants, security personnel, or invigilators during opening times

10. planning the hanging and clean up afterward

11. writing all the exhibition texts including captions and titles (see Chapter 12)

12. organizing publicity and invitations (see Chapter 13)

13. planning exhibition design and presentation (see Chapters 14–16)

The timetable

(see the checklist in the Appendix for a draft timetable)

Every exhibition has its own timetable, which needs to be drawn up as early as possible and to be both realistic and slightly flexible. One of the main aims of a timetable is to make sure that all the many tasks, usually involving a number of different people or services, have been scheduled and that responsibility for each task has been allocated. It should be possible to use the timetable as a checklist to ensure that everything is moving along, everyone involved is on target, and nothing has been forgotten.

The main difficulty inherent in timetabling is that exhibition tasks usually cannot be undertaken in a particularly logical or chronological order. The order in which things need to be done is often dictated by fixed external factors, like venue booking or publication deadlines, which mean that, for all sorts of practical reasons, decisions have to be made

regardless of the fact that the exhibitor may not be ready to make them. For instance, press prints may have to be chosen before the final selection of images for the exhibition is complete, or an exhibition venue may have to be booked before the number of exhibitors has been confirmed and the organizers know how much space is needed. This can be stressful and it can be infuriating but, unfortunately, most exhibition timetables work in this way, and it is crucial to keep to the timetable or the whole process may come to a halt.

In approximate chronological order the tasks that need to be scheduled include:

- the production of final copy for printed and press materials (website, press release, advertisements and listings information, press prints, and invitations)
- dates booked for copy to go to printer, with turnaround time for proofreading and delivery (invitation, catalogue, printed brochure)
- the printing of photographs
- the planning and booking of talks and educational events
- arranging insurance
- arranging transportation
- text production (artist's statement, captions, price lists, supplementary texts)
- the matting and framing of the photographs
- private view preparation
- the mail out of invitations and press information
- arranging security personnel, gallery attendants, or invigilators
- the reminder to press and colleagues of the opening date
- the preparation of the gallery for the new show and decorating if necessary
- hanging the work
- overseeing the private view or artist's reception and clearing up afterward
- documenting the work
- taking down the exhibition and cleaning or decorating the gallery

There is an art to drawing up a good and useful timetable. A timetable, if it is to work well, must be detailed. Most galleries do this well because they do it all the time, their systems become routine, and they work with the same suppliers for each exhibition so they can predict turnaround times. It is much harder for a small organization or individual to draw up an accurate timetable, and it is worth putting a lot of time, effort, and research into doing it and liaising well in advance with all the other people and organizations involved (press, printers, framers, transporters, and so on) to make sure that it is going to be accurate. This means, for example, not simply asking a framer how long it will take to frame a certain number of prints, but also when they can fit it into their schedule, how busy they are, and whether they can still complete the framing if it comes in late or, perhaps, if just one or two prints arrive at the last minute. Every eventuality needs to be thought through.

Some aspects of a timetable, like press deadlines, will be absolutely inflexible, whereas others, like writing exhibition captions, can usually be allowed to slip slightly. However, most items in a timetable depend on other tasks so if one deadline slips, others follow. For example, writing captions may sound relatively trivial in the grand scheme of the exhibition, but if the captions are not ready quite early on when press prints are sent out, it can cause major delays and missed opportunities for publicity. Or if the final selection of work is not done on time, then press prints cannot be sent out, frames cannot be made, or price lists drawn up. If a press print is sent out despite this, it may turn out to be an image that is not in the final exhibition; this will undoubtedly result in complaints from people who have come to the exhibition because they saw and liked that particular image in their listings magazine. Or you may feel forced to include an image that you wouldn't otherwise choose.

It is a good idea to build a little extra time into the timetable for emergencies and missed deadlines. However, it is a mistake to think that deadlines can be set unrealistically early. If too much time is built into the timetable, what tends to happen is that everyone involved recognizes that this has been done and they start to ignore the timetable and to work instead to a set of personal 'real' deadlines. Usually the result is chaos. So the answer is to allow an extra day here and there between tasks so that if, for example, a van breaks down and frames are delivered a day late there is a spare day available between the delivery and the start of framing the work.

Although a timetable can be amended during the process of organizing an exhibition, this should not keep happening. When it does happen, it is crucial that the revised schedule be clearly dated or numbered so that everyone involved continues to work to the same timetable rather than various different, earlier versions, as may happen if timetables are undated or unnumbered and get muddled.

Drawing up a timetable means working backward from the date of the exhibition opening. It's important to include at least one free, unscheduled day before the opening so that staff and artist can relax before the opening party and be ready to promote the work rather than surreptitiously trying to make sure the captions are in the right place or being too tired to enjoy the event. Large public galleries often have the exhibition hung a week before it opens to the public; smaller galleries are usually closed for a much shorter period between shows.

Drawing up a timetable involves making an estimate of how long each task will take. Specialist providers, such as framers and printers, are usually precise about such things because their profits depend on it. Artists, colleagues, and gallery staff tend not to be precise and to underestimate how long each task takes, so it is worth making generous estimates for their input. Most people, for example, when asked how long it takes to produce a press release, might say an hour or two. In fact a day is probably a much more realistic estimate, and it can only be done when all the decisions about dates, opening hours, titles, educational events, sponsors, and so on have been finalized. Estimating time also involves building in time for delays, deliveries, and reviewing and redoing work as necessary. Anything printed or computer generated has to be checked for errors and reworked if needed. Printers may accidentally lose a crucial logo on the invitation and need to reprint the entire run in order to include it. Framers have been known to produce matted prints using the wrong color card. Staff time cannot be double booked to simultaneously proofread text and oversee framing.

Estimating times can also be difficult when the creative work involved in an exhibition is concerned. Most creative processes defy rigid timetabling yet have to be scheduled for an exhibition. It may take one artist an hour to make a final selection of his or her work and another artist several days. Some people can produce good text at speed and under pressure, and many more cannot. Many people postpone some of the apparently simple tasks, like providing captions, until the last minute. In fact, it is a very good idea to schedule these sorts of tasks early, either so that they are done and can be forgotten about or so that they can be considered, reconsidered, and rethought as many times as it takes without affecting either tempers or the schedule.

Actually hanging the exhibition is the task that most people tend to underestimate by a factor of about three. It is a process that is almost impossible to hurry, so it is worth allowing an extra day for it so that, for example, if an exhibition is due to open on a Thursday evening, the work is hung by the Tuesday evening. This allows Wednesday and Thursday for the staff to clean up, relax, catch up on other work, sort out the private view arrangements and make any

[In] Appropriate Appropriation, at the Truman Brewery, London E1. Every aspect of an exhibition needs forward planning—text has to be written well in advance if it is to be produced as vinyl lettering for the wall. Image © Georgina McNamara.

last-minute adjustments. It gives them time to call reviewers and say how good the show looks and for reviewers to visit before the show opens.

Publicity work must be done in stages, and publication deadlines have to be established as part of the process of timetabling. Glossy magazines have deadlines of anywhere between three and six months ahead of their publication date. Specialist photographic magazines may only be published a few times a year; their deadlines will also be well in advance of the publication date. Crucially, the publication date for a photographic magazine may not coincide with your exhibition, so it is important to check precise dates and make sure that the deadline is relevant to the exhibition date or information may be published after the exhibition has closed.

If a magazine comes out rarely but is interested in a particular exhibitor or exhibition, it is well worth inviting the magazine to preview the work. Listings and 'what's on' magazines usually work to deadlines of about a month.

A printed (or PDF/e-mail) press release should be written and sent out as early as possible, but invitations should not be sent out early or people will forget—between two and three weeks in advance is usual. Telephone calls or e-mailed invitations to press or colleagues are important reminders in the last week before the exhibition opens.

Framing should not be scheduled in too tightly. A little flexibility is needed here. When the gallery frames its own exhibitions, time should be allowed for the inevitable breakages and discovery of missing clips and mirror plates as well as for cleaning glass and frames.

Both the show and the private view should be photographed as a record. The documentation of the exhibition should be booked into the timetable and made as soon as the exhibition is hung, just in case work gets damaged later.

The budget

(see the checklist in the Appendix for a draft budget)

It is essential to keep a budget for even the smallest exhibition. Even if the budget is tiny, keeping a record of income and expenditure is good practice. It will also be useful information when planning future exhibitions because you can estimate costings based on the figures you have and base funding applications on your previous experience. A budget can be kept very simply in an account book or computer program. All receipts should be kept, numbered, and related to income and expenditure columns.

Keeping a budget is a two-stage process. The first stage is to draw up an estimated income and expenditure budget before the exhibition starts. This means asking for estimated prices for each contracted item, from framing to transportation. It also means costing in time, materials, publicity, and administrative tasks in advance of the work being done. The ability to draw up accurate estimates is a skill that can be learned over time and when estimating for the first time it is worth being slightly over generous rather than trying to cut costs too hard (on the basis that things tend to come in at slightly over the estimate rather than under). The second stage is to draw up an actual accounting of costs when the final bills have been received. Comparison

of the estimated and actual budgets is the basis on which anyone can learn to make more accurate estimates for future exhibitions.

Successful fund-raising depends on being able to present a detailed and realistic estimated budget to a potential funder. For most funders, an important priority will be to ensure that their money will be wisely spent, and they are likely to ask sharp and detailed questions about a budget. This should not be difficult to respond to if each figure has been arrived at by a demonstrably realistic method, either with written quotes from suppliers or by estimates drawn from previous exhibition budgets. For example, if the exhibition organizers need help to install the exhibition, an estimate of the costs will be determined by the number of hours it will take. This can be derived from looking at how many people installed a previous exhibition, how long it took, and how the previous exhibition compares with the current project in scale.

It is also important to include in-kind help in the budget—for instance, when someone donates the use of a gallery or curatorial assistance instead of charging for them. It is important to include this for two reasons. First, it would give a false picture of the budget if an obvious item like a hire fee is left out. Second, it makes a donation very visible. Potential funders are always encouraged to give money when they see that another individual or organization has thought this project worthy of support.

In-kind help should appear as an equal amount in both columns of the accounts—as income donated and as expenditure—and the two amounts must balance out. For example, in 1998 the Royal College of Art in London supported a weekend conference I organized by lending us their lecture hall and adjacent spaces. The hire fee for this would have been £3,500, and it appeared in the accounts both as an expenditure of £3,500 on venue hire and under income as a donation of £3,500.

As part of budgeting it is also essential to keep a record of the time spent working on an exhibition, especially when no one is being paid, on the basis that time is money. This can also be entered as in-kind help in both columns of the budget. Having realistic and accurate figures from previous exhibitions is particularly useful when estimating costs for an exhibition when people will be paid for their help—whether it be as a freelance curator or in helping hang.

It is also good practice to include a contingency amount of 5 or 10 percent of the total budget to cover unexpected costs and emergencies. Emergencies are likely to happen—no one can predict costs absolutely precisely, even if every item was carefully estimated in advance.

For photographers who need to keep their costs down, drawing up a budget can be painful because standards need to be professional but professional exhibition production can be expensive. So where can you save money without compromising on quality? Consider these possibilities:

- If you use one printing or framing firm regularly, they may well offer a discount for a bulk order in return for a credit (in the exhibition or on publicity material) for the exhibition prints or frames.
- The Internet has become a good source for economical frames and supplies.

- You can learn to cut your own mats for smaller works (but will need to buy extra card in case you make mistakes).

- Prices to mount and frame work vary more than almost any other item, so thoroughly researching what is available well in advance may result in reasonably priced options.

- If you have a good home printer, captions and wall texts can be printed, mounted, and cut by hand.

- Visitors can be asked (politely, by leaving a bowl marked 'donations' rather than by bar staff) to contribute to the cost of drinks at the opening or private view, and you need not produce food or nibbles.

- An exchange of an amount of time (for tasks such as hanging, working at the bar, and being present at or invigilating the exhibition) can keep down staff costs.

Fund-raising and sponsorship

Finding funds and sponsorship for exhibitions is time consuming and is the sort of task many artists dislike intensely. It is also a slow process that needs to start well in advance of an exhibition. It necessitates having concrete information about the exhibition—like an exhibition title, a booked gallery, and the number and names of exhibitors—to give the potential sponsor so is a good reason to get details agreed early. And, of course, it is not always possible to find financial support. Or sometimes people who offer support want too much in return—for example, the regular use of the gallery space to entertain their clients in return for a contribution to the private view budget. This can cost the gallery a great deal in time spent attending these events and clearing up afterward and may put fragile work at unnecessary risk so offers of support do need careful consideration.

However, it is well worth exploring options in this area because one of the ways in which this sort of support is invaluable is in creating a firm base of support for a gallery and introducing new audiences to the work.

The sorts of financial support you may achieve include:

- drinks or food for the opening night (supplied by firms who want to advertise their product or to introduce it to a new market)

- photographic printing (by printers who will give a discount in return for advertising)

- printing, of invitations and catalogues (by printers who are using down-time on their equipment and hope to gain a market in specialty printing for artists)

- support for exhibitions on particular subjects such as poverty or homelessness (from related organizations and charities who will support a project that raises the profile of their charity)

- support in kind (by local firms such as caterers, florists, or decorators in return for advertising by word of mouth or in a gallery leaflet)

In return, firms usually want the name of their product prominently displayed and their logo on all publicity material. A 'thank you' can be included in text in the gallery itself.

Just as important is a real 'thank you' made in person by phone or by letter. Sponsors should always be invited to the opening party. If they do not come, it is well worth phoning them the next day to give them an informal report back. This is a way of ensuring their continuous support. Many commercial organizations enjoy supporting the arts because they find them glamorous, and inviting the directors or other personnel to occasional events or an informal lunch, keeping them informed and in touch with ongoing developments, is a way of keeping their involvement and interest. Never think of sponsorship as being a one-off, your aim is to keep the sponsor involved and supporting you, your group, or your gallery for the long term.

Many artists hope to avoid having to learn how to get sponsorship, but it is a skill that can be learned and gets easier over time. Good fund-raising is done when everyone in an organization is aware of the need for it and what funds are being sought rather than when it becomes the remit of one person alone. This is because the initial fund-raising contact or opportunity is likely to come through previous contacts, chance, word of mouth, or casual conversation rather than by

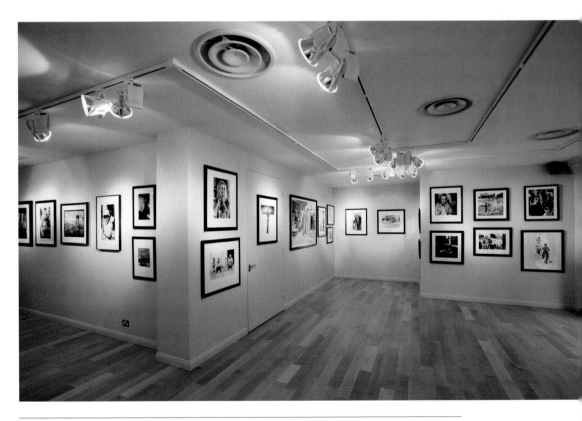

Installation view of Terry O'Neill *Fifty Years at the Top* at Chris Beetles Fine Photographs, Piccadilly, London. Image courtesy Chris Beetles Gallery. www.chrisbeetlesfinephotographs.com.

cold calling. A gallery that is well thought of in its local community is likely to find more financial help through this sort of connection than is one that keeps itself apart from that community.

Cold calling to ask for sponsorship takes nerve. If you don't know who to speak to, phone first and get the name of the person who handles charitable applications. Before you phone, write out your blurb or pitch. Be direct, precise, and brief. Have amounts, dates, and numbers ready. For example, if you are looking for drinks sponsorship for the opening night, you need to be able to give the date, the approximate number of people who will attend (based on previous figures or knowledge of who has been mailed), and how much you are looking for. With cold calling like this you have about thirty seconds to make your pitch. If this makes you nervous, then practice on friends first! It gets easier each time.

Transportation and insurance

Transportation needs to be planned well in advance, particularly if distance is involved or if the work is too large for the use of the exhibitor's own vehicle.

If the works are small and can be framed in the gallery rather than the studio, it is worth considering transporting the work unframed rather than risking damaging both frames and images in transit.

Specialty transportation firms for the arts are much more reliable and experienced than firms that specialize in domestic or commercial moves, although they also tend to be more expensive. However, it often worthwhile to use a firm that understands the careful handling of artwork.

Works can be packed using bubble wrap. Corners should be additionally protected by padded or solid corners. These can be bought from framers or be homemade by using corrugated cardboard or large padded envelopes. Mirror plates should be removed before packing the images because the plates may snag against the work, prevent the frame from resting flush on the floor of the van, or tear packaging materials. The plates and screws can be put in an envelope and taped to the back of the frame.

If a set of framed images is to be moved, they should be packed in pairs face to face. A large number of works in frames should not be packed flat on top of each other, as the weight can damage the work at the bottom. Framed images should be stacked flat. Old blankets or heavy-duty cardboard should be used to cover the floor of the van or car. This will absorb vibration and protect the frames against scratches caused by metal projections. You must make sure you have a detailed list of what is being moved and that it is checked both when it leaves your space and when it arrives in the gallery.

Insurance

Insurance in the arts can be a problem because insurers, and in particular domestic insurers, are unaccustomed to insuring or valuing artworks. Reputable arts insurers should be used wherever possible.

Most galleries have their own insurance that will cover artwork while on the premises. However, while theft is relatively straightforward to prove, artwork that has been damaged while in the gallery is often more problematic. It is worth drawing up a delivery note, which the gallery signs when receiving work, to make sure that the work is seen to have been delivered in its entirety and in good condition. This should be checked by both artist and gallery together. This may seem unnecessarily bureaucratic, but it safeguards both artist and gallery.

A gallery's insurance will not necessarily cover work being transported to or from the gallery. Specialty art movers will insure the work while it is in transit and make sure that they pack and handle the work appropriately. Commercial firms, however, may well take on moving work and not treat the work with appropriate care because they are not used to moving artwork. They may then refuse to pay for damage on the grounds, for example, that the work was inadequately packed. Although photographing work as it is being packed will help it is difficult to prove that work has been properly packed and difficult to put pressure on the insurers if the insurance was taken out to cover a single journey.

Exhibiting work in nongallery spaces is a riskier proposition than showing in a gallery, so the costs for insuring a building for a one-off exhibition may be prohibitively high. The work is likely to be more at risk from vandalism and opportunistic burglars than from art thieves. In fact, artworks are sometimes stolen by burglars who really only wanted to steal equipment but the art gets lifted too because it is in the equipment—for example, an irreplaceable CD that is in a CD player. Artists showing in a gallery that seems at risk do well to recognize that equipment can be replaced but work lost is often irreplaceable—and so they should take

A corner of the gallery is used for exhibition catalogues and to store portfolios accessibly. Image courtesy Chris Beetles Gallery. www.chrisbeetlesfinephotographs.com.

appropriate steps. For instance, work can be removed from computers and projectors when the gallery is locked up at night. Then if the equipment is stolen, at least the art is safe.

It is probably also worth removing price lists at night if this is possible. A colleague of mine packed up all her framed work after an exhibition in which she sold nothing, only to find that the space was burgled over a holiday weekend. Every piece of artwork was taken. At first she was surprised but then remembered that the back of every frame had the price marked on it and assumed that the burglars (who were undoubtedly opportunistic rather than art thieves) thought they could sell either the frames or the work. In fact, it is unlikely that they could have sold the signed work publicly and the frames were worth only a fraction of the value marked on the back. Nonetheless she lost a year's work simply because of the prices marked on the back of the work.

It can also be difficult to reclaim the full value of an artwork that is damaged or stolen while in a gallery. Insurers are unlikely to be sympathetic to a claim of rarity for a photograph that can, hypothetically, be reproduced an infinite number of times.

Planning accompanying events, educational programs, or artists' talks

Educational events can range from the major programmes run by the larger institutions to a single artist's talk given in a smaller gallery but, even for the smallest and most informal of exhibitions, an artist's talk is always a good idea.

An educational event can be a condition of funding or sponsorship and will be helpful when talking to a potential funder. It can also be a selling opportunity since buyers often like to meet the artist and get the back story on the work and may initially do this by attending an event rather than asking to meet the artist before they have made up their mind about buying. Gallery visitors usually appreciate the chance to meet the artist and hear the work discussed. For the artist it is a good opportunity to present their work in some depth and, hopefully, receive useful feedback. It should be more personally rewarding than discussion at the private view.

Whether it's a major programme or a single small event this is best planned and booked early so that it can appear on every piece of publicity the gallery distributes; is mentioned in broadcast reviews and the speaker has a chance to prepare slowly. It may also mean booking, hiring, or borrowing equipment or chairs and providing drinks and all of these things need to be done well in advance. All of these things need to be budgeted and timetabled.

Preparing the venue

At this early stage this only includes checking the state of the gallery and looking at what items need time and attention and what the budget implications might be. It means

checking the state of the walls and floor—the condition of the walls is particularly crucial to the hang (Will the walls need filling or repainting? Does the exhibition design dictate repainting one wall a signature colour? Will the condition of the walls necessitate special equipment for the hang or even that they are replastered); the gallery lights and furniture (are repairs and replacements necessary?) will chairs or tables need to be borrowed or hired and windows cleaned? Does the gallery toolkit need replenishing? All these things need costing and timetabling—especially painting the gallery since work cannot be hung till the paint is dry.

Planning the private view

The most important thing about the private view at this stage is that a date should be firmly fixed months before the event. This gives both artist and gallery time to invite people personally and means that the date can be included in all publicity material. Costings will include extra staff (bar and door); refreshments; hire of glasses if necessary and possibly flowers or an extra visit by a cleaner or washer-up.

Many galleries avoid having their private view on a Monday or Friday and most stick to a regular day in the week so it is well worth checking around well in advance to make sure that the private view is not going to fall on the same day as competing private views. Sunday afternoons are often popular times for studio shows and galleries in areas which do not close down at the weekend.

Organizing gallery attendants, security personnel, or invigilators during opening times

Invigilation is an important aspect of any show and one that is all too often neglected by exhibitors in nongallery spaces. It is important not simply as a security measure but because the invigilator is the interface between the exhibitors and their audience and should be welcoming, informed, and helpful.

Most galleries either ask their staff to spend time invigilating exhibitions or have a regular staff to do so. It is important that this staff should be involved in the gallery and interested in and able to discuss the work being exhibited. Major galleries will often take on art students and recent graduates and train them thoroughly for exactly this reason. For the exhibitor using a nongallery space being realistic about the invigilation is crucial and a realistic discussion about this should be held very early in the process to determine how to organize it. It is worth budgeting for invigilation if this is going to ensure that the gallery is open on time and welcomes visitors.

Planning the hang and the clean up afterward

At the early stage of the exhibition planning process it is important to cost and timetable the hang so, even though the presentation of the work is unlikely to have been finalized, an estimate will be needed. The main issue is whether the hang will need more time, more people or specialist equipment. Making sure the gallery is clean and ready for the opening night may be the work of the hanging team, the gallery staff, or a cleaner but it needs to be timetabled and budgeted. As we see from the account later in this chapter, everything may change during the process of the hang, but the crucial early stage is to make sure that this will be possible and the artist and curator will be supported.

Face of Fashion at the National Portrait Gallery: putting Mario Sorrenti's photographs on the floor to plan the hang. Image © Susan Bright.

> *Hanging 'Face of Fashion' was challenging. All the photographers came in to do the hang with me and it was a highly collaborative process. Working with Mario Sorrenti was both a privilege and a learning curve as working directly with artists should be but sadly isn't always.*
>
> *Mario was nervous about the hang and it's easy to understand why. There were twenty-five pictures of varying sizes which needed to go on one wall. He is not experienced at*

hanging in a gallery as his work is most commonly disseminated through the printed page. There were also a lot of people present (gallery staff and art handlers) which can be off putting when you need to quietly work your way through something.

Previously, Mario and I had worked out a plan over many e-mails and pdfs and so we knew the pictures fitted on the wall! But of course when you get into the physical space it's often very different. You need a large picture to have impact and the corners (which were quite tight in actuality) didn't really come across as such in the plan so we had to work around that. Also he was opposite Paolo Roversi whose works were very small. We had to make sure that Mario's images didn't overpower Paolo's more gentle Polaroids.

We had a few very difficult hours propping up the pictures where they would have to be double hung but it just wasn't coming together. Eventually Mario said 'lets put everything on the floor' that way we could all look at it as if it was on one flat surface. This was much easier for Mario who not only works primarily for magazines but has always produced collaged diaries so in a way it was replicating those. We got ladders

Installation photograph of works by Mario Sorrenti included in *Face of Fashion* at the National Portrait Gallery, London. Photograph by Prudence Cuming Associates Ltd.

so that we could see from above how it was shaping up. Once this decision was made the actual placing was quite quick. We measured everything out on the floor and then it could just slide up the wall. I say 'just' but it was a very difficult hang and the art handlers showed enormous skill and patience.

The captions then became an issue. If they were scattered around the wall under each picture it would look messy, so we had to very carefully work out a good sight line for them (not too high as to exclude children and people in wheelchairs and not too low). We spent a lot of time on this. One of the most common complaints that museums and galleries get is regarding captions so you have to treat them with as much care and attention as the pictures themselves.

The Head of Exhibitions was very helpful with the captions and eventually—three days later the wall was finished. Both Mario and I were sent home on the final decision of the placing of the captions as we had such terrible colds! The end result was beautiful and the highlight of the show for me.

Susan Bright

The main aims are to cost and timetable every aspect of an upcoming exhibition, to identify those areas of the process that will need further research, work, or funding and to make sure that everyone involved is aware of their role and what the plan is. Doing this will, however, start to put constraints on the plan so it is important to be realistic because changes may cause problems further down the line. So, for example, if an exhibitor initially decides to present their work cheaply and informally by pasting hundreds of small images directly onto the wall the budget will reflect that and may make it necessary to raise additional funding if the exhibitor subsequently decides that they want the most expensive of presentational methods. Timetabling, budgeting, and creative decision making are interdependent and starting to plan as early as is possible helps make the exhibiting dream real and realistic.

CHAPTER 11

Texts: One—Personal

Visitors studying the work of Hans van den Boogaard in the exhibition *Collection Vrolik* at Foam in the Netherlands. Image © Karin Bareman.

Even when photographs are not provided with accompanying text (sometimes on the gallery wall or the odd advertisement), the viewer brings experiences and beliefs with them; we fit the images into narrative contexts.

Steve Edwards

In the 1980s, photo exhibitions were text-intensive as a reaction against the formalist aesthetics of the previous era where any contextualization or captioning was excoriated. But the pendulum swung again, and today text is usually shunned in the gallery space and banished to the artist's statement available at the gallery desk or as a handout for visitors. Photographers can be creative at supplementing their images by using sound, narrative forms, or producing their own gallery guide, or brochure. But it's not seen as acceptable at the present time to 'force' visitors to read texts if they do not wish to.

Deborah Bright

One way to envisage the difference between 'art' and 'documentary' in photography turns on this relation to language and narrative. In the main, documentary is a closed form, designed to produce preferred interpretations. As such, images are usually combined with some form of anchoring text that steers the viewer/reader in a particular direction. Photographic art, in contrast, typically abjures words, or employs elliptical text, in order to leave the image open to associations and interpretations. For art, vagueness or ambiguity are often the preferred modes.

Steve Edwards

Seating also disappeared from museum galleries but has reappeared in the nineties. It is arranged so that its focus is not the art. A catalogue and other, varied reading materials are placed beside, on or in front of the usually hard chairs or benches. The pleasure of sitting and looking at art has been replaced by the task of reading about it. The work ethic prevails.

Reesa Greenberg, art historian

Think for a moment about your reaction to the text in an exhibition. Do you read text first or last? Do you feel unable to look at the exhibition until you have read all the accompanying texts? Do you look at an image and then at the caption, or vice versa? How different would the exhibition experience be if no text were provided?

In his essay *Rhetoric of the Image*, Roland Barthes (1977) asked us to look at the interdependence of text and image and the way that the 'linguistic message is indeed present in every image: as title, caption, accompanying press article, film dialogue, comic strip balloon.'

In the gallery the danger is that the text will become more important than the image. There are many possible reasons for this. We live, we are told, in a visual world. Surrounded by images, we have a sophisticated understanding of them.

While this may be true of images from television, advertising, and journalism, it is less true in the gallery context. In fact, many of us experience an uneasy shift from our daily experience

of being bombarded by photographs that carry an obvious message ('buy this' or 'feel this') to the more complex experience of standing in front of a photograph in a gallery where we are being asked to look, to feel, to contemplate possible meanings or perhaps ask questions of the image. We don't always give an image the time it needs. In a gallery an audience can be tense and wary, uncertain of their place there and unsure of their reading of the images. As a result, an audience can rely too heavily on the explanation provided by the exhibition text instead of looking at the images for themselves. Observe the way an audience clusters around a text panel rather than in front of an image and you'll see what I mean.

For both curators and photographers, an important objective is to get the viewer to spend time with the image and to look thoroughly. As Simon Norfolk says (in an interview with the author for the *Oral History of British Photography*, 2003), 'I aim to get people to look at my images for more than the usual four seconds.' Every exhibition will have a different need for, or relationship with, text but to foreground image over text it helps if the text is short, unobtrusive, and as clear and straightforward as possible. Removing text from the exhibition itself and placing it on the gallery desk, as a handout, or creating a separate reading area can be a way of making sure it does not compete with the photographs for the attention of the audience.

In the past, many photographers insisted that their work spoke for itself and so provided little explanation. Today we frequently have the opposite problem and the work may have been interpreted for us before we see it. This should never be allowed to happen—the purpose of any text should only be to give information and provide ways into understanding the work.

Wall text for Paul Hill's exhibition *White Peak Dark Peak* at Eleven Gallery, London. Image © Maria Falconer.

So the use of text is a subtle and crucial part of an exhibition. On a practical level, writing text for an exhibition is one of the tasks that is worth doing early in the planning process rather than, as often happens, leaving it until the last possible moment and producing it under pressure. Writing about an exhibition before the exhibition has been designed is a useful exercise, which should clarify issues and ideas about the work for both artist and gallery; and doing this can make it easier to find the best way to present the work. A good text acts to support an exhibition, and a text produced in the early stages of an exhibition helps ensure that everyone involved can talk about the exhibition in a coherent and informed way.

Exhibition texts should always be as short as possible. As critic Lucy R. Lippard famously said, 'I'd rather not read standing up!' Most people can comfortably stand and read a panel of text of between fifty and one hundred words. Three or four simple paragraphs are usually sufficient for an introduction to an exhibition, an artist's statement, or a press release.

An exhibition introduction and additional texts may not be necessary. They are there to provide the audience, who could have wandered into the gallery without knowing the exhibition title or theme, with background information. On the other hand, if the exhibition is divided thematically or chronologically, each new section may need an introduction—the decision about text depends entirely on what is needed to support a particular body of work.

Writing text

One of the most difficult areas of exhibition preparation is generally the text. There is good reason for this: it can be because photographers see themselves as visual rather than verbal people and may have little experience in writing, may dislike writing or think it should be academic rather than written for a general audience. They may also fail to recognize just how important words are to an exhibition and so neglect the text or leave too little time to do it well.

There is also little consensus about what good writing about photography is or what is appropriate to an exhibition. But exhibitions almost always entail a certain amount of textual material and it is well worth learning to produce good text or the text will let down the rest of the show. Learning to write well about your work often goes hand in hand with learning to shape your ideas and speak about the work and is a very useful skill to develop. All the texts for an exhibition are important and they will all take time and detailed consideration.

The texts for an exhibition can include:

- an introduction to the exhibition and short texts that accompany the images or different sections of the exhibition and/or gallery guide or leaflet
- artist's statement(s)
- titles
- captions

Improving one's writing

In the short term and for the occasional emergency you may well be able to get someone to write on your behalf but in the long term you need to learn to do it yourself. There's only

one way to learn to write and that is to keep doing it and, if possible, write to deadline. If you need to find a way to get started there are a lot of possible approaches. There are many books on the market about how to write well. Attending a writing class or joining a writing group is usually a good, if slow, way of improving one's writing and can also be a valuable creative input to making visual work (something about the different ways writers and artists view the world can trigger more than just a good sentence or two) as well as being confidence building, good support, and informal market research (you read them your artist's statement and if they don't get it then you can be sure the exhibition audience won't either). Writing with colleagues can work well (you write something long and rambling and they edit it then you re-edit their text). Sometimes recording or making notes from a conversation or dialogue with a colleague is a good starting point (they ask you why you made the work and push you to say more if the answer isn't quite right). Getting into the habit of making notes as you work can mean you end up with a statement which has written itself by the time the work is complete.

Doing a lot of short pieces of writing and doing it to deadline will mean that writing becomes easier over time—if you take on writing small things (letters to funders, paragraphs of publicity material, short reviews) and ignore the small voice telling you to postpone writing till inspiration arrives then you will learn to write more quickly and more confidently. Any professional writer will tell you not to postpone writing or wait for the 'right' moment but just to get it done. So, start writing early on in the process of planning an exhibition and allow yourself the time to do it properly even if it means writing draft after draft. You will eventually train yourself.

Some basic guidelines about writing text for an artist's statement or an exhibition are:

- Keep text short. Too many words will be seen as privileging the text over the images and will distract the audience from the artwork.

- Keep text as straightforward and jargon free as possible.

- Make sure that basic and essential information is covered—places, dates, and names are usually important to the audience (even if they are unnecessary to an understanding of the images).

- Do not try to influence the reading of the work, critique it, explain or interpret it, or describe what is in the images. All these things get between the audience and their experience of the work and you need to allow them the chance to engage with the work without feeling that they are being told what to think.

- Avoid emotive words and keep an objective tone. If the work is emotional, it will be undermined by the use of an emotional text.

- Avoid deeply intimate and revealing personal statements. It is possible to present very personal work and still keep your privacy if the text is impersonal enough (see page 189).

- If you have the confidence, then take a risk. Don't feel you have to write something worthy and dull but try to speak directly to your audience—you might, for example, write a list of questions titled 'six questions I asked myself while making this work.' But only think about this sort of strategy if it's appropriate to the work and the venue.

Intros & text panels

Whether an exhibition needs an introductory text or not will depend both on the venue and on the work. An exhibition introduction may be an artist's statement or it may be written by the gallery, the gallery and artist together, or an independent writer or critic. It is there to contextualize the work and usually to provide some basic information about it and about the artist. Texts should be short and informative and can include information on where, when and why the work was made. Text panels can also be used in the same way as chapters are in books and can be a useful way to mark out separate bodies of work or different approaches within an exhibition.

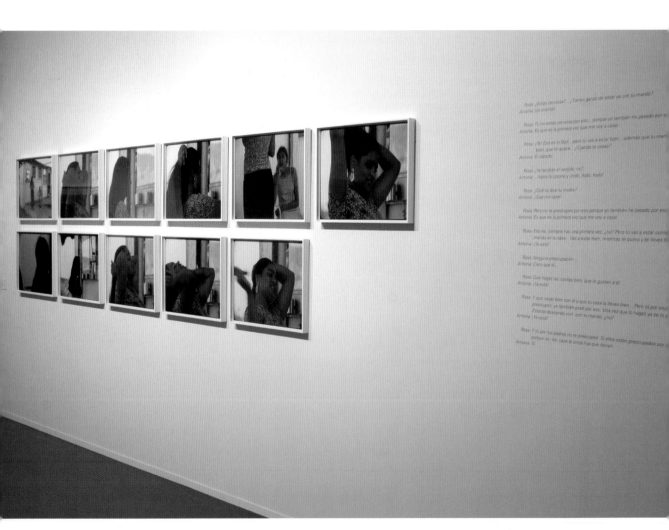

Hannah Collins exhibition at Caixa Forum, Madrid. Image courtesy Hannah Collins.

Artist's statement

An artist's statement is very important and an essential part of the artist's or photographer's exhibiting toolkit. Anyone setting out on a career as an exhibiting artist should write a statement and then revise it regularly—both to update it and to provide a separate text for each exhibition or project.

A statement is often useful when applying to a gallery or to a curator and is sometimes used as an exhibition introduction, although it is useful in a number of other ways. It is usually a very good starting point and reference for anyone writing a press release about the work and a way of making sure that they represent the work accurately. It is also appropriate text for any short leaflet, handout, or catalogue and can be used as an introduction for an artist's talk.

Artists often find it difficult to write a statement but need to find a way to do it (a good way to start is to get some help) and to make sure to allow enough time to do it well. Writing a statement serves as a way into the work for the artist as well as for the public because it is a good exercise in shaping and clarifying ideas about the work. Another, perhaps surprising, use is as record and reference for the artist. Making work can be such an intense and all-absorbing process that many artists forget that, in a few years' time, there is a real possibility that they will not remember how the work came about. For most artists it is a good idea to start writing down ideas which might be useful in a statement at the beginning of the work rather than at the end so that there is a record of how the work developed (which may or may not be useful in the statement).

The statement should be short, accessible, and cover the what, why, and how of the work. The 'what' and 'how' are short paragraphs and the longest is the explanation for the work or the 'why.'

This statement on *Maps from Nowhere* by Roma Tearne gives an idea of how to approach writing something that can be both personal and distanced. It was written before she undertook the work as a way of making clear for a gallery director, and for herself, a starting point for the work:

> *In 1991, soon after my youngest child was born, I moved from the house where I had lived for many years. Having moved the furniture I left a large rosewood box with my most personal belongings standing in the middle of my studio. The box was one that had travelled with my mother and myself across seven thousand miles from Colombo to London. It had once held all the belongings we brought with us from the tropics. Now I filled it with the photographs, the diaries and the mementos from the intervening years. I intended to collect it in the morning. So, having packed the box up, I placed a large 'Do Not Touch' notice on top of it and went away for the night. The following day I was due to vacate the house. But on my return I found to my horror that the rosewood box had vanished along with the other debris. It had been removed by the house clearance men. Everything I owned, all the memories of generations of my family had been dumped somewhere in the North Sea. Discarded.*

> *I have been looking for those stories, those diaries, those maps of my past for sixteen years now. Every photograph album in every junk shop I pass is a source of ardent curiosity. Who knows, I tell myself, they might still appear.*

'Maps from Nowhere' is a project about this loss. It is an investigation on what might or might not be found after time. It is about a journey I may or may not undertake back to my home in Colombo, a journey that has been more than forty years overdue. It will not be easy to go back. My family is dead, my relatives untraceable, there is a war on in Sri Lanka, dengue fever is rife, as is malaria.

And, even if I do go back, what can I hope to discover? The white house on the hill beside the coconut grove cannot possibly exist any longer. The school I attended—will it have withstood the war? Even the sea might have changed. I have heard that the tsunami has swept some of the rocks away from Mount Lavinia Bay. I had carved my name on one of those rocks. Roma Chrysostom, age 10, Colombo, Ceylon, The World, The Universe.

'Maps from Nowhere' will take the form of a photographic project. It will be part of a journey into the interior, of a place, constructed by me over a lifetime. Nowhere was the place where my parents longed to return to when life became hard. It was a place that has existed for so long in the collective imagination of my family that finding it will not be easy, but by the writing of this proposal the journey itself has already begun.

This is an artist's statement that stands as a piece of writing in its own right and works whether or not we see the images. While it is intensely personal, it is both thoughtful and accessible and explains the photographer's intent clearly.

Titles

Titles, both of the exhibition and of each work, are crucially important. They can be:

- descriptive
- locating
- allusive
- metaphoric
- contextualizing
- subverting

A title should be short, precise, and, if possible, both resonant and memorable. Titles can also be borrowed from books, poems, film, or music or be a direct quote.

Alternatively, they can simply be a date, place, or name. Candida Hofer or Andreas Gursky will locate an apparently entirely anonymous modern institution by giving us its name: 'Beinecke Rare Book and Manuscript Library New Haven CT IV' and 'Prada 1' are both title and comment. Equally, a title can point out an absence of locating information: 'Untitled,' 'Set 1,' 'First Series,' and 'Monochrome' are titles used to prompt the viewer to look at the image rather than seek information from a title.

However, a title can also be personal and perhaps slightly inexplicable; it does not need to be explanatory or even very accessible. Rut Blees Luxemburg, for example, called one of her works *Cauchemar*. This means 'nightmare' in French, but the word itself is resonant enough

Cray XT3 2.6 GHz from *I'm sorry Dave I can't do that* (The Supercomputers). Image © Simon Norfolk.

for it not to matter if it is not immediately understood. It opens a door to interpretation rather than pinning the work down too specifically.

Titles can also point to the important element in the work but you should avoid describing something that can be seen in the image. Again, this is about not using text to do the job best left to the audience. Consider, for example, a photograph taken in China of an old woman's

feet. This can be described as 'Feet'; if the title is 'Bound Feet' it is overly descriptive. The audience will be aware that the photograph is interesting precisely because it is a photograph of bound feet and of a custom that has all but disappeared. 'Boy, Serbia' or 'Red Dress' are also overly descriptive if the child in the photograph is clearly a boy and the dress clearly red.

However, if the red dress was only a very small element in an image this title would act to add another layer of meaning to the image, shifting and challenging the viewer's perceptions of what they think they are seeing with words and image acting as counterpoint to each other.

Titles to avoid are the sort of generalizing and slightly sentimental 'poetic' captions used by many magazines, such as 'Light and Shade', 'Sudden Smile', and 'Time and Tide'.

Appropriate titles can be surprisingly difficult to arrive at, and the task should not be left until the last moment. Word games, brainstorming sessions, and dipping into favorite books and poems are useful ways of finding titles. Sometimes they simply come about over time. If you start thinking of possible titles at the beginning of the exhibition process, write down every possibility and spend a few minutes each day mulling over words; you may end up with a useless list, but at some point the right word or words are likely to emerge from the subconscious mind.

Captions

The interaction between image and caption, ever-present in magazines, advertising— and textbooks—had been shunned in art photography, which expected the image to carry the full burden of meaning.

Mary Warner Marien

The convention for producing caption information is as follows, and in this order:

- the photographer's name
- the title and date of the work
- any necessary additional information like 'from the series …'
- the print type and size (e.g. Giclee, C-type or silver gelatin) and mount information

If this is a selling exhibition or fair, the caption will usually include further detail such as:

- archival information (such as 'archivally processed, mounted on rag board')
- the edition information or number (e.g. 'edition of five' or 'number three in an edition of five')
- a price (or two prices if the work is being offered either framed or unframed) or a number related to a price list

This information should be kept simple and unobtrusive, the text aligned left, and each data item on its own separate line. Use as little punctuation as possible; commas or full stops at the ends of lines are unnecessary and make the caption appear fussy. Emphasis can be added by putting one item in bold and one in italic typeface (usually the name of the artist

and title of the work). Otherwise, using several different typefaces on different lines should be avoided.

If the photographer is not known, the caption should say either 'photographer unknown' or 'anonymous.' If the print is vintage or taken from an old negative, then this information should be included with the print type—for example: 'vintage silver gelatin print' or 'printed later' if it is a contemporary print from an old negative. If the print has been loaned, then this information is included as the last line—for example, 'courtesy of …' or 'gift of. …'

Captions are usually approximately $3\frac{1}{2} \times 1\frac{1}{2}$ inches (the size of a sticky label) and mounted on card or foam board or printed in black on clear sticky-backed acetate which can be stuck directly to the wall. Print size may be 12 or 14 point.

It is worth printing two sets in advance so that if a caption goes missing or needs to be replaced for any other reason, it can be done with the minimum delay. It is also absolutely crucial that the gallery staff have another way of relating image, caption, and price list that does not depend on the memory of staff members or the caption on the wall—just in case a caption goes missing. A missing caption can cause chaos if the gallery staff does not know the work well and is asked for further information, titles, or prices. Two ways of avoiding confusion are to make sure that there is a copy of the caption label on the back of the frame and that there is a full list of captions with thumbnail images, image numbers, or positioning held by gallery staff.

Texts: Two—Publicity

Press photo for Michelle Sank's *The Submerged* at Hotshoe Gallery. Image courtesy Michelle Sank.

Publicity

An exhibition is a great shop window for a photojournalist as long as the exhibitor makes as much effort doing publicity as putting the work up. Newspapers will often use images from exhibitions, especially if they cost nothing, and having an exhibition can be an occasion to e-mail picture desks or make contact with editors. Working with an appropriate organization can also be useful as they often have press departments and access to radio and TV. Actionaid did the publicity for my exhibition at the Oxo Gallery and that brought in an audience and media contacts I wouldn't have had the time to approach. Timing is crucial though, and forward planning helps a great deal, particularly if the exhibition coincides with an anniversary or seasonal event—this can really help get a picture story published.

<div align="right">Jenny Matthews, www.jennymphoto.com</div>

There are five basic tools to publicize an exhibition and a sixth—the publicist—who can make them work to maximum effect:

- the press release
- the press prints
- the invitation or private view card
- the press pack
- the catalogue

At this point in time galleries and artists tend to use a mix of electronic and hard copy for most of the above, except for the catalogue, which is usually printed on paper. Both are acceptable; electronic systems tend to be cheaper but the press release and private view card have a longer life, higher visibility, the potential to reach a wider audience, and more impact when hard copy is produced. Most established galleries will use both systems, but using only electronic media is great for one-off, short-term exhibitions.

Publicizing an exhibition is one of the tasks that a gallery will routinely organize. Most galleries do this well because their reputation depends on their exhibitions being well received, they have built up a good publicity machine over time and, crucially, because they know their audience.

It is usually harder for an artist or group of artists to organize their own publicity. This may be because they are inexperienced, feel awkward promoting their own work, or find it hard to write about profoundly serious work with the right distance, or they are unsure who their audience is and how to reach them. One answer is to hire a publicist to promote an exhibition.

However, it is useful for any artist to learn to produce publicity material and to understand how the publicity machine works in order to make it work for them. Whether or not the artist is very actively involved in producing the publicity material it is also important to be involved enough to keep some control over the process. The danger for artists is that if they hand over publicity to others, they or their work may be misunderstood or misrepresented.

The photographer anyway needs to find direct and honest ways to talk about the work and for any publicity to reflect this. Although trying to publicize one's own show for the first time can be daunting, it is a very good way to learn marketing skills, which can then be developed over time as the artist learns how to talk to his or her particular audience. One way to start this process is to collect publicity material from galleries showing similar work or the work of an artist at the same career point and use it as a template for both writing and design styles.

Publicity material has a number of different functions. This can be explained as 'AIDA,' which means it should:

- Attract (so the exhibition will get noticed)

- Inform (so the audience knows what the exhibition is about)

- Desire (so it creates a desire to see the exhibition and is persuasive)

- Action (so it induces action—that is, it tells you what to do next, like how to get in touch or get to the gallery)

While these categories are essentially accurate and useful, they do tend to suggest that art can be sold in the same way as soap powder. Indeed it can, and the art market is right up there with gold and coffee in the world commodity markets. But there is often a difficult negotiation for the artist over the professionalization of art marketing. The temptation, especially for new artists, is to try to attract an audience through dramatic publicity (the 'attract' and 'create desire' aspects of the AIDA mnemonic). While sensation and scandal in the art world, from Mapplethorpe and Jeff Koons onward, has been a part of bringing new audiences into galleries, most artists would prefer to have their work understood and valued for its own sake. 'Talking up' work can be counterproductive: it may mislead an audience, who start to expect art to have entertainment or shock value or may simply experience a disheartening gap between what is being said about the work and what they experience when they visit an exhibition. For artists whose work has been over-promoted, the danger is also that they will start to believe the promotion and may find it hard to recover their sense of direction once the exhibition is over.

It is also a mistake to believe that marketing will, in itself, sell artwork. Eminent financial advisor and art buyer Alvin Hall was speaking for many collectors when, in conversation with critic Sarah Kent on BBC Radio4 (25 April 2007), he commented, 'I buy art totally on gut reaction.' He explained that if he tries to buy art for any other reason, including investment value, he often fails to make good decisions. He is not alone in thinking in this way and, although a percentage of buyers are entirely concerned with buying for investment, most people buy work because they love a photograph and can imagine living with it. No amount of marketing can shape individual taste to the degree needed to sell work to people who are not interested in it.

So, in my view, it is much more useful to focus on producing informative and insightful press materials than using more aggressive marketing techniques. If press material is written by someone who understands the work and can highlight some of the issues or concerns of the

artist, it will do a great deal to engage an audience. Many people who lack training in the arts are unsure of how to start when looking at an exhibition, and a good press release is invaluable in helping them find ways into understanding and enjoying the work as well as ensuring that all the listings and press mentions will have something concrete to say rather than being empty 'puff.'

The publicist

A combination of charm and persistence, as well as a good understanding of the way the media works and a knowledge of artists and the art world, are the most useful qualities for the job of publicist. Larger galleries usually have a publicity department or someone for whom publicity is a full-time job. Small galleries may have one person in charge of publicity for whom this is only one aspect of their job. A gallery director will often write publicity material for his or her gallery.

The most important task for someone trying to get an exhibition reviewed or noticed is to make sure that the press material is thorough, interesting, and produced on time. Publicity for the show opening is key. Once a press release has been distributed, the task is to follow up with phone calls or e-mails. There are two aspects to this. One is to ensure that the exhibition is in all the listings magazines and remains there for the full run of the exhibition, as some listings magazines will drop a listing after a week or two if they are not reminded to keep publishing it. The other is to target publicity to reach the magazines and reviewers who will be interested in covering the show in more detail. Such coverage may vary, from the use of an image with an accompanying paragraph of information to a detailed review. An experienced publicist will have very valuable contacts and should also be able to predict what sort of coverage a particular magazine will use and shape publicity specifically for that magazine when approaching them.

It is also just as important to target the appropriate critic. Many critics have clearly defined areas of special interest, and it is well worth making sure that these critics are approached directly. One in-depth and well-informed review is more rewarding for a gallery and artist than a splatter of short newsy pieces.

Targeting publicity is not difficult, but it can be very time consuming for someone who is not a publicist. For the artist publicizing his or her own show, it is usually well worth studying reviews and publicity pieces carefully to see what the magazines are looking for. Reading photography reviews regularly will develop an awareness of which critic might be interested in reviewing a particular kind of work. The artist's role in working with a publicist is both to impart useful information that can be incorporated into press materials and also to suggest appropriate reviewers, since the artist's knowledge of his or her particular area is likely to be well developed. Keeping an up to date record of appropriate critics, reviewers, curators, and magazines is something the artist should work on as their career develops.

Press release

(see the checklist in the Appendix for a list of what information should be in a press release)

A press release is crucial to publicizing any exhibition and, if possible, should be written when the original contract is drawn up between gallery and artist. This is both because it will then probably be true to the thinking that originated the exhibition and because it will provide invaluable publicity and reference in the months before the exhibition opens, and can easily be distributed widely (in the gallery itself and through the artist who can hand it out when they meet people.)

It can be sent out months in advance of the exhibition and then again nearer the exhibition opening. It should be printed in bulk and widely distributed through a regular mailing; it should also be enclosed in every letter sent out from the gallery as well as visibly present on a reception desk during previous exhibitions and so available to all visitors over a period of time.

The two people best placed to produce copy for a press release are the curator and the artist. They should have the most detailed understanding of the work and the proposed exhibition. If they don't write the press release themselves, they should produce a draft or comprehensive notes for the person who will write it.

Press releases. Image © Georgina McNamara.

A press release should be fairly short and cover no more than one side of A4 or letter-size paper. Three or four fairly condensed paragraphs will suffice. These should describe the work, the exhibition, and the particular interests, methods, or subject matter of the artist as well as a brief biography or exhibiting history. It can include a quote by the artist if a personal description of his or her ideas or method of work brings it to life very vividly.

A press release need not include an image, although some galleries like to do so. There are probably more reasons not to use an image than there are to use one. It is often hard to find a single image that can adequately sum up the entire exhibition; the image will necessarily be small and may be too complex to be read easily. Since the press release is likely to be photocopied and copies possibly recopied, the reproduction may deteriorate to the degree that it becomes a sooty black image that does a disservice to the original photograph.

The press release should be on letterhead paper (including company or charity registration) and include a contact number or e-mail for the person who handles gallery and/or press information as well as the address, dates of the exhibition, and opening times of the gallery. It should also include information about any talks or educational events. Most crucially, it should also include the logos or names of any sponsors of the gallery or exhibition. Arranging for these to be included and checking the appropriate wording can be a tedious task and delay the production of a press release if it is left until last, so arranging for the use of the appropriate logos should always be a starting point when compiling a press release.

The language used for the press release should be accessible and, as far as possible, free of jargon. One reason for keeping the language jargon free is that the press may well use a paragraph or more of text taken directly from the press release or rewrite it very slightly before publication, and they will only do this if the meaning of the original copy is direct and clear.

A press release should also aim to 'show, not tell,' by which I mean it should avoid telling the reader what to think about the photographs and should steer clear of providing a judgment. Consider this example of a poor press release issued by the communications and marketing department of a London college: the photographs, it says, are 'powerful, graphic and lyrical images.' This is a fairly meaningless assessment and will do nothing to attract an audience. No reviewer is going to use it as a quote. By putting a judgment of the work between viewers and the work itself, such a press release makes it hard for viewers to look at the work freshly and come to their own conclusion.

A more useful approach is simply to describe the work in the exhibition in enough detail to interest an audience and give a potential reviewer what he or she needs to produce a short review or a piece for a listings magazine without necessarily having to see the exhibition. There should also be sufficient information to be used in a longer review.

Generally the first paragraph of a press release is about the exhibition itself. For example:

> *This will be Juan Cruz's second exhibition at Matt's Gallery. 'Portrait of a Sculptor' takes as its starting point a painting by Velazquez in the Prado, Madrid: 'The Sculptor Juan Martinez Montanes,' catalogue number: Prado 1194, painted in Seville ca 1648.*

Using the spaces of Gallery 2 and the bookshop/reading area, Cruz has employed text, photography, video, and architectural interventions to make an exhibition that both comments upon and adopts the reflexive nature of the painting.

<div align="right">Juan Cruz at Matt's Gallery, London</div>

and

Grouped loosely into three areas, the exhibition will open with images of sleep, of dreamers, and of nightmares. Secondly come the dream messengers and their vehicles, horses, birds, ecstatic flight, sheep as night visitors, spaceship travel. Thirdly will be the 'man of my dreams,' images of archetypal, heroic male figures.

<div align="right">Arthur Tress at Zelda Cheatle Gallery, London</div>

The second paragraph gives more detail about the artist and their work. For example:

Rickett's subjects are exclusively photographed at night and are located in primarily peripheral and mundane environments such as deserted parking lots, motorway bridges, the grassy island of an arterial motorway with light provided by street lamps or car headlights.

<div align="right">Sophy Rickett at Emily Tsingou Gallery, London</div>

and

Davis generally works in series, and his photographs tend to investigate the architectural and ideological structures that are created within society. After documenting in minute detail the workings of a publishing house and a hospital, Davis decided to photograph the interiors of America's colossal retail stores in an attempt to uncover the ways humans make meaning in an architectural setting that is designed to go unnoticed. Finding himself frequently escorted off these commercial premises, he shifted his focus from the structures of the stores themselves to the very physical outer limits of their presence: the way they illuminate, alter, claim and degrade their neighbouring communities.

<div align="right">Tim Davis at White Cube, London</div>

The final paragraph is often about the artist, their exhibiting curriculum vitae or brief biography. For example:

Philip-Lorca diCorcia has exhibited extensively in the United States, including at the New York Museum of Modern Art and in the Whitney Biennial at the Whitney Museum of American Art, New York, as well as throughout Europe, but neither of these series has yet been seen in England.

<div align="right">Philip-Lorca diCorcia at Gagosian Gallery, London</div>

and

Josef Koudelka was born in Moravia, Czechoslovakia. In 1962 he started to photograph the gypsies in Eastern Europe, whilst continuing to work as an aeronautical engineer

until 1967 when he turned exclusively to photography. He received the Robert Capa Award anonymously for his coverage of the Prague spring (1968) after which he had to flee his country. He was granted asylum in England and thereafter in France, where he became a citizen in 1987. He began work on 'The Black Triangle' when he was finally able to return to the country that he had left twenty years earlier. He has been a member of Magnum since 1971.

Koudelka at Photofusion, London

These examples were chosen, more or less at random, from a selection I keep for teaching purposes, but it should be noticeable that all of them privilege giving information about the artist and the work over offering judgments—though, of course, they establish that the artist is well respected by including brief and significant biographical details. This should not be a problem for a younger artist; it is equally useful to mention where they studied and their current work and interests.

Press prints

A gallery and artist will select between five and ten images to copy, usually digitally, in order to provide the press with images with which to preview or review the exhibition. It is usual for the gallery to make a selection of key images well in advance and not to offer the press a choice of all the images in the show, as there is a danger that the entire exhibition will then appear in print, making it unnecessary for anyone to visit the exhibition itself. Press prints need to be chosen carefully, both for their strength as images and to accurately represent the range of ideas and images in the exhibition. A single strong image can market an exhibition more effectively than anything else.

In a group exhibition, it is important to select press images that represent the full range of the work included in the exhibition. Different magazines and newspapers will use the images that fit with their interests and style and it is important to keep this in mind when making a selection. They also have a preference for images that are graphic, dramatic, and attention grabbing. Images that are subtle in tone or content usually do not make good press images since they may not reproduce well. Nor can you predict at what size the image will be used so an image selected for a pres print must work well at any size. It is also worth making sure that some images are available in black and white or will convert well to black and white, since some newspapers do not use color and will not select an image that reproduces poorly.

The press prints need to be selected at a very early stage in the exhibition process, since there is usually no way of predicting how soon they will be needed. Quarterly magazines, for example, have very long deadlines and publication dates that are unlikely to coincide with the exhibition opening; they may well need images between four and six months ahead of the exhibition in order to publish the information in an issue that is distributed around the time of the exhibition. As a rule, when they are needed, they will be needed quickly.

Artists loaning a paper print to a gallery for press purposes should be careful to put their stamp or name, copyright symbol, and contact address on the back, as well as a full caption and 'press print only, to be returned to the artist.' They should also reclaim the print at the earliest possible moment, since most people treat press prints fairly casually. If the print is not reclaimed, it may get damaged, lost, or stolen and next be seen framed on someone's wall. None of these things may seem much of a problem at the time but could be just a few years down the line if the photographer has to try to reclaim a print or if substandard press prints turn up for sale on eBay.

Opening view card

(see the checklist in the Appendix for a list of what information should be on a private view card)

The invitation to a private view or opening party for an exhibition is important because it will reach a wide group of people and because the image selected for it may well come to represent the exhibition in the long term and, if well selected, may be widely reproduced. A strong image from an exhibition used as an invitation may give the show a clear identity that makes it easy to publicize so always choose a stand-alone image which can represent the exhibition well.

Private view cards. Image © Georgina McNamara.

Most established galleries still produce and post a paper or card invitation although many will also send the same invitation out electronically. Most e-mailed invitations use the traditional format for invitations—when using e-mail I would always put the date and title of the show in the subject line or body of the text because busy people do not open all the attachments if they are inundated with e-mails.

The most usual invitation is an unfolded card with a full-sized image on one side and printed information on the other; these tend to range from postcard size to a card measuring 8×5 inches. Folded invitations are expensive to produce and usually signify an upmarket gallery. Most galleries will have a recognizable design style or format.

An important factor to consider when designing an invitation is the method of posting. Envelopes are produced in standard sizes, and designing an invitation that does not fit neatly into a standard-sized envelope means that it will require either a too-large envelope, which does not look good, or a specially made envelope, which is costly. In my view it is better to stick with standard sizes. An alternative, which saves both time and money, is to print an invitation that can be sent as a postcard, with space for an address on one side and the invitation on the other. This looks less formal than an invitation in an envelope.

The invitation needs to be mailed between two and three weeks before the opening party. As a general rule, if you send an invitation out too early (over a month ahead), people will forget about it; and if you send it out too near the time the exhibition opens, people will already

An invitation to a vernissage which can be e-mailed or printed and posted. Image courtesy Matthias Olmeta.

have made other arrangements for that evening. If, however, you are holding a special exhibition and asking your invited guests to confirm their intention to attend, you need a different timetable. In this case, the invitations should be sent out about a month to six weeks in advance in order to give people time to confirm that they will be attending.

The date for the opening will have been set months in advance, however, and gallery and artist will have let people know so that they already have the date on their calendar. Galleries tend to favor holding openings on one particular day of the week. When settling on a date for an opening event, it is a good idea to check, as far as is possible, that it will not coincide with other openings.

It is also worth asking the printer the cost for an additional run of the invitation image without the exhibition information on the back. Most printers can do this at no great cost, and it is useful to have a supply of images to use as promotional cards. Any such card must have a full photo credit on the front of the image so that it is not lost when the other information is removed.

Press pack

A press pack, as the name implies, includes more extensive and detailed information about the exhibition, the artist, and the gallery than the press release can cover and is provided to give the press additional material to draw on when reviewing an exhibition.

Larger galleries sometimes provide a pack to all members of the press attending a private view. These packs are often beautifully designed and can resemble a child's party bag full of small sponsor- or promo-related gifts such as T-shirts, pens, and CDs.

In addition to copies of all the exhibition material already available in the gallery, a press pack could include an artist's statement and c.v./résumé, one or two sample images, an update of information about the gallery, and their latest catalogue or brochure. It could also include further information about the artist in the form of an interview or a review of previous work, a copy of texts in the exhibition, or a full caption list.

Smaller galleries might want to avoid the expense of providing a large number of smartly produced packs, but collecting the information together to hand out on request or to selected reviewers will still be invaluable and ensure that reviewers have a great deal of background information on which to draw.

Catalogues and brochures

The most enduring legacy of an exhibition is usually the catalogue. A good catalogue should be, as the name implies, a complete list of the work exhibited, an additional essay or two, and supporting information. Catalogues are expensive and time-consuming to produce. For this reason, they have tended to be the domain of bigger galleries and well-established artists.

Small catalogues and brochures. Image © Georgina McNamara.

In recent years, however, with a fall in printing prices and more widespread expertise in reproducing photographs, more galleries have been able to afford to produce small exhibition catalogues. There are a number of good ways of doing this and they are of great value to the exhibiting artist, since the small catalogue or leaflet long outlives the exhibition itself and is invaluable both as a record and as a promotional tool.

Most galleries and curators receive a great number of unsolicited exhibition applications on a daily basis. Many of them will hit the wastepaper basket as soon as they are opened, for no other reason than the gallery has no time to deal with them. Sending a gallery or curator a small catalogue to represent the work is more immediately compelling than almost any of the various alternatives including CD or slides. It takes only a moment for the curator to look at the images and judge whether they are likely to be of interest to the gallery. It also at once establishes that the artist is a professional with a track record of exhibition. If anything is going to catch the attention of a gallery and ensure that the work will receive serious attention, it is this sort of publication.

'Catalogue' is usually a misnomer as these publications tend to be an introduction to the work and a partial, rather than complete, record of an exhibition. There are as many different names as forms and uses for this sort of publication; they can be catalogues, booklets, pamphlets, brochures, or leaflets and are not to be confused with exhibition guides, which are usually essentially text based rather than image based and are produced by large galleries as a room-by-room guide to an exhibition.

They can be a collection of cards in a folder or envelope, several pages or several dozen pages folded, stitched, or stapled in traditional book format, or a single sheet of paper with an accordian or other type of fold. Sometimes they have a double function—one side used as a poster and the other as catalogue. The type and amount of information included can range from a collection of images with no text to a single image and short statement per artist for a group show, to something much more closely resembling a catalogue in everything except size. As long as the print quality is good, all of these give a fast and revealing insight into the work.

For a group exhibition, a single image for each exhibitor with caption, an accompanying hundred or so words of text, as well as the name and contact details of the photographer (if appropriate to the type of exhibition) will make an interesting publication. If there is time to commission it, a single longer piece of writing may be useful and provide insight into the exhibition. Catalogue images need to be selected carefully for their standalone qualities. An image that works in the context of a set of images may not work in isolation. Equally, the image that does work well by itself may not represent the work as a whole. If there isn't an immediate and obvious choice of image for a catalogue, the only way to make this sort of decision is by testing out each image to see what works and drawing in other people's opinion. Another option is to print two or more images at a smaller size, although small catalogues usually work best with large images even if this means using fewer images. This careful decision making takes time but is worthwhile, since the image and catalogue may well be widely seen and come to represent that photographer in all sorts of contexts.

One of the main considerations in producing this kind of material is time, and timing. It usually takes many days and weeks to collect and select images, write, edit, proofread, design, and print anything. The planned timetable needs to ensure that the catalogue is printed several days before the exhibition opens, at the very latest. If the catalogue is small, or essentially a large leaflet, and can be mailed out at no great cost, then it should be produced in time to be mailed with the press release or opening invitation two to three weeks before the exhibition opening. If it is too big or costly to be mailed to everyone on the gallery list, it should be produced in enough time to send out copies to key critics or clients.

For many photographers, the problem this raises will be that the exhibition content is not finalized when the catalogue information is being collected. Unfortunately, print deadlines cannot be postponed, since a catalogue that arrives in the last few days of an exhibition is almost worthless as publicity material. If a catalogue is to be sold the main selling point is at the exhibition opening, it will continue to sell during the exhibition run but very probably be reduced in price or removed from the sales area at the end of the exhibition although it will sometimes continue to sell long after the exhibition is over. Decisions about image and text

will have to be made regardless, and a certain amount of ruthlessness may be needed. Student degree show catalogues frequently do contain images that are not in the show, and this is always disappointing, particularly for the curator who visits degree shows as a way of keeping an eye out for emerging talent, since it means the catalogue is far less useful as an aid to memory than it would otherwise be. But better still is for the exhibitor to commit to showing the work that is in the catalogue and ignore the temptation to keep revising the exhibition content right up until the last minute.

Small catalogues are usually given away. It is difficult to sell them and it may be counter-productive to try, since the small sums of money involved may be difficult to collect and more trouble to account for than they are worth. Since the aim is to publicize the photographers and provide a record of the work, it is also counterproductive in that it limits circulation.

Universities, however, will increasingly pay for these small catalogues to accompany degree shows as they act as advertising for their courses. Catalogues can also raise revenue in the form of advertising, although this may primarily come from suppliers already connected with the course or institution.

Case Study Five

Karin Bareman: Dutch Photography Centers

TERRORISM IS IMMORAL, AND IT RESPONDS TO A GLOBALISATION T IS ITSELF IMMOR

Installation at the Nederlands Fotomuseum. Image © Karin Bareman.

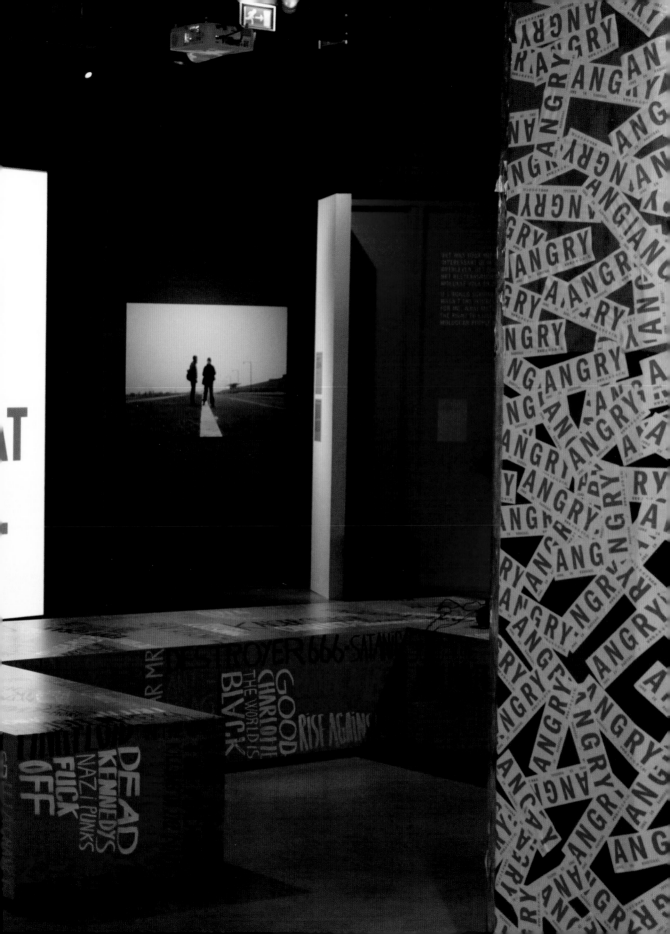

The Netherlands is teeming with activity with regards to photography. There are many organizations dedicated to showing, promoting, or publishing photographic images and educating and supporting photographic practitioners. The field, however, is dominated by the four photography museums, which have come into existence more or less simultaneously at the start of the twenty-first century. Each museum has its own distinct view on the medium. I will describe the four, and outline the similarities and the differences between them.

Let's start with Huis Marseille in Amsterdam, the first photography museum to be established in The Netherlands, which was set up in 1999. It programs four exhibitions per year, which attract about 36,000 visitors. The museum is run by a small staff, consisting of four members. It possesses a library containing about 2,000 books and a collection consisting of over 420 works. Huis Marseille is privately funded by the De Pont Foundation in Tilburg by means of a bequest by J.H. De Pont. The latter was a lawyer and businessman who lived from 1915 until 1987. The bequest enabled the establishment of both the contemporary art museum De Pont in Tilburg as well as Huis Marseille. This means that the museum is independently financed and does not have to rely on government grants or sponsorship deals. It also means that Huis Marseille can program exhibitions or purchase works for its collection, without having to worry about visitor figures or having to meet grant or sponsorship criteria. However, the museum will be expanding to twice its original size having acquired the canalside building adjacent to it. By having just brought in a new curator, it is looking to show more of its collection next to other presentations, as well as program more diverse activities.

Huis Marseille in Amsterdam. Image © Karin Bareman.

Huis Marseille puts much emphasis on the intrinsic quality and speciality of photography. The visual quality and meaning of the image is paramount for the museum, as is the way in which the image is experienced. It provides a highly specialized outlook on photography, showing artists at a stage in their career where they have developed their own style, are known amongst fellow photographers, but not necessarily amongst a larger audience. Huis Marseille dedicates roughly half of its exhibitions to Dutch photographers. These shows are generally in-house productions, or the result of collaborations with other Dutch institutions. Examples are *Jacqueline Hassink—The Power Show* in 2007, *Hellen van Meene* in 2006, and *Rob Nypels* in 2009. The other half of the exhibitions containing the work of non-Dutch photographers tend to be travelling exhibitions loaned by other institutions or developed in conjunction with them. Examples are *Bernd & Hilla Becher* in 2000, produced in conjunction with Die Photographische Sammlung in Cologne, *David Goldblatt* in 2007, loaned by the Museum Kunst Palast Dusseldorf, and *Fazal Sheikh* in 2009, loaned by Fundacion MAPFRE in Madrid.

Fotomuseum Den Haag was established in 2002, and programs six exhibitions a year. It welcomes on average 59,000 visitors. The museum also has a collection measuring over 1,400 works. It is run by one curator. However, Fotomuseum Den Haag is part of a complex of city council museums, and is based in the same building as GEM, the contemporary art museum within this framework. The museum is mainly financed by the city council. Fotomuseum Den Haag regularly cooperates with the Leids Prentenkabinet, a large photographic archive linked to the Leiden University, as well as the KABK Den Haag, which is one of the major providers of BAs in photography. In terms

Fotomuseum Den Haag. Image © Karin Bareman.

of the exhibition and collection policy, the emphasis lies on imaginative, manipulated studio photography. Photographic views on humankind take center stage, resulting in a wide variety of genres, disciplines, practitioners, and eras on show. The collection comprises portraits, still lives, landscapes, and interiors, preferably made by photographers from The Hague or depicting The Hague.

The presentations are fairly evenly divided between Dutch and foreign photographers, and between group and solo exhibitions. The modern Dutch photography shows tend to be in-house productions, whereas the historical Dutch photography presentations are often produced in cooperation with the Leids Prentenkabinet. An example of the former is *Koos Breukel—Amongst Photographers* in 2005, an example of the latter is *Emmy Andriesse—A Retrospective* in 2003. The non-Dutch photography exhibitions are regularly travelling exhibitions. Examples are *Gregory Crewdson—Retrospective 1985–2005* in 2007, produced by the Kunstverein in Hannover and *Leonard Freed—Worldview* in 2008, organized by Musee d'Elysee in Lausanne and Magnum Photos Paris.

Whereas Huis Marseille and Fotomuseum Den Haag are relatively small operations, the same cannot be said for the Nederlands Fotomuseum based in Rotterdam. This centre was established in 2003, but was relaunched in 2007 when it moved from its smaller inner-city premises to a large complex in a renovated part of town. It currently hosts around eighteen exhibitions a year, receiving around 50,000 visitors. It is aiming to increase its audience to 70,000. The Nederlands Fotomuseum is a complex organization consisting of about forty-five members of staff and twenty volunteers divided over four

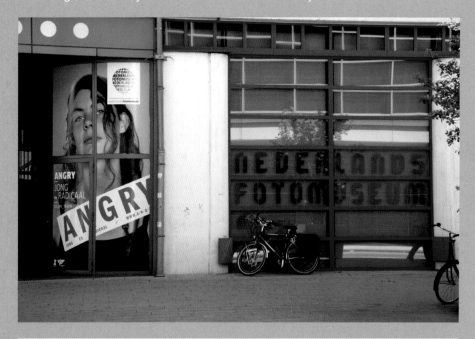

The Nederlands Fotomuseum. Image © Karin Bareman.

departments. These are respectively General, Collections, Conservation and Restoration, and Presentation. The museum has a library containing 11,000 volumes, a film lounge, and a very extensive collection. The latter consists of 129 archives by seventy Dutch photographers. These contain overall four million objects such as negatives, slides, prints, and albums. The museum is in the process of digitizing the collection, and has processed 90,000 items so far. It also has a dedicated restoration workshop, acclimatized depots, and a presentation room.

The Nederlands Fotomuseum is a merger of the Nederlands Foto Instituut[1], the Nederlands Foto Archief[2] and the Nationaal Restauratie Atelier[3] to form a national knowledge center about photography. The center is largely financed by the bequest of H.M. Wertheimer (1913-1997), a lawyer and amateur photographer. In his will he earmarked ten million euros to establish a photography museum dedicated to both professional and amateur photography. Whereas the other two museums have as a primary goal the showing of photography, the collection forms the raison d'etre for the Nederlands Fotomuseum. The focus lies on the acquisition, conservation and restoration of socially engaged, documentary Dutch photography from the twentieth century, and making this accessible to a larger audience. Especially in the early years, this impacted heavily on the exhibition policy. However, the center is now gradually moving away from Dutch, collection-based presentations to more diverse shows. The Nederlands Fotomuseum has also taken upon itself to act as a mediator between the different institutions in the form of shared platforms such as the website http://www.fotoleren.nl, and to function as the main source of specialized knowledge about the medium, varying from restoration and conservation to fund-raising and education.

In terms of exhibitions, the museum deals with all forms of photography, from historical to contemporary, from Dutch to international and from amateur to professional photography. Photography is seen as a way to produce a visual culture, which is subsequently studied as a phenomenon, the conclusions are presented to the audience. Exhibitions are therefore really diverse and wide-ranging. A collection-based exhibition is, for example, *Ed van der Elsken—Jazz* in 2007. The presentation *70s Photography and Everyday Life*, loaned by La Fábrica, is a good example of not only showing an important developments in photography at the time but functions also as a visual historical record. *Baghdad Calling* by Geert van Kesteren in 2008, on the other hand, is a modern in-house production.

The fourth museum in The Netherlands, Foam, was established in 2001. It programs between twenty and twenty-five shows each year, welcoming 185.000 visitors. As an organization it has grown exponentially, from having a couple of employees to currently employing about twenty members of permanent staff and about thirty volunteers, interns, and freelancers. It has a small collection containing about 250 works and a small library

[1] The Dutch Photo Institute
[2] The Dutch Photo Archive
[3] The National Restoration Workshop

Foam in Amsterdam. Image © Karin Bareman.

with roughly 2.500 publications. A significant difference from the other three centers is that Foam was established with the grassroots support of Amsterdam-based photographers and photography experts. Another important difference lies in the sources of income. Whereas the other three had relatively stable sources of income, either from private funds or government grants, Foam was forced to look for alternatives in its starting period, since it was judged negatively by the Amsterdam art council. The result of this is that the income for the museum is currently evenly divided between admissions and membership schemes, sponsorships, and government grants.

Because of its grassroots support as well as its income situation, Foam pays attention to all aspects of photography, from fashion to documentary, from autonomous to street photography, from contemporary to historical. The museum explicitly programs young emerging talents in conjunction with established names. Not only does the museum present photography, it has also expanded its role to publish a magazine, sell photography via the in-house print sales room and the temporary pop-up shop, and educate via in-house workshops and tours and a dedicated project location. All these activities try to show the same mix of young talents versus established names, working in various photographic disciplines. In terms of exhibitions, the shows are fairly evenly divided between solo and group shows, in-house productions, and travelling exhibitions taken over from partner organizations, and Dutch and international photography. *W. Eugene Smith—More Real than Reality* in 2010 was loaned by La Fábrica, *Charlotte Dumas—Paradis* in 2009 was a solo show containing animal portraits by a young, talented Dutch photographer, and *Bound for Glory* in 2006 showed color photography produced by the FSA and was made in conjunction with the Library of Congress.

Karin Bareman

Note: In Dutch we do not have the same distinction between museum and gallery as you have in English. A gallery in Dutch is automatically a commercial gallery, run by an art dealer, whereas a museum (privately funded or not) has a not-for-profit motive to show art or instruct in sciences. I suppose this is where much of the confusion between Dutch and English comes from.

Interestingly enough, the Museumvereniging in The Netherlands has stipulated that an organization can only call itself a museum if it meets a number of requirements. One of the more important criteria is that the organization has a permanent collection. In the case of Foam, this is why the organization started to acquire works by photographers.

http://www.huismarseille.nl

http://www.fotomuseumdenhaag.nl

http://www.nederlandsfotomuseum.nl

http://www.foam.org

Texts: Three—Mailing Lists

Terry O'Neill, *Brigitte Bardot* (Spain 1971) at Chris Beetles Fine Photographs in Piccadilly, London. Hanging an iconic, dramatic, or large image where it can be seen clearly from outside the gallery will often attract an audience in to look at the work. www.chrisbeetlesfinephotographs.com. Image © Tim Roberts.

Mailing list

Every gallery will have its own mailing list, which will include artists, press, critics, funders, supporters, and clients, and usually the gallery will deal with most of the publicity. However, a personal mailing list is invaluable, and every artist should have one which they build up over time and keep up to date. Data protection means that this can only be done with permission from the person added to the list.

This sort of list includes:

- family
- friends
- work colleagues
- curators who have seen the work
- anyone who has written about the work
- anyone who has bought work
- museums which collect similar work or have expressed an interest in the artist
- anyone who has expressed a genuine or informed interest in the work
- anyone whose gallery shows related work or where the artist can realistically see him/herself showing in future
- other artists working in a similar way, with similar subject matter or techniques (for example, it is useful for a landscape photographer to keep in touch with other landscape photographers and keep them informed about the work)
- (if the work is subject-based) any organizations or individuals who work in that field (whether the subject is skateboarding or homelessness, there will be people and organizations motivated to come to an exhibition for what it has to say)

This sort of list has two functions. It is first a list of friends who will be personally supportive and who can be depended on to arrive at a private view in good time and stay late to help clear up if necessary. They can be asked to talk to unknown guests or run out to fetch something and will be there to take the artist out to dinner afterward if needed. They will be knowledgeable and enthusiastic about the work and this will help create a good atmosphere at a private view.

The other part of the list is of people who have been professionally supportive. Keeping them informed means inviting them to every exhibition (no matter if its tiny or in another country and they are unlikely to come) and this is a way of building on their support and keeping them informed and up to date with the work. This is the personalized and targeted list no gallery can duplicate, and it is important that the artist compile it (if someone shows interest in the work ask them if they would like to be on your mailing list and make sure you have this information about people who have bought work even if the gallery has been responsible for sales).

A gallery will usually either ask the exhibiting artists for their list and include it with their mailing or give the artists a number of invitations to send out themselves. If the gallery has the list, it is important that the artist check that the people on it actually receive the mailing. One of the side effects of new technology is that people are less reliant on, and so less careful about,

traditional mailing. If the mail out is electronic then it's a good idea for the artist to do it themselves rather than hand over their list, which the gallery may then continue to use. Put key information in the subject line of the e-mail.

Organizing a mailing

One of the most important things about a mailing list is that it should be kept up to date and be appropriate to your gallery or exhibition; otherwise a mailing is a large expense for what will be an inadequate return. Galleries regularly update their own mailing lists, removing names of people who have left organizations or whose invitations have been returned as 'moved away.' A visitors' book is useful as a way to add to the mailing list names of people who come to exhibitions.

Galleries, magazines, and membership organizations all have their own mailing lists. They are unlikely to loan their lists to you because of data protection regulations. However, they will sometimes agree to include another organization's mailing with their own in return for a fee or practical help with the mailing. This possibility is worth exploring, although it will depend on the proposed mailings being scheduled for the same time frame.

Invitations should be sent out between two and three weeks in advance of the opening night. Unlike press releases, they should not be sent out too far in advance or people will forget about the private view. They can be sent second-class post in the UK, bulk mail or media mail in the USA. Bulk buying envelopes in advance is very much cheaper than buying in small quantities at the last minute. It is also helpful to organize a production line of sorts.

If the invitation is a postcard the printer may include labelling and mailing as part of their service. If you are organizing your own exhibition, and therefore your own mailing, it is worth planning this carefully. Mailings are time-consuming and can be very boring. In one day, two people can insert about 3,000 invitations or handouts into envelopes, attach address labels and stamps, seal the envelopes, and pack them up for the post. Many galleries use volunteers who end up putting invitations into envelopes for hours on end. This is a good way to lose their support. In my experience, the best way to do a mailing is to turn it into a social event. Book a long lunch or an afternoon into everyone's schedule, get them to stop their other work, and spend a few hours sitting around the table catching up on news and gossip while they put invitations into envelopes. Nice food helps. Students or young relatives can often be tempted to come and join in. An event like this forges working relationships and breaks down barriers within organizations and groups. An intern told me that chatting with the director of the gallery while doing a mailing gave her a real sense of the gallery's policy and targets and kept her motivated in her work.

The audience

The aim of publicity is to ensure critical coverage and to bring an audience to the exhibition. But who is the particular audience for your exhibition? How do you reach them? These are crucial questions with different answers for different types of venue.

Taking the work to the audience: Peter Kennard at the stock exchange, London; moving the work with his news truck; Peter Kennard and Cat Phillipps show their collaborative work in Trafalgar Square. www.kennardphilipps.com and www.peterkennard.com. Images © Peter Kennard and © kennardphillipps.

Most established galleries have a regular audience or clientele which they have built up over time and who visit the gallery frequently because they are interested in the overall showing policy of that particular gallery rather than in one particular exhibition. So, for instance, they may well attend a private view and be prepared to pay serious attention to the work of an artist they have not previously heard of because they trust the knowledge and taste of the gallery's director or curator. For exhibiting artists, the priority here is to make sure that the marketing is targeted to reach an audience appropriate to their work as well as to the gallery's usual audience. This means helping to shape publicity material and bringing their own mailing list and knowledge to the gallery so that the mailing is specifically relevant to their show.

A gallery in the foyer of a cinema, theater, or hospital or in a café or restaurant has an audience that will be there for other reasons entirely but will enjoy an exhibition as part of their visit. For exhibiting artists, the priority in this situation is to make sure that their work will attract the attention of a passing audience and also that they invite an audience of their own to a private view or other event. If the venue is local to the artist and the people they invite this should mean that word of mouth will bring an audience in to see the work during the run of the exhibition.

It is more difficult to attract an audience to a show in a new gallery, a gallery that has been hired on a one-off basis, or a space that is not usually used as a gallery. An audience for a new venue will usually take more time and effort to reach than the audience for an established gallery. One possible problem in attracting visitors to any of these venues is that they may miss the exhibition because the publicity takes too long to reach them. To get the timing right, the artist should try to secure pre-opening publicity rather than post-opening publicity and to consider opening the exhibition for longer than the usual three to four weeks to give reviews a chance to bring in an audience.

The moment to consider who the audience for a particular venue might be and how to reach them is while producing publicity materials.

Reaching an audience can be through:

- specialist photographic press
- listings magazines
- local press
- blogs and social media
- the gallery mailing list
- your personal mailing list
- word of mouth
- footfall or walk-ins (casual passers-by who are attracted by the street presence of a gallery)

The first three of these rely on good, targeted publicity material sent out in good time with follow up phone calls as necessary. Mailing lists will bring in a major component of the audience. The key to bringing in an audience by word of mouth is that the show is exceptional in some way—so, for example, I saw an exhibition of ambrotypes in a clothes shop in a fashionable shopping area of London and told everyone I knew would be interested in the technique

or I thought might shop in that area to go and look—but there are very many different things which can make a show different and the publicity should focus on them. Footfall depends a great deal on where the gallery is and what is done to make it welcoming rather than intimidating to the casual visitor.

Attracting a local audience

One of the audiences an artist can reach is a local audience—casual passers-by as well as regular visitors, people who have seen a review in a local paper or heard through word of mouth that the exhibition is interesting. Local audiences are sometimes slightly resistant to looking at artwork, feeling perhaps that it is outside their experience to visit a gallery, so it is worth making a particular effort to bring them into the exhibition.

Local papers are often very interested in covering arts events. An initial press release can be followed up with a phone call to the reporter who covers the arts to invite them to the gallery at a time when the artist or a staff member can take them around the show and talk about the work. If time can be made, this is well worth doing before the show is open—either when it is being hung or even beforehand, by inviting the reporter to the artist's studio or to look at a portfolio—so that an article appears just as the show opens. You probably won't talk to the local press in the same way as to the arts press; in fact, you may need to explain the work in much more detail with the local reporter, and to spend more time on it, since he or she won't necessarily come to the show with an idea of what to write about. The danger here is that not all local papers have staff with any specialist knowledge of the arts, and they may find it easier to write about the artist rather than the art. This is likely to focus on a story with some slight news value that may be completely irrelevant to the exhibition (such as the artist having won a local prize when they were at school or breaking a leg when out taking photographs), so the priority is to try to get the reporter to write about the art and to make the show of interest. You may want to ask the reporter what sort of information might interest the local audience and shape the conversation accordingly. You may also want to have handy a ready fund of stories about the making of individual images, explanations of techniques, the reasons for making the work, and so on. It's crucial to remember that this is being aimed at people who probably do not have specialist art knowledge but may well be supportive of local art initiatives and interested in developing their knowledge.

It is also a good idea to take time to go into the shops, wine bars, cafés, or restaurants in the immediate vicinity of the gallery with a press release and talk to the owner or staff about the exhibition. This is not only polite, but can be very useful. It means, for example, that the gallery is much more likely to get included in local initiatives and marketing events than if it is seen as slightly elitist, as can happen with galleries. It's also a good idea to inform wine bars and restaurants of the date of an opening event so they can be ready for extra visitors. They are going to talk about the gallery whatever you do, so approaching them first makes it much more likely that they will be friendly toward the work. Local word of mouth can be an invaluable way of bringing new visitors to an exhibition and ensuring a friendly reception rather than a slightly suspicious or hostile one.

The Truman Brewery is in a busy area of London frequented by shoppers, artists, and casual visitors and well known as a venue for summer student shows. At other times of the year a sign on the street will attract visitors into the venue. Image © Georgina McNamara.

The exhibition needs to be visible and inviting to people who are passing by. Attracting foot traffic will happen if the street presence of the gallery is welcoming and it is clear to potential visitors that entrance is free and that they will not be pressured to buy work. Many people do find galleries intimidating, and there are number of ways of overcoming this. One of the simplest ways is to leave the main door open. A sandwich board immediately outside can also work well, as can using windows to display work specifically designed to draw an audience in (rather like a restaurant that displays its menu outside). If the gallery is less immediately visible—because it is down a side alley, for example—more thought will need to be given to this, with a sign or poster at the end of the street or planters full of blossoming plants outside the door or large lanterns in the alleyway. At the Margate Photo Festival each venue was marked by a large green helium balloon, which simply and effectively signalled that a wide range of venues

A large green balloon marks a temporary venue at the Margate Photo Festival, is easy to spot and a good way to attract visitors. Image © Natalia Janula.

from studios to empty shops were part of the weekend event. Of course, in any of these situations, the gallery has to be careful not to obstruct the way or complaints may cause problems.

Getting reviewed

In Britain it is notoriously difficult to obtain press exposure for exhibitions of contemporary art. And when you do, it's usually the wrong kind. Unless there's a sensation, a scandal or a silly-season absence of news, many sectors of the mainstream press just don't want to know, and even the most committed of art critics need to be steered, prodded and cajoled—as well as provided with the facts.

Louisa Buck

The trouble with acting like an art historian is that it detracts from the job critics can do better than anybody else, and that is to be lively, spontaneous, impressionistic, quick to the present—shapers, in short, of the mind of the moment.

Mark Stevens

Artists do not usually meet with press or art review writers, in my experience; this is left to the gallery staff or the director. When I was a reviewer myself, I never wanted to meet with the artist in order not to be swayed by my impressions of that person. But perhaps other art writers have different views on this.

<div align="right">Deborah Bright</div>

There are very many different approaches to the task of writing about art. Curators, art historians, and critics will all bring different interests and areas of knowledge, as well as different understandings of their role, to their writing about photography. Writer and critic A. D. Coleman, for example, argued in 1975 that the critic should be 'independent of the artists and institutions about which he/she writes,' whereas a curator is likely to see their role as writing in support of the artists they show or are interested in. (From 'Because It Feels So Good When I Stop: Concerning a Continuing Personal Encounter with Photography Criticism,' in *Light Readings: A Photography Critic's Writings 1968–1978,* New York: Oxford University Press, 1979, pp. 203–14.)

Still, a major aim for the artist is to get his or her work reviewed, and understanding who might approach their work sympathetically is part of this. New exhibitors have a tendency to direct all their marketing work toward one or two major critics, hoping to tempt or persuade them into visiting a show of new work and believing that this will lead to critical success. In my experience this almost never happens. Major critics are busy, inundated with demands, tend to have highly specialized knowledge, and as a rule are expected to write about established artists. Another mistake many new artists make is to think that with sheer volume a publicity mailing will bring in a good response. In fact, publicity targeted more specifically, and followed through with a phone call or email, is more likely to be successful. One good review or informed media mention will be more useful than a scatter of listings information, and it is worthwhile to focus on how that can be achieved.

So what else can you do? Look at the question the other way around: is there a critic who does write about the sort of work you make? Make sure you invite them to see the show. Or do you have a colleague who writes well, understands the work, and might be interested in approaching a magazine on your behalf or writing a review on spec in the hope of placing it somewhere? If you suggest a review and a writer to a magazine, they might accept it if you are able to offer them a package of words and images. At the very least they will consider it seriously.

Marketing exhibitions is about targeting information. One of the key things a good gallery publicist learns to do is anticipate the ways in which a particular show could make an interesting article or mention in a particular magazine. They learn to pitch their talk about the work specifically to whomever they are talking to. This is a skill that can be learned through practice and if you are part of an exhibiting group it will be very useful if all the group members start to develop this skill, work on it together, and brief whichever member speaks to the press appropriately.

Inviting the art world

The art world is an important component of any gallery audience. Arts organizations, galleries, arts educators, and artists working in a similar way to those in an exhibition will be interested in attending an exhibition opening and making contact with both gallery and artist. An exhibition is a good time for introductions and for building a personal mailing list. The art world depends on networking, is very self-aware, and watches what is happening in and around itself. Word of mouth is usually an important element of this and will bring in as many people in the art world as invitations and reviews. When compiling a mailing list, individuals from these groups are crucial and the bigger galleries may well hold separate private views for arts educators with specialized teaching packs provided to encourage programs of visits and workshops.

CHAPTER 14

Thinking about Presentation

White Peak Dark Peak by Paul Hill, installation at Eleven Gallery, London July–August 2011. Image © Maria Falconer.

Exhibiting between 1971 and 2011

When I was first asked to have an exhibition of my work in 1971, I had no option but to use frames borrowed from the local art college by the Wolverhampton Museum and Art Gallery where my photographs were to be hung. On the installation day, I discovered that they were frames used for large posters (clear plastic on hardboard with clips at top and bottom). My pictures looked lost, so I mounted two in each frame using the recently available double-sided Sellotape! At that time there was, amongst photographers of my acquaintance, a reluctance to use wooden frames and glass because it was what printmakers (aka artists) did, and because of the cost. Aluminium frames looked modern, but they were also expensive.

When this work went to the newly opened Photographers' Gallery in London the following year, I asked them to put the prints on the wall and cover each one with a sheet of glass secured by right-angled mirror clips screwed into the wood-clad gallery walls.

A cheap way then was to use hardboard with the glass secured by what (I think) were called Arnolfini metal clips. This reminds me of a show I had at the Arnolfini Gallery, Bristol in 1975. As they had a reasonable budget for the exhibition, my co-exhibitor, Thomas J. Cooper and I were persuaded to use Perspex 'box' frames because it didn't cast a greenish hue like glass was prone to do. What we soon found out was that though this may be true they attracted dust because of the static. I think we used a vinegar solution to try and eliminate this—with little effect!

One of the best mounting solutions was one used by the Serpentine Gallery for their first photography group show in 1973. They stuck each print onto a composition board and sprayed it with clear acrylic varnish. There was a centrally drilled hole in the back, which only needed to be pushed onto a nail on the wall. And it worked! The exhibition toured for two years at least, and the varnish only started to 'craze' around 1990.

What these experiments proved to me was that over-matted prints, under glass in good quality wooden frames, are probably the best solution despite the problem of reflections. And that is what I prefer for smaller works where you have to look 'into' the picture. My much larger pieces, particularly the color ones, look good block-mounted and unglazed, and you, of course, don't see yourself reflected in the image—and, in addition, there is no glass to break!

Paul Hill
www.hillonphotography.co.uk

At the end of the day it's all about editing, scale, and presentation. And that is as important as taking the photograph in the first place.

<div align="right">

Camilla Brown, Senior Curator,
The Photographers' Gallery, London

</div>

Presentation is crucial to the installation of photographs in the gallery. Photographers talk about the presentation of their work all the time, unlike painters and sculptors for whom presentation is usually a secondary consideration. For both curator and photographer discussion of different options in mounting, framing, sizing, and editing or sequencing work can be as important as discussion of the photograph itself.

There are a number of possible reasons for the fact that this is so important to photography. One is that the gallery has the task of changing or challenging an audience's usual relationship with the photograph. It has become a cliché to observe that we are surrounded and bombarded by photographs and, as Victor Burgin pointed out in the 1970s, 'It is almost as unusual to pass a day without seeing a photograph as it is to miss seeing writing. In one institutional context or another—the press, family snapshots, billboards, etc.—photographs permeate the environment, facilitating the formation/reflection/inflection of what we "take for granted."'

This everyday quality of photography, the fact that we are so used to photographs that we take them for granted and assume that they can be read and understood quickly, means that a gallery or curator will have to work to make a space in which the photograph will be looked at differently, more slowly and thoughtfully. Even if the photograph is from one of the contexts Burgin mentions, if it is a press image, a family snapshot or taken from an advertising campaign, it will have been taken out of this original context and represented in the new context of the exhibition. The method of presentation has to create a new way for the audience to view the photograph and also make it clear that, as audience, we are being asked to take the time to look and think about an image which we perhaps would have barely considered previously. There are very many ways in which the curator can work with this issue but a starting point is to make a physical change (in scale, print quality, and framing, for example) from the way the image would originally have been seen.

Photographer and writer John Stathatos has called the way in which the photograph can shift its meaning depending on its context 'photography's polymorphous perversity.' One of the tasks of the curator is to create a context for an image, set, or series of images. This depends on many things of which the most crucial are the gallery space and exhibition concept and text which, as it were, set the scene in which the images will be read and understood.

Another reason for the centrality of presentation to the curation of photography is that, in the long struggle for photography to be accepted fully into the gallery system and art market, it has had to make visual claims for itself as art. Photography, as a relative newcomer to the gallery system, has had to make a case and a place for itself in order to be taken seriously. This has meant that in the past photography curators have borrowed heavily from the conventions of art display and, in particular, used scale, formal framing, presenting

works as if they were paintings, providing critical support and creating a certain precious-ness around the work. This in turn created a type of presentational orthodoxy. It is only rela-tively recently that photographers such as Wolfgang Tillmans, Fiona Tan, and Joachim Schmid have been among the many active in challenging the conventions of photography display by pinning, taping, and tacking images to the wall and finding other ways to remind us that the photograph is simply an image on a piece of paper and can be shown in a way which reminds us of its ephemeral qualities and its capacity to speak very directly to the viewer.

So scale, context, sequence, method of mounting or framing, the amount of space around an image, and the relationship of the image to the mount or the wall are all key to the way in which the work will be presented and read.

Fashions in exhibition presentation

It is useful to be aware that there are also fashions in exhibition presentation. These change year on year as new ideas and techniques of showing are developed. The most traditional method of presentation is for every print to be shown at the same size in the same type of frame and shown in a single or double stacked narrative line on the wall. More recently work has been presented mounted on aluminium and without border or frame. A few years ago at an exhibition of work from recent postgraduates, the curator pointed out to me that, for the first time in some years, almost every image had a border and was in a frame and suggested that exhibitors were abandoning aluminium mounts. More recently much of the work I have seen has been shown with the minimum of presentation—framed without glass or without a mat or face mounted onto Plexiglass—to create what almost makes a convention of an anti-presentational approach.

The Victorians borrowed from fine art conventions of their period and hung photographs close together from floor to ceiling without greatly considering how each photograph impacted on its neighbour. From 1905 Steiglitz showed painting, sculpture, and photography in mixed exhibitions at 291 Gallery in New York as part of his ideal of getting photography recognized as a fine art. After World War II, design conventions started to shift as increasing magazine production and popularity impacted on exhibition design. In 1955 *The Family of Man* exhibi-tion drew its design from the conventions of magazine layout. This touring exhibition, curated by Edward Steichen for the Museum of Modern Art in New York, remains the exhibition which, with an audience of over nine million worldwide, has been seen by more people than any other. Since Steichen's intention in the postwar era was to make universal statements about the condi-tion of mankind the picture magazine layout would have been a design convention that was familiar to the audience in the many countries in which it was seen and by relying on this set of conventions the exhibition became much more universally accessible than it might otherwise have been had a different display mode been chosen.

By the 1960s and 1970s, many photographic exhibitions were routinely hung in regular rows of light aluminium frames. If the presentation seemed dull and conventional there was good

reason for it in that photographs were still not regarded as art and therefore to use the most conventional exhibition design made a statement that this work was to be taken seriously. As Deborah Bright points out, this also 'reflected the dominant aesthetic idea of photography's having an inherent formal language distinct from that of painting and the other graphic media. So having all the prints more or less the same scale and in black and white showed this to advantage.'

However, from the late 1970s, as Douglas Crimp describes, in *Photography at the End of Modernism*, the radical reevaluation of photography meant that 'photography took up residence in the museum on a par with the visual arts' traditional mediums and according to the very same art-historical tenets.' This meant that as exhibiting photography became much more common practice the styles of showing could become more diverse and experimental. Changes in ideas of photographic presentation reflect the new capabilities of digital technology and, more important, the increasing centrality of the fashion and advertising industries to postmodern discourse and art in hyperconsumer societies.

In practice presentation can be a complex issue for the curator and photographer. While the ideal is simply to use presentational methods to show the work to its best advantage there are very many different considerations to take into account when showing work—not the least of which is that the presentation is in itself a statement about the contemporaneousness of the work.

Understanding presentation

There are conventions of exhibiting that most of us are probably not very aware of when we visit a gallery. Most of these are designed to habituate visitors to the experience of looking at exhibitions and make it easy for them to concentrate on the work. One example of this is that exhibitions usually start on the left side of the gallery and the audience is expected to move from left to right or clockwise round the gallery. Another is that captions tend to be placed immediately underneath an image on the left hand side. We also read from left to right so the reason for both these standard practices is probably that they duplicate the way we read and make us feel more at ease and familiar with the process while looking at photographs.

New exhibitors often feel that they can pose a radical challenge to convention by breaking the unwritten rules of exhibiting and that their work will appear fresh and vital and attract publicity as a result. In my view this can be a mistake and one that may result in the exhibition being ignored or seen as amateur work. It can also undermine the seriousness of the work. My advice to anyone who is new to exhibiting their work is to follow the conventions of exhibition and work within them until you are able to break the rules with panache and take the audience with you in your rule breaking.

In fact strategies to break the conventions of showing are difficult and complex to devise and are often risky in that we cannot necessarily anticipate how an audience will react. What seems obvious to someone who works with visual images may simply be missed by someone who is not conversant with gallery practice. In the early 1980s, for example, I worked at Camerawork, a gallery on a major shopping street in the East End of London. We showed mainly

documentary photographs and had pioneered a practice of laminating photographic exhibition panels under plastic so that they were light and as a result could be toured to other galleries easily and cheaply. We also believed that the use of rather downmarket laminated exhibitions rather than more formal frames made the gallery seem a relaxed and informal environment and that shoppers would drop in to look at our exhibitions because of this. In fact the opposite was true and there were sometimes disappointingly few local visitors. The gallery was in an area of town that had no other galleries and it was only when we exhibited conventionally framed photographs that I discovered that our local audience, unused to having a gallery in a street of shops, understood that the convention of framed photographs signalled an exhibition and felt welcomed into the space. For them the laminated panels were off-putting for the very reasons we had thought that they would be attractive.

Another example of this is exhibition invitations. People often want to make these as eye catching as possible and experiment with design graphics and photographic references to do so. In my view this is frequently misplaced effort. A strong and interesting image gets an audience to the exhibition every time.

Robert Mapplethorpe is a good example of an artist who was able to use the conventions of photography to good effect. Although many people found the content of his work offensive, the fact that it was very conventionally and formally photographed as well as beautifully printed and displayed meant that it could be defended as art despite his subject matter. Exhibiting photographers can learn a useful lesson from Mapplethorpe. His potentially difficult and controversial subject matter was made more accessible to a much wider audience by the conservative way he handled it.

Other photographers have also been strategic in their use of the conventions of the art world. As Vicki Goldberg points out (in *Light Matters,* 2005), 'Over the last twenty-five years, color photographs bulked up on steroids. Thomas Struth's reach 7½ by 6 feet plus; some of Andreas Gursky's are 16 feet wide. They have prices to match. They are no longer just big enough to hold their own with art on the wall; now they require mansions, where they elbow paintings out of the way.' (*Gursky's Der Rhein 11* sold for over $4 million in 2011.)

But, perhaps, now that photography has the confidence to 'elbow paintings out of the way' new approaches to the presentation of photography have become possible? Perhaps, too, audiences for photography have acquired a familiarity with looking at work which makes it more possible to reflect photography's multiple and ephemeral nature and to show vernacular and fine art photography equally but using the presentational methods appropriate to each? There are no simple answers to these questions because, while photographers can take more risks in showing work and audiences may be more accustomed to a wide variety of modes of presentation, a selling exhibition may still depend on traditional framing of the work.

So it is useful to understand in planning an exhibition that presentation plays a crucial role and that the conventions of exhibiting do, as a general rule, make it easier for an audience to focus on the work and understand the photographer's intentions. While there can be good reason to challenge or change them it can sometimes be counterproductive to do so and a great deal depends on the circumstances in which work is shown. Curiously, it is often easier for the bigger

and more established galleries to take risks with the conventions of exhibiting, simply because they are established and so audiences will do more work to understand an exhibition than they might elsewhere. Small galleries or new exhibitors take a bigger risk in challenging exhibition convention and may be unwilling to take the risk of alienating their audience. On the other hand, of course, they may see this as an important part of their role and be confident of their ability to take an audience with them.

The photographer, then, has to take into account what the work demands in terms of presentation as well as how the presentation locates the work historically, ideologically, and in or out of the market place. In planning an exhibition every aspect of the presentation will play a part in this.

Travelling and exhibiting

> One body of my work which has travelled extensively demonstrates the way that a show often has to be rethought, resized, and reframed to suit each different gallery space and showing situation. Everyday Dada is a series consisting of around fifty images arranged into four sections (or chapters) and the work has been seen very differently in each of five shows.

Serving Suggestion 1 from *Everyday Dada*, 2005. Image © Sian Bonnell.

From *Everyday Dada*, curated by Beate Cigielska for Galerie Image. Image © George Meyrick.

A small selection of images from it was first exhibited in Galerie Image in Aarhus, Denmark in March 2006. Working closely with the curator, Beate Cigielsksa, who ran the gallery, we selected images specifically to fit the space—three images to be made very large (approximately A0 in size) and mounted under Plexiglass; five medium sized images were sized at 30 × 24 inches and flush mounted onto aluminium and ten smaller images (approximately 12 × 10 inches) were mounted and framed.

The same images were used again for a second exhibition curated by Ute Noll for Kunstlerhaus Mousonterm in Frankfurt, Germany in May of the same year. This time the small images were removed from their frames and flush mounted on Foamex (a much cheaper material than aluminium) because the original frames and mounts looked clumsy in the more minimal aesthetic of this gallery space. For this show we also added in twelve very small black-and-white images in white boxed frames which worked well in the new exhibiting context. These images were featured in a weekend supplement of Frankfurter Rundchau, the scale of which changed the context for the work but created a lot of interest prior to its opening.

After the Frankfurt show had opened, a selection of these images was featured in an online exhibition in Germany On-Photography.com at the same time. Because of the

From *Taglich Dada*, curated by Ute Noll for Kunstlerhaus Mousonterm. Image © Sian Bonnell.

Images from *Everyday Dada* shown in Domestic Interiors, curated by Celia Davies, The Regency Town House, Hove, UK. Image © George Meyrick.

difference in scale as well as being on screen the context for the work was different again, as was the audience, and this had the effect of opening up debate around the subject area (as well as causing some controversy in the subsequent online discussion).

In October 2007 the work was shown to coincide with the publication of the book FOOD, by John Knechtel of Alphabet City. It was shown at CONTACT Gallery, Toronto, Canada and featured in a photography festival to coincide with the book launch. Because of shipping costs we decided to send a roll of unframed and unmounted images which the gallery then framed. The same work was then shown at the Light Factory in Charlotte, North Carolina in 'Food for Thought' curated by Ariel Shanberg. This worked well as the institutions shared the shipping costs.

In May 2011 the work was shown in Domestic Interiors: Regency Town House, in Hove, England. For this show, three of the existing middle sized aluminium mounted images were exhibited along with a new set of slightly larger prints which were made digitally from the same series. These prints were unmounted but placed in the original frames from the first Aarhus show, so that they were in fact boxed within these frames.

Sian Bonnell
www.sianbonnell.com

Case Study Six

Bridget Coaker: Troika Editions: How to Start an Online Gallery

Let's start a gallery. Let's do it online. Let's launch it during a recession

Troika Editions was founded in 2009. The brainchild of photographer Michael Walter and me, it grew out of our deep personal interest in art photography and our very practical need to find an alternative business to our press agency. Michael had studied print making at the Slade and I had begun my working life in a print gallery but we had both subsequently moved into journalism where our paths crossed when working at The Press Association.

In 2000 we decided to start our own photographic agency—Troika Photos. We wanted to follow the well-worn path of producing good photojournalism; large scale images for the newspapers and photo essays on international stories. Our first forays into this world met with great success. Michael's previous experience of working in the Balkans in the early 1990s led us to cover the collapse of the Milosevic regime in 2001, resulting in the cover of *Time* magazine and consequent assignments from *The Guardian* and *Newsweek*. Further work both in the UK and abroad, such as during the Iraq War and conflict in Darfur, suggested to us that our choice to go it alone, outside of the major agencies, had been the right one.

But in 2007 we began to see a decline in revenue from the newspapers. Well ahead of the actual collapse of the banking system in September 2008 the printed media were already suffering from reduced advertising spend and declining circulation figures. It was clear that the message had gone out to many of the picture desks to stop spending money.

We had some stark choices to make about how to make the business survive. Should we change the type of editorial work we had been doing, should we go into video, should we shut up shop or should we consider doing something else photographic?

Our principal ethos for the photography agency had always been about the integrity of the image. We had never wanted to be a stock agency producing filler images, which whilst lucrative, was not something we had any interest in and consequently were not very good at. We had always wanted to produce photographs that demanded space on the page. So it was not very surprising that in our discussions about future plans it was our passion for the photograph itself that dominated our thoughts and ultimately led us towards considering ideas around contemporary art photography.

Osmosis, rather than a ruthless business strategy, best describes our approach to developing new projects. Ideas abound in the office, some get discarded very quickly whilst others linger, forming the nucleus of something bigger.

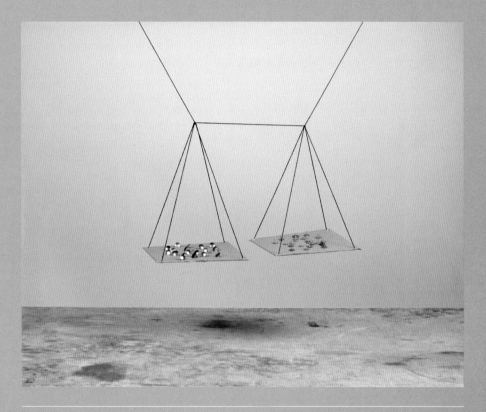

Acutomancy by Victoria Jenkins Courtesy of Troika Editions.

Ideas don't happen in isolation and are often prompted by external stimuli. One such provocation was the Royal College of Art's annual Secret Postcard sale. The frisson of buying something blind in the anticipation that it was by someone famous was great but what I was really interested in was the idea of buying art at just £40.

I kept coming across references to affordability and art. The Affordable Art Fair was really coming into its own, selling work from just £40 and for no more than £3000. In the US, a number of websites had launched selling art online, at affordable prices. They appeared to be doing very well. And so one of our ideas moved beyond the tentative stage and gradually began to form itself into something more concrete—an online gallery, selling contemporary art photography at affordable prices.

We started by looking into the market in the UK for selling art photography. Searches at Companies House suggested that in 2007 The Photographers' Gallery had turned over £1 million across their bookshop and print gallery, which was very encouraging. The newspapers were full of the buoyancy of the art market with record prices being reached at auction for photography. Photography was the new black.

In the US it was clear that online galleries were doing well and with a belief that if you could sell art online it would be photographic art, better suited to being presented on a screen than painting or sculpture, we started to approach photographers to discuss

Saved items

You can easily make a gallery of your favourite photographs or collect books to browse later. Simply click the "save photo" or "save book" link next to the item.

Bill Jackson
Shoes

» enlarge
» remove photo
» artist video

Matthew Booth
Untitled Interior #1

» enlarge
» remove photo
» artist video

Jan Dunning
Bedroom

» enlarge
» remove photo
» artist video

Bill Jackson
Four Eyes

» enlarge
» remove photo
» artist video

Zhang Xiao
Coastline 12

» enlarge
» remove photo
» artist video

Noemie Goudal
Dominique

» enlarge
» remove photo
» artist video

Don't forget

A saved photo is not a reserved photo. The edition may sell out!

Latest editions

view »

Katrin Koenning
Two Women

BUY

Katrin Koenning
Woman with A

BUY

Katrin Koenning
Lone Woman

BUY

Recent Editions

This month ▶

November 11 ▶

September 11 ▶

August 11 ▶

May 11 ▶

More editions ▶

Quick Links

Submissions & Reviews ▶

Critic's choice ▶

Collections ▶

Follow us on twitter! ▶

Contact ▶

Sign up for newsletter ▶

taking their work. At the outset we decided that we did not want to take the traditional approach of representing artists, which would have meant taking most of their work. Instead we wanted to hand pick a small number of images from each invited artist that we would sell, sharing the profit 50/50.

Our idea was to post up each week a new set of images by a different artist, gradually revealing our catalogue of artwork. We also started out with the idea of being a broad church in our choice of photography. We were very clear that everyone we invited to join Troika Editions had to be a practicing artist and must have produced a coherent body of work, but we were not overly proscriptive on the type of genre. So initially we looked at documentary through to conceptual work. Our mission was to promote photography itself rather than any one aspect of it. (As it turns out that has changed over time and today we only take work that we describe as expressive, but more of that later.) We had also decided that Troika Editions would be a curated site and not a general submission space. We felt it was important that our voice and experience lent authority to the quality of the art presented.

In looking at other online spaces we were surprised by the lack of in-depth information about the work being sold. We wanted Troika Editions to be more than a shop and so

Precarious Rooms: Bedroom by Jan Dunning Courtesy of Troika Editions.

we decided to produce reviews and detailed c.v.s/résumés of each artist, enabling people to read about the work and discover something about the person who had made it. By providing a context for the selected artwork and a background to their practice we wanted to encourage our visitors to the website to view the work seriously. This we felt was all the more important because we were representing photography, a medium not always taken seriously as art. We were also very interested in using the properties the web could offer and in particular the ability to embed video onto the artist's page. Including video has turned out to one of our most important decisions as it offers visitors to the gallery something they can only get in the virtual world, making the online gallery experience something special.

Affordability was one of the cornerstones of Troika Editions; we wanted to reach a new audience offering them an easier and more affordable access to the art market. One way to do this was to produce a large print run and sell them at a low price. Within the gallery world this is of course controversial and many people advised us against it, arguing that it would deflate the market and people would not buy the more expensive and larger prints. Artists are generally advised to keep their edition numbers low in order to produce rare objects and thereby justify higher prices.

The whole question of editioning opened a can of worms and researching the subject did not provide us with a very clear answer. Within photography you can buy a vintage print which may or may not be in a limited edition, which may or may not be reprinted at a later stage by a different printer. You can buy unique photographs that will never be reproduced. Some artists produce their work in just one print size, others produce two or three different sizes. So faced with such a variety of responses on how to reproduce and limit photographic prints we decided to look at the traditional printmaking market for clues as to how to limit the print runs.

The concept of a limited edition object has its roots in the technical constraints of traditional printmaking. Before the invention of lithography and photomechanical processes, which enabled true mass printing, there were two forms of producing prints; either the intaglio methods (etching, engraving, or dry-point) or relief printing. In both processes the plate degrades as each print is made, necessarily limiting the number of prints that could be made from any one plate. It was not a predetermined number that introduced the concept of limited print runs but the production process itself.

The modern printing processes of lithography, silkscreen, and photography can theoretically produce unlimited print runs, and so we had a look at some of the contemporary printmakers. As in photography, there was no clear practice and print runs varied from 25 to 300+. So we decided to stick to our original idea that to offer a print run of 300 at an affordable price was an acceptable way forward. We also decided to offer the same image as larger prints at higher prices and in smaller print runs.

We had done most of our investigations, commissioned the build of the website and ordered the stationary well before the recession started. By January 2009, however, it was clear that the drop in the global stock markets, collapse of the UK banks, and onset of the recession would have a direct impact on our launch of Troika Editions and we had to decide whether to mothball the project or go ahead in a hostile market.

This was a very difficult call to make. To launch would continue to give our bank balance a hammering but to do nothing seemed to be a waste of what we had created and so we decided to go ahead. In the maelstrom of the global financial meltdown we posted up our first limited edition prints in April 2009. We did not exactly launch with champagne corks popping, but neither did we launch with a whimper and in the first week we sold our first limited edition print online.

At the beginning of our venture a close friend had told us that Troika Editions would change beyond recognition within two years. While much of the website still looks the same our ambition for the gallery has changed and in some ways beyond recognition. At the beginning we were adamant that we would only ever be online, but in June 2010 we opened a small gallery in Clerkenwell where we have put on a number of themed shows, drawing on the work we have up on the site.

We have entered into partnerships with the FORMAT International Photography Festival and the online magazine *1000 Words* to provide them with a portal through which they can sell their own collections. We have stopped posting up new work every week and are now in discussions with some of our artists about representing them in the manner of traditional gallerists/agents. We have attended art fairs. We have launched a series of artist talks and we offer portfolio reviews and artist mentoring.

We have combined the real and the virtual world in order for each to complement the other. We have collectors who will only buy when they can see the print first, in the gallery or at an art fair, but we also have collectors as far afield as Tokyo, Sydney, and New York who browse the website, watch the videos, and click on the shopping basket.

One of the areas we have changed the most is the type of art we select to showcase on the gallery. We have developed our own gallery style and our 'eye' can be seen in the type of work we seek out, which can best be described as expressive photography. In much in the same way as a painter uses a paintbrush to make a mark on a canvas or paper, many artists are now approaching photography in the same way, using the camera and/or film to articulate their visual and conceptual ideas. This is an exciting time in photography and a central debate today is the question of how comfortably conceptual and constructed photography sits within our idea of what art photography is and should be. There is a discernible move away from the strictly documentary form, which has dominated the medium since the 1970s and for a new wave of artists working with photography, the quest to present images of reality and truth has been overtaken by their desire to produce work that deals directly with concepts of expression and imagined realities.

We have decided that our interest lies with artists who are choosing to move the photograph beyond the document and explore the possibilities it can offer them in expressing their visual ideas.

When we started Troika Editions, our research suggested that we had found a good business alternative to the editorial agency. But this was before September 2008 and the collapse of Lehman Brothers. This side of the financial crisis we are more sanguine about how long it will take us to make the project profitable. It is clear that even those

Black Landscape #2 by Aliki Braine Courtesy of Troika Editions.

established models clearly doing very well before the autumn of 2008 are finding that life is tough post crash.

If a recent article in the *New York Times* (21 June 2011) is to be relied upon then there are green shoots for the art industry and in particular selling art online. Artnet, the online auction house, established in 1999 has struggled to turn its auction site to profit, but projects that they will begin to turn a profit towards the end of 2011. Elsewhere, a number of galleries have started to sell online, including large publicly funded spaces such as The Whitechapel and The Photographers' Gallery. All of this seems to suggest that the future must include an ability to sell online and that art buyers will accept this as a legitimate way to make their purchases along with their books from Amazon and food from Waitrose.

Bridget Coaker

www.troikaeditions.co.uk

CHAPTER 15

Pre-Planning: Using the Exhibition Space

Contemporary Media Practice students show in a yurt at P3. Image © Dave Freeman.

Having access to one of the largest exhibition spaces in London is exciting for a degree course, such as Contemporary Media Practice at the University of Westminster, but also a real challenge.

Most of the student work is film and video, complemented by 2D photography and multimedia installations. The P3 space which used to test concrete structures for Spaghetti Junction for civil engineering, while being excellently located opposite Madame Tussaud's, dwarfs even the largest 2D work and doesn't lend itself to screen based work. In 2011 rather than running separate shows of varying media we made a decision to place a yurt in the center of the P3 gallery. It not only acted as an organic focal point in the large rectangular space but also provided a space where audiences could chill out and spend time with the film program which was ten films totalling two hours duration. With a student discount and an enthusiastic promoter at Yurtsup, lots of cushions and an HD projector the high quality of the film and video work was apparent to all comers and the aesthetics of the yurt were universally popular, and crucially the whole project came in within budget. Over many years exhibitors have tried to tackle the enormity of this space; Kinetica by filling it up, Spruth Magers laid a carpet and turned down the lights for Anthony McCall. The yurt was a third and highly successful option. If we do it again? Aircon in the yurt, and an even bigger tent!

Graham Evans

I could never bear unnecessarily elaborate installations—designers who impose their 'look' on an exhibition instead of letting the work speak. It's very much a museum thing to do with a perverse notion of increasing accessibility. It says to me that the museum doesn't have confidence in the work.

John Gill, Director, Brighton Photo Biennal

I think you get to see more when the pictures are bigger. I always want you to feel like you're in the room with that person. It should look like real life.

Tina Barney, photographer

Preplanning

Planning the exhibition hang should be undertaken long in advance of the exhibition date. It's useful to start work on it as soon as the venue is confirmed because the hanging plan determines the final content of the exhibition and which images are to be printed and therefore the timetable and budget—getting this right from the beginning saves time and money later. There will be time to review details of the hang before the work goes on the wall but the main decision making is best done early on.

A 'good hang' is one of the most important aspects of an exhibition. A good hang will work at a fairly subtle and unconscious level and show the work in a way that seems natural or inevitable, as if each image is in its proper place and this is the only way that the work can be shown. The task is to plan the overall look of the exhibition and its impact in the space as well as to sequence and juxtapose the work in such a way that the audience will progress smoothly from one image to the next. The hang should focus an audience's attention on the work itself rather than the multiplicity of possible distractions. When a show has been hung badly an audience will lose interest, feel uncomfortable with the sequence of images, or feel that they have somehow missed the point of the exhibition.

A good hang takes time and careful thought and combines awareness of the work and of the space it is placed in. A space can, and should, dictate the way work is shown, and every aspect of the presentation has to be sympathetic to the size and atmosphere of the space as well as to the work itself. The photographer should bring some strong ideas of how the work might best be presented, or how they would like the work to be presented, to the discussion of the hang. The curator should bring an ability to speak on behalf of the audience for the exhibition and an awareness of how the gallery space works in practice.

The person who makes these decisions varies from gallery to gallery. Ideally, it's a collaboration between photographer, curator, and exhibition designer or technician. Large institutional galleries may employ exhibition designers who select frames and organize the sequencing, size, and placement of photographs as well as the placement and style of accompanying texts. However, in some large galleries the hang is entirely decided by the curator, supported by in-house exhibition technicians rather than designers. In most galleries, it is a negotiation between curator and artist, and in small galleries the artist may be expected to organize and hang the work by him or herself.

The sequence of planning an exhibition installation is as follows:

- look at the space—measurements, ceiling height, atmosphere, and if it dictates the way an audience will move around it (to consider how best to use it to show this particular body of work)
- look at the work (to see what it will dictate about the use of the space and number of images)
- group the images (according to the dictates of the work and of the space, the number of walls and the way it is divided)
- decide on frames, picture sizes, and presentation methods
- plan a hypothetical hang on paper
- allow time to reconsider the plan once the framed work is in the gallery and the actual hang is about to start

Two key issues should be resolved by this process:

- how many photographs will be shown and at what size
- approximately which photographs go where in the gallery and/or how the images will be sequenced

For some exhibitions, a final hang can be decided at this stage, although for others this will wait until the actual installation of the work. Initial ideas about placing photographs may change, though usually fairly minimally, during the actual hang, and sometimes the decision to leave certain photographs out of the exhibition is made at this later stage. This is because, in essence, a hang is dependent on seeing the actual photographs at full size in the real space which can usually only be done at the start of the hang. No amount of previsualization or preplanning can accurately duplicate this experience. Most curators will make an initial plan but leave enough time to rethink a hanging plan during the hang so that the final version shows the work to full advantage and makes the best possible use of the space.

Gallery Exhibition Spaces

A floor plan is an essential to planning an exhibition hang because of the need for precise measurement and because most of the planning may well take place away from the exhibition space so the floor plan will provide an accurate guide to what is possible. Image courtesy of Street Level, Glasgow www. streetlevelphotoworks.org.

Step one in exhibition design: the space

When starting to design an exhibition, the curator needs to spend time familiarizing him or herself with the space and to take account of several things:

1. The size of the space (ceiling height as well as wall space)

Gallery size is estimated on running wall space. This is the amount of wall space available to hang work on, so it excludes windows, doors, 'dead' or unusable space (small areas between windows or behind doors, for example) and pillars. It is measured horizontally rather than by square footage. Knowing the amount of running wall space allows the curator or exhibitor to estimate how many photographs can be shown.

Most galleries have a floor plan, which usually includes wall measurements with windows, doors, pillars, and electrical outlets and lists any additional freestanding panels or flexible wall systems that can be rearranged.

If you are curating your own exhibition, you will probably be doing most of the planning when you are not actually in the gallery space, so it is important to have a floor plan to work from. Photographs are also useful, though they can be misleading when it comes to size. I have also known people who worked with scale models. It is surprisingly difficult to remember a space accurately when you are not in it and very easy to miscalculate the number of photographs that will fit on a particular wall, so a floor plan is crucial and you should draw up your own if necessary.

It is also crucial to know where the electrical outlets are, particularly if projectors, light boxes or plasma screens will be needed in the exhibition, since they will probably have to be installed near those outlets. No gallery can risk the danger of trailing wires which could trip the unwary visitor. The lighting situation also needs to be checked in case the lighting is uneven and there may be places where it would be inadvisable to hang very dark images. Both things can be entered on a floor plan.

2. The space itself and its feel or atmosphere

Just as important is the 'feel' of the space, its atmosphere, and the way it works visually. A great deal of thought has to go into getting the best use out of the space. Most spaces dictate the way exhibitions are hung to a certain extent. For instance, a formal space—such as a perfectly proportioned, purpose-built gallery—may suggest the work should be hung formally in straight lines or a grid pattern. An informal space, such as a corridor or an unusually shaped room, may suggest that the work could be hung more experimentally. Alternatively, the curator may decide that a formal hang in a formal space will make the work look dull and so hang the work in a deliberately informal or apparently random way. Or the curator might decide that the informal space needs a formal hang in order to overcome the haphazard layout and so hang the work in a straight, evenly spaced line which takes no account of uneven floors, unexpected steps, or turns in the corridor but keeps the audience's attention on following the line set by the photographs. Whichever decision is made, the final installation will be a negotiation between what the space and the work each suggest. The crucial thing is to take the space itself into account when looking at exhibition design.

On a practical level, spaces that are built to show art or that include large, uncluttered rooms are usually easier to work in and it is more challenging to work with spaces that were not originally designed as galleries but have been adapted. Such spaces can have awkward areas with quirky corners, curving walls, large or unevenly spaced windows, and pillars impeding sight lines although an awkward space can be an advantage rather than a problem and add to the interest of an exhibition, if used imaginatively. Where a large space can intimidate the visitor, a series of smaller spaces can be intriguing and give the visitor a sense of privacy in which to respond to the work. This may mean that they feel more able to pause, meander, and take their own time to view the art rather than succumb to the relentless few seconds in front of each image that large galleries sometimes seem to impose.

An experienced curator gets to know and understand the way the space works by spending time in it and looking at it from every angle, walking around it, and seeing what the space itself dictates. Where does the light fall? Where does an audience coming into the space tend to look first? Where are the sight lines? Do certain walls need to be used in particular ways? Will a straight line of photographs work if the ceiling line curves? Is there a danger that the audience could miss parts of the exhibition because of the layout? Might a low ceiling, uneven lighting, or a dark floor create a slightly oppressive atmosphere that will not suit particular photographs? A curator at The Photographers' Gallery told me that one of his achievements was to lay a temporary floor over the gallery floor when he recognized that a particular exhibition of light and delicate imagery would be overwhelmed by the dark gallery floor.

Again, when planning to design your own exhibition, you will need to note strategic places to hang key works, places where a pillar, alcove, or doorway could get in the way of the sequencing of the work, odd spaces that will need to be used in a different way to the rest of the hang, and where you can't hang the work into the corners.

3. The flow of the space or how a potential audience will move through the gallery

The 'flow' of the exhibition is how your audience will move around the space and how you keep them interested in seeing the whole show and in moving from one piece of work or area of the exhibition to the next. In most spaces the audience will move in a clockwise direction, that is, from left to right so the exhibition hang starts on the left. Occasionally a space will have a different logic to it so it's always important to work it out. It is also particularly important in non-gallery venues like old factories or shops that have odd spaces or several floors and you have to make sure people get from one space to the next. In most galleries the flow is dictated by the space itself and by the placement of items like the reception desk, office doors, and internal staircases. I experienced how this can go wrong when I went on a bus tour at the opening of a photography festival in a city I didn't know with a group of critics and curators. The first exhibition we visited was in a converted shop. The shop was long and narrow, and I followed the people in front of me as they moved around the exhibition. I found myself back at the bus quite quickly, so I returned to look for more work but could find nothing. There was no list of exhibitors so I had no way of checking whether I'd missed something. Later I found out that there had been more work on a different floor, but the door was unmarked and had been accidentally closed behind one of the visitors.

As a result, more than half our group on the whistle-stop tour had missed a sizeable part of the exhibition, and there was no time to return and see the rest of it. This situation could easily have been avoided if the exhibition curator had thought to continue the work up the staircase, fix the door open, or attach a sign saying 'exhibition continues upstairs' by the door.

In addition to making sure the audience moves easily from one space to the next, the curator thinks about how the audience will move from one image or set of images to the next. To make the flow work, the images should connect visually or by subject. This need not be subtle and can also simply be about juxtaposing different bodies of work that will be sympathetic to each other.

The curator should also be thinking about the overall look of the whole space. Standing by the entrance and imagining how the audience will be drawn into, across and through the space is a good way to do this. Often this means putting a large and striking image at the far end of the space to attract the visitor right across the gallery. One year at Photo London, for example, when a whole vista opened up through doors which led through room after room with only the end wall visible from the main doorway Hoopers Gallery placed a single, large, predominantly red image in that space so the audience, who were too far away from the image to see it in detail, found themselves drawn through all the other exhibitors' spaces to look at that one, dramatic image.

4. Information points

Thinking about the flow also includes planning the placement of captions and any text and information panels. It is essential that this is taken into account at this early stage, even though the text may not yet have been written, because space has to be allocated to these panels. An approximate calculation of what text will be necessary can be made and the panels placed within the overall design. The number of text panels designed into the exhibition at this stage will then dictate the amount of text that will be written, and it is important to get it right. Few galleries have the sort of flexibility of space to allow extra text panels to be inserted at the last minute.

Text usually includes a panel at the beginning of the exhibition which acts as an introduction and context. There may also be a panel at the end with thank you to sponsors, logos, and credits for work done on the exhibition. Text panels can utilize a gallery's dead spaces; these are spaces that are too small or too awkwardly placed to show photographs. Text can also be a way of dividing different sections of an exhibition and marking the introduction of a new exhibitor, a new concept, or a new period of time in a chronologically ordered exhibition as well as letting the viewer know where the exhibition starts.

Placing captions, usually immediately under the image on the left side, has also to be considered at this stage. Consistency is the most important thing here because if the audience has to search for each caption their attention gets distracted from the image and so if space is tight or frames are butted up then a way needs to be found to create the same image-caption relationship across the exhibition. This may mean stacking the captions—again, this is usually done to the left of the photographs so the captions are read before the images.

5. Practical issues particular to that space, such as the condition of the walls or floor

This early planning stage is when the exhibitor or curator should ask practical questions of whoever is responsible for the hang. This may mean talking to a gallery manager rather than the director or curator. The aim is to find out what systems are in place, who does what, what they expect of the artist, what technical help and equipment are available (does the gallery have a toolkit or long ladders, for example) and to check timings (for example, what hours do the technical staff work or is the gallery open for work to be delivered or installed on the weekend). It is also essential to check if there are fire, health and safety, or other regulations about what you can and cannot do in the space. This might mean knowing what notices can and cannot be removed, which exits have to be left completely clear, and so on. One of the biggest mistakes I nearly made was many years ago when I took an exhibition to the Royal Festival Hall on London's South Bank. We had drawn up our hang fairly precisely. The largest piece was a single image approximately 16 × 12 feet and there was only one wall where it could be installed. Unfortunately no one had thought to discuss this in advance. We discovered on the day of the hang that the Royal Festival Hall is a Grade-2 listed building, which means that no one is allowed to drill into the original structure, but there was no other way to secure the piece to the wall. In the end, after a long day of discussion, the gallery director took the drill and made two tiny, invisible holes himself and the work went up. No one else was able to take that responsibility.

Many of these design issues are only meaningful to the curator or exhibitor—an audience will barely notice the space or exhibition design if the space is used well. It is usually only when it has not been thought about or handled successfully that the audience becomes aware of the space itself or the layout of the exhibition because it distracts them from looking at the work itself.

Step two in exhibition design

The first decision to be made is usually whether the work will be placed on the walls using a traditional, fairly formal, grid pattern or in a less structured, apparently more random and free-form pattern. This decision will in most cases be dependent on what the work itself dictates rather than on the space. So, for example, images with a theme or clear narrative thread might be hung in a single line or using a grid which will encourage the viewer to make connections between the work while images with fewer obvious connections might be unevenly placed across the wall so that the viewer will consider each separately rather than trying to find connections between them. The size of the images may reflect this decision—if a narrative thread links the work it will usually be consistent in size whereas if there are no links between the different images one way to make that visible is to vary the size of the prints.

Then, having also taken the dictates of the space into account, the curator starts to work in more detail on the overall look of the exhibition, planning how the photographs will be presented, what size they will be, how many photographs to show, and approximately which photographs go where or how the images will be sequenced. All of these decisions are interdependent and relate to the space itself because, for example, a decision made about the number of images affects their possible size and vice versa.

Sea Change: Solway Firth Low Water 5.20 pm 27 March 2006. Image © Michael Marten.

Sea Change compares identical views at high and low tide around the coast of Britain. The whole work is made up of pairs of photographs so, in thinking about how to present them, I considered printing two images on a single piece of paper or keeping them separate. In the end I decided that the best way to present them would be separately, probably without borders, and hung in pairs fairly close together.

So, for example, in a large, high-ceilinged space the curator might decide to show four images by an artist, all of which are presented at their maximum size in order that the space should not overwhelm the images. In a smaller space, or a space with lower ceilings, the curator might use more images from the same set of images at a smaller size. One way to test the proportion of the images to the available wall space is to make rough prints of various sizes or use sheets of colored cardboard cut to the proposed size of print and attach them to the wall in order to make a visual assessment of the best size of print to show in that particular space.

The curator will probably consider each wall as a separate hanging area rather than as one continuous hanging line. The exception to this is when the work has a clear narrative thread, which means that it has to be shown in a particular sequence with a beginning at the start of the gallery and an ending near the exit. If the work is by a single artist then the way each wall is designed will echo or refer to each of the other walls, if it is a group show each wall may be dramatically different in order to emphasise the unique qualities of each body of work.

Sea Change: Solway Firth High Water 12 noon 28 March 2006. Image © Michael Marten.

The curator will usually start the process of exhibition design by looking at what practical issues dictate certain choices in placing the work. There are all sorts of possible practicalities to be taken into account. In a group exhibition, for example, this could mean that one person's work can only fit on a particular wall because there are either too many or too few images for other walls. Or that a large image can only go on a particular wall because it needs a good viewing distance (that is, the audience needs to be able to stand well back from the photograph to take it all in) which can only be found at that one place in the gallery. When dealing with projectors or light boxes, the positioning of electrical outlets may mean that these can only go in specific places. Or the curator may know that certain images are fragile and want to place them where they are least at risk from casual damage or will be directly under the eye of the gallery staff. Once decided, other choices can be made around these initial decisions.

Once choices have been made out of necessity, there are choices made because of the overall look and feel of the exhibition or images. Size, impact, and flow are all thought about here. It could mean that certain images are best hung separately because they are busy or disquieting and need space around them. It could mean that particular images are chosen to hang at the start or close of the exhibition because of either their dramatic or their contemplative quality. In a fairly bland gallery space, the curator may well want to place a dramatic

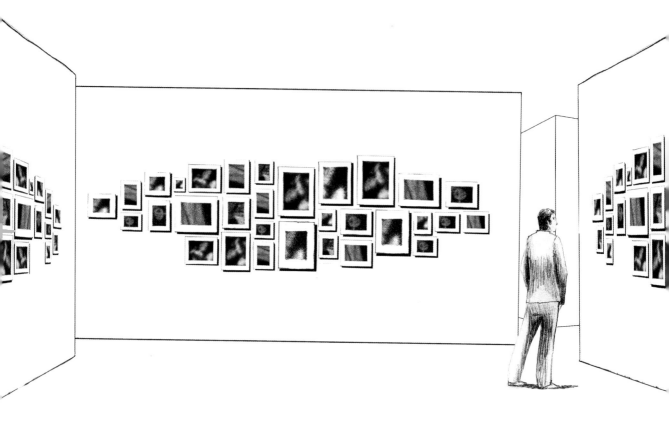

The curator may consider each wall as a separate hanging area. Image © Arno Denis.

image or grouping of images where the visitor's eye alights from the entrance, to draw them across the space.

Choices made about the size and framing of images depend both on the images themselves and on the space they will be shown in. Not all photographs can be resized to suit the scale of the gallery space. Some images may have to be a particular size or have already been printed at that size. In an installation of Fiona Tan's work *Vox Populi* (*Sydney*) at The Photographers' Gallery, for example, she showed images from family albums. The images were small and represented a genre of photography that is most usually read as small images. She therefore retained the size but showed over ninety photographs which filled the wall space in much the same way that family photographs fill a family album.

The scale of the gallery and the print should be related where possible. In a large gallery, small photographs tend to disappear in the space unless they are hung in groups. In a small gallery, it may not be possible to stand back far enough to take in a very large print. A large print will appear smaller in a large space but move it, for example, to a smaller space between two

windows and it can become overwhelming and appear cramped in the space. As a general rule, the larger the image, the more space it will need around it.

In a mixed exhibition the curator will want to consider how to group work and how each group of works leads on to the next. Color, composition, subject matter, and style all play a part here.

An example of this is an exhibition of student work in a gallery in which the gallery space was divided into five discrete areas. There was no overall theme to the exhibition, and the students had produced eighteen sets of very diverse personal work. It was exactly the right amount of work for the space available, so fitting it into the space was not an issue. The issue was how to group the eighteen sets of images to fit into the five spaces while ensuring that the juxtaposition between each set of images would enhance, rather than distract from, each set.

After much discussion we grouped the work in this way:

- three sets of images on the landscape of the human body (these included closeups of hands, of heads, and a set of back views of women with exceptionally long hair)

- two sets of images where the subject matter appeared out of darkness (one of trees at night and one of joints of meat hanging in the dark interior of a meat store)

- four sets that shared a cool objective look at their subject matter, all devoid of people and slightly desolate or melancholy (interiors of rooms to let, shop fronts, decaying industrial scenes, and empty corridors)

- six sets that had a more subjective, gentle, and personal feel to them, some in soft focus or showing movement (they included light reflecting on a old mirror, a beach in the rain, sun through a car window, odd moments of London light, and the edge of a palm leaf)

- three sets in which the print size and style held the sets together because they were all panoramas (of skating, water, and street scenes)

So, within one exhibition, it is possible to group work using a variety of completely different types of link—in this case, the subject matter (the body landscapes); the mood of the photographs (the objective and subjective approaches); the contrast of light and darkness of the images and the shapes or format used (the panoramas). None of these links was subtle, nor did they need to be. The division of the space into five discrete areas meant that the audience unconsciously expected work to be presented in five discrete sections. Each section was held together visually. The groupings meant that the transition from one image to the next was made easier for the audience. If we had put the exhibition up more randomly—by, for example, putting a set of images of the human body next to bleak industrial images—we would have undermined the impact of each set and perhaps encouraged the viewer to make connections between the works that were not intended.

Once the work is grouped, it is a great deal easier to decide which set of images to place on which wall. This will be determined by the relative size of the walls and of the groupings of work as well as by the overall flow of images. The curator then decides how the work should be placed on the wall. All sorts of options are possible here. It is no longer the case that

Hanging photographs down from an (imagined) top line.

Hanging photographs from an (imagined) central line.

Hanging photographs up from an (imagined) bottom line. Images © Arno Denis.

photographs must be hung in neat, single or double rows of identical frames. We do not expect images to be presented at the same size, in matching frames, or even in frames. There are many alternatives to traditional frames, including mounting on aluminum or board; attaching directly to the wall with pins, tape, or behind acrylic glass (Perspex or Plexiglas); light boxes; hanging work clear of the wall; and using display boxes.

The wall itself can be designed to be viewed as if it were a page in a magazine or book, or like a theater set in which the photographs are used to make a shape on the wall. Photographs placed on the wall in the shape of a circle, triangle, or cross all work, as does a more amorphous shape. Photographs can also be placed on the wall in an apparently random way, stacked tightly to fill the wall or placed at uneven intervals. However, even the most apparently random hang will work upwards and downwards from an imagined central line at around 5'1" or 155cm. The wall itself can be painted, written on, or stenciled on. Text can be placed on panels but can also be attached directly to the wall by using precut vinyl lettering.

While each wall can be designed separately, the look of the whole space is kept in mind along with the way that each wall leads into the next set of images.

There are many different ways to consider how to hang each wall:

- A single line of pictures can indicate a narrative sequence.

- If images have no connection between them (other than they have all been made by the same person) then a random placing of them on the wall, at different heights and with uneven distances between the images, will indicate this.

- Stacking images—horizontally or vertically—can indicate that there is a shared subject matter or theme but not necessarily a narrative.

- If a set of images is placed across a wall (stacked vertically and horizontally) in a semi-formal way then using exactly the same amount of space between images (above/below and side by side) will help make the wall work visually. Using multiples of this amount of space will do the same thing (so, for example, if most images are 10 cm apart, then 5 cm, 15 cm, and 20 cm gaps will work better than, say, a 13 cm gap).

- Closely juxtaposing two or more images will mean an audience looks for a connection between them.

- In a single line hang images can still be broken into groups to indicate sub-themes or connections—(think of the way books can be broken up into chapters).

- Some images need space around them and others can be hung very close to each other—'quiet' images or images which call for contemplation usually need space whereas images with more immediate impact may not.

- In a group show each photographer can use a different display method and this will delineate the different bodies of work. However, the space should still be viewed as a whole and a shared central hanging line will make sure that the exhibition holds together across the different works.

- Using devices such as differently colored walls and differently sized or framed work will make each section of work in a group show clear from a distance.

- Using large or dramatic images on the wall furthest from the entrance will draw an audience into and/or across the space.
- Using large, dramatic, spectacular, or intriguing images opposite windows onto the street will draw an audience into the gallery from outside.
- Very small images suggest intimacy and draw the viewer into them, because of the need to stand close to see them (which also makes the experience seem like a one-to-one between photographer/subject and viewer).
- A hang can act as a metaphor for the way images were originally made, for example, pictures from bus or train windows which are all the same size and butted up closely repeat the sense of repetition and/or monotony of a journey.
- Watch out for corners when planning a hang—the convention is not to hang right into them but to leave space on one or both sides so that people looking at the work don't bump into each other.

Estimating hanging times

It is usually useful to assess how long it will take to hang the exhibition at this stage of planning. Hanging is often slower than one expects and it is important to allow time to re-consider the way a hang works in practice once everything is in the space. So pre-planning the hang means looking both at the timing and at the practicalities of how many people will be needed. Unless you are experienced and it's a straightforward hang get additional help if possible from people with practical or specialist (for instance, computer or projection exper-tise) skills and people who will be happy to run errands. However much pre-preparation has been done, there will always be delays caused by small tasks that have to be done precisely and therefore take time. See Chapter 19 for more detail on estimating hanging times.

To sum up

The forward planning of an exhibition design and installation is a major part of the exhibition and can be difficult, time consuming, and finicky. And at times it will feel like wasted effort as the timetable or the budget may well have to change during the months of exhibition preparation. But, once this planning is done, the exhibitor should feel much more in control of the whole process of exhibiting and can start printing and framing work, a process which should be liberating in itself because it moves the whole exhibiting process forwards. Sorting out the detail well in advance, even if it does necessitate making hard decisions at quite an early stage, should allow the exhibitor the time and the freedom to focus on showing the work to best advantage and a long lead-in to a show is usually useful to the exhibitor.

Pre-Planning: Practical Issues

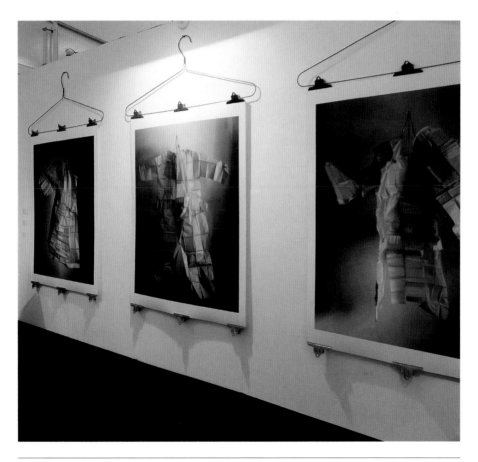

Bill Jackson *Imaginary People XII, III and VII* from *Cabinet of Curiosities*. Shown by Troika Editions at the
LONDON ART FAIR 2012. *Imaginary People*: uses a collection of paper dress patterns, refashioned to
create illusory people. Giclee on photorag paper, unique print. The massive coat hangers are made out
of 4 mm steel and the chrome clips aged by heating with blowtorch, plunged into nitric acid and water
and then left to rust. Image © Georgina McNamara.

Once the decisions about the overall look of the exhibition and how the work will fit into the space have been made it is time to get down to the practical details.

Framing options

There are a large number of options for ways to frame and present photographic work. Choosing a presentation method depends on a number of things, including:

- what is most appropriate to the work
- what is most appropriate to the gallery or showing environment
- what is most appropriate to the possible marketing of the work
- cost
- possible and appropriate image size
- protecting the image from damage
- issues of archiving or conservation of the print (which can be crucially affected by framing)
- fashions in presenting work
- personal preference
- the weight of the finished piece can sometimes be an issue, depending on how and where the work is to be hung

There are other decisions to be made, specifically concerning:

- whether the work needs a border or not
- whether it needs a frame or not
- whether to use a mat or not
- whether to protect the image by sealing it or putting it behind glass
- whether to spray or dry mount the image

When deciding on framing or mounting methods, the most important considerations, after looking at what the showing space might dictate, are what will show each image both appropriately and to its best advantage in line with the overall theme or presentational style of the exhibition. Different types of work necessitate different approaches and careful thought about the subtle shifts in meaning which will be conveyed by the each option is crucial. It's preferable to spend time and thought and some practical experimentation if it helps (for instance with different types or color of frame and size of mat) before finalizing a choice of frame rather than to start rethinking one's choices when it may be too costly to make changes.

So, for example, dark or heavy frames that look good with black-and-white prints can overwhelm delicate color works. Borderless prints mounted on aluminum may look good on the large white walls of a loft or industrial space but look lost in a more traditional

space. Some work looks better with a frame around it because the subject matter, the tones or composition ask for a sense of containment or a traditional method of presentation. Intimate or personal work may be best shown small so the viewer has to stand close to it and engage very directly and personally (both because they are close and because it will of necessity be a solitary experience if the image is too small for two people to view it at the same time). If the subject matter is ephemeral then the best way to frame it may be one which emphasises that fragility or it may be one which does the opposite and tries to make it seem more solid—the decision will depend on what suits that specific exhibition.

The photographer will probably find that is worth testing their ideas with or asking advice from gallery curator, framer, and colleagues. Curators know what works in their space. Framers are usually particularly good at practicalities, advising on types, color, and width of frame, and sometimes on whether a work is better framed or presented frameless. Colleagues tend to focus on the work and what complements or makes sense with the subject matter or composition. And, once again, the decision about framing is often best made by taking time to test out the different options—a good framer will have a stock of possible frame edges and will spend time working out which best suits the work. The decision may be based on something as simple as using a frame which echoes the tones of the image but it may take an experienced framer to suggest this possibility.

The space of a gallery can dictate the method of presentation. As a rule, large spaces call for large images and small spaces for smaller images, but this need not be the case in every instance. As long as a large image has enough space around it so that it does not appear cramped and there is sufficient viewing distance for the viewer to stand back and see the image properly, it may be compelling in a small space. If the subject matter is overwhelming why not try to overwhelm the viewer? Generally these sorts of decision are best made in the space itself, where it is quickly apparent whether or not something works visually. I use a paper template to make size decisions in the actual space if the work hasn't been printed to that size.

Frames, mats, and borders are all means by which the photograph gains a (breathing) space around it and is more contained and the viewer more distanced. Borderless and unframed work, which is regarded as being more contemporary, is usually more immediate and can be more confrontational and viewers may feel they are intended to be part of the event or image rather than observers. It can also remind us of the transitory nature of much of photography. Framing work is seen as the classic way to look at a photograph and, for instance, a vintage twentieth century image will almost certainly be presented in a frame. However, many contemporary photographers also use framing just because of the distance it imposes between viewer and photograph and as a method of arguing for the seriousness of their work.

A frame also helps to protect the image from accidental damage and environmental pollution, whereas an unframed work is at much higher risk from accidental damage by visitors—although as we see below this damage can also become part of the work.

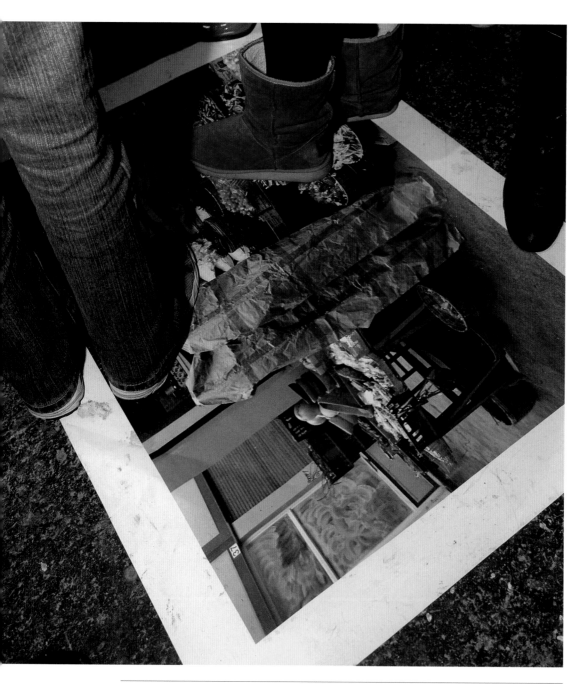

Some You Win Some Deleuze private view. Helene Sorensen's documentation of the Sorensen & Byrne postal art piece *They're There* in which the two artists were packed and freighted on a cross channel ferry as a metaphor for the situation of refugees. For this event, she chose to place the print, made on art paper, on the floor of the exhibition unprotected by lamination or vanish so that damage accumulated over the period of the exhibition. www.helenesorensen.com Image © Georgina McNamara.

Types of presentation and frame

Let's review the choices of presentation and frame.

1. On the wall:

 a. unframed, with or without borders, but spray mounted/dry mounted on

 - polyboard/foamboard/foamcore
 - Foamex
 - thick board or medium-density fiberboard (MDF) (block mounting)
 - aluminum or other metal base such as di-bond
 - aluminum behind acrylic glass/Perspex/Plexiglas/Diasec
 - sandwiched between sheets of glass or Perspex

 b. unframed and unmounted

 - pinned, taped, pasted, or spray mounted directly to the wall
 - attached with magnets to metal strips on the wall
 - hung from nails with clips such as bulldog clips
 - hung from thin horizontal rods or poster holders

 c. framed

 - conventionally with wide mat/mount to the edge of the image and a frame of wood or metal, of any width
 - as above but without the mat so the image fills the entire space without a border of any sort
 - in a gutter box (about 1" deep) in which the image sits unprotected by glass
 - in a box frame (about 1" deep) in which the image sits behind glass; the image can be raised slightly from the backboard and seem to float in the box
 - handmade frame with a border of fabric, leather, mirror, mosaic, papier mache, or other material

 d. light boxes

2. Not on the wall:

 - suspended from the ceiling, usually with eyelets and ceiling hooks
 - sandwiched between glass or acrylic (Perspex or Plexiglas) or heat sealed
 - individually clipped to wire or cord
 - as a long roll of unprotected paper

3. And also:

 - as a projection
 - on a table under glass
 - on a plinth
 - in an artist's book on a shelf or in a vitrines or display cabinet
 - on the floor or ceiling

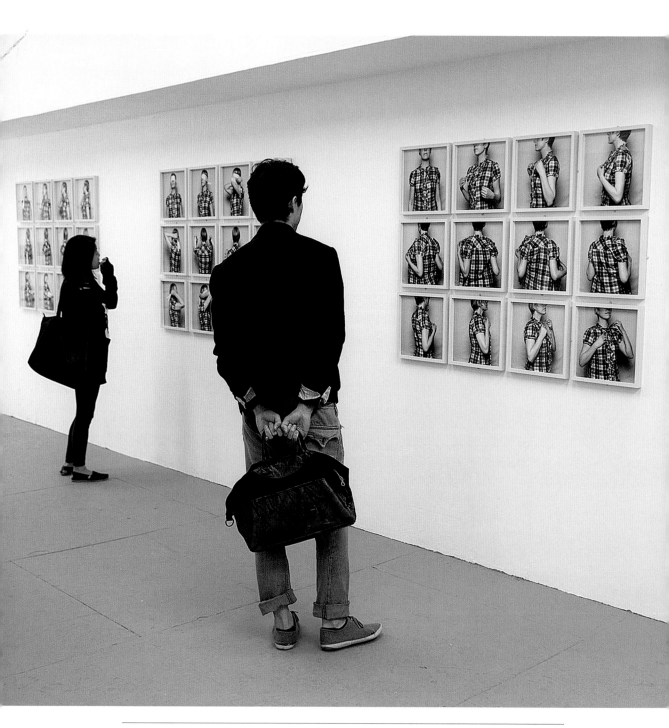

Georgina McNamara's work at Central St Martins School of Art and Design, London 2011. Image © Georgina McNamara www.georginamcnamara.com

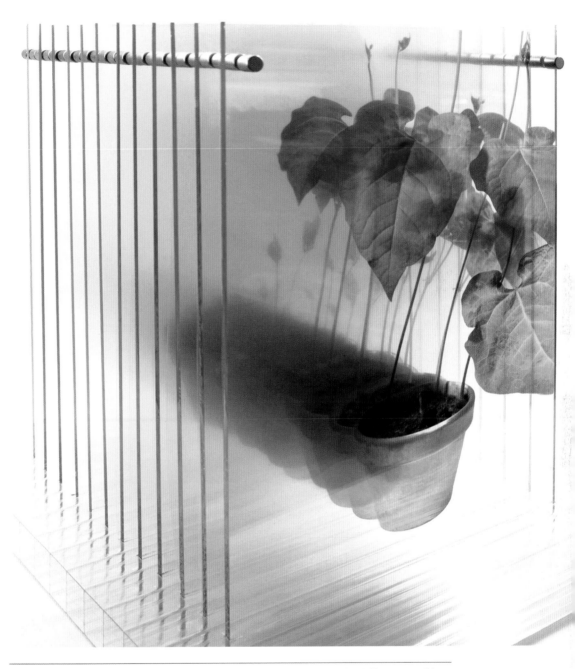

Catch Me If You Can (Runner Bean 12 Days); about which the photographer Myka Baum says: 'I have recently begun to explore more experimental ways of exhibiting my work, moving away from the traditional framed photographic print. The presentation of the image is becoming more and more integral to my work and is beginning to form an extension of my photographic practice and a continuum of the image itself. The developmental phases of the emergence of a runner bean plant are represented on sequential layers of glass, each depicting a moment in time. The sheets of glass are held together by a row of magnets.' www.seephotography.net Image © Georgina McNamara.

Sealing the work

A Diasec mount is one in which the image is face mounted to Perspex, which in turn is dry mounted onto an aluminum backing. The backing has a subframe on its back which gives it extra support and provides the means to hang the piece.

This process is irreversible, as the Perspex is stuck directly to the image. It is accepted by museums and is proven acid-free. However, the process has only been around since the 1980s, so there is no telling how archivally sound it is. It is also not particularly durable, as Perspex scratches fairly easily (more easily than glass, for example), and if the Perspex is very badly scratched, then the whole thing can be ruined.

When a large image is presented mounted on aluminum but is not protected behind glass or Perspex, it can be protected with a layer of mat sealant. Opinions differ about whether this is worth doing, because a seal is no more robust than contemporary photographic paper and sealing can result in a slight loss of image clarity. A seal will protect the image against, for instance, fingerprints, but not against the sort of accidental damage that occurs when the image is dropped or something sharp pierces the surface. At an exhibition I attended recently, visitors with backpacks or large bags were asked to leave them in the cloakroom since the exhibitor had already had a print badly damaged by someone's bag. There may also be problems if there are any inconsistencies in the print such as handling marks or dents in the surface, as the seal will not take properly when applied and can peel off. A seal can be wiped using a special duster which can usually be purchased from the supplier of the seal.

Frames

Photography is a system of visual editing. At bottom, it is a matter of surrounding with a frame a portion of one's cone of vision, while standing in the right place at the right time.

John Szarkowski, *The Photographer's Eye* (2007 [1966])

Frames are available in a large range of types, styles, and colors, all of which can be carefully considered. Black, shades of brown, and white tend to be the most popular. White, which was rarely used in the past, is now popular for contemporary work and color, once avoided as belonging in the home, is beginning to appear in galleries though needs to be used with great care and forethought since it can look unprofessional. The width of the frame is also significant since a wide frame can look too heavy for some images. Box frames, which are deeper than the standard frame, tend to suggest that the work is historical, archived or precious, or that the viewer is looking more deeply into a scene. Choosing a frame which is appropriate to the work is usually best done by eye and a professional framer will usually be ready to spend time with a client trying out different types of wood, color, and width of frame. I am an advocate of keeping frames as simple as possible in order not to distract from the work although at this moment in

Framing samples at Oaksmith Studio with, left—right, different types and color of frame, box frames and flat frames. Images © Georgina McNamara.

time a great deal of experimentation with different styles and approaches to framing is taking place. The place to consider and compare all these options are the large photo fairs, such as Paris Photo, where very many different galleries and artists show individual works and give one a bigger range of possibilities gathered in a single space than at any other time.

Working with a framer

Framers vary a great deal in their levels of skill, knowledge, and the sorts of frame they produce. Some are only equipped to deal with smaller frame sizes or do not dry mount large works. Some are much better equipped for exhibition production than others. Costs vary a great deal too. It is well worth asking around to find a good and reliable framer who has experience producing work for exhibition, understands deadlines, and with whom you can establish a good working relationship. If you use the same framer on a regular basis, you are more likely to get better service, good advice, lower costs, and someone who understands your work and will help out in emergencies.

Buying ready-made frames

Because photographs, unlike paintings, tend to come in standard sizes dictated by paper size, it is usually straightforward enough to find a suitable ready-made frame in the smaller sizes—that is, below 24 × 36 inches or 594 × 841 mm. You might think that in looking for a ready-made frame, the priority should be finding one that looks good. However, the most

important element is, in many ways, the back of the frame rather than the front. Inexpensive frames can look good from the front but still have a number of problems:

- poor construction and weak corners, which means that being moved around will cause the frame to collapse eventually
- problems in attaching the plates or wire to hang it by, because the wood is too soft to hold a screw
- small metal teeth holding the removable back of the frame in place, which can break and fall off after a time—the fastening system for the back of the frame should be strong
- cheap wood used for the frame, or a poor wood finish, which means the frame is vulnerable to being dented or scratched and makes its appearance difficult to maintain
- metal frames may not be finished well and may scratch or otherwise damage other frames

If you anticipate reusing frames, then it is worth investing in the best you can afford, because they will look better, will be sturdier and very much easier to use, and will last longer.

Galleries sometimes sell used frames, framers do have sales, and the Internet can be a good source for economical frames. But beware of acquiring too many varieties of frame simply because they are reduced in price—a set will always be more useful.

Making your own frames

Painters often make their own frames and it is possible for photographers to do so as well. However, few photographers take on this task, because it requires a high level of skill to achieve the standards expected for showing photographs.

Making frames is a specialist craft skill that has to be learned and requires space, time, and good equipment. It also creates dust, which is the worst possible thing in a photographic environment.

Conservation issues with frames

Frames are usually available in a range of materials, the most popular being wood. Metal frames have decreased in popularity in recent years, in part because they are increasingly seen as being at the amateur end of practice and because they can badly damage other frames when stacked or while being moved. Increasingly, the key issue in choosing a frame is the conservation standard of the frame. Good-quality modern wooden frames are likely to have been made to conservation standards; cheap frames, by contrast, cannot usually make that claim. That said, it is the backboard that can do the most damage to prints, because of the acids that may leach out of them. To prevent this, there should always be a sheet of acid-free paper between the print and the backboard of the frame to keep them from being in contact.

Behind the scenes at Oaksmith Studio. Image © Georgina McNamara.

Many artists who come to us have never thought about how integral the picture frame can be to the final presentation of their piece. Sometimes a frame can make or break a photograph. An informed choice is necessary regarding the various frame styles (ie. box frames), frame finishes (wood, metal, stained, painted, gilded), mount color and styles (window, float) and glasses (UV, antireflective, acrylic). All of these factors can have a significant effect on the photograph and advice should be sought to achieve a final result that is not only sympathetic to the artwork, but can even enhance its impact and longevity.

We might suggest, for example, using a box frame when a photograph is to be shown in a contemporary context and the printing paper used should not touch the glass. Alternatively, should a piece be shown in a more classic setting, we might suggest framing it with an unobtrusive white mount in a flat black or white frame giving it a clean and modern look as a whole. In this instance the framing offers more of a supporting role. Another approach we often take is to look for 'clues' in the art itself. If the subject matter is of a natural theme, we might suggest a bare or stained wood frame with visible grain. If there are lines or blocks of color, we might suggest picking a frame to mirror the weight of these compositional elements. There are no definitive rights or wrongs, but there are some key visual elements that should be considered to achieve a balanced result.

Anna Tjan and Mauro Saccardo, Oaksmith Studio Fine Art Picture Framers.
www.oaksmithstudio.co.uk

Glass and reflections

Acrylic glass (Plexiglas or Perspex) and nonreflective glass can both be used to cut down on the reflective qualities and glare of glass. Both are very expensive, and most forms of acrylic glass scratch easily and may discolor slightly. New forms of nonreflective glass are currently being developed specifically for photographs, and they are very effective. Unfortunately (from a cost point of view), it is particularly important to use nonreflective glass when displaying very large images, since otherwise they can be impossible to see properly as a whole. With smaller works, viewers can simply move their heads to see the parts of the image obscured by glare. Glass must be kept clean and free from dust and fingerprints, which requires daily checking once installed in an exhibition. In any case, strong sunshine is far from the best environment in which to stand and study a print or exhibition, so most galleries use blinds to create a shaded environment, and they avoid hanging prints in direct sunlight where there is a danger that the print will fade. So nonreflective glass should be used wherever possible, though the cost may sometimes prove prohibitive. It is usually more necessary to use nonreflective glass in galleries where artificial light predominates.

Fillets or spacers

Photographs should not touch glass (contact will destroy the emulsion). A mat will prevent the photograph from contact with the glass, but where the photograph is in a box frame, a

(left) A range of colored and wooden fillets and colored and transparent mini spacers. (right) A box frame that uses a ½" white fillet. Images © Georgina McNamara.

fillet or spacer is crucial to keep it at a distance from the glass. Fillets come in many different sizes (eg ¼," ½," ¾" and 1") and standard colors of black, white, and cream and can also be hand covered in color to match the mount board at an additional cost. Very small mini-plastic spacers in black and white have also become available—these are around 2 mm and so small that they are invisible inside the frame but still protect the work.

Unframed images

Mounting an image on aluminum or di-bond (a cheaper metal base) is the first and best way to show an unframed image although, since it cannot be removed from the aluminum, this means that there are possible conservation issues. There are many situations in which not framing an image is a good choice. So, for example, when an exhibition is only on show for a short time or the work has an immediacy which would be spoiled by a frame the work can be pinned, taped, stapled, pasted, or spray mounted to the wall. The last two options usually make it impossible to remove the image from the wall in one piece so are best used when fly-posting in public places rather than in a gallery. The work can also be hung from bulldog clips. All these methods look good when used appropriately but will carry the message that the image is not precious so should not be used with delicate or fragile work or valuable prints which cannot be duplicated.

The major issues here are practical. The print needs to be on paper which is not too heavy or it will lift from the wall, at the same time it needs to be heavy enough to lie flat. If the wall itself is not entirely smooth then simply pinning an image to it may cause problems and it may be necessary to mount the image on board (foamboard or Foamex) first. When doing this is a good idea to look at the edges of the board and consider coloring them (using a felt tip is usually adequate) because the cut edge of board can display layers of compressed material and distract from the image itself. If the work is hung from bulldog clips it may curl unless held at the bottom edges as well at the top. The clips may also make small dents in the paper.

Mounting work

Spray mounting can be done by the photographer and is useful for smaller work. It is difficult to spray mount an image of more than about 12 × 16 inches. Many kinds of spray mount and glue will damage the print over time, so if these products are used, the print cannot be sold as archivally permanent.

A dry-mounting press is an expensive investment to make. But it produces a better and flatter result than spray mounting. Most professional framers can dry mount large image sizes. The process is permanent, however, and the photograph cannot be removed from its backing if, for instance, the card mount gets damaged.

Foamboard (also called foamcore) is a core of hard foam held between two paper layers. It is softer than Foamex (a brand name) and a bit spongy. Foamex has a solid plastic core and is difficult to dent. It is more durable and more expensive than foamboard.

Anne Kathrin Schuhmann's work *Gummibaum (I&II), 2010* at the ICA in Bloomberg New Contemporaries. www. annekathrinschuhmann.de Removing the barrier of glass and frame between image and viewer draws the viewer into the work, makes the work more immediate, and emphasizes its physical properties. Image © Georgina McNamara.

Spray or dry mounting onto foamcore or Foamex are the least expensive methods of mounting and are perfectly adequate for one-off exhibition, although they are regarded as being at the amateur end of photographic practice. They are also useful for the display of text panels.

Window mounts or mats

Window mounts or mats are used as part of the display of prints in a frame. A window mat consists of two pieces of (archival) board which hold the print in a sandwich. The print is attached to the bottom layer of board and viewed through a window cut in the top layer. Although the mat protects the edges of the print from most handling damage, the matted print is usually also in a frame and behind glass to protect the surface of the image.

Mats are most commonly used for vintage or smaller prints or prints best shown in a conventional type of display.

The mat has five or six great advantages, both practical and aesthetic:

- A mat helps keep the image flat. A framed photograph is very hard to view if it is not held flat because gallery lights will reflect differentially off both the glass and small uneven areas of the emulsion. Photographs also tend to buckle over time as paper and emulsion respond differently to atmospheric conditions and the mat helps prevent this.

- A mat protects the print from damage to the edges and corners, mostly caused by handling.

- A mat keeps the photograph away from the glass. A photograph should not be in contact with glass because it will be damaged by the contact and, if the photograph starts to adhere to the glass of the frame, it may prove impossible to remove without also removing pieces of the emulsion.

- A window mat (or a border on the print) creates a space around the image and focuses the viewer's attention on the image itself. A print in the smaller size range (8 × 10" and below) is almost always aesthetically enhanced by a deep border. This is particularly useful with very small prints, which might otherwise get lost against distracting backgrounds or in competition with other images.

- The advantage of the window mat over dry mounting is that it is not permanent and can be dismantled if it is necessary to replace the mat or reframe the image. This may be essential, for example, if the print is to be shown in a different context or in another exhibition using a different shade or type of mount board. It preserves the print and the print border whole and allows access to the back of the print which may hold a signature or other information.

- A mat announces to viewers, in no uncertain terms, that this image has been considered worthy of serious attention by the photographer or curator, which encourages viewers to

look at an image they might otherwise ignore. This is very useful if, for instance, a curator is working with imagery that traditionally might have been thought unworthy of a gallery, such as found photographs, photo booth images, amateur snapshots, and vintage press prints. However, this tactic may also be seen as pretentious and as an attempt to inflate the interest or value of intrinsically uninteresting work, so it should be used with care.

- A mat can also be used to emphasize the fact that the print is only an image on a piece of paper and is essentially an insubstantial and fragmentary object—in contrast to making it look more permanent and solid, as dry mounting tends to. This is usually achieved by 'floating' the whole image, including its border, inside the window mount (as described below).

Boards used for matting prints are available in a range of colors but are generally used in a range between white, grey, and cream. The board should be thick enough to be rigid or it will move or start to sag minutely in the frame. It should be of archival quality, which is sometimes called museum or conservation board, acid-free or rag board. These are usually more expensive to buy than other boards but will not damage the print over time, as other boards will do as chemicals leach into the print.

There are three options in deciding the size of the window in the mat:

- The window is usually cut to be very slightly smaller than the photograph itself (by about 1/8 inch or 2 mm) so that only the image area of the print is visible. The print is then held in place by its border which is hidden underneath the mat.

- If the print has an unevenly printed edge or is borderless, however, the mat may need to overlap the image itself in order to hold the print flat. This will crop the image very slightly. Usually the loss of image in this situation is so slight that it is not a problem, but if the whole image area has to be visible, the print can be either dry mounted or 'floated' as described below.

- "Floating" the whole image in the window means that the viewer sees the border as well as the photograph. This works well when the border itself, or the information on it, is of interest or significance—for example, with small snapshots that have something written on the border, or with Polaroid images, where revealing the border makes it immediately apparent that the print is a Polaroid. Sometimes a border on a vintage print has been damaged in a way that gives a fascinating insight into the history of the image as when, for example, a corner has been folded over like a bookmark. It works less well when it simply looks like a mistake in measurement or an unnecessarily fussy way of framing the image. It will also draw attention to any differences in the shades of white in the image border and the mat itself, so a careful choice of the color of the board is important.

You can cut your own mat, but it is a skill that demands patience and experience so should not be undertaken for the first time just before an exhibition, when time pressure is likely to make the inexperienced clumsy. Most framers cut mats relatively inexpensively as part of the framing service and bring useful experience to the choice of board, color, and window size.

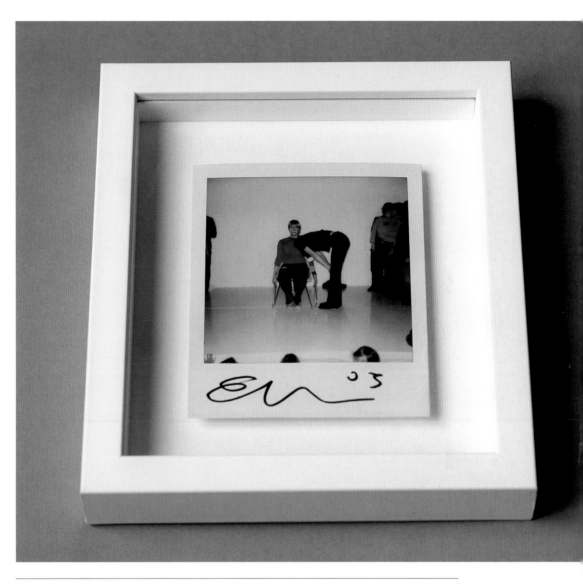

Polaroid image of a performance by Erwin Wurm, 2003. The (unmatted) Polaroid is raised on foamboard laid on white card within a white box frame with a ½" fillet. The foamboard is cut smaller than the Polaroid and so is not visible from the side—it also casts a shadow intended to emphasise that the image is a precious object. Image © Georgina McNamara.

My colleague, Ruth Fuller, gave me this description of cutting a mat:

Having tried several mat cutting systems, I have found the Maped System to be by far the best, producing mounts that are indistinguishable from professionally cut mounts. It is portable and simple to use and consists of a cutter which slides onto a custom-built ruler. There are two types of cutter, one that cuts the window at a 90-degree angle and one that cuts at a 45-degree angle. The cutters are interchangeable and can be used on

different length rulers. The correct type of cutting blade (either 45 or 90 degree) must, of course, be used on the cutter it is designed with.

Use conservation or museum board for archival mounting. These boards are acid-free and come in various shades, colors, and thicknesses. There are recommended ways of cutting out the window and instructions usually come with the system. I have always found the following method the most accurate and easiest way of measuring and cutting. It is suitable for cutting a 45- or 90-degree window. Always stand up when cutting; otherwise you can't hold the ruler down firmly and you can't cut straight. It is a good idea to practice on some scrap board before cutting the final board.

Use two or three layers of any kind of board underneath the board to be cut (the cutter will ruin a cutting mat). Make sure the surfaces of the boards are clean.

Make sure the blade in the cutter is sharp. A semi-blunt or blunt blade will make cutting labored and will tear the board. Measure absolutely exactly and draw lightly (with a very fine pencil) the size of the window to be cut on the back of the board. If cropping the image a little bit is not a problem, make the measurements a millimetre or two (1/8–1/16 inch) smaller than the image size both lengthways and widthways. This ensures the window will not be too big. Always be very careful measuring and drawing out the window.

Cutting from the back to the front of the board requires that the cutting ruler and blade be placed on the inside of the drawn out window, with the blade pointing outwards, towards the edge of the board. This will ensure that when cutting a 45-degree angled window, the cut will slope from the surface of the board in towards the print.

Line up the ruler and the blade along one edge to be cut, so that the tip of the blade will touch the drawn line when the cutter is pressed down, both at the top and bottom of the line. This may take a few attempts, but is essential for an accurate cut. Holding the ruler firmly in place, press the blade down and lightly score a cut from the top to the bottom of the line. This gives the blade a guide cut. Over-run by around 3 mm or 3/16 inch (depending on the thickness of the board) at the top and bottom for clean-cut corners. This over-cut should not show as long as the blade is sharp. Some people can cut a window without an over-cut but most people find it difficult. Keep holding the ruler down, and cut along the line again, this time pressing more firmly. Repeat until the board is cleanly cut through.

Repeat this process on all four sides, and the window should fall out cleanly.

If there are any bits of board that are a little ragged (there shouldn't be!), it should be possible to remove these stray bits with a sharp hand-held knife or scalpel.

To fix the image behind the window mat, acid-free paper can be used to make corners for the photograph which can then be attached to the back of the board using an acid-free archival tape. This method ensures that the photograph is not mounted directly onto the board and can be easily removed and replaced. Self-adhesive linen cloth tape is available to buy; it should have a neutral pH acrylic adhesive of archival quality. This tape is also excellent for hinging the window mount to a backing board.

Mounting corners are also available to buy; the most suitable are made from polyester film (which is completely inert and therefore archival). They should attach to the mount

with an adhesive that is chemically stable, long ageing and archival. Again these ensure that the photograph can be easily removed and replaced in the mount.

Window mats that are consistent in size, board color, and positioning are one way of making a set of very diverse prints in an exhibition cohere. The visual impact of a single tone of mat will create a strong unifying link between the images and make differences in size, condition, tone, and density seem less noticeable. This works particularly well for unifying a diverse set of black-and-white prints.

Photographs are usually matted and framed in keeping with how they were originally taken—that is, a horizontal image will be framed and presented in a horizontal frame and a vertical image framed vertically. However, this is not always the case, and a horizontal image may be found matted and framed horizontally in a vertical frame. There are three reasons to consider presenting an image this way:

- The image will look very good, possibly because it's a familiar convention in photographic books.
- A vertical frame takes up less running wall space than a horizontal one, so it is one way to include more images in an exhibition if you need to.
- When a show includes both horizontal and vertical images, hanging all the images in a single, standardized way (so that every image takes up the same amount of

A portrait image with a landscape mount and a landscape image with a portrait mount. Image © Georgina McNamara.

space) can make a better narrative flow. The eye will move more easily from one image to the next; a row of frames all presented vertically is quicker to 'read' and makes better sense on the wall than a set that includes both vertical and horizontal frames.

Conversely, vertical images are sometimes matted and framed in a horizontal frame, although this is much less usual and often less visually satisfactory because the image may appear overwhelmed by the wide borders at each side.

There is no general rule about the size a mat should be, although most are generous because a small mat tends to make the image look cramped in the frame. Even the smallest image usually works well in a large mat, and I have seen vintage 35 mm contact prints in mats at least 2 × 2 feet or 600 × 600 mm. Using a large mat around an image usually works well, unless it is taken to ridiculous extremes. The way to test out what will work is by experimenting with different sizes of card borders before making a final decision.

Large mats on smaller images work well in part because small frames can get lost on gallery walls (unless they are densely packed), and mats help the photograph make more impact in relationship to the wall. Good frames are also an expensive investment, so some photography galleries own a limited range of variously sized frames which they use regularly and with every size of image. This is made possible by the fact that the mat can be cut to fit the frame whatever the image size.

Consideration of the positioning of the mat is itself an issue. There used to be strong conventions about the positioning of the matted photograph within the frame. The convention used to be for 'bottom weighting,' i.e. that the left and right borders of the mat were always equal in width but that the borders above and below the image usually differed in their depth—with

Different sizes of window mount including a 'bottom weighted' mount (mounts are 1," 2" and 2" bottom weighted). Images © Georgina McNamara.

the border underneath the image being from a quarter to half as deep again as the top border. This convention, although still used for older prints, is disappearing in favor of center weighting the image so that all the borders are equal in size.

This decision can be made on the basis of what pleases the eye or suits the work but the need for consistency across a set of frames that are going to line up along a wall might also affect the placing of the mats. For instance, if horizontal and vertical frames are placed unevenly in a row across a wall, one way to create a visual consistency may be to line up the tops of the prints (rather than the frames) at the same height across the wall so that the top line of the photographs draws the eye along the wall. This can be achieved by varying the depth of the borders above the photographs because the eye will be held by the darker line of the images rather than the lighter color of the mats.

Unmatted framed work—tray frames

Over recent years it has become more popular to present work unmatted and in a frame. It is one way to make the work look more immediate and can indicate a desire to avoid the perceived pretensions of a mat while still protecting the work from damage. These frames are called gutter boxes or tray frames and the image is held firmly away from contact with glass. This is done by a step in the frame and the artwork is either glued into the step if it is on aluminum or screwed into it if it is on MDF or a wood based board.

Samples of tray frames showing the step which holds the image and with a photograph dry-mounted on aluminum sited on the inner step. The frame can also be painted or stained to suit the artwork. Images © Georgina McNamara.

Fixings/mounting hardware

There are a number of options for attaching a frame or mounting an image to the wall. Professional framers often have a preferred method of doing this, appropriate to the weight and type of frame or mount, and they may well provide this without consulting you—unless you make a point of checking it first.

The option you should not use is the one you may have at home: picture wire. In a gallery setting, this leaves the picture too vulnerable. The picture can easily be taken from the wall or knocked out of alignment. The wire is also very springy, so it can be difficult and slightly dangerous to use and because it becomes brittle over time it can also break.

However, if you are doing this yourself, you have a variety of choices, both for the fittings on the frame and for attaching the frame to the wall. The choices are:

1. picture rail hooks, and picture cord used with screw eyes/D-rings used with picture rails

2. picture hooks used with screw eyes/D-rings

3. screws

4. mirror plates

5. strap hangers used with J-hooks

6. metal battens

7. split battens (wooden)

8. concrete wall hangers for use on difficult walls

Fewer galleries use picture rails and picture rail hooks than once did, but in some places they are the only available system. They are often used in old buildings, where the walls are

Fixings/installation hardware: (top row left to right) picture rail hooks, picture cord, screw eyes, strap hanger, and J hook. (bottom row left to right) picture hooks, mirror plates, concrete wall hanger, and D-rings. Image © Tim Roberts.

(left) Screw eyes, which can be bought from framing or hardware shops, are attached to the frame itself rather than to the backboard. Reinforced cord is used and the fixings face inwards so that they are not visible when hung. (right) Hang Its are used only by framers and cannot be bought by the general public. Like the screw eyes they are used for lightweight frames with cord. The Hang Its are, however, fixed to the backboard not the frame. Images © Georgina McNamara.

wooden or impossible to drill into without excessive damage. Picture rail hooks come in different sizes and colors and are used with picture cord attached to the frame by two screw eyes or D-rings. D-rings are considered more secure than screw eyes. When using a pair of screw eyes or D-rings, they are best placed at about a third of the depth from the top of the picture frame to provide maximum support. Picture cord is generally used by framers in preference to wire because it is safer. It is reinforced low-stretch white nylon cord and usually available from good framing shops. It is sold in different thicknesses and by the yard or meter.

Picture hooks can be bought in hardware shops and come in double or single sizes. They are attached to the walls with the brass pins that are provided with them. As with picture rails, they are used in conjunction with frames with screw eyes or D-rings and picture cord. The cord should be hidden behind the frame. However, picture hooks are not often used in galleries, as the pictures are then vulnerable to theft because they are easy to lift from the hook and are also easy to knock out of alignment and may not hang completely flat.

If the frame is slightly deeper than the removable back (that is, if there is a shallow hollow space behind the frame), then the picture can be suspended directly from two screws in the wall. The screws should be placed at about one-quarter to one-third of the way in from the edge of the frame to provide maximum support. This is a quick and perfectly efficient way of hanging work, unless it is a very heavy frame and should probably have more support (such as a strap hangers and J-hooks). It is not, however, the most secure way of attaching the frame, since it is not hard to lift the frame off the screws.

Frame back and front showing tiny mirror plates. 'As this framed photograph was only 33 × 33cm, it was essential to keep the mirror plates as small as possible otherwise they might distract from the work. The brass ones shown here measured just 2 × 2cm. I used this method of hanging for a grid sequence of twelve photographs, which were to be hung on a white wall. To make things easier for myself, one side of the mirror plates was sprayed with matte white enamel before attaching to the frame so that the visible "tongues" would not have to be painted in situ which can be very fiddly especially when (as in this case) the frame was a different color to the wall." Images © Georgina McNamara.

Mirror plates are small metal fittings that attach to both frame and wall and are very secure. They look rather like a jigsaw piece with a tongue protruding from a square block and can be bought in different metals and sizes from hardware shops as well as specialist framing shops. You use two mirror plates and attach them either at the top and bottom or, more usually, on each side of the frame. Two screws attach the larger part of the plate to the back of the frame and one screw attaches the smaller 'tongue' to the wall. They will hold a heavy picture frame but are visible and rather unattractive, although they can be painted to match the wall and will then be much less obtrusive. They cannot be used on metal frames, although there are metal frames available that have very similar fixings already attached. They also make it impossible to butt the work up closely in a stack of four pictures, for example, since each plate protrudes from the edge of the frame and it is impossible to put the next picture any closer than the end of the mirror plate.

Strap hangers are hidden behind the frame and so look neat and professional. The strap is usually metal and shaped like a belt with a large eyehole shaped like a belt buckle (without a prong) which hooks over either a J-hook or a screw in the wall. They depend on very accurate measurement, since there is only one place for the J-hook or screw to go, and if they get out of alignment the picture will be crooked. Strap hangers are very secure and will take heavy frames or light boxes.

Thin metal battens are usually used for hanging photographs that are mounted on aluminum. They will be attached by the framer. Usually there are two parallel battens near, but not at, the top and bottom of the frame. There are two so that the picture hangs flat at an even distance from the wall. Each batten is a squared off and upside-down U-shape. One arm of the U is

shorter than the other and this rests on screws in the wall. The longer arm of the U is attached to the aluminum backing of the photograph. This hanging method, unlike straps, allows the installer to adjust the horizontal placement of the image after it has been hung, something that is very useful when several images have to be precisely spaced along a wall.

Split battens make it very easy to install the picture. This depends on a single batten that is placed near the top of the photograph and runs parallel with the top edge. The batten is in two pieces with a diagonal join (called a male/female fitting). One side is attached to the wall, with the diagonal cut facing inward toward the wall. The other is on the back of the frame, also with the diagonal cut facing inward toward the back of the image. Once the first batten is attached to the wall, the whole picture can be lifted and slid into place where it is held firmly by two battens and the diagonal cut. A second parallel batten at the bottom of the image makes sure that it is held flat, away from the wall. Like the battens on aluminum, it allows some sideways flexibility for positioning the picture on the wall.

Specialty concrete wall hangers are available from good hardware shops and framers. They have several small prongs rather than a single long one and are used on walls that are difficult to drill into.

(left) The back of a lightbox showing strap hangers. Strap hangers are used with J-hooks for heavy work (large works, mirrors, and lightboxes). They should never be used with cord which will not take the heavy weight. Image © Georgina McNamara. (right) The back of an aluminum mounted photograph showing split battens. The batten on the left is fixed to the back of the photograph; the next one (with screw holes) is ready to be attached to the gallery wall. The lower batten (right of image) is used as a spacer to ensure that the work is held at a consistent distance from the wall. Image © Georgina McNamara.

Case Study Seven
Katrina Sluis: Exhibiting Online

 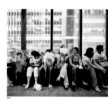 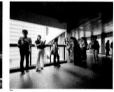 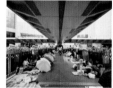 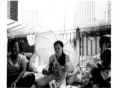

Jonathan Winstone's portfolio is designed with Indexhibit. He uses an unconventional interface where his images scroll horizontally and not vertically. All images copyright Jonathan Winstone. http://www.jonathanwinstone.co.uk/

 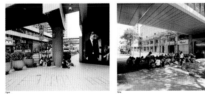 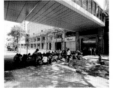

If an audience is what you prefer (as opposed to a physical thing like a book or a show as the testimony to your photographic talent), then the Internet is for you.

Jason Evans,[1] thedailynice.com

Exhibiting photography online is materially very different from a gallery space where issues of scale, texture, sequencing, and lighting all come into play. Online, the way in which you categorize, organize, and contextualize your images are more critical to the way in which a viewer may encounter your images and interpret them. On the web, your work has the potential to reach a more diverse audience, not necessarily connected with a gallery space or genre of work. With the popularity of social media websites such as Flickr, there has been a renewed interest in the potential of photography online and the possibilities which these platforms offer. As such, photographers are faced with a daunting array of tools through which they can establish a web presence. In the following text, I hope to outline some of the curatorial and practical issues you need to consider when exhibiting online.

From print to screen

For some critics, the web is a very problematic milieu for photographs to inhabit. The web browser and the computer screen have been accused of flattening out photography— by dematerializing the photograph and placing it alongside millions of other images. It is estimated that Flickr.com holds over four billion photos and that Facebook will host a staggering 100 billion photos by the end of 2011. In an environment that appears to value the ephemeral over the monumental, one wonders what chance individual photographs might have of holding our attention.

The Internet's image glut encourages very different viewing practices. On the web, we are encouraged to jump restlessly from image to image, across a hyperlinked landscape filled with distraction. It is possible to scroll through streams of images with the flick of the mouse, causing images to blur together almost cinematically. As the screen becomes an increasingly popular vehicle for viewing photography, the material differences between a calotype, Polaroid, or fiber-based print as well as subtleties in the printing process are condensed into the relative uniformity of the JPG file. As a result, it has been argued that the web encourages us to look at photography as pure content, pure signification. It is suggested that without the distinct materiality and texture of the photographic object, it is only the photograph's representational value which remains.

In spite of these anxieties, it is important not to fall into the trap of thinking that the web simply represents the dematerialization of the photograph into an intangible plane

[1] From his essay 'Online Photographic Thinking' in *Words Without Pictures*, Alex Klein (ed.). (2010). 1st Aperture Edition, New York: Aperture and LACMA, page 43.

of 'cyberspace.' The web presents us with very different, though no less important material implications of software, code, and screen. Making your work accessible online means giving up control over the viewing environment: your audience will encounter the image via an array of different sized monitors with varying resolutions, contrast and color balance. Whether an image is featured on a blog, portfolio site, or an online magazine, it will inevitably always be embedded in a software interface made up of links, buttons, and graphics—a far cry from the uncluttered, refined space of the gallery. In this respect, it is important to understand that the software interface becomes a cultural layer that frames the image with its own values—the typography, headings, navigation, and design all produces a context for the work and frames the way in which it is understood.

For these reasons, you should consider what your aims are in establishing a web presence and what platform best supports these needs. Are you wanting to create an online portfolio as a convenient alternative to a print portfolio? Do you want to experiment and develop a photographic work specifically for the web? Do you want to get feedback on your work in progress, learn new techniques, and network with others? Do you want to sell prints online or generate income from licensing your images? Do you want to dip your toes into web design or are you technophobic? What kind of photographic practice do you have and how will you communicate this through your site design? Your answers to such questions should help guide your route into exhibiting online.

From gallery to web: the options

Today, it is possible to have your own site with a beautifully designed interface and a complex database powering it for next to nothing. Social media platforms have removed many of the hassles in getting your work online, and photographers have emphatically embraced these tools. Inspired by the popularity of web applications, a number of companies now offer low-cost fully hosted portfolios sites which you can customize yourself. And if you prefer to have complete control, there are hundreds of templates, tutorials, and tools (e.g. Adobe Flash, JQuery, Javascript) to help you do it all yourself.

Option 1: the photo sharing website

Possibly the easiest option is to create an account on an online photo sharing platform. Flickr, SmugMug, Photobucket, DeviantArt, and Snapixel function as photo sharing and image management applications, which facilitate the formation of social networks around the content users upload. Therefore, these platforms can be important tools for self-promotion, finding new collaborators, learning new techniques, organizing events, and contributing to debates concerning photography.

Photo sharing communities can provide a rich source of ideas and have an experimental approach to exploring different modes of photographic production. Flickr is known for the playfulness of its 'Groups' feature, in which users group together to share images around a specific theme. For example, 'Social Documentary Photography' is a group of over 17,000 photographers who have contributed over 47,000 documentary photographs to their collective pool of images. This is a very different model of exhibition where the trope of the edited image gallery is discarded in favor of the fluidity of an image 'pool' whose content is in a constant state of flux.

Aside from the ease with which these sites allow you to construct and update your online portfolio, photo-sharing platforms allow your work to be seen by a potentially larger and more diverse audience. Those who may be put off from visiting a rarefied or geographically distant gallery space have the opportunity to engage with your work from the comfort of their home or office twenty-four hours a day. It is important to emphasize this difference in audience and context. Photo-sharing sites tend to blur the distinction between professional and amateur by providing an open platform for participation and discussion. Enthusiastic hobbyists share their latest studio portraits with commercial photographers; newlyweds create online galleries for wedding guests to contribute their snapshots to; and students, artists, backpackers, and companies all use these spaces to display their work in what can be a very casual and playful environment.

One of the most valuable aspects of photo sharing sites is the way in which they facilitate the social tagging of images. Tagging is the process of adding keywords to an image, so that the image is more easily retrieved when searched for. The more tags associated with an image, the more visible the image becomes across the network and the more attention it is likely to receive. Recognizing the semantic value that tagging brings to images, Google and other search engines now index the images contained in these platforms. Tagging thus improves the likelihood that your images will be discovered not just by other community members, but by a global audience who increasingly rely on Google as their default map of the web.

With so many images tagged and easily searchable, photo sharing sites also function as massive stock photography databases. They have attracted the attention of those requiring images to illustrate a piece of journalism, website or for an ad campaign. For example, a *Boston Globe* photo editor paid $150 to license an image he discovered searching Flickr. At the time of writing, Flickr is in negotiation with Getty Images to build into the interface an option to allow Getty to handle licensing enquiries, contracts, and payments on a photographer's behalf.

Flickr has also provided a way for institutions such as the Tate Britain Museum to invite photographers to participate in their exhibitions. *How We Are: Photographing Britain* was a show that invited members of the public to submit images to be shown on screens inside the exhibition. Elsewhere, Ranjit Bhatnagar's work was discovered by a curator for the Metropolitan Transport Authority, New York, for a series of light boxes in Brooklyn's Atlantic Avenue subway station. Flickr was the interface for the discovery, selection, and editing process for the show.

Flickr is one of the oldest and most established photo sharing sites, but many photographers prefer the professional features of competitors such as SmugMug. In order

to evaluate which platform is right for you, you should always keep in mind the following:

- The terms of service: Each website has differing terms of service concerning how it treats your copyright. Be sure to read the fine print, as you may unwittingly be giving the company rights to make commercial use of your images. Be careful using Facebook for this reason.
- The pricing structure: Most platforms offer tiered accounts with different pricing according to the features required. Search for online discount codes before you sign up.
- Design and layout control: How does the site present images? In chronological order? Image streams? Galleries? What level of customization is possible?
- Advertising: Check whether advertising will be embedded in your site, and whether you can remove ads and platform branding through upgrading your account.
- Statistics: Some platforms have tools for tracking the activity (eg. number of views) your images attract. Will this be important information for you?
- Bandwidth restrictions: Many platforms restrict how much bandwidth is available for your site. All download or upload activity on your photostream (including each page view) counts toward your site's bandwidth limit. The more popular your site, the more bandwidth it will use.
- Video support: If you work in other mediums alongside photography, you may want to check whether the site can host them.
- Uploading tools: Apart from the web interface, you may be able to upload your images via e-mail or mobile phone.
- Privacy options: Check what options are available to restrict access to your images, if required.
- Integration with other social media: Does the site make it easy for you to share images in blogs, embed in website or circulate over Twitter?
- Commercial tools: Do you intend to sell prints and license your images? Do you want e-commerce tools?
- Censorship: Some platforms have more restrictive policies on censorship and are known for their heavy-handedness in removing user accounts at short notice.
- Community: The SmugMug platform is more geared toward photographic professionals, whilst DeviantArt deals with all creative mediums and is more for aspiring artists. Think about what kind of community you would like your work to be associated with.

Further resources

Flickr	http://www.flickr.com
SmugMug	http://www.smugmug.com
Shutterfly	http://www.shutterfly.com
Snapixel	http://www.snapixel.com/
23	http://www.23hq.com/

Option 2: a hosted portfolio

Another alternative is to sign up to a fully hosted content management system (CMS). A CMS is the technical term for a software application that makes it possible for nontechnical users to publish content to a website. Layerspace, Carbonmade, and Photoshelter are just a few of the portfolio platforms that offer a CMS with features specifically addressing the needs of photographers, designers, and other creative practitioners.

The advantages of these sites are that they are well designed, with sophisticated templates which work to show off your images and not overpower them. As web applications specifically geared towards the needs of creative professionals, they provide customizable interfaces for displaying images in flexible sequences and layouts. Most of them operate on a paid subscription basis, with the monthly fee varying according to the features you require.

The range of features that online portfolio management platforms offer are generally more extensive than photo sharing sites. You can use their predesigned templates, or you can rework the entire design if you have the skills in HTML and CSS (the language for describing web pages). Most of them claim to have excellent search engine optimization (SEO), which means that your site will be coded in ways which will improve your search engine ranking. Your ranking can be further enhanced by using your own domain name (http://www.yourname.com) and by adding keywords using SEO tools built into the CMS. Almost all offer social media integration, in the form of buttons which help visitors to share your work virally via Twitter or Facebook. In order to further distinguish themselves, some portfolio management platforms guarantee that your site will be optimized for viewing on iPad or iPhone, and others offer e-commerce tools should you wish to go down this route.

What is great about these platforms is that they offer you the opportunity to have a sophisticated portfolio without the expense of hiring your own web designer. You don't need to get involved with the technical nuances of web development unless you want to, and you have the benefit of a website which you have greater ownership of.

Further resources

SquareSpace	http://www.squarespace.com
LayerSpace	http://www.layerspace.com/
View Book	http://www.viewbook.com/
Live Books	http://www.livebooks.com
FolioLink	http://www.foliolink.com/
ZenFolio	http://www.zenfolio.com/
Photoshelter	http://www.photoshelter.com/
CarbonMade	http://www.carbonmade.com
Cargo Collective	http://cargocollective.com
ClickBooq	http://www.clickbooq.com/

Option 3: blog

A blog, or web log, is generally characterized as a website that is updated on a regular basis, in reverse chronological order. Part online diary, part content management system, the blog format provides an easy tool for self-publishing that has been embraced by photographers as a research tool, a discussion platform and a model of exhibition in its own right.

When a blog's main content is photography as opposed to text, it is usually referred to as a photoblog. A photoblog differs from an edited portfolio site as it offers a model of exhibiting which is both ongoing and temporal: the most recently uploaded image

Part artwork, part performance, Gert Rietveld's photoblog *Running from Camera* is hosted on the free Blogger platform.

http://runningfromcamera.blogspot.com/

will always be the focus of the main page, with an archive of previous entries a click away. One intriguing example of a photoblog is *Running From Camera*. The website presents an unfinished archive of 124 images taken since June 2006 by the photographer Gert Rietveld, who uses this simple rule: 'I put the self-timer on two seconds, push the button and try to get as far from the camera as I can.' In this respect, the photoblog produces a structure that automatically produces a self-archiving record of an engagement with a specific subject over time.

Other photographers have found that having a blog can help to facilitate further opportunities to exhibit and create networks while developing one's practice. *I Heart Photograph* is a photo blog which launched the curatorial career of Laurel Ptak, who established her blog as a cheap and accessible platform to champion photographic work which interested her. *The Sartorialist* is another successful blog, started in 2005 by Scott Schuman in order to share photos of people that he saw on the streets of New York who, he says 'looked great.' His work has been featured worldwide in fashion magazines and in 2009 a book based on the images from his blog was published.

It is also entirely possible to use your blog as a conventional edited portfolio site, by customizing its interface and adding various plugins to show image galleries and avoid the reverse chronological format. However, this is not recommended unless you are up for the technical challenge.

Further resources

Blog Platforms
Tumblr	http://www.tumblr.com
Blogger	http://www.blogger.com
Wordpress	http://www.wordpress.com

Photography Blogs
Running From Camera	http://runningfromcamera.blogspot.com/
I Heart Photograph	http://www.iheartphotograph.blogspot.com
The Sartorialist	http://www.thesartorialist.blogspot.com/
Little Time Machine	http://www.vanilladays.com/
Made in Tokyo	http://www.fgautron.com/weblog/

Option 4: the complete diy solution

For complete control of your website, there are a number of popular content management systems you can download and administer yourself. This approach is more for someone who is patient and technically minded, and who is willing to learn about web development. You will first need to sign up to a web host, which is a company who maintains the web server on which your files will sit. You will also need to buy a domain name through them (preferred) or through a third party (more complicated). You will

prev | next 1/23

Resort
2009 - 2011

Ocean Hotel Restaurant, 2010

Website of British Photographer Anna Fox. Designed by Andrew Bruce and built with Indexhibit.
http://www.annafox.co.uk/

need to ensure that your web host meets the technical requirements of your chosen CMS—so check the fine print.

Indexhibit (Index + exhibit) is one of the most popular content management systems which power the websites of many artists, including the photographer Anna Fox. Indexhibit describes itself as, 'A web application used to build and maintain an archetypal, invisible website format that combines text, image, movie and sound.' It is designed to be so unobtrusive and minimal that there is ideally no need for further customizations, and is free to download and distribute. The default layout is very simple, with a content area on the right for your images, and a list of links on the left hand side. Indexhibit takes its inspiration from white cube of the gallery in order to ensure the focus is on the content itself and not the website interface. Although installing Indexhibit on a web server may seem daunting, there is a large community of users who have shared tutorials and help troubleshoot issues on the forums at indexhibit.org.

It should be emphasized that the main attraction of the DIY approach is the potential to cast aside the stylistic conventions of the online portfolio and establish new models of digital exhibition. One photographer who has tried to be more experimental in their approach is Jason Evans. Concerned by the deluge of images online, he decided to create *The Daily Nice* (http://www.thedailynice.com) which consists of a single photograph on a white page which is uploaded to the web once a day, every day. The site's design consciously frustrates any desire to scroll through a stream of previous

images by providing no archive. Each image has only twenty-four hours of fame before being replaced by another. Attracting 34,000 visitors per month, *The Daily Nice* offers a different model for exhibiting whilst raising questions concerning the nature and quality of our engagement with photography online.

Further resources

Content Management Systems
Indexhibit	http://www.indexhibit.org/
StaceyApp	http://www.staceyapp.com/
Joomla (advanced)	http://www.joomla.org/
Drupal (advanced)	http://drupal.org/

Built with Indexhibit
Anna Fox	http://www.annafox.co.uk
Peter Dekens	http://www.peterdekens.com/
Alex Catt	http://alexcattphoto.co.uk/
Jonathan Winstone	http://www.jonathanwinstone.co.uk

List of Accredited Domain Name Registrars
http://www.icann.org/en/registrars/accredited-list.html

Further considerations

Copyright and licensing

Uploading your work to the web is always a risk: your images could unwittingly end up on cheesy merchandise, unauthorized advertisements, or in someone else's portfolio. Whilst it is generally acknowledged that the benefits of being online outweigh the risk presented by copyright infringement (particularly when starting out your career), there are some interesting new tools for photographers concerned with copyright. TinEye (http://www.tineye.com) is a reverse image search engine. It allows you to upload an image to find out where it exists (altered, defaced, or otherwise) online elsewhere using complex pattern recognition. It is a handy tool for those people who want to investigate if anyone has published their work elsewhere online without permission, and enforce IP rights. Google has launched its own version of this service, which can be accessed by clicking the camera icon at http://images.google.com/

You may also want to consider releasing your images under a Creative Commons license. These standardized licenses work alongside copyright to give you a framework for granting your audience permission to share and use your creative work—on conditions of your choice. In this model, you change the terms of your copyright from the default of 'all rights reserved' to 'some rights reserved.' One advantage to licensing your images in this way is it becomes possible for others to reproduce your work on their blogs, without having to ask you first for reproduction rights. In the free and open

spirit of the web, Creative Commons offers you a way of releasing your images into the public domain, in order to be remixed or recontextualized in new forms. Platforms such as Flickr support Creative Commons licensing and provide options for specifying this in the interface. For further information visit: http://creativecommons.org/

Search engine optimization

Even if you make your own website from scratch, and never touch a social media platform, it makes sense to consider how Google will index your work. With so much work circulating online, the way in which an audience discovers your work is of increasing importance—with no formal publicity, how will people know you are there? If the platform you use supports it, using tagging and keywording tools will ensure that your website is 'readable' to search engines and therefore improve its ranking and visibility. The ranking of your site depends on many factors, such as how many other high quality websites link to you, how often your site is updated with new content, and what keywords are in the text on your page.

A free guide to SEO for photographers can be downloaded from the Photoshelter website: http://www.photoshelter.com/mkt/seo-kit-for-photographers

Learn more about your visitors using web analytics

If you invigilate a show in a gallery, it is common practice to record how many visitors you receive per hour the show is open. With tools such as Google Analytics, you are also able to understand something of your online audience and the how they respond to your site in a quantitative sense—which page or images are most popular, how long they stay on your site, which websites your visitors have travelled from, what country they reside in. Google Analytics is free to sign up to, and can be found at: http://analytics. google.com. Once you sign up, you can access a piece of code which you need to insert into every page on your site. When people visit your site, their behaviour is tracked and logged with Google. You are then able to log into Google Analytics which provides a dashboard overview of the statistics it has collected. A free guide to setting up Google Analytics for Photographers can be downloaded from the Photoshelter website at: http://www.photoshelter.com/mkt/google-analytics-for-photographers

Concluding remarks

The loss of the print and the arrival of the JPG has given a new mobility to photography. The fluid and ephemeral nature of the web suggests the need for new curatorial experiments and photographic work, which addresses the coded spaces of networked platforms. Paradoxically, whilst the web produces an endless deluge of images to compete with, it offers the tantalizing possibility of reaching a much larger audience. Today, young photographers fret about how their images translate to the screen in the same way photographers once worried about how their prints survived their transformation into the more mobile form of 35 mm slide.

As a platform for self-publishing, the web continues to offer an alternative route to exhibiting, in which it is possible to bypass the traditional gatekeepers of photographic culture: galleries, publishers, and curators. But the visibility and accessibility of photographic work online is increasingly entwined with the dynamics of software and search engines, which influence the way in which we navigate online. At the same time, social media provide exciting new possibilities for the curation and viral distribution of photography in ways that are yet to be fully understood. With this in mind, think carefully about what sort of viewing environment you want to create with software, and take time to choose the platform which supports the character of your own photographic practice.

Katrina Sluis

Printing for Exhibition
by Mike Crawford

John Myers exhibition *Middle England*. Image courtesy of the Ikon Gallery, Birmingham.

In the digital age the quality of the print remains a crucial aspect of the exhibition and collection of photographs despite the disappearance of many traditional darkrooms. In this chapter Mike Crawford, a printer using both digital and analogue technologies, raises the issues that affect his work.

Of the many considerations that organizing a photographic exhibition requires, one of the foremost should be the quality of the prints. Sequencing and arranging their order will give the exhibition its narrative, framing and hanging will complement the display; however the prints are the finished works. As a photographic printer, the majority of my work involves printing specifically for exhibitions, using both traditional and digital methods of production. Prints may be required to present a new series or project, or perhaps a variety of images from a photographer's career which need to be displayed together. However, for many exhibitions, particularly retrospectives, there will often be prints ready to exhibit. Indeed, access to a particular collection or the desire to show an existing body of work will often be the prime motive for an exhibition in the first place.

For example, throughout his life, Henri Cartier-Bresson employed various printers who inevitably would have used different types of photographic papers, (obsolescence of materials is a reoccurring complaint throughout photographic history), producing prints in a range of sizes. Some would have been for previous exhibitions, while others for press and reproduction purposes. An exhibition of Cartier-Bresson's vintage prints shown in a commercial gallery would highlight this individuality, their exclusiveness appealing to a potential collector. By comparison, to celebrate the photographer's ninetieth birthday in 1998, several major museum retrospectives were held world wide showing contemporary prints made specifically for the various exhibitions, printed to the same dimensions and with similar tonal values.

Many photographers print their own work, often regarding this as an important part of their practice, while others will prefer to use a commercial lab or professional printer. Early in his career, Robert Frank processed and printed everything himself, especially during the production of *The Americans* in the 1950s. By the late 60s, however, Sid Kaplan was printing for Frank and has continued to work for him ever since. Both methods have practical benefits. Aside from the obvious financial advantages, if the photographer is responsible for the printing, they have full control of how the finished photograph will look. However, not all photographers will have the time, experience, or indeed equipment required for printing their work. In the last twenty years, as photography has grown in stature as a visual art, the physical size of many exhibition prints has greatly increased. Producing high quality prints at such a scale is normally the role of a specialist lab. Whatever the size, the printer is trusted to interpret the work, sometimes in close collaboration with the photographer. Whether in the darkroom or on the computer, they need to bring the photograph to life.

Before digital, there were two choices, black and white, which for decades was pre-eminent, or color. Exhibition prints were produced in a darkroom using traditional processes. Most required a negative to be optically projected onto light sensitive paper, which was subsequently processed in chemical baths to produce a positive print. Although photographic materials have evolved and changed from the 1830s onwards, the fundamental use of a film negative and a positive print remained common to most processes until the arrival of digital.

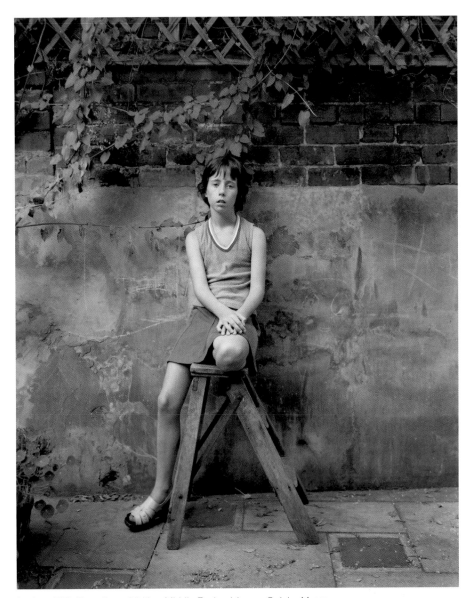

Louise, 1975. From the exhibition *Middle England*. Image © John Myers.

Middle England was an exhibition held at the Ikon Gallery in Birmingham in 2011 of photographs shot by John Myers in the 1970s. The black and white series, combining formal portraiture, urban landscape, and typological studies, were photographed close to the photographer's home in Stourbridge in the Midlands, using a large format 5x4 camera. His archive is held by the Birmingham City Library and the majority of the works exhibited were vintage prints, made by Myers around the time the photographs were taken. However, as original prints were not available of all the images selected, my brief was to produce traditional darkroom prints from the original negatives to match Myers' own prints in size, tonality, image tone, and surface. Different papers, using a choice of developers and toners, were tested to find one with a similar look to the colder emulsions used in the mid-70s. Having discussed the tests with Myers and the exhibition curator, the missing photographs could then be printed.

One interpretation of photographic history is defined by advancements and changes in technology. The early processes of Daguerre and Talbot were replaced by the collodion negatives and albumen prints of the second half of the nineteenth century. Gelatin silver papers (otherwise traditional black and white photographic papers) were first produced in 1885. They were more light sensitive, making enlargements possible, leading to a reduction in film and camera sizes. Previously prints were produced by contacting negatives onto the paper's emulsion and needed lengthy exposures to sunlight. A 10x8 inch print required a camera large enough to produce a 10x8 negative. Color processes were commercially available by the 1930s following decades of research and innovation and by the end of the twentieth century had eclipsed black and white in popularity.

The rapid succession of digital over film based practices is another technological marker leading to an inevitable change in photographic printing. New methods of production, while not completely replacing the old, have become more widespread in the last decade. For most photographers, the inkjet printer has replaced the role of the darkroom and today many photographers, using digital exclusively, will never have been inside a darkroom. Despite such changes, traditional photographic prints continue to be produced and exhibited, indeed the fine art market is one of the last areas of photography in which darkroom prints still have a strong hold. However, they are now often, (at least where color is concerned), exposed directly from a digital source instead of a conventional photographic enlarger. Although the technology used in traditional and digital differs greatly, the aesthetic choices possible, and the level of control required by each process have much in common. It is the knowledge of these skills which is essential when making successful exhibition prints.

Controls in photographic printing

One of the prime considerations in printing is tonality; the combination of colors, the depth of tones, and how these relate to each other. It should be relatively straightforward to produce a print with the correct, or standard tonal reading, what we would term a 'straight' print. This may be the most accurate interpretation of the original scene, though if desired, we can change the mood by choosing to print a degree darker or lighter. Likewise, adjusting the contrast will further enhance or reduce the character of the photograph. One of the strengths in traditional black and white printing is the ability to change the grades of paper, which controls the contrast. Color photographic paper is only available in one grade, so prints are governed by the inherent tones of the negative, though if working digitally, we do have the option to change contrast on screen prior to output.

It is usually necessary to selectively darken or lighten areas of a print. This is often to compensate for a wide exposure latitude, which cannot be retained in a straight print or in digital capture. Highlights may need to be darkened and shadows brightened so more detail is visible (dodging and burning). In the darkroom, this is done by manipulating the enlarger's projection of light. Hands or cardboard tools are used to hold back parts of the projected negative to let the remaining areas receive a longer exposure. Digitally, these actions can be replicated in Photoshop, though there will be many possible ways to achieve the desired effect. Needless to say, an understanding of traditional printing is beneficial to working digitally.

While these techniques can be used just to correct or enhance a print's tonality, they are often practiced to change the visual intent of a photograph. Sometimes this will be very subtle, just added to strengthen or pinpoint a key subject, while on other occasions they will radically alter the atmosphere. A skillful printer will know which different techniques will be suitable depending on their understanding of the photograph and the work of the photographer.

They can also be essential to ensure that the print is tonally balanced. This does not refer directly to the composition, but instead, how the tones and shapes of the print work together so it can be visually 'read.' When we, the viewer, look at an image, we decide what is the key subject (or subjects), so the tones of the print are often subtly controlled to ensure that our eye is led to these areas of interest. This may involve darkening edges of the print, or toning down highlights. It is then possible to view the print and understand what is the content and context of the photograph, while at the same time examining the main objects of interest without being distracted by less important parts of the image.

Print color will also affect our emotional response to the photograph. From starting with a neutral color rendition, color balance can be altered, either in Photoshop or in the color darkroom, to change the print's character. Adding blue to achieve a colder tone could suggest a sense of remoteness or a nocturnal setting. Alternatively an increase in yellow or red will have the opposite effect, giving an impression of early morning light or the added warmth will perhaps draw the viewer closer to the subject. These are quite simplistic examples, but they are techniques, similar to cinematic practices, used often when a story or narrative is suggested. Changing saturation levels will also alter the color rendition. Some photographers' work is recognizable for their bright, vivid colors, achieved by adding saturation, while a reduction can be used to impart a nostalgic impression; perhaps the more an image is desaturated, the older it will appear.

We also describe black and white prints by their image color or tone. While the wide range of darkroom papers once available has diminished in recent years, there is still a choice giving the printer a broad palette of materials to work with. The most popular tend to have a very neutral tone, while warm tone papers yield a slightly brown black. Colder emulsions will appear in comparison to be bluish, though all these different papers, if viewed separately, would be considered as 'black and white.' We tend to think of colder papers being more appropriate to documentary work, while portraiture may suit a warmer tone. However, while these are conventions, they are certainly not steadfast rules. Different developers can be used to enhance or reduce the tones of the paper while it is also possible to use an array of chemical toners to further change the color of the print. If producing black and white inkjet prints, the color intent of the black can be modified to replicate the warmth and coldness of traditional papers.

Some thought should also be given to the surface of the paper. The choice of traditional black and white materials is predominantly between a semi-gloss or matt, though historically, papers were once produced in a wide array of different textured surfaces. The reflective nature of gloss will inherently produce a deeper black, giving the impression of more contrast, though many photographers prefer the softer tonality of matt. Color darkroom papers are available with similar surfaces, though the matt is more reflective and the gloss has a far higher sheen. Inkjet papers are manufactured in comparable surfaces, but in addition, many use fine art bases ranging from smooth to highly textured.

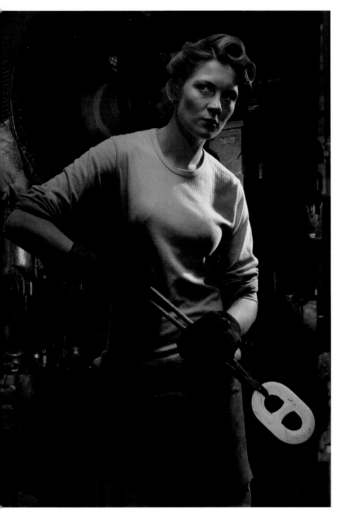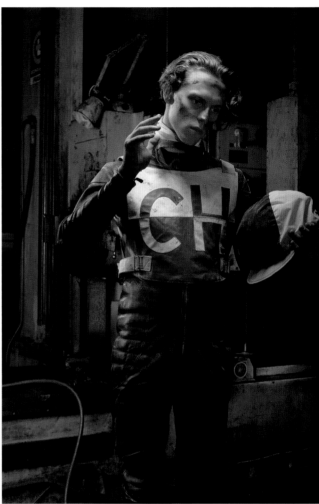

'Chain Maker' (left) and 'Cradley Heat Speedway Rider' (right) from the exhibition *The Black Country*. Image © Brian Griffin.

Brian Griffin is well known for projects depicting the worlds of business and industry and for his expressive portraits of musicians, politicians, and actors. For his exhibition, **The Black Country**, he chose to concentrate on his own past, producing a body of work which reflects and re-imagines himself growing up in the 50s and 60s amidst the heavy industry and factories of the Midlands; the 'Black Country' of the exhibition's title. The work is inspired by a wide range of influences. Visually, from artists as diverse as Carravagio and Stanley Spencer, though thematically he draws on memories of his family, local history, and childhood heroes. It was first exhibited in 2010 at the College des Bernardins, Paris and in 2011 at the New Art Gallery, Walsall. It purposefully mixes colour and black and white images as well as traditional and digital prints. Several vintage Griffin photographs, which reflected the themes of the show, were also included, which I printed in the darkroom. For most of the exhibition, both colour and black and white, I produced large format digital prints using a paper with similar visual characteristics as the traditional photographic paper used for the earlier work. While Griffin chose to present his photographs at various sizes, in different styles of frames, to give the impression of a collection which had grown over time, it was important that print quality and aesthetic was consistent throughout the exhibition.

Exhibiting and editioning

When printing an exhibition, these different controls and techniques are used to ensure that there is a consistency between the prints. For many exhibitions, a uniformity in print type, size, and framing is important to present the work as a cohesive series. This has been a standard method of presentation for decades, however, some photographers and artists such as Wolfgang Tillmans, make a point of breaking away from this sense of order. Tillmans purposely exhibits images produced with different media at various sizes, usually unframed and pinned or taped directly to the gallery wall. The stylistic differences present within the work create a diversity, giving the wide range of images equal status. As the title of his 2003 Tate Britain show suggested, *If One Thing Matters, Everything Matters*. Paradoxically, while his manner of presentation offers something ephemeral, even disposable, his gallery prices place him among the hierarchy of contemporary European artists.

Aside from museum shows, photographers will usually hope to sell prints during an exhibition, often as part of a limited edition. If so, some consideration should be given to the ethics and issues involved in printing, or to be precise, publishing an edition. Effectively, an unlimited amount of photographic prints could be produced from a digital file or negative, so an edition is a conscious decision to market the photographer's work. Editioning is a practice taken directly from etching and other methods of ink based printmaking, where after a set number, the etching plate or silk screen is destroyed. This is either to limit the availability of the work, making it more exclusive, or because the printing plate was only capable of a certain amount of prints before deteriorating.

If a photographer (or their gallery), decides to limit their work, it is paramount that the size of an edition is strictly adhered to. Most galleries, and sometimes labs, will keep details of an edition's progress. Naturally, the size of an edition and the status of the photographer will directly influence it's price. At the high end of the fine art market, artists such as Andreas Gursky and Cindy Sherman tend to produce very small editions, certainly less than ten, often just three or four. On the other end of the scale, larger editions of fifty to a hundred, especially by less well known photographers, will be priced accordingly at a far lower level. This tends to be the practice of many online galleries. Many editions also have one to two 'artist's proofs' in addition to the number in the edition.

Often, gallerists will insist that a complete edition is printed to give it authenticity; otherwise to declare that these are the finite amount of prints that will be available. However, for most photographers this will not be practical, as it would require a large financial investment with no guarantee that the work will sell. In such circumstances, it is prudent for the photographer or printer to retain a test print for the rest of the edition to be matched to. If they are darkroom prints, details should be kept on exposure times, while digital files must be carefully backed up and archived. I find it useful to keep notes in the file's metadata to record print sizes, the ICC profile used, printer settings, and paper type. One potential problem when printing at a later stage, which is particular to darkroom prints, is the possibility of a make of paper being discontinued.

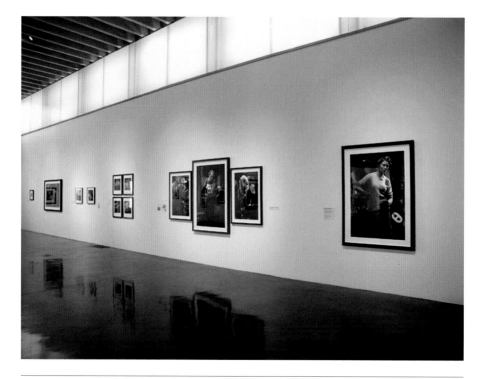

Brian Griffin *The Black Country*: image © courtesy of the New Art Gallery, Walsall.

A final and important issue regarding exhibition printing, which runs throughout all the planning stages of the show, is timing. Two matters common to all exhibitions, regardless of their scale, are the budget and the deadline. It is the responsibility of the printer or lab to complete the work to the schedule agreed and this should include the time required for testing and also allowing for the possibility that some images may need to be reprinted. There will be occasions when the prints will not be right. The colour or contrast may be different from the photographer's expectations, or an individual print's tonality may not match others in the exhibition. The potential for different interpretations is limitless, but with further consultation there should be a better understanding of what is required. Sometimes, certainly with retrospectives, there may be previous examples by other printers, or the photographer to match and use as a visual guidance. This could be in the form of reproduction. A photo book often becomes the definitive work long after a previous exhibition has finished and the prints been dispersed, sold or damaged. By the time the show is open to the public, the printer will have come to know the work very well. Considering the amount of hours required to produce a series of prints, they may have spent more time studying individual images, through working on the fine details of a print, than even the photographer themself. It is the opportunity for collaborating with photographers on such projects, interpreting their work for exhibitions, I find most satisfying and personally rewarding.

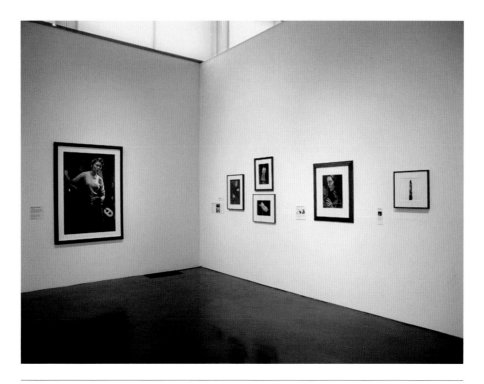

Brian Griffin *The Black Country*: image © courtesy of the New Art Gallery, Walsall.

Print types

It is common practice in exhibitions and catalogues to give a description of print type. While not comprehensive, the following list briefly explains different photographic print processes currently in use, both digital and traditional; their advantages, disadvantages, archival qualities, and title variants.

C type print

(Chromogenic Color Print, Dye Coupler Print, Color Hand Print)

A color photographic print produced in the darkroom, from a color negative. Such materials, described as chromogenic, have been in use since the 1930s, following the production of the first commercial color negative films. The accuracy of color rendition is controlled in the darkroom by the printer varying the filtration of light used for exposure. The color enlarger required for printing C types, uses cyan, magenta, and yellow filters, which match the three layers of sensitized dyes held in the paper's emulsion. For decades, color printing was used predominantly by labs for the amateur market, or for professional photographers. In the 1970s, photographers such as Stephen Shore and William Eggleston started to have their color photographs exhibited in galleries and museums, regarded at the time with much controversy.

Until then, black and white had always been considered the only medium for 'fine art' photographers, though by the 1990s, color had become the preferred medium for most contemporary work. Formerly, C types had a reputation for being chemically unstable, especially if exhibited for long periods of time, though today its archival qualities have greatly improved. Modern color paper is available in gloss, lustre, or matt surfaces, and uses a resin coated paper base. It is possible to process in the darkroom using trays of chemicals but usually, an automated processing machine is used. While still popular for photographers using color film, its use has declined with the growth of digital and the possibilities of producing digital C types.

Digital C type print

(Lambda Print, Lightjet Print)

For many photographers and galleries, the digital C type has become the preferred choice for color exhibition printing, from both scanned film and digital photographs. The process uses traditional color photographic paper, but instead of a photographic enlarger, exposure is made using specialist machinery which projects red, green, and blue lasers from a digital RGB file onto the paper. (Hence the variant descriptions named after the two main types of printers; Durst Lambda and Océ Lightjet.) The paper is optimized specifically for digital projection, but is processed in the conventional manner. This is especially useful for extra large prints which have become the standard for many photographic artists. Because of the size of equipment used, digital C types can only be produced by large photographic labs, though much preparation work can be done by the photographer on the digital file prior to printing.

Gelatin silver prints

(Fibre Based Print, Bromide Print, Black and White Hand Print, Baryt Print, Resin Coated Print)

A visit to any photographic graduation show will demonstrate how color has overtaken black and white as the favoured medium for 'serious' work. However, for most of the twentieth century, black and white was the preferred, if not only choice, and Gelatin Silver prints have a long heritage of over 125 years. An enlarger is usually necessary to project a negative onto paper sensitized with silver chlorides. Technically, the process is quite straightforward; the exposed print is developed, fixed, washed and dried, though great care has to be taken to ensure that this is done accurately and the wash has removed all potentially harmful chemicals. Contrast is governed by the choice of paper 'grade,' either to accurately match the tonality of a negative, or to increase or reduce contrast to enhance or change the mood of the print. The paper once came in boxes of different grades of contrast, though today, most are variable contrast, using filters in the enlarger to select the correct grade. The image tone can vary from a warm to cold black depending on the type of paper and developer used. Subsequent chemical toning can then change the color to a greater degree.

Black and white paper was once manufactured in a large variety of surfaces (as well as emulsion and paper base tones), but today the choice is limited to gloss, matt, or semi-matt.

It is available on a traditional Fibre Base (FB) made from pulped cotton rag, or a Resin Coated base (RC). This material is thinner than FB and the paper base is protected by a polyethylene coating which prevents chemicals penetrating the base, which in turn provides faster wash times. RC materials are more convenient papers to use and additionally can be machine processed, however, for exhibition work, the depth of tone of FB papers is the usual preference. In addition, Gelatin Silver prints, if correctly processed, are considered very archival and selenium toning is commonly practiced to increase their longevity. While their popularity has been superseded by both color and digital printing, for most photographers working in traditional black and white, they remain the preferred choice for printing.

Ilfochrome prints

(Cibachrome, Silver Dye Bleach Print, Dye Destruction Print)

Launched in 1963, this is a darkroom process which produces color prints directly from positive transparencies. Similar to C types, it requires a color enlarger, but is a more complex process using very different paper and chemistry, and likewise, the processing is usually automised. They are still widely known by the original trading name of Cibachrome, but the material is now manufactured in Switzerland by Ilford Ltd. Ilfochromes are very stable and can produce accurate, vibrant color prints. They were often preferable to C types not just for their excellent archival qualities, but also due to the popularity transparency film once had over negative stock for commercial and fine art photography. Compared to C types, dye destruction printing has always been a more specialized and expensive process, and while there are still some labs printing Ilfochromes, its use has greatly declined.

Inkjet print

(Archival Digital Print, Giclée Print, Ultrachrome Print, Archival Pigment Print, Pigment Ink Print, Iris Print)

The technology used in inkjet printing is a direct by-product of the reprographic industry. Its machinery was originally developed to output CMYK proofs prior to offset printing, predominantly for publications and packaging. With the development of Photoshop in the early 1990s, photographers and labs explored the potential of printing digital images, (often onto water color paper), using the Iris printer, an early high quality inkjet. This market was later overtaken by larger companies such as Epson and Hewlett Packard, already established as manufacturers of office printers. However, their machines initially lacked the quality of the Iris and the dye base inks were not as stable, let alone archival. More than a decade later, after much research and development, the inkjet printer has taken the place of the darkroom for most photographers. The machinery has improved; the inks are now pigment based, and the archival qualities of the process is regarded as exceptional. In addition, the variety of printing papers available has continued to grow.

Conventional inkjet papers are useful for proofing, though specialized materials are usually preferred for exhibition printing. Fine art matt surfaces are very popular, and for many years were considered the standard for high quality digital prints. However, the introduction of

'Baryta' papers, which use similar barium sulphate coated bases as traditional fibre based darkroom papers, can now produce prints with a similar aesthetic and tactile feel to traditional photographic prints. While the stability of the inks has improved, the fragility of the prints remain. Unlike a darkroom print which has a supercoating to protect the emulsion, an inkjet has a delicate layer of ink sprayed directly onto its surface. Unframed prints are best stored in archival sleeves or between tissue or interleaving paper as the surface is easily damaged or scuffed.

Inkjets have revolutionized photographic printing, but as the list of variant names suggests, they are undergoing a gradual process of acceptance by the art market. Initially there were problems with image stability, primarily due to earlier machines using dye based inks with non-archival papers. After much research, pigment inks replaced dyes, which are now the standard for professional printing. It is possible to buy cheaper, non-branded inks for large format printers, but often they do not have the same archival qualities, and can possibly damage delicate print nozzles. From the beginning, the term 'Inkjet print' was not popular. Giclée, (derived from the French verb 'to spray'), was an early suggestion used in an effort to raise its stature and perhaps hide its true description. Though still in use, many galleries and museums prefer pigment print, or even archival pigment print. While they are accurate descriptions, it still appears to lack some confidence in the process, suggesting a less photomechanical method of printing.

Platinum print

(Platinotype, Palladium Print, Platinum/Palladium Print)

This is a traditional contact printing process, invented in 1877 using sensitized iron and platinum salts, which has seen two distinct periods of use. Unlike most nineteenth century process, the image tone was a more neutral black, though this could be changed depending on formulation, processing, and paper choice. It is an expensive, luxurious process, offering a long, delicate tonal range and was particularly popular within the Pictorialist movement of the early 1900s. The production of commercial Platinotype papers ceased in 1916, but the process saw a revival, with other hand coated 'historical' processes, in the 1980s. Aside from its tonality, Platinum is considered the most archival traditional process, though there are only a handful of professional platinum printers working today. Most photographers exhibiting platinum tend to print their own work, seeing the print itself as a key element of their work. Palladium is a similar process and it is common to mix the two chemicals to vary the contrast and warmth of the print. As it is only possible to contact print, enlarged negatives are often used unless the work was originally shot on large format film. In recent years, digital negatives, produced by inkjet printing onto acetate, have added greater flexibility to the process.

Mike Crawford
www.lighthousedarkroom.com

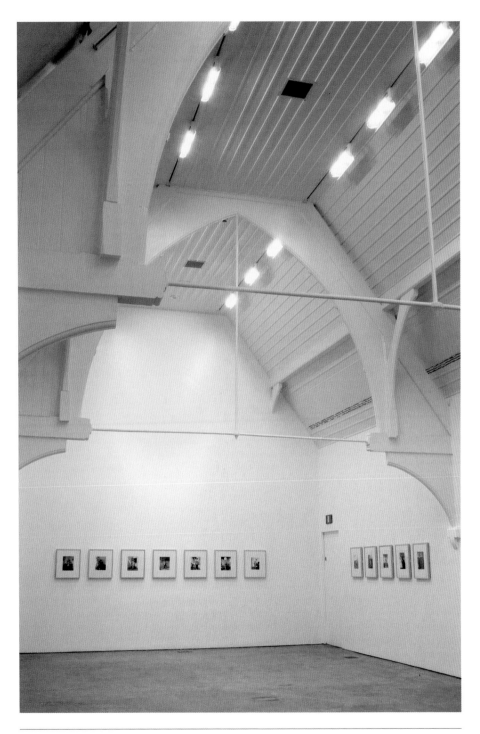

John Myers exhibition *Middle England*. Image © courtesy of the Ikon Gallery, Birmingham.

CHAPTER 18

Sales

Three swallows. Image © Gary Woods www.garywoods.co.uk

Galleries that depend on sales for their income have usually exhibited work they might expect to sell perhaps at the expense of a coherent and reflective account of my own preoccupations. Exhibitions in Japan for example have shown prints selected for their market and my exhibition at the British Council in Abuja, Nigeria though a 'documentary of the problems of that country' permitted no 'negative' images. In the 1980s my exhibitions in galleries usually avoided problematic images. No dust marks, creases,

glitches or stains—now the traditional recipe for acceptable photographs has been under challenge as painters and other artists have become involved in the market. I print a number of versions of an image to try to draw on its potential. Galleries prefer editions of the same print, I might try this with a few images perhaps producing three or four prints but with limited resources I'm more interested in experimenting with other negatives than in trying to reproduce the same print time and again. I probably develop and treat the negatives more like a painter, than a forensic scientist retaining evidence, and the lack of a prolonged life and usefulness of my negatives reflects this. Sometimes the print proves impossible to reproduce especially so at a later date when perhaps the paper originally used has changed or become unavailable or the combination of chemistries and chance are unrepeatable. I like the experience of putting pictures in sequences, either in an exhibition or in a book, it's like editing a film. Marker's 'La Jetée' is, I guess, a model for this. Preparing an exhibition is also a great stimulus for work. A deadline! Ideas, those uninvited guests, often turn up.

Gary Woods

The record of astuteness in selecting the exhibitions for Limelight was matched in depth only by the lack of any tangible response in terms of sales. A good sale for an exhibition might consist of two prints, usually at $25 each—another stark comparison to today's extravagant activity in the photography market.

From 'Helen Gee and the Limelight: A Pioneering Photography Gallery of the Fifties,' Inside the Photograph (Bunnell, 2006)

It all began with money, as almost everything does: in the early 1970s, as art prices broke pocketbooks, collectors looked elsewhere for high aesthetics at lower costs; lo and behold, photography qualified. Photography prices then rose; buyers congratulated themselves on wise investments; the market expanded.

Vicki Goldberg, Light Matters: Writings on Photography

The most expensive single photographic image to date is 'The Pond—Moonlight.' It was taken by Edward Steichen in Mamaroneck, New York, near Long Island Sound, in 1904, when the photographer was in his mid-twenties. A print of the image was sold during a special auction at Sotheby's in New York on February 14, 2006, as the Metropolitan Museum of Art 'deacquisitioned' material from the Gilman photography collection, which it bought in 2005. There are only two other prints of the image, one still at the Met and the other at New York's Museum of Modern Art.

American Photo 2006

I believe that auction sales have made a significant contribution to the evolution of the market. Already, in the 1970s, the first sales attracted considerable press and other media attention. This publicity helped us reach a larger audience of buyers, and these were principally American. ... I believe that auctions sales have helped establish criteria of quality and value. These stand as reference points.

Philippe Garner, auctioneer for Christie's (Photographie International no. 29, 2002)

We rarely buy directly from artists. Primarily we buy through galleries.

Katherine Hinds, Curator of Photography, Margulies Collection at the Warehouse, Miami

John Swannell's exhibition of his Nudes *at Hoopers Gallery (November 2006) was very successful but also highlighted market differences between the UK and US. The prints at Hoopers were selling (unframed) for £1,800 + tax. One month later one of the signature prints of the exhibition sold at auction in New York for $19,000! This has resulted in an increase in the price for this print in the UK but it will be well under the US price.*

Helen Esmonde, Director, Hoopers Gallery, London (www.hoopersgallery.co.uk)

I'm delighted photographers can now make a living from selling their work, but I can see that, unless you are sure of yourself, you might get swayed by the market. Collectors buy indiscriminately now.

Stephen Shore, photographer

In an overcrowded market there is increasing pressure to stand out: online picture sales are on the increase; micro-stock sites, selling low-price amateur images, are just the latest digital phenomenon undermining the professional market. Developing your own approach and signature style is more important than ever.

Ed Barber, photographer

The art market is very entertaining but also short-lived. Something that is hip now might be forgotten about two years later.

Dr Inka Graeve Ingelmann, Head of the Department of Photography and New Media, Pinakothek der Moderne, Munich

Until the last quarter of the twentieth century, very few photographers could expect to make a living buying or selling prints. The development of the market for both vintage and contemporary photography dates from this period and was led, and is still dominated by, American collectors. Prices remain higher in the United States than elsewhere, although important auctions are now held in Britain, France, and Germany, as well as the United States and sales of photographs continue to improve.

Although photographs have been collected publicly and privately since the invention of photography, they have been collected as much for the information they hold as for their beauty, artistic merit, or authorship. Universities such as Harvard used original prints as teaching tools, and institutions from museums and libraries to the military and business kept photographs as records. As Douglas Crimp points out in his essay 'The Museum's Old, the Libraries' New Subject' (1993), it was only in the 1970s that photography began to be reclassified for its intrinsic interest as photography rather than for its informational content and to achieve serious prices in the art market. The Victoria and Albert Museum in London, which started collecting photographs in 1856, is typical of many similar institutions in not having a designated photography department and curator until the 1970s.

A number of factors contributed to opening up a market for photography between the 1960s and 1990s. Artists like Andy Warhol and Robert Rauschenberg had, by using photography, blurred the traditional divide between art and photography, making it easier for photography to be revalued. The market itself was growing in strength at a time when most of the world's major paintings had been acquired by museums and were increasingly rarely coming onto the

market—the supply of 'old masters' was drying up. Popular interest in, and the exhibition of, photography was growing. It also became clear that the problem of the infinite reproduceablity of photography could be addressed as artists started to produce limited editions of photographs. The concept of the vintage print, which gave the print made around the time at which the image was taken more value than a modern print, also limited the production of modern saleable photographs from old negatives.

Although there had been sporadic photography sales before this period, the first major sale of photographs in London was in December 1971 at Sotheby's under auctioneer Philippe Garner. It was entirely devoted to nineteenth-century photography and was designed to be the start of a program of photography sales. Since then the number of nineteenth-century photos available for sale has gradually diminished, and in May 2007 the sale at Christie's in London included no nineteenth-century photographs for the first time since 1971.

The market for the 'great masters' of twentieth-century photography also started to develop in the 1970s. Philippe Garner recounts that in 1975 the Photographers' Gallery in London held a benefit auction. Prints by Ansel Adams, Cartier-Bresson, and Robert and Cornell Capa were among those sold. The highest price achieved was £250 (approximately $390) for an Irving Penn print. This was seen as such a high price that it bought gasps from the audience. It was also the first Irving Penn print to sell at auction; the print, which was bought by Sam Wagstaffe, is now in the Getty collection.

The market for contemporary work was slower to develop and only started to establish itself seriously in the mid-1990s. In 1987 Abigail Solomon-Godeau wrote, 'The market was and is dominated by painting, and the prices for photographic work, despite the prevalence of strictly limiting editions and employing heroic scale, are intrinsically lower. Nonetheless, the fact remains that in 1980, the work of Levine or Prince was largely unsaleable.'

Since then, the market for contemporary photography has developed to such an extent that in 2005 'Untitled (Cowboy),' a photograph by Richard Prince, sold for $1,248,000 at auction. It was the first contemporary photograph to sell for over a million dollars.

However, knowing that photographs are beginning to achieve good prices at auction doesn't help individual photographers to price their work. Pricing artwork is complex, and no standard pricing structures or universal guidelines exist as yet. Prices also vary widely between countries; prices in the United States, for example, are higher than in Europe. Major international events such as regular auctions, festivals, and photo fairs do, however, suggest that prices will start to achieve international parity.

A combination of factors can help a photographer decide print prices, and there are a number of things to take into account:

1. the photographer's reputation and exhibiting record (this is the major factor)

2. the showing context

3. print size

4. the mount or frame

5. editioning

6. rarity value

1. Prices build up over time as the photographer becomes established. A young artist cannot expect to sell his or her work at the top of the price range unless there has been great critical attention and market interest for that work and, most probably, the artist has been taken up by a prestigious gallery which puts their reputation behind the work.

2. If a photographer is represented by a gallery, that gallery is likely to have an established range of prices, which in turn depends on the gallery's position in the art world and on their client group. The gallery will want the photographer's prices to fit within that range, which effectively fixes the works' prices since the photographer will not be able to sell the same print elsewhere for a markedly different price. If the photographer is not with a gallery, then there is a great deal more latitude in the price range although, generally speaking, the independent photographer's work will sell for less because they do not have the implicit guarantee of a gallery's support for that price.

3. Although print size is not calculated by the square inch of image size, the same print will sell for more in a larger size than it would in a smaller size. Large contemporary prints do sell for proportionately higher prices than the traditional standard exhibition sizes of 20 × 24" or 20 × 16."

4. If the print is presented in a frame, it will usually be offered with an option to buy the print either with or without the frame and two prices will be quoted. The price for the frame will be kept at or near its purchase price. However, a number of contemporary mounting methods entail permanent mounts, meaning that the print can only be sold as it is presented. This includes images dry mounted onto aluminium and Diasec or PlexiPhoto mounts (face mounting using silicone sealants). These are state-of-the-art and expensive methods of presentation and the price will reflect these production costs.

5. An edition is the means by which the photographer guarantees that only a fixed number of prints are in circulation. Edition prints are usually of the highest quality, signed, numbered, and dated; and the photographer or dealer keeps track of the edition and of sales. In theory at least, the whole edition will be made at the same time, in the same size, and with the same print quality, using all the same processes.

 Currently, prints tend to be sold in much smaller editions than in the past, when print runs could be upward of twenty-five. Editions of ten or fewer are customary; and the price per print usually rises as the edition starts to sell out. So the ninth print of an edition will probably cost considerably more than the first print sold from the same edition. It is also acceptable for the photographer to produce two or more editions of the same print by printing at different sizes, although this fact should be made clear from the outset.

6. Real rarity value is primarily an issue with vintage rather than contemporary prints although it can be an important factor with, for example, hand stitched or over painted imagery or one-off camera-less images. So, for example, Susan Derges's unique large Ilfochrome print *Full Moon Hawthorn* was for sale at the London Art Fair in 2011 for more than ten times the price of her smaller editioned prints and a large hand sewn photographic patchwork was one of the most expensive photographic images at the Fair.

Philippe Garner, on being asked to comment about vintage prints for *Photographie International* (no. 29, 2002), said, 'A precise dating is not the only issue. Different criteria regarding print quality and desirability apply to different photographers. One must ask many questions. Was the print made by the photographer? Was it made by someone else? Was it approved by the photographer? Is it signed? Is it stamped? Is it annotated? Does this matter? Ultimately a print has an intrinsic object quality or it doesn't. This will not always be determined according to whether it was printed the day the negative was made or a week later or a month later or a year. Some photographers are obsessed with print quality, others see the magazine page as their medium.' Much of what he said also applies to contemporary print sales and a photographer may find to their surprise that they have an image which sells well for reasons which aren't entirely clear and that this may push the price of the rest of their work up—or it may not.

For photographers who have to price their own work, it is difficult to know where to start and, unfortunately, there is no easy way to arrive at a price unless you are working with a gallery or curator that is prepared to advise you.

However, there are probably two good starting points. The first is based on the production costs of the image. How much did the final print cost to produce? Include the costs of printing and mounting as well as labor costs but not additional production costs (like traveling halfway around the world to take the picture), and then multiply this by three or four. This should give a reasonable price range. The second way is to look for photographers and photographic work with which you can make a relevant comparison. This means work of similar genre, size, and production values and an artist at the same career stage and position. Look at their prices and relate a price to theirs. This will only work if there is a genuine parity between the work and the artists' positions and is particularly relevant if you are part of a photographic collective or exhibiting group. It should be a discussion point in any group exhibition because prices in an exhibition need to have some consistency—if they differ too wildly without an obvious rationale the prospective buyer may well be put off by the discrepancies and think the exhibitors don't know what they are doing.

Pricing information is also available on the Internet (see www.artprice.com, for example) and in a number of annual publications. Such information is mostly aimed at collectors, however, and includes prices at the top end of the market, so it is not necessarily helpful to the less established photographer.

New exhibitors are sometimes tempted to underprice their work in the hope of selling more, and students are sometimes encouraged to overprice work in the hope that they will establish themselves in a good place in the market at the outset of their career. Neither is a good idea since it may well necessitate a hike upward or downward later. A better tactic is to get some good advice and establish a price structure you are happy with and can build upon over the years.

Gallery representation makes a difference. A gallery will take anything from 20 to 60 percent commission, and this affects the price you ask for. This needs to be clear in discussion at the outset or you may end up disappointed if the gallery sells the work for the price you mentioned and then takes their commission rather than adding their commission to your price.

The commission percentage should be in keeping with how much work the gallery will do for their artist. A local restaurant may take only 10 percent as a token payment. For this they

may well have given you only a place to show the work and their enthusiasm for the project. An established gallery will usually take between 40 and 60 percent, in return for which they should market and promote the work and bring it to the attention of their client group. They will put time and money into the exhibition and to continuing sales afterwards as well as introducing the work to an existing market.

Most art dealers and galleries are not primarily interested in one-off sales but in building up a list of regular clients who they nurture over time. They know the artist and understand the work and will bring client and work together when it seems appropriate to them. Some buyers like to continue to buy from the same artists and photographers over the years so the seller should keep in touch with people they have sold with and keep them informed of upcoming shows.

Sometimes people who want to buy an artwork will approach the artist privately during the exhibition run, hoping to bypass the gallery and buy the work for less. This may be tempting for the artist, who would receive more of the purchase price instead of paying a percentage to the gallery. However, it is a great mistake to do this; the gallery is likely to find out, it will destroy the relationship of trust between gallery and artist, and the gallery will be unforgiving.

The photographer should also carefully consider the role which selling plays in the making of the work and the shape of their career. Buyers are often conservative and the photographer who wants to take risks with their work should not let the work be driven by what sells or they may endanger the integrity of the work.

Gifts and loans

One of the problems with valuing photographs is that people outside the industry are often not aware of the value of an editioned print or the difference between a selling image and an amateur photograph. They will confidently ask for a copy of a print they like or expect a photographer to give prints as presents to their circle of family and friends. This can be quite a difficult situation for the photographer, and on the whole is it a good idea to avoid handing out prints as gifts, except fairly occasionally.

A photographer once asked me if it was standard practice to give a curator a print in return for the curation of an exhibition. In my experience it is not general practice to do this, except in recognition that someone has curated an exhibition exceptionally well, helped the photographer greatly, or formed a close bond. However, it can greatly benefit the photographer to do this since curators look carefully at what other curators choose to show on their walls (in their office or at home). Photographers who like each other's work also often exchange prints, and this is a great way to build a collection.

A gallery director or owner may also sometimes 'borrow' a work to hang in his or her home as a kind of long-term loan. It can be treated almost as a gallery director's 'perk' to collect the works he or she likes without paying the artist. A lot of unwritten and unacknowledged appropriation of this kind can happen, and it is very difficult for the artist, who needs the gallery's or the director's goodwill, to ask for the work's return. One answer here is for the artist to produce a contract for a 'loan' (based on a standard gallery contract), using the excuse that his

'Plane Tree' from the series of photographs *Transient Space*, which was made in response to demolition and regeneration in my neighborhood. They were exhibited locally in The Hidden Art of Hackney and it was here that I met Shaun Caton, Arts Curator at Homerton University Hospital. He was very supportive of my work, offered me a retrospective and included me in the project 'Model Patients.' When the arts budget was cut I donated several prints to the hospital as a thank you for the support they had shown me. Money was raised for framing costs, and the prints are now on permanent display in the X-Ray 2 Unit. Image © Jane Clark.

or her financial advisor insists that every work from an edition is fully accounted for. This means that the artist at least has a record of the 'loan' and a chance of reclaiming the work a year or two down the line when he or she may be in a stronger position to do so.

There are also good reasons to loan or gift work if the artist can be certain that it will be looked after. Once work has been shown it can drop quickly out of circulation and be forgotten. Once work is framed or mounted it can be difficult or costly to store. Loaning a work to someone who is going to put it on their wall saves storage costs and means that the work will continue to be seen. If that person is a curator who invites photographers, curators, and critics to their home or office so much the better since it ensures the work will continue to be seen and not be forgotten.

Pricing your work

Paul Herrmann, the Director of Redeye, the Photography Network (redeye.org.uk) gives his membership the following advice on pricing and selling photographic prints:

> *Selling prints is a growth area in photography. But there are some rules to play by; it's a good idea to find these out before you are asked to sell your work, and prepare by asking yourself a few questions.*
>
> *The range of prices can seem quite arbitrary. Producing a print might only cost a relatively small amount, but its selling price comes from a number of factors:*
>
> * *how much work went into making it;*
>
> * *the demand for the photographer's work;*
>
> * *the photographer's attitude to how they want their work distributed;*
>
> * *the print's rarity;*
>
> * *its quality.*
>
> *It's a complex formula, and so prices are often set primarily based on the photographer's—or more often their agent's or gallery's—experience and judgment. If you're lucky enough to have a gallery representing you, they'll probably tell you the price at which they would like to sell your prints. But it's worth informing yourself by looking at each of the factors above in a little more detail, and not rely on market prices.*

The work involved

> *Often a photographer, like many other businesses, will begin pricing their work based on the break-even point for their business, and consider how long and how much skill it took them to produce the work, overheads, and any other variable costs involved, against the number of works (whether commissions, image library, or print sales) they expect to sell. If your entire income depended on print sales, how much would you need to charge for each one to stay in business? Many photographers limit their print sales to a small selection of their work. Trying to sell prints of every single image you produce is hard work, can confuse buyers and reduce the work's value.*
>
> *Considering the time, skill, and effort that's gone into making the picture is still a good starting point for print pricing, but it's difficult to draw conclusions until you know more about the market for buying your work.*

The demand for your work

Photographic print buyers tend to fall into three broad categories:

- *Casual buyers, or consumers, who might not really expect to spend more than double figures [£100, €100, $200] on a work. Mostly they buy online, from chain stores such as Ikea, from friends, from the cheaper art and craft fairs, or might stray into local galleries from time to time.*

- *Art lovers, or aficionados, who could spend well into the hundreds for work they like. They buy from art fairs, galleries, direct from artists or photographers, occasionally auctions.*

- *Serious collectors or investors, for whom the price is arguably less important than the work's enduring or increasing value, along with other factors like the work's provenance and its critical approval.*

Which of these markets most interests you as a photographer? Any of them takes hard work to break into. Some photographers produce different types of prints from the same work to try and appeal at more than one level, while others stick firmly to a single level. Building demand through clever marketing, and coming across as a serious and committed photographer with a long-term career, will help your selling prospects.

Your attitude to distribution, and rarity

Should you limit the number of each print you produce, through editions? Editioning is a relatively new phenomenon in photography, but has been adopted enthusiastically by photographers and buyers. In theory a photograph can be printed an infinite number of times, but this does not appeal to a collector or investor for whom scarcity is important. So through an edition, photographers promise only to produce a limited number of each print, then never print any more. That way an investor knows that the print has a greater chance of increasing its value, and the sale price can be higher.

Edition quantities typically range from three to fifty. Each print will be numbered; for example 4/10 on a print means it's the fourth print in a edition of ten. It is acceptable also to produce a small number of artists' proof prints of an edition, labelled A/P, which sometimes sell for a lower price. Some photographers produce different edition numbers in two or more sizes, but some also report that the larger, more expensive, shorter-run prints sell better. So this is an area where the more homework you can do, the better.

How do you feel about limiting the number of your prints? Many photographers are naturally democratic, and wary of reducing the number of prints available by editioning. Some get round this by producing both unlimited runs and a limited edition of their work. Others realize that they are unlikely to sell huge numbers of prints, and produce editions of higher numbers.

There's a few other guidelines about editions—ask around and seek plenty of advice on these matters if you're not sure:

- *It's very important that you don't break an edition—don't ever print more at the same size after the last one has sold. Word will get out, buyers of the original edition will feel cheated, and it will be damaging to your career. Use common sense and put yourself in the position of the buyer. A new edition at a slightly different size is usually not acceptable; whereas a significantly different print produced for a specific purpose might be more acceptable.*

- *Restrict the number of artist's proofs; it should only be a small fraction of the total number in the edition.*

- *Most photographers number and sign each print, more often verso (on the back), sometimes recto (on the front), if the latter perhaps in such a way that the signature can be hidden behind a mount.*

- *Supply each print with a letter or certificate authenticating it, mentioning the edition and date it was produced.*

- *Unlike other forms of printmaking the higher numbers in a photographic print edition can be more valuable than the lower ones, since a gallery might put the price up as fewer are left to sell. If one print sells particularly well, some photographers consider holding back the last one or two of an edition, as their value is more likely to increase with time.*

Other factors can affect a print's rarity and value. So-called vintage prints—those made within a year or two of the photograph being taken—usually sell for more than later ones, though this can be more relevant to collectors than to photographers. Still, it's worth producing the best possible prints you can at the time you make the work. The provenance of vintage work is very important to buyers, so it's worth keeping good records of what work you produce when, and whom you sell it to.

The production and quality of the print

It almost goes without saying that you are producing the best possible quality of work you can. People are paying for a valuable object and it needs to be flawless, and packaged appropriately. If it suits your practice, work that has some hand-added or -finished element can add extra appeal. While many collectors will be happy to buy a digital print, for a few, an 'analogue' hand print has extra appeal.

If something unexpected goes wrong with a print, for instance if it fades or discolors within a relatively short time, you might be expected to replace it at your own cost; if you do, you need to ensure that the print that is being replaced is returned to you.

Certain processes and mounting techniques can affect a print's longevity. There's a mixture of folklore and developing research on this subject that can make it difficult to know the best thing to do. Seek advice from a reputable photo lab, or a museum specialist

if possible. Properly processed black and white prints on fibre-based paper, color prints on Ilfochrome, or the best inkjet prints using a tested combination of ink and paper, should all have a good lifespan. A modern Type C paper such as Fuji Crystal Archive also has a good reputation, though historically not all such papers and processes have lasted as long. Be careful of any process that bonds a print to a substrate; it might be suitable for making an impact at a short-term exhibition, but check its longevity.

Artist resale right

One final factor that might affect pricing is that of artist resale right, also known as droite de suite. In Europe and certain other countries, an artist, including a photographer, is now entitled to receive a percentage of the sale price any time his or her work is resold after the first sale. It only applies to work that sells for over €1000, and only applies where a professional intermediary such as a gallery or dealer is involved. The artist receives a royalty of 4% of the sale price for works sold between €1000 and €50,000, then a sliding scale applies. More recent legislation means this now applies to artists' heirs, within a certain time limit. This royalty may be claimed via a collecting society such as DACS (Design & Artists Copyright Society) or ACS (Artists Collecting Society) in the United Kingdom.

Paul Herrmann

Print Sales at The Photographers' Gallery, London

Print Sales at The Photographers' Gallery is an important constituent within the wider network of commercial galleries that support photographic collecting within the United Kingdom. Our aim is to be the first point of call for those who are seeking information on collecting photography, and in so doing, build the confidence of a new generation of collectors. We provide exhibition opportunities for emerging photographers alongside offering expert advice. As part of the first public gallery dedicated to photography within the UK, we seek to continue our longstanding reputation for supporting and representing a strong range of highly acclaimed photographers; from emerging talent through to established names. The gallery aims to appeal to the broadest possible public, from first time buyers to major international collectors.

Print Sales currently represents over thirty-five photographers and offers British and international, modern and vintage work for sale. The work is largely divided into three main groups:

• *contemporary emerging photographers, who are young talented artists at the very beginning of their career*

• *established contemporary photographers, who already have an international reputation, and*

• *the estates of photographers who were represented by Print Sales during their lives and continue to be represented posthumously (this includes vintage prints as well as posthumous editions).*

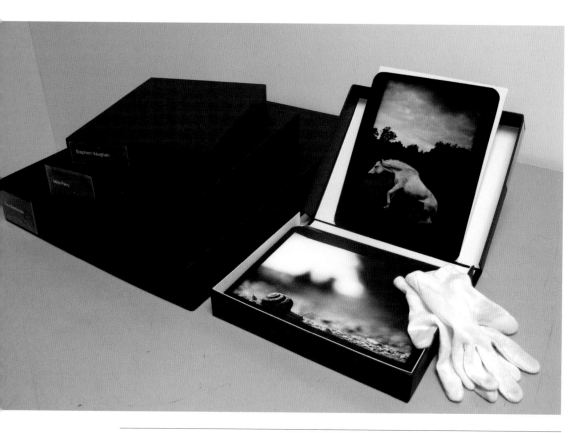

Portfolio Boxes in Print Sales at The Photographers' Gallery, featuring the work of Giacomo Brunelli. Photo by Anstice Oakeshott. Courtesy The Photographers' Gallery, London.

Photographers at Print Sales are largely selected through recommendations from a range of experts including the team responsible for the public program at The Photographers' Gallery. Outside links with the public program, we independently select photographers in response to their individual merits and our specialist knowledge of Print Sales' client base. Typically, photographers would be approached after their work is seen at a portfolio review or a final year degree show, published in a magazine or after having been awarded recognition through a public prize. Some of our photographers have worked with the gallery for over quarter of a century whilst others are relatively recent additions.

Print Sales chooses a variety of different channels to present work to the public. Our annual calendar of exhibitions allows a select number of photographers the opportunity of a gallery exhibition within the Print Sales space, and beyond the gallery we prepare off site exhibitions and loans to corporate or public collections. A selection of work is also shown annually at international photographic fairs such as Paris Photo which attract a large number of influential collectors, photography curators, and corporate buyers.

Due to the high volume of work we are handling, our website and portfolio boxes are the most important tools for representing our photographers, providing clients with the

opportunity to browse through the extensive collection of photography we offer. The website acts as an online archive, within which each photographer has his or her own page where their work is summarized and photographs can be viewed in a slideshow presentation. This online archive is supported by a large collection of work stored at the gallery in portfolio boxes and plan chests. Our portfolio boxes tend to hold twenty to thirty photographs by each photographer, thus providing a strong summary of their different bodies of work. In many cases, what we sell is not physically in the portfolio box but will be ordered from the photographer after a client has seen the image as a JPEG and examples of similar prints in the portfolio. Where photographs are sold directly from the portfolios we usually ask our photographers to replace the work with the next print in the edition.

Print Sales do not ask our photographers for sole representation, and we actively encourage their development and wide exposure by linking each photographer's personal websites to their page on the Print Sales website. We do not have a policy on editioning photographs but prefer to offer advice to photographers based on the work they produce. Typically our photographers choose smaller edition sizes of five to ten, which they print in two or three different sizes. When setting prices there are various things to take into consideration; the photographer's reputation, the type of print, size and paper used, condition of the print, if it is an iconic piece or a vintage print, whether it is signed. The time and cost of producing the print is also an important consideration, especially for new photographers. At Print Sales, our price point starts in the low hundreds of pounds sterling but ranges up into tens of thousands.

Often our photographers step their pricing system so that the price of each print increases as the edition runs out. This is a useful system to encourage clients to buy a photograph early on after its release, it also allows the photographer the flexibility to start selling at a lower price point (thus appealing to a wider audience) but to make up for this as the edition sells out and the prices rise.

Our collectors range across the board from public institutions, to corporate companies or private individuals. As part of The Photographers' Gallery we tend to find a lot of our clients are photography enthusiasts who have an ongoing interest in photography. Outside of this group of people, the main clientele are art consultants and interior designers. Due to our central location within The Photographers' Gallery building we also generate a high level of interest from casual visitors, many of whom are new to collecting.

The type of work represented by Print Sales aims to appeal to a broad and diverse audience, from a first-time buyer with little or no knowledge of photography, a photography enthusiast who has a particular interest in a subject or particular aspect of the medium, to a long-term collector seeking to develop his or her specialist collection. Some collectors are looking for photographers who are challenging and manipulating the medium in a new and unique way; whilst others are more attracted to images with immediate aesthetic appeal. At Print Sales our stock covers a wide range of subject matter and stylistic approach; from social documentary, street photography and conceptual work through to still life, portraiture, and landscape photography.

Due to the popularity of the medium and the high number of talented students under-taking degree courses, photography remains a competitive field. With various important exceptions, it is not easy to make a living solely from selling fine art prints. However there are a number of steps you can take to kick-start your career and make sure your work does receive the best response. Firstly, it is important that you constantly build on your cv and your exposure by entering competitions, open submissions, putting together independent exhibitions and taking part in photography related events. Attend-ing focus groups and portfolio reviews will also allow you to gain invaluable feedback from professionals (thus ensuring that your portfolio is well edited and of the highest possible standard). Finally it is essential that you have a presence online with a website or photography blog. It is through these various platforms that arts professionals are seeking new and talented photographers. The more involved you become the higher your chances of recognition, constructive advice, and further success.

Anstice Oakeshott
Print Sales, The Photographers' Gallery

Simon Norfolk talks to Shirley Read about gallery representation and sales

Simon Norfolk is one of Britain's most successful exhibiting photographers. He is a landscape photographer whose work probes the meaning of the word 'battlefield' in all its forms. His work has been internationally recognized, published, exhibited, and collected—he won Le Prix Dialogue at Les Rencontres d'Arles in 2005, his monograph *Afghanistan:chronotopia* was published in five languages and his work is in the Deutsche Börse Art Collection and Getty Museum in Los Angeles as well as other major collections. In 2011 his exhibition *Burke + Norfolk: photographs from the war in Afghanistan* was shown at Tate Modern, London.

Shirley Read *Do you call yourself an artist or a photographer and is this relevant to your exhibiting career?*

Simon Norfolk *No, not at all, I don't think about it. It doesn't matter to me or change anything I do and ignoring that gives me flexibility.*

SR *I know you didn't start out with an exhibiting career in mind—what made you change direction?*

SN *I was a photojournalist working on magazines until 2001 when the Afghanistan work changed everything for me. Now I work via books, exhibitions, commissions, a website, and I even, occasionally, do small bits of advertising work. It's about not having to rely on a few financial sources but also believing that ideas are sold short by just being in one outlet—if it's good enough for one it's good enough to also be a book, to have an exhibition or a television program or to get a poet to write about it, or whatever. I'm trying to make the material work a lot harder.*

Half the stuff I have on a gallery wall either started out as a magazine assignment or was something I thought of and then took to a magazine to help me get access or

Ascension Island. BBC World Service Atlantic Relay Station, 2003. Image © Simon Norfolk www.simonnorfolk.com.

something I produced and then gave to a magazine. I've always liked to have a sort of stacked democratic distribution. Possibly I can get £6,000 for a print in an edition of seven but I never became a photographer to have a dialogue with seven people. So beneath that I have a special edition of the book which is £300 and beneath that I have an edition which is £40 and beneath that I have a magazine article in the New York Times, *which is £1.50 and beneath that is my website which you can look at virtually*

free—so each of those is a different object with different meanings but you can enter the work at any of those different price points. I think that's quite democratic. But if I spent six months on a single piece of work, as painters do, I would have to sell it to one person for a great deal of money which would limit my connection with the outside world. So I like having all these different places where the work is seen.

SR *How important is exhibiting to your career? What role does it play in terms of your income and in finding work and commissions?*

SN *Eighty percent of my income is from print sales. I take magazine commissions, (where the pay is pathetic) but they're quite important because they give me access, which is something I need to do my work. Having powerful friends enables the work as well as giving me a good outlet for it—the magazine pays my costs and gets me in and gets the work seen. A book run is two thousand copies; ten thousand people might see a successful exhibition; but the New York Times has a readership around the 1.7 million mark. It's important to me to have multiple audiences and reach as many people as possible.*

SR *On a practical level how much time do you spend working on exhibitions?*

SN *Last year I employed someone to work for me for the first time and she spends about two days a week working on exhibitions—everything from sending out jpegs to sorting out exhibition proposals, getting prints made, sorting insurance, and sending out crates of work. It's taken a huge burden off me. I also like to get work seen quickly so I do a lot of exhibiting at festivals because there's a quick turnaround and audiences are good, lively, and sharp. A museum will have a ponderous schedule and a two-year schedule turnaround is all very well if you're photographing flowers but for me—well, we might not be in Afghanistan in two years time so I like to get the work out fast! There's no money in showing at festivals and one's approach has to be flexible so I'll use less fancy frames for example, or I can thumb-tack the work to the wall if I need to. I've just been from Paris Photo to show at the Athens Photo Festival and I sent to Greece a DVD of files which they got printed locally and the images looked great (though I don't usually let the high-res scans out of my grasp.) You have to be unprecious sometimes and in Athens it was important just to get the ideas out. At Paris Photo I was more precious about presentation because collectors and gallery directors are going to be there and the work has to look sensational and compete with everything else that's on the walls.*

SR *Is there one country you exhibit in most?*

SN *I exhibit all over the place though possibly more in the USA than anywhere else and at least 50 percent of my income from exhibiting comes from my New York gallery. My Los Angeles gallery is next and London comes last. If I have a lot of shows anywhere I also get more editorial work there. But I'm happy to exhibit anywhere, it always leads to other things, the only country in which I haven't done much in is France which is a shame because I'm quite a Francophile.*

SR *You are represented by a number of different galleries. How does this work? Don't they want exclusivity?*

SN I am represented by Bonni Benrubi in New York, Theresa Luisotti in Santa Monica, Michael Hoppen in London, and Moeller Fine Art in Berlin (where I am the only photographer they represent). I have a looser connection with a gallery in Antwerp and have just started to work with one in Zurich. It is slightly unusual to do this and there can be problems around precedence; who is getting what and what goes where; and they notice differences between each other in presentation and framing. My prices do also vary internationally because I set the price in pounds and the dollar has fluctuated a lot against the pound over the last few years—much more than the euro has—so the price fluctuates with the dollar. As a rule though, I don't get involved with the prices and the money end of things.

When I was considering galleries I saw that many of the fashionable galleries which initially made me offers were short term in their aims and made all the easy sales. I was more interested in longevity. So, for instance, if you looked at the Paris Photo catalogues from a few years before there wouldn't be many photographers' names which were still on those galleries' lists. You could see that there was a sort of churning going on where these very fashionable galleries, with very high overheads, take on photographers and make all the easy sales for a year or so then, instead of continuing, say 'goodbye' and get the next bright kid onto their books because it's easier just to flog their stuff rather than build the first photographer's career. This made me very nervous. They have beautiful expensive spaces and glamorous staff but I have to be a photographer in ten and twenty years' time. My reasons for working in the art market were that I could see it would give me some sort of longevity. I couldn't see any 55-year-old magazine photographers being treated with the kind of respect 55-year-old artists are treated with.

Each of my galleries is different, Bonni is very important and its important to have a presence in New York, it's a great gallery; Teresa doesn't sell as much but sells more to museums, which is increasingly important to my idea of my career. I get very good advice from her because she is wise and in it for the long term. She has a long term relationship with her artists (like Bonni) and thinks strategically.

It means I have to think more about conservation and archival issues which is good because I want the work to be around in 130 years time and to make sure it has the meanings I want it to have when I'm not around to speak about it. I'm not sure how well collectors look after work. But museums do!—the Getty museum has the most beautiful cold-storage facility!

But the problem is the first thing museums do is cleanse the work of its politics; look at the way Paul Strand, who was intensely political, is presented for example—his Hebridean work was about the way the British military took over the best land in the Hebrides to test missiles but you won't see that in any of the captions. They say things like 'Seaweed on Rock, 1954.' I can't stop a reinterpretation but I can place on record one interpretation and I make books to ensure the work is anchored in its interpretation because the greatest thing about a book is that it is printed on paper (!) which lasts—everything else has yet to be proved. For example I've just made seven archival boxes of Burke + Norfolk prints and made the book, which has my introductory essay, captions and sequence in it, and

the book is in a drawer which is a part of the box so it can't be removed without leaving a physical hole in the object. It is politically important to me to keep this sort of record, to counteract the standard media view (of the war); archiving is not a vanity project. Maybe some day, someone will find it just as I found John Burke's work after 130 years.

Exclusivity (between galleries) is a tricky problem. Galleries do usually expect some kind of exclusivity. I don't do that, everything comes through me and I choose where

The Ushenish S.E.A. pens from *The Hebrides: a slight disturbance of the sea.* Image © Simon Norfolk www.simonnorfolk.com.

The waters off the west coast of Scotland play host to the majority of submarine exercises in the UK. Following the sinking of the Antares trawler in November 1990 by the submarine HMS Trenchant, a system called 'SUBFACTS' was introduced that divides all the sea off the west of Scotland into boxes (S.E.A.s: submarine exercise areas) and a daily broadcast tells fishermen which boxes to avoid.

the shows are held, which order they go up in, I send out the prints from the UK when they're sold and do all the paperwork. So I am at the center of my operation and that isn't normally the way it works in America, as Bonni keeps reminding me! With a lot of the American photographers Bonni represents she is their representative so she will do all that and oversee the reproduction of prints, hold all of them and decide which of the other galleries get what, decide the prices and take a small percent. It was a bit difficult to negotiate—I do want to control my own affairs. But I work very hard to make it work and, for instance, when I produce a new picture it goes out to all the galleries on the same day, when I produced Burke + Norfolk it opened in LA and then in New York only a week later so no one felt they were getting the scrag end.

Galleries take 50 percent of sales. I used to do editions with a staggered price rise, as many photographers do, in which the price gradually rose as the edition sold out. But it made for practical problems when you have several galleries so now I do a smaller edition of seven, keep the prices level and don't offer artists' proofs though I do keep two artists' reserves. I do an edition at 20 × 24" and an edition of 40 × 53." I moved out of London and part of the reason for living in Hove is that I work with Spectrum who are based there and did all my scanning (when I was working with negative) and do my mounting and framing, experimenting with new printers and even assembling archival portfolio cases.

SR Do you have any advice about exhibiting for young photographers just starting out?

SN Only work on something you feel passionate about.

Hannah Collins talked to Shirley Read about gallery representation and sales

Hannah Collins is an artist who works with various media, including film and photography. Her large scale photographs have been described as images which 'can be experienced as an image and as a kind of architecture; as two dimensional surface and as sculpture.' She has lived and worked in London, Barcelona, and California. In 1993 she was the first person working with photography to be nominated for the Turner Prize. Her work is held in many major collections including Tate Modern, the Victoria & Albert Museum, the Pompidou Centre, The Walker Art Museum, Minneapolis, and the Luxembourg Museum.

Shirley Read You are an artist rather than a photographer—is this in any way relevant to your exhibiting career?

Hannah Collins It is in the sense that my motivation for an exhibition, a book or a group of works is rarely technically driven—the limits of what a photograph might be on a gallery wall would never dictate what I might try and express photographically. I would follow a path conceptually, hence moving and still images coexisting in the same space, the space around an image being as important as the space occupied by the image and large images being hung directly on the wall.

SR Did you start out with an exhibiting career as your aim?

HC Yes, although I didn't know what that entailed then.

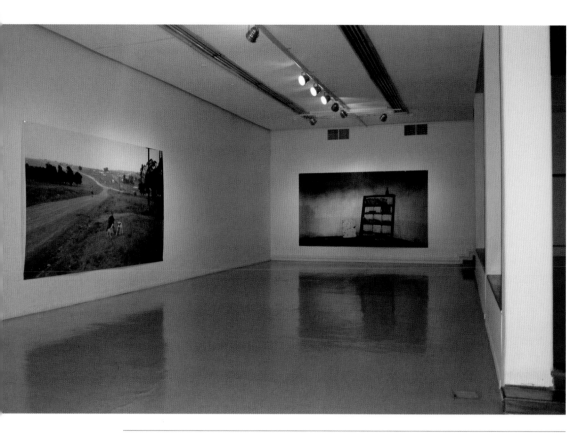

The Road to Mvezo at the Museo National de la Universidad de Colombia. Image courtesy Hannah Collins.

SR *How important is exhibiting to your career? What role does it play?*

HC *It's vital because it makes a statement and makes the work public and visible. It's also a push-pull situation because exhibiting is expensive but what follows are sales and commissions and a general enhancement of your position and an ability to maintain prices. Galleries change so one's situation changes over time and you have to adapt continuously.*

SR *On a practical level how much time do you spend working on exhibitions?*

HC *I'm almost always working on one. It takes at least one to two years to prepare an exhibition. Even if the work preexists there's still a year in the planning, catalogue preparation, and all the other things that go into making a large scale exhibition possible. Books and exhibitions coexist and overlap so right now I'm doing three book launches and two exhibitions and thinking a year ahead.*

SR *I know you exhibit internationally—is there one country you exhibit in most?*

HC *I probably exhibit and get published most in Spain, Latin America, and the Spanish speaking world because of living in Spain for twenty years. Even though art is global in reality things are remarkably local and there are many interrelated worlds. So there*

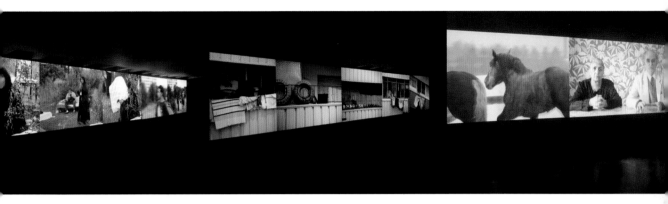

(left to right) *La Mina* installation, Museo National de la Universidad de Colombia; *La Mina* installation, Museo National de la Universidad de Colombia; and *Current History* installation at Caixa Forum, Madrid.

is a eurocentric world, an eastern world, and the worlds of art fairs, biennales, and festivals and all of them are interrelated.

SR *Have the importance or practicalities of exhibiting changed over time?*

HC *The world of photography has been professionalized and begun to coexist with the art world during my career. When I started making 3 × 4 meter images people looked at them a little like 'arte povera'—a question of materials in a physical sense—whereas now people take greater note of what can be conserved. Conservation issues are more important and people are much more careful about what they buy. The analogue era is almost over and the repercussions of that haven't yet been absorbed.*

SR *How important is curation to you/your work?*

HC *Curators are an essential part of the art world and of my world. Over the last ten years the curator has become more dominant. That's both good and bad—good because they provide a context within which you show; bad because they are sometimes distant from your intentions or create a context which isn't accurate for what you are doing if they are ruled by their own parameters rather than your work.*

SR *You have been and are represented by a number of different galleries. How does this work?*

HC *Most people are represented by more than one gallery now because they work in different countries and contexts. The gallery has become less important than earlier in my career because as the work becomes more complex it is more difficult for a gallery to do the immense amount that needs to be done to allow the work to really exist, the preparation, the moving about, the magazine articles, the contextualization—it takes a gallery with an excellent infrastructure to manage all of this.*

SR *Do you have any advice about exhibiting for photographers just starting out?*

HC *Work with experienced people as much as you possibly can.*

www.hannahcollins.net

Case Study Eight
Andrew Dewdney: The Quest for a Digital Gallery

Preface

This second edition has given me the opportunity to revise and extend my original inter-view in the light of subsequent developments. Four years have elapsed since I first spoke to Shirley Read about the project of the Digital Gallery at London South Bank University and more than eight years since the gallery was proposed. These are not inconsiderable periods set against the fast pace of technological change. Since 2007 I have been preoc-cupied with directing the *Tate Encounters: Britishness and Visual Cultures* research project at Tate Britain[1] and the digital gallery at the university has receded somewhat as an active practice. Over the last four years the gallery has been used mostly for student exhibitions and installations, with a loose booking system, which I have continued to organize, but with colleagues taking responsibility for undergraduate student exhibitions and with final year and Master's students working directly with technical support on installations. Some impressive work has been shown using the three screen projectors, sound and lighting board. Other exhibitions have been impressive because of the strong ideas and relatively simple use of technology. But no exhibition has been mounted using the content management system, which in theory is capable of delivering content to fifteen separate screen outlets, including a wall mounted 3 × 3 Panasonic LCD screen grid.

In this revised case study the original interview remains largely as it was, with a few minor amendments and is regarded as pertinent and relevant to contemporary debate. A new introduction and conclusion has been added in order to provide an update on practical developments as well as extending the context of the discussion surrounding the use of screens to display contemporary photography and the uses of computers to control the programming of image sequences and their juxtapositions.

Introduction

The initial conception of a new public digital gallery for London, able to run a continuous program of screen-based exhibition, derived from multiple online as well as stand-alone digital platforms, continues to remain beyond the resources and current interest of the

[1] *Tate Encounters: Britishness and Visual Cultures* was a three-year AHRC funded project (www.tateencounters.org/).

university and tantalizingly out of reach curatorially. There are some very real and interesting reasons for this state of affairs which are touched upon in what follows. Indeed the discussion surrounding the development of screen-based exhibition and the use of computer networks and software in exhibition programming is more advanced than any current practical interest within the exhibition field. In photographic and contemporary art circles there is a resistance to exhibiting images on screens, other than work specifically designed for screens, such as installation, video, or new media art. In museums and art galleries LCD and plasma screens are more likely to be used for supplementary information in the interpretation of work, than as a platform and medium for exhibition. In contrast walk down any shopping precinct in any major city and you will see screens in every other shop window. Regent Street in London is one such current example, where life-sized models parade down virtual catwalks on large screens positioned to catch the eye of the passing shopper. Why is it then that screens and content management systems have continued to flourish in the commercial exhibition sector but not in contemporary art? Such a situation raises a number of important questions about both the aesthetic and cultural context of screens, questions which concern the cultural status of the screen and the materiality and surface of the still and moving image when rendered on a screen.

The opportunity to reconsider such questions and the digital gallery project here is a welcome one and coincides with a moment in which a range of academic conferences have returned to the territory of the photographic image in digital culture.[2] One of the practical opportunities to do this has been a series of discussions with Brett Rogers and her colleagues at The Photographers' Gallery London, on their plans to have a digital screen presence in their refurbished building due to open in the spring of 2012.[3] Their plans are at an early stage and they rightly have many more questions than answers in wanting to include digital screens for the display, exhibition, and programming of photographically based work in the future.

What has surprised me in reconsidering the period and the project is how little digital galleries have developed within the art, photography, and new media worlds. Not that I have undertaken an exhaustive search, but certainly it is the case in London that the major International museums, Tate, V&A, National Gallery and the Hayward have concentrated on their websites in the wake of Web. 2.0 and the rise of social media, rather than upon exploring the potential of digital screens for exhibition. The only time it would seem screens are deployed is in dedicated new media exhibitions, such as *Decode* at the V&A during 2010[4]. On the whole and despite the visibility of LCD screens at fairs and festivals the walls and spaces of museums and galleries it would seem remain resolutely analogue and art organizations have chosen to investigate the virtual realm of online media as a platform for audience engagement. This year my attention was drawn to two developments, which encompass something of the vision of a digital gallery.

[2] *The Versatile Image*, June 2011,Sunderland University.

[3] The Photographers' Gallery London, 18-20 Ramillies St, W1. has relaunched in 2012.

[4] *Decode* at V&A. April 2010. http://www.vam.ac.uk/microsites/decode/.

The Ryerson Gallery and Research Centre in Toronto, Canada, which opened as an adjunct to the university's media courses in 1990 is moving to a new building in the autumn of 2012 and will include what they are calling a New Media Wall consisting of eighteen 18×46inch screens mounted in a grid pattern of six horizontally and three vertically, which they describe as being dedicated to 'avant-garde and new media programming.'[5] Also in May 2011, Anglia-Ruskin University, Cambridge launched what they announced as the 'UK's first permanent digital gallery,' described in a BBC regional news piece as offering 'a state-of-the-art medium for displaying and exhibiting art.'[6] These projects have yet to prove that they can sustain screen-based exhibition programmes using computer content management programs and I await the results with interest.

I first glimpsed the possibilities of a new media gallery in London as far back as 1992 in discussion with Frank Boyd, then director of ARTEC,[7] which provided a one-year vocational training course in interactive media, which included training in an early version of the software program Director. ARTEC became involved in working on a number of artists' new media projects funded by the Arts Council, including one I was involved in entitled *Silver to Silicon*.[8] In a small workshop behind the Angel Tube Station in Islington, packed with what were then state of the art, Apple G2s, groups of people would gather to look at and discuss screen-projected prototypes. The training was based on Macromedia's software Director and at ARTEC there was all this training and fantastically interesting projects going on but very few people saw it because the Internet was not as graphically developed as it is now. The only way to see new media was on a CD-ROM platform and played back on individual computers. Although there have been the odd experiment with new media installations in London galleries over the last decade, you can still ask why London doesn't have a gallery that is dedicated to the exploration of new media. It was in those moments at ARTEC that I envisaged a future hybrid of cinema, broadcast television, video games, and a gallery and I imagined this as venue based with an audience.

Of course at that time the Internet was still 1.0 and social networking was dimly on the horizon, unnamed and its potential unrealized, but media convergence was decidedly in the air and talk of the possibilities of new cultural forms, such as a digital gallery, were not without foundation. What then has actually happened in consumer led technology over the last two decades is the convergence of mobile phone technology and the Internet, creating the variety of Wi-Fi enabled hand-held screens capable of transmitting embedded media at faster and faster download speeds. In such an environment there is little obvious need for people to gather in front of screens,

[5] http://ryersongallery.ca/visitor-information/directors-vision/.

[6] http://www.bbc.co.uk/news/uk-england-cambridgeshire-13344264.

[7] ARTEC, Arts, Technology Centre founded in 1990 for new media training.

[8] *Silver to Silicon* was an interactive exploration of the historical development of the photograph and its transformations in digital culture and was produced by ARTEC, designed by Annie Lovejoy and codirected by Andrew Dewdney and Martin Lister.

networked or otherwise in gallery spaces. Over the last few years cinema has become more spectacular and immersive with advances in 3D filming and post-production rendering, while the Internet is winning the war of remediation against television. Now we are on the brink of the consolidation of electronic databases containing the history of all previous media and documentation, which can be accessed by a Google search. Such developments present new opportunities for greater public participation as well as problems of control security and authority for traditional archival collections of objects as well as for image based archives. What happens when digital copies of everything circulate though the nonlinear, distributed, and nonhierarchical space of the Internet? The honest answer right now is that we don't really know in any great detail how people are taking up and using the possibilities presented by the distribution of the contents of the analogue archives. But there is an urgent and growing need for cultural institutions as well as many other agencies to understand user net behavior and to develop new forms of exchange through dialogues in social media. In one important sense this is where a digital gallery project could be reprised in so far as the need to know more about audiences creates an opportunity for specialist cultural institutions to engage with them through online projects and screen-based programming. This then is a useful moment to revisit the original edited interview as a means of looking at the institutional and technical context form, through which the digital gallery emerged.

2008 case study interview

In 2002 I became the Principal Academic Investigator, for a large HEFCE Science Research Infrastructure Funding bid, part of which involved the proposal to develop the digital research gallery at London South Bank University. I thought the university should have a digital gallery because, unlike many of the established photography schools, our arts and media courses were 'born digital.' There were no chemical darkrooms here and there was no tradition of teaching analogue photography. We currently run five undergraduate digitally based programme of which the BA (Hons) Digital Photography is one. Of course the majority of photography courses now include digital photography, but as far as I know we are the only exclusively digital photography degree in the UK.

The digital in the title expresses a philosophical outlook on photography, not simply that we are using different technology. We are teaching in a digital age about something that isn't quite photography any more, it's something else but, because we don't quite know what it is, we still call it photography. At LSBU there is a distinct rationale for the teaching of digital imaging - whereas in many other colleges digital photography is understood as a technological tool and seen as the most recent extension of an existing history of analogue photography. What we're saying is that we need to think about digital photography in a different way from the start of our course. Digital imaging does have a relationship to what is, in a sense, its pre-history of analogue photography but

the actual practice of digital photography is something else and probably somewhere between graphics and animation.

So, having gone down the road of making a huge investment in the teaching of digital photography and beginning to enumerate what that philosophy was, it was logical for us to have a digital gallery instead of a conventional gallery.

The opportunity to have a digital gallery was, like lots of things in higher education, very finance dependent and as I mentioned I had put forward a bid through SRIF, the Science Research Infrastructure Fund, which is a capital scheme for universities to update and extend their technological resources. I wrote a rationale and developed a specification for a digital gallery and was awarded £190,488 for a project entitled 'New Media Digital Research Gallery and Archive.'

The university gave the project a space which is not ideal in that it is too small for the equipment it contains, although it is located in the reception area of one of the university buildings so it's very accessible. The gallery consists of a closed network of computers, screens, and speakers. There are fifteen computer hard-drives, which are networked to a central piece of software that allows you to load up digital files, distribute them within this network of fifteen computers and also then write a playlist of how you want them to work. So you have nine plasma screens—which are arranged as a wall at the moment - three very powerful data projectors which project onto three screens and three other LCD screens which are in the reception area outside the space. These three operate as the public noticeboards for what's going on as well as being part of a program. In addition to the screens, there are three mushroom sound cones, which allow you to play the sound in a very confined space—this effectively means you could have three films playing with three soundtracks and you would walk into the space where sound is being projected and then out of it and into the next one. So in a relatively small space you can have lots of sound related to lots of different images. We also invested in a series of computer programmable lights, which allowed us to have a time-based lighting sequence across the spectrum. The initial rationale was to have the most flexible and variable kind of set up that would be interactive, would allow us to show anything digital and also to connect the system to the Internet so we could programme different screens with different websites. The gallery was designed to have a user friendly software interface. The first generation software was called ViewFlex and it used a Creston AMX touch screen control panel. Getting that much equipment to 'talk to each other' was a very tall order.

At the time we did the research for the project nobody else we knew was doing this kind of thing. Interestingly enough when we went to look for a company to work with, the leading edge of this technology was in the commercial sector, who are basically doing stuff for trade shows, some of which is quite gimmicky and novelty led. Content management programs are used by shops that want to replace printed advertising with screens or to use shop windows with screens. Music clubs, trade shows and big concert venues are also using audiovisual display which project images onto flat screens and even three dimensionally through smoke, or steam in order to create spectacle. All of these systems need a computer based content management system. So the technology

we were looking for was not to be found in a fine art or educational context at all but in the commercial sector.

The technical manager of the university and I went to a firm called TouchVision who offered us what I thought was a very exciting, user friendly set of options for a multiple display platform and flexible content management. The actual piece of software we used, Viewflex, involved distributing the asset files onto the hard drives. So in principle an artist or photographer would be able to come with their files and work out how they wanted to display their work in the space and on which screens. They then load up their files, the computer distributes them to the software that controls the screens and then they write a playlist that says 'turn screen one on and keep it going for five minutes then stop, bring two on and let that run' and so on. So you make up a program as you would have done for a slide-tape show and in fact I began to see the gallery as a digital remediation of slide-tape. In Britain I think slide-tape shows reached an historical apotheosis with the Great London Council's 100 carousel 'cake,' which was a multimedia audio-visual display about London (1987). Slide-tape was somewhere between art house cinema and a gallery installation. There were some wonderful examples of what could be done with slide-tape and I see it as an early version of a time-based media that never managed to get in the gallery on any permanent basis because it was seen mostly as an instructional medium as opposed to an artistic medium. Maybe that's the same position that content managed digital projection is currently in, because a lot of the software is really marketing for informational use and has too much built-in control for the artist or photographer who want to use them in very flexible ways.

Having commissioned the installation for the digital gallery from TouchVision the subsequent story is one of a struggle with the limits of commercial software in a creative led environment. There is both a good and bad story that comes out of this struggle, because I think we were trying to prototype something and, although the software promised to do the two things we asked of it; that it would take all formats of digital imagery and that you could write the order you wanted your digital assets to play using a graphical 'drag-and-drop' interface, we hadn't quite worked out how it would be used. More importantly, SRIF was a capital project, with no money for ongoing technical support, which we thought would be unnecessary as the software front-end would be sufficiently user-friendly.

After the technical commission was signed off a number of the academic staff went on a training course offered by TouchVision and I then set up some very open-ended digital residencies. They were based on my experience of working at Watershed Media Centre in the 1990s of how you program experimental exhibition spaces. NODE, an Arts Council funded new media network, had also recently got going so I put out something to ask if anyone was interested in a digital residency. We had a couple of people start residencies and they immediately ran into software difficulties. Our software (Viewflex) proved to be not very user friendly at all, which I think now is because it was PC, rather than MAC based (although most software is now virtually identical between Mac and PC versions) and required a four-stage process of loading files, distribution files,

creating a playlist, and then creating a show. It would have been fine in a situation in which we had a dedicated technician to work with the photographer/artist, but as a piece of software which had to be fairly nontechnical and accessible it turned out to be very complex and unstable.

The software and the networked configuration worked for someone who knew exactly what they wanted their show to look like, but from an artist's point of view they want, initially at least, to experiment with how things look before committing to a final show, but every time you wanted to make a change in the order of screening you would have to reprogram the playlist. Commercially the software was written for very simple instructions where a set of screens in retail spaces play one asset on repeat on several screens.

In practice everyone who came in to do something in the gallery needed access to technical support, however, the university's own IT technicians didn't have enough time to support the work. TouchVision gave us a good after sales service and came in and supported several of the exhibitions but it then became the case that only they could make the software work. This was in any case very much a test-bed situation with a developmental arc and teething and development problems were something we expected. So, alongside the fact that we have been able to use it continuously as a gallery, we have had this kind of reflection with the company on the problems of the software and how to adapt and change it—which is quite difficult with a commercial company where there is no service agreement in place.

I currently think that the easiest way of showing new media artifacts is still to have a separate computer for each programmable element and have a fairly full time technician. We tried to leap forward and do away with the technician by installing a piece of automated software. One of the potential advantages we saw was that the software could store, program, and manage many exhibitions. This would have the advantage over gallery exhibition where work is put and taken down sequentially, the digital gallery could store twenty to thirty exhibitions, or more concurrently and display them in any sequence. We imagined a display program where the computer would play one show in the morning, another one in the afternoon, or, to let one play for three days then change remotely. The potential for the system was huge and would allow us to shift between, for example, a student show then a research project or Internet based art projects. Again, that has happened but so far it has always had to happen with a lot of dedicated technical support.

Being able to show large amounts of work on a rolling program is a great advantage. When I was curating photography at the Watershed Media Centre there were always many more people than we could ever show—we had three programmable spaces, booked up two years in advance with a selection committee which had to say no to lots of good people. In a digital gallery you don't have to say no to anybody because you can give someone a show for half an hour if you want. It's only time limited and you can show things twenty-four hours a day and just keep it rolling. We've never got to that capacity as yet because of the software problems so in fact how we've run it is

more conventional in that we create slots, advertised in advance, where we either show student shows or we show research work. That's part of what the funding was for so we show work from academics doing practice research within the subject area of media and communications.

Another way of looking at it is to say that the gallery could display the content of screen based work, rather than become involved in the installation form, which is the inevitable compromise with a fixed system. Knowing the limits of the configuration was part of understanding how it could be used creatively. The focus was to see what content people would put into the gallery whether it was digital stills, video, or sound and that's still the mission of it. If anything it is a remediation of cinema rather than the modernist white cube.

Having worked upon it for two years I can now see why no one else has done this as yet because its still very experimental—which is fine because part of our remit is to experiment with the technology and to be able to develop the form through work in progress shows, which have given us a small number of interesting case studies. It has been harder than we ever wanted it to be and has raised lots of issues we can now evaluate. We are now at a point where we are going to change the software. Viewflex software proved intractable, too difficult to use, not user friendly enough, and also required that the files had to be presented in a certain kind of format so there were limits to what could be done with it. The interesting thing is that there wasn't another piece of software around that you could have just got off the peg at that time. The great irony of our experience is that we might as well have had a bespoke installation set up for each show as we had to provide support for each artist through the company in order to get their work displayed.

After two frustrating years we hope that the new piece of software, Panasonic's NMStage, will do the job we want it to. We are determined in the coming year to be able to get to where we wanted to be a year ago which was programming lots of work. Our initial assumption was that computer content management would obviate the need for a technician, which I now see as a common fallacy about technology—the dream of automation, the dream Vannevar Bush had for his Memex machine. I now think we do need a full-time technician and we will have to think of how that post can be funded.

I think the gallery could be developed into a teaching resource, which would support the programming of the space, because it would support teaching students fairly continuously from two courses. The first would be from our arts management curatorial students who want to curate new media. Here we could develop the idea of having an annual new media internship attached to the gallery. The second would be that you'd be teaching new media students, particularly photography students, to get them to think about the nature of exhibition in general and all those issues to do with the projection of their work. You know and I know that most photography students are a) inexperienced in editing their own work and b) not good at understanding what happens when their work goes on the wall as a print—they don't understand things

about scale, about framing, and about space and usually they're not taught any of those things. Our degree, like most degrees, doesn't have a unit that's specifically dedicated to exhibition practices and so we see the digital gallery as helping students with these issues. Timing and editing for narrative would be things that you could teach because you've got a piece of technology that is ultimately a big digital slide tape machine. But you can also use the high definition screens like a light box if students want to work with one image. And you can deal with the issue of size because it's completely possible to play with scale when you have a big data projector or a whole wall of screens.

If you think about it as a teaching gallery then there's the opportunity to get students to exhibit their photographs literally every week. Digital cuts out the amount of printing and organization needed so you speed up the process by which you can see something. Our first year had their first show after only one semester. They had done one module and normally they'd submit the work either as a digital file on a CD or they'd e-mail the images to a tutor or, if they were on another photography course, they'd probably have handed in some prints and that would be it. They'd be assessed in a closed system whereas these students—within the time scale of a very pressured semester with a lot else going on—were able to have a show in the digital gallery of the work they'd produced for assessment. Using the digital gallery teaches them to think about the reception of their work because the gallery has a real audience. I think that's a very good way of beginning to see how exhibition shapes the way you work because you get a huge amount of feedback once you get an audience. The digital gallery can support teaching about the circulation and distribution of the image at the same time as tutors teaching about the conventions operating within the frame, which I think is different from teaching analogue photography, which has a strong material separation between the process of producing a print and the process of exhibiting.

Exhibiting new media in dedicated space also has something to do with how you make new media work accessible once it has been archived. The Whitney in New York has a new media curator, Christianne Paul, whose job is to program new media as well as run an online archive of new media work. There are a number of other organizations trying to do that such as Professor Beryl Graham who established Curatorial Research for Upstart Media Bliss (CRUMB) a research center for new media curation at Sunderland University in the late 1990s. Tate Intermedia and the London-based new media organization Furtherfield are other examples. My thinking now is that museums will develop new media galleries at a point where there is a content management system for all file formats and where archived material is shared in a network or database. New media has become naturalized through the PC and Internet in a way that makes the technological trajectory seem unremarkable, undercutting any historical sense of wonder as well as critical enquiry about the media. Screens are ubiquitous and seemingly without aura, although I consider the screen retains a huge power to capture attention. A new media gallery would of course have multiscreens, sounds, and interactivity, but I think in a sense the jury is still out on how much a new media gallery could attract an audience and become a focus for the showing of new media or conventional photography or film work.

In a sense you could say that we have the technology but without a cultural form. But there is something very powerful about having a very intense set of technologies in a physical space because there is so much potential for combining image, music, and text, a dream of a Post-Barthian semiotext. Multiscreen computer controlled content management could create such rich media environments. A lot of people have said that, as a space, the digital gallery doesn't feel like anything that they've ever been into before and it's a cross between a fun fair, some kind of science museum exhibit, a gallery, or a cinema—it is truly a kind of hypermedia environment. So I think there's something about this media environment which undoubtedly excites people—they immediately get the point and see the potential. Creating environments where you are able to have very rich sensorial experiences and which are clearly not in the tradition of a mainstream European gallery really interests me. The dream of the automated programmed digital gallery has powerful appeal in terms of being able to put many different kinds of content into a very rich environment. So if you then able to support the program as a gallery I feel pretty sure you'd get a good audience.

Against this the digital gallery is bit like a chameleon in the way that digital technology can pretend to be another media. It is here simply a technological platform, a relay system. LSBU is going to put on a David Bomberg show in the digital gallery. Bomberg taught the Borough Road Group at the university. In mounting a digital display of Bomberg I think of the digital gallery as a kind of rich cerebellum, a space where it is possible to look at a physical charcoal drawing by Bomberg on the wall, whilst at the same time seeing all the work he ever did on the screens. There is of course the question of copyright clearance, but I won't go into that now. Bill Viola is probably the artist who has been able to develop the use of plasma screens more than anybody else using screens with the same richness of resolution as the surface of a painting and inviting the viewer to ponder on the difference between the material and the immaterial, the moving and the still. It is now possible to make a screen get pretty close to being like a print. Daniel Meadows was saying to me recently that in the recent Tate photography exhibition, *How We Are: Photographing Britain*, (2007)[9], there was no reduction in quality from the original prints he made in the 1970s which had been scanned and projected, even though you still know you're looking at a screen and not chemicals on a piece of paper.

Although there are all these human perceptual differences in the apprehension of surfaces, which is fascinating, but I think the amount of information—that is, screen resolution—will not be the issue for much longer—the issue is will be how we understand objects. There is still much industrial traffic between digital photography and photography as a print media, but I think the way things are going the biggest opportunity for most students to circulate their images and possibly make money will be online. I think further technological development of the networked digital image and high definition screen is going to radically change notions of the circulation of 'photography.' Students are quite

[9] *How We Are: Photographing Britain*, curated by Susan Bright and Val Williams. May–September 2007.

happy that the work is in print form but I think for many of them the natural home of the image is now on screen and in an online environment. A student could now undertake a very successful degree course in photography with no more than a mobile phone and an Internet connection, because right now everything is about the circulation of the instant, real-time image—the total ephemerality as well as dissolution of the photographic image.

Conclusion

On reflection the interview stands the test of time and many of the issues it raises remain relevant, if not more so now in the light of the web continuing to sweep all before it. The web is the biggest global media phenomena in human history and has been established on a world scale in less than twenty-five years and with the development of Web 2.0 realized in only the last five years. Social media is a real force that no politician, nor corporate executive, dare ignore and the Internet is a source of knowledge that no educator can dismiss. Access to the web on a global scale is common and constant and screens now come in all shapes and sizes and yet, as my recent discussions with The Photographers' Gallery have shown me once again, the interface technologies suitable for curators, photographers, and artists remain underdeveloped, presumably because it has such a small market. Commercial content management software is primarily customized for bespoke purposes and still requires technical support for changing combinations of outputs. Such software is designed to deliver discrete content files to specific outlets for programmed periods of time requiring a script or playlist. Content management companies will supply and customize file management software for defined combinations of screens with set programmed options. London South Bank University's digital gallery has been very instructive in testing the limits of bespoke content management software and the experience has been incredibly frustrating and disappointing. Whilst the problems are formulated in terms of what software will and won't do there is a deeper reason for what can only be described as a cultural impasse. The reason is this, that whilst the hardware and software commissioning companies share amongst themselves a set of commercial purposes, common technical language and understandings about desired outcomes, the curatorial and artistic community speak an entirely different 'aesthetic' language of the screen and have completely different methodologies for controlling the duration, scale, framing, juxtaposition, and saturation of images. At present this gulf in purpose and intent between commercial application and contemporary art installation appears unbridgeable, which is why contemporary museums and galleries staging new media, do so on a needs basis, hiring in and technically managing each individual installation. There is still very much something of the analogue special effects mentality operating in commercial new media for exhibition purposes. It is still a case of smoke and mirrors, only now it is computers and screens, and like the Wizard of Oz, the end user experience is designed to be awe-inspiring, but behind the curtain it is usually a group of technicians frantically

turning the wheels, or more properly clicking the mouse and tapping the keyboard to keep the show on the road. The problem lies in cultural rather than technical application. Apple's iPad is a screen to be cradled and stroked by an ambient comfortable individual user, while the 3D Imax screen is like a cliff wall designed to enthrall mass audiences in the spectral dark. Receiving content on screens remains a matter of the conditions of reception. When artists use projection and screens they go to great lengths to decontextualize the popular context in which screens are apprehended in order precisely to wrench the image out of the everyday context of reception of the TV or computer screen.

There is something of a high culture/low culture divide running through the cultural and institutional separation of the context of screen reception and yet digital images continue to be distributed across many platforms and it is this that is giving renewed urgency to the need for further understandings of the context of digital platforms and screen reception.

Recent developments in Web 2.0 are fuelling the current interest in the networked image, with a quickening sense that, on the one hand, it is the scale, flow, temporality, and circulation of images which should now concern us, and, on the other, that there is a need to understand the experience and behaviours of the user and the ways in which s/he generates image content through the many image led social networking sites. There is then an emerging recognition in contemporary debate that photography is on the verge of a further technical revolution, which will have significant impact upon the cultural contexts of photographic practice and how they are viewed and understood. If this is even half true then it suggests that this is not the moment for curating something already known under the rubric of digital or online photography, but rather a moment of inquiry in which research offers a valuable set of practical tools.

The desire for computers to be able to intelligently order, retrieve, and curate images is limited as computer scientists have not yet managed to find an algorithm which approximates human vision. The semantic value of the photograph is therefore dependent on a number of processes at the level of code: the quality of its metadata, the accuracy of its tags, its ability to be read via pattern recognition software. The photograph, whether embedded in a blog template, remixed through mashups, multiplied virally by Twitter or syndicated as information feeds, is linked to the politics and performance of software. This presents a challenge to existing tools for understanding photography and representation, through the generation of new forms of knowledge which require new frameworks for interpretation and education. The way in which new practices subvert these new systems of circulation and representation has further implications for how one might develop interfaces and content management systems for photographic collections and how cultural organizations might engage their audiences.

Andrew Dewdney

Bibliography

Lister. M. *The Photographic Image in Digital Culture*. London. Routledge.

Lister. M *New Media: A Critical Introduction*. London. Routledge.

Dewdney. A & Ride. P. (2006) *The New Media Handbook*. London. Routledge.

Rubinstein D. and Sluis K. (2008) 'A Life More Photographic; Mapping the Networked Image.' *Photographies* (1,1) Routledge.

Manovich. L (2002) *The Language of New Media*.

Mitchell. J.W. (1998) *The Reconfigured Eye*. Massachusetts. MIT Press.

Paul. C. (2003) *Digital Art*. London. Thames and Hudson.

Lovejoy. M. (2004) *Digital Currents: Art in the Electronic Age*. New York. Routledge.

Parry. R. (2010) *Museums in a Digital Age*. London. Routledge.

Rubinstein, D (2010) 'Tagg, Tagging,' *Philosophy of Photography* (1,2)

Sluis. K (2010) 'Algorithmic Memory? Machinic Vision and Database Culture' (2010) in: Mousoutzanis, A. and Riha, D. (eds) *New Media and the Politics of Online Communities*. Oxford, UK. Inter-Disciplinary Press.

Sluis. K. (2010) 'Words Without Pictures,' *Philosophy of Photography* (1,2)

Hanging the Exhibition

Installing Hannah Collins's work *Walking Umthata* at Caixa Forum, Barcelona; image courtesy Hannah Collins.

Estimating hanging times

Hanging a show, if it is to be done well (and of course it should be done well) usually takes more time than anyone imagines and it can be important to assess the time needed when planning the hang. Look at the space, look at the work, estimate how long it could take to hang your photographs, and then multiply that number of hours by three and you may get somewhere near a realistic estimate.

Always allow at least one extra day to hang. The task can't be hurried. Unless you are experienced and it's a straightforward hang get additional help if possible from people with practical skills and people who will be happy to run errands. However much pre-preparation has been done, there will always be delays caused by small tasks that have to be done precisely and therefore take time.

In addition to the slow process of actually hanging the work, two things usually take the most time during a hang:

1. Checking and rechecking the original plan for the placement of the images to see whether it works in practice. This can mean moving the images around and testing different layouts until everyone is satisfied that the work looks its best in the space. It is very important to do this since it is only when the work is actually framed and in the space that you can be certain that the exhibition is working to plan.

2. Working out exact measurements for the hang. Very few people can hang a show by eye and get it right.

This chapter includes a few examples of the time it takes to hang an exhibition. In all of these situations, the people hanging were fairly experienced, all the work was already mounted, the hanging systems were already in place, and the basic design of the hang decided.

• In an exhibition in display cases in a college corridor, a colleague with fifty-four 16 × 20" photos, already window-matted and mounted on board, took between five and six hours to organize the images into groups of two, three, and four, and attach the images to the soft board interiors of purpose-built large frames, using long-shanked pins.

• In a conventional gallery space, it took ten hours for two people to put up a wall of twenty-two images. This included seven photographs under acrylic glass (Perspex), thirteen mirror-plated small frames, and one large box frame. The Perspex was predrilled, and most of the frames were mirror-plated before the start. Some work had to be completed on the large box frame, one image had to be remounted in its mat, and four additional mirror plates had to be attached.

• In a studio gallery in a factory, it took six people a full day to hang an exhibition of twelve large images by two photographers in a gallery space with six walls. The images were 30 × 40" and 32 × 32" and had two different, but simple, fixing systems. The day included a lunch break, one person arriving late because they'd gone to collect catalogues, and a fairly early end to the day. All six people were experienced, the layout had been worked out in advance (although not in mathematical detail), and it included putting up a text panel and large vinyl lettering. We had all the equipment we needed

and nothing was broken or needed replacing on the day. We did it a week before the show was due to open, something that is not always possible, and returned to put the captions and price list up and light the show on the evening before the opening.

- In a student exhibition, it took one of the students four hours to hang six photographs. I don't know what happened, but he was the most experienced of the students and I think he not only took a great deal of time experimenting with different layouts but stopped hanging his own work in order to help other, less experienced students. Both these things frequently happen during any hang (and are often part of the pleasure of hanging a show).

- In an exhibition that had to be hung in an afternoon a projection piece, which we had anticipated would be the most straightforward element of the hang, eventually took one person four hours to install. Time has to be allowed for technological glitches.

Preparing to hang the show

Whether or not you hang the exhibition yourself this should be a very rewarding moment when months of preparation finally pay off and the work suddenly looks at its very best. It's a time for being careful and precise but also for double checking that all the decisions which have been made work in practice or that a decision needs to be revisited and changed. The most important element here is, once again, to allow enough time to do the task well.

So, you are in the gallery to hang the show. Where do you start? Here is the appropriate sequence of steps:

- collect everything together
- frame all the work if it is not already framed
- place it and finalize the decisions about where everything will be hung
- hang the work
- put the text and captions up
- light it
- clean the outside of the glass, if work is under glass, and clean the gallery (again)

Before you start the hang, check that:

1. the gallery is clean and dust-free and has been repainted if necessary
2. you have all the work (already framed if possible)
3. you have any texts, captions, titles, or printed materials to be placed on the wall
4. you have a list of works and any diagrams, floor or hanging plans you have made
5. you know the condition of the walls and have the right fixings to use
6. you have all of the tools you expect to use
7. you have a table or clear surface to work on and a secure place to leave coats and bags
8. you have enough help

Michelle Sank's exhibition *The Submerged* arrives at Hotshoe gallery; each image is propped up below where it will be hung, ready to be unpacked and installed, 2011. Image © George Meyrick.

(1) The gallery needs to be clean and dust-free and should have been repainted if necessary. It doesn't have to be immaculate, but you must make sure that dust and dirt in the environment can't get into the framed work. Sweep the gallery before starting work if it is dusty; otherwise the dust will lodge everywhere. Any holes left from the previous show's hang should have been filled and repainted and the paint now dry. Don't attempt to work around wet paint. You can retouch any marks you have made after you have hung the work, but if the whole gallery needs repainting, it must be done well in advance. It is possible, though risky, to repaint piecemeal,

just painting the parts of the space that need it. However, unless the paint type and color are exactly the same as the previous coat of paint, the patchwork effect is likely to show in sunshine or under bright lights.

(2) Ideally, all of the work should be framed before the day of the hang. If the work has not yet been framed, your first task is to frame it. Framing needs to be done slowly and carefully and cannot be rushed so allow plenty of time. As long as you have enough space, framing can be done by a group of people without experience, provided they are very careful. Always clean glass surfaces with the panel lying flat on the worktable to avoid cuts on sharp edges. If you do cut yourself, walk away from the framing area immediately so you won't bleed on the work or on the mat (although the work should be kept safely packaged elsewhere, anyway, until the frames are clean and ready). Wearing either white cotton lint-free gloves, available from most art and photo supply shops, or inexpensive medical gloves will keep you from smudging the newly cleaned glass. The most crucial part of framing is to make sure that the inside of the glass is spotless before you put the photograph and mat inside, since even a single speck of dust will be highly visible and visually irritating (and may damage the print). This means dusting the glass and inside of the frame first and then cleaning the glass with a nongreasy cleaner, either vinegar based or methylated spirits (also called denatured alcohol).

Methylated spirit is a very effective cleaner, but you need to use it in well-ventilated environment or it will leave you light-headed or with a headache. For acrylic/Perspex, there are special spray cleaners/polishers that should be used with a soft lint-free cloth or special paper towels so as not to mar the surface. You don't need to clean the outside of the glass thoroughly (unless it is very dirty indeed) until it is hung, since you will probably get fingerprints on it during the hang.

Check that the image is straight in the frame and there are no specks of dirt before finally fixing the back in place. The finishing touch is to label the back of each frame with an adhesive label. This should have on it a copy of the caption information including the artist's name and/ or the number of the image that relates to the list of works. This is particularly important if the work is to be hung or taken down and returned without the artists or curator present, or if the show is slated to tour. Unlabeled work is a disaster waiting to happen in these circumstances.

If a piece of work is missing for some reason (a late delivery or a broken frame being replaced), you need to make sure you are not going to forget it when you hang the show. It is surprisingly easy to make this mistake. A simple way to remind yourself is to cut a paper or card template to the correct size and write the image number or caption on it and then attach it to the wall temporarily in place of the missing image.

(3) For the hang, you need only the texts that are to be attached to the wall—you won't need price lists, catalogues, and so on. Because your first task is simply to work out where these texts will be placed, it is a good idea to work with correctly sized photocopies at this stage; otherwise you risk marking the text or damaging the corners if the text is not protected behind glass. If you do not have the texts yet, then cut paper or cardboard to the right size and attach it to the wall to represent the text, just as you would a missing image. If you do not have a visual reminder of the missing text, you may either forget to leave space for it or leave too much or too little space.

(4) Keep all the paperwork, floor plans, and lists together in one place—in a clip file, for example—or they will get lost during the day as people move around the gallery with them, put them down to adjust a photograph, and forget to return them to the central worktable. Valuable time can be wasted searching for a missing diagram if you do not do this.

(5) You need to know in advance what type of walls you are dealing with in order to choose the right method and tools for hanging the work. In most galleries this won't be a problem and the gallery director should anyway let you know but you should make sure to check. Some galleries have hanging systems which you have no choice about using (usually this is to protect their walls)—for example, wires suspended from a high rail or fixed fittings which will necessitate designing the presentation to suit the preexisting system. Sometimes a gallery will have a number of different surfaces—brick, plaster, concrete block, painted wood, and so on—and it is helpful to be aware of this in advance, particularly if a wall is old and the surface fragile and so requires a stronger fixing than you would otherwise use. You also need to check how smooth the wall is and that there is no curve or distortion that will prevent large works from hanging flush to the wall.

(6) Most galleries have a tool kit (see the Appendix for a list). However, many people are hopeless at keeping track of their tools, so, if you can, you should double-check the tool kit in advance to make sure that it has what you need. If you are using your own equipment bring extra amounts (by about one-third) of everything like nails, screws, mirror plates, and Blu-Tack. Such items can easily break or get lost during the hang, and you can lose a lot of time in replacing them. Extra equipment usually comes in handy (especially things you will need more than one of like pencils, hammers, tape measures, and levels).

Don't accept the reassurances of gallery staff that they have everything, and be ready to bring your own tools to supplement theirs. At one venue, for example, I was told that ladders would be available for a hang, only to find that on the day we needed them they were elsewhere so we had to ask tall students to stand on chairs to place some images (which was both slow and unsafe). I have also worked on an exhibition that involved constant locking and unlocking of over thirty Perspex panels with a single Allen key (or hex key). With nine exhibitors working at different paces, this would have taken a very long time if two exhibitors had not bought in additional keys.

(7) You may or may not need a table to work on, but it will be a good place to keep the bags, fittings, tools, and paperwork together. It should be placed for ease of access for you and out of the way of anyone else who might be passing through the gallery. Security can be an issue here. Many galleries are open to the public during a hang, and people passing through can be opportunistic thieves if they see an unattended bag, electric drill, or artwork. Keeping everything in one place makes it easier not just to keep things together, but to keep an eye on it. In the absence of a table many people work on the floor so keeping the floor clean and dust free and/or having a floor covering is important.

(8) You may well not need help for the whole of the hanging, but it is worth making arrangements in advance for people who can help, if only for part of a day. It is also worth planning this as carefully as possible so you do not keep busy people hanging around with nothing to do just because you will need their help later in the day. Some tasks need as many

people as possible to work on them, while others are best done by one or two people. If the gallery has to be repainted, then the more people to do it the better. Framing is slow work best done by several people. Deciding where each image should go is usually best done by one person. Hanging is best done in pairs. One of the nicest things during a hang is to have someone who is not necessarily part of the hanging team but can be called upon to run errands and make cups of coffee, and who will appear with lunch, sandwiches, or biscuits at a good moment.

The actual hang

Before starting to hang the work, you need to keep a few guidelines in mind:

- The carpenter's motto: 'measure twice and cut once' applies to hanging photographs. The secret of hanging is in the preparation: good preparation saves you time; get it right and you are fine. If you fail to check your measurements at every stage, you will still be in the gallery at midnight filling the holes you drilled in the wrong places!

- The first rule of hanging an exhibition is not to hang the work too high. This is a mistake often made by first-time exhibitors and tall people. The standard height for hanging exhibitions is much lower than you would expect. One reason to keep photographs low is that while tall people can bend their knees to be at the right height to look at the image, small people, people in wheelchairs, and children simply cannot see above a certain height. Most exhibitions follow an (imagined) hanging-line height of about 5'1" or 155 cm. The hanging line is an imaginary, invisible line that runs around the space at this height. You use this as a central line in the exhibition along which the main visual emphasis of the exhibition is focused and on which the images are centered as a way of making the work cohere.

- The height of your actual hanging line depends on your hang. You can line the photographs up at the top (hanging down from the line), at the bottom (up from the line), or through the middle. As a general rule, lining up the middle of each frame is pleasing and looks less regimented than if the images are aligned at the top or bottom.

- Remember that you do not hang photographs right into both sides of a corner or your audience will be bumping into one another and this will break their concentration. Most people leave space on both sides of a corner, but it is possible to hang work into one side and leave the other side free of images. However, if the corner is an outside corner—that is, if hanging work to the corner leaves the edge of the frame at or protruding past the edge of the wall—then do not hang work to the edge because it is too vulnerable; someone passing by may bump into it and damage it.

- When planning the hang, the positioning of the captions must be preplanned. Because captions are small, it is very tempting to leave them until after all the images are installed. However, in a close, tight hang it may be difficult to place them consistently. An inconsistent placing of captions (when, for example, one image has a caption underneath it and the next has a caption to one side) not only looks obtrusive and

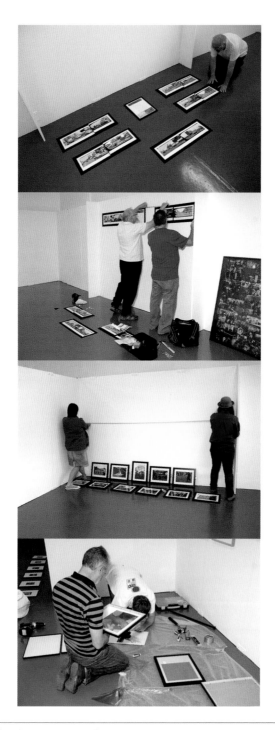

Students on the MA in photography, De Montfort University, Leicester, England, installing their degree show. Images © Mike Simmons.

messy but distracts viewers from the work because they need to think about finding captions instead of concentrating on the images.

- In many buildings, particularly older buildings, the floor and walls may have shifted slightly out of true. Hopefully you will be aware of this before you start but during the hang it is very important to constantly check what you are doing by standing back and looking at the work from a distance. If you rely on a spirit or laser level for a straight line and work close up to the wall on which you are hanging the images, it is perfectly possible to hang an entire row of photographs that are perfectly lined up according to your level and then step back and discover that the line doesn't actually look straight simply because the floor and ceiling aren't parallel—making tiny adjustments (by eye) as you work may be the only way to make this look right. It is also possible, when you line each image up with the last one you hung to be very slightly inaccurate and even a small deviation in height from one side of the wall to the other will be very noticeable indeed. If you step back from the wall and check from the middle of the room after each picture has gone up, then you can make small adjustments as you go along. This is one of the times in a hang where it is useful to get several people to have a look. At the end of the day, you have to trust your visual sense rather than the spirit or laser level.

- For most exhibitions with a set of images that are to be regularly spaced, you also need to decide before starting how much space to allot between each image. This is another task usually best done by eye. For a single line of photographs, it will usually be somewhere between two and six inches. The decision depends on the size of the individual images, whether they need to be closely grouped or need space around them, and how much space you have: Is it better distributed between the images or at the edges of the wall? Too much space and the images will seem to float disconnectedly. Too little and they will crowd each other. Large images need more space around them than small images. Once you have made this decision, it will help the overall coherence of the exhibition if you keep this spacing consistent throughout. So, for example, two walls of different length will have a different number of images on them but will look consistent because the spaces between the images are the same on each wall. If you do increase or decrease the amount of space it works well if you can do it consistently—so, for example, one wall has exactly double or triple the amount of space between images as the amount of space between images on the previous wall.

Revisiting the hanging plan

Once the preparation is complete, the first task is to revisit the hanging plan. In my experience this part of the process usually takes a few hours even if you have made a detailed plan in advance. You need to look again and again at both the overall space and the individual sequence of images and move photographs around until you feel certain that you have a planned hang that will show the work to its best advantage.

Michelle Sank rethinking her hanging plan at Hotshoe gallery—although this image worked well on its own the single image broke up the flow of the exhibition which was more closely hung on other walls. So, by adding a second image, the flow was carried across the exhibition and the single image no longer stood out so prominently. Images © George Meyrick.

You may well have done most of the preparation already; you may have the photographs in sequence and a good idea of which one is to be hung where. However, this will probably be the first time you have looked at all the work together in its finished and framed state and in the actual space, so you need to be sure that what has worked on paper, in discussion, or in your imagination will actually work in the space. You need to allow time to think about the ordering of the images and check every decision.

This is one of the tasks probably best done by the curator alone or with an assistant with whom the curator can discuss different hanging options. It can be done by a group of people as long as that group has some agreed-upon way of making a decision or see their role as assisting the curator in making decisions rather than in arriving at a consensus, since this may never happen. I would advise any curator not to allow the artists to be present for this part of the hang, if that is possible, since the artists are likely to want to privilege the positioning of their own work over the look of the whole exhibition. However, I would also advise artists to be present at the hang, to make sure that their work is shown sympathetically. So a careful negotiation may be necessary, and it is up to the curator to give the show a strong visual coherence and not make compromises just to keep the artists happy.

If you have worked out a hanging plan or a sequence of photographs, then the first step is to prop the (unpacked and framed) photographs against the walls approximately where they will hang according to the plan. Clear your mind of all distraction and walk around the gallery, absorbing the way the images work together and work in the space, to check if the plan works in reality. If you have too many pieces, this is the moment to think about it and decide either to remove some images or to risk a very packed hang. Once you are sure that the whole exhibit physically fits into the space, you can start moving frames around to see what positioning, sequences, and juxtapositions do and do not work. The only rule to remember at this stage is that it is not a good idea to hang work right into the corners.

The hanging process is both practical and intuitive. On the practical level you need to check that the images fit in the space, that one wall will not look too crowded or another too bare, that the positioning of large or small photographs work as you had anticipated. Does the large photograph draw visitors' eyes across the space? Do the small images look intriguing where they are, or are they going to seem to float in too much space? Are they in danger of being lost against the large works?

On the more intuitive level this is about making sure that images work together. The simplest method of doing this is to move the pictures around and test pairings or sequences by putting them together and making a simple yes/no decision: these two images work well together or they do not. In this way you can build up sequences or decide to isolate particular images or pairings. Although this whole process takes time and decisions are made, tested, and remade, each individual decision can be made quickly because it works on an instinctive level. This is not the moment to alter previous decisions about the underlying meaning of the exhibition; you are simply trying to ensure that the flow from image to image works smoothly and photographs complement each other. So, for example, in an exhibition I worked on recently, two sets of images went together because the tones in them were complementary; one set because the shapes echoed each other; and another because they all used blur. This may seem quite

crude, and indeed it is, but it does make the exhibition flow and therefore easier for the audi-
ence to move from one image to the next.

If you have not planned the hang in advance, the starting point is, as before, to prop the
pictures against the walls so that you can look at them all as you work. Then start by selecting
the images that can only go in one particular place. This will usually be for practical reasons—
for example, you may have a set of images or a sequence that needs to be kept together and
requires a specific amount of wall space and so can only fit a particular wall. Or you may have
a single, large image that needs to be kept on its own and that exactly fits or suits one wall.
With a group show, it may mean making decisions entirely based on giving every exhibitor a
wall on which their work fits without distracting from other exhibitors' work on the adjacent
walls. With quiet or contemplative images, it is usually a good idea not to hang them next to
very busy or highly colored images. These two factors—making sure the amount of work fits
the space as well as complementing the adjoining work—may completely dictate the hang.

An alternative starting point is to select a few key images and place them prominently. Or
there may be several key images that need to be evenly spaced throughout the show. Or you
may start by choosing the first or last images in the exhibition. The first image may be there to
create drama or to set the tone for the whole exhibition. The last may be there as the one that
most epitomizes the mood of the whole exhibition. An image may be a popular press or poster
image and so placed to be visible from outside the gallery. Doing this gives you a point from
which to work even though you may still make changes as the hang progresses.

Once you have about half a dozen images in strategic places, it becomes easier to place the
other photographs. Either way, you place certain images in key places first and then work around
them. Someone once described this to me as being like a chain-link fence in which you hammer
in the fence posts (the strong key images) first and then put in the links. It can also be seen like
a piece of writing: within a paragraph one of the important things is the punctuation (again, the
strong images), those things that make you pause or come to a full stop. However you choose
to think about it, an exhibition does usually have some sort of rhythm underlying the progress
from first to last image.

If the images are to be stacked on the wall (that is, hung one above the other), propping
them against the wall may not be an effective way of seeing how they will work in the space.
An alternative is to use the floor space in front of the wall as if it were a wall and put the pho-
tographs flat on the floor to arrange them.

Keeping a record while you hang

If you have a large number of images to hang it may be necessary to make a record of your
final decision about the hang by taking a digital photograph, by making a list, or by numbering
the backs of the frames in order and entering this on the floor plan. You will, most probably,
need to keep the frames where they are until you have worked out the precise measurements
for placing the fixings or mounting hardware on each wall. Once that is done, you should
move the pieces away so you won't get dust in the frames when you drill into the wall.

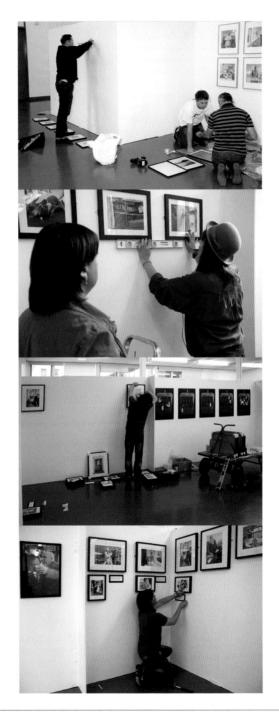

Students on the MA in photography, De Montfort University, Leicester, England, installing their degree show. Images © Mike Simmons.

It is important to keep this record and the picture sequence in mind while hanging or to regularly check the hang against the hanging plan (or at least every time you start or finish each wall) to make sure that you are still on track. I once worked with a brilliant young intern who volunteered to start hanging a show while I was out of the gallery. When I came back he had hung the entire exhibition. Everything about the hang was meticulous. I don't think we had ever seen the gallery looking quite so good—except for one thing. We had sixty or so identically framed photographs in the storage space, from which he had brought only a few images at a time into the gallery. While he hung the whole show to our pre-agreed order, he didn't realize that the calculation of the space between each image was very slightly wrong. So when he completed the hang he had one photograph left over and there was nowhere to put it. What he had done was to start hanging the pictures in order but without double-checking the measurements or checking the hang against the plan. Had he propped the whole set of images against the wall at the start, in their allocated places, he would have realized that he had one too many and redone the calculation before finishing the first wall. This is a very easy mistake to make and could have happened to anyone, but there was no way to rectify it without starting all over again, since the gap between each photograph needed to be closed by a tiny amount. To return to our original plan would have meant rehanging every single image, except for the first and last, which would have taken us an additional day to do. Luckily for both of us, the image was not crucial to the sequence of the exhibition. We compromised and hung it over the reception desk just outside the gallery, and no one else knew of the near-disaster.

Finding a hanging method

There are many different ways to hang the work once all the decisions about what goes where have been made. Most people who hang exhibitions regularly have their own favored method, and you will probably develop your own over time. Some people, usually those with a great deal of experience, can hang an exhibition entirely by eye without measuring anything, though I would not recommend this to anyone who has not hung an exhibition before. Many people like to work with one photograph at a time, placing each photograph on the wall before drilling the holes for the next. In my experience this is when tiny mismeasurements can accumulate so that over an entire wall, the hanging can end up being inconsistent. In my view, the better way to approach a hang is to measure and mark up a whole wall at a time, check it by eye and then put all the fixings up and finally hang the images.

My method is to first decide which images are to be hung on which wall and the approximate spacing between each image. Then, to hang one wall at a time, I measure and mark up (in pencil) one entire wall for the drill holes before starting to hang the work (you can rub this line out once the work is in place). Although the math can be complex and it can take time to mark it all up, once this is done the actual hang is very quick. This method also has the advantage that one person can do everything, although two people will probably be needed to actually lift and position the images on the J-hooks or screws.

This is also one of the stages of the hang when the work is best done by one person. Two people trying to do the same calculations will pretty inevitably make a mathematical tangle.

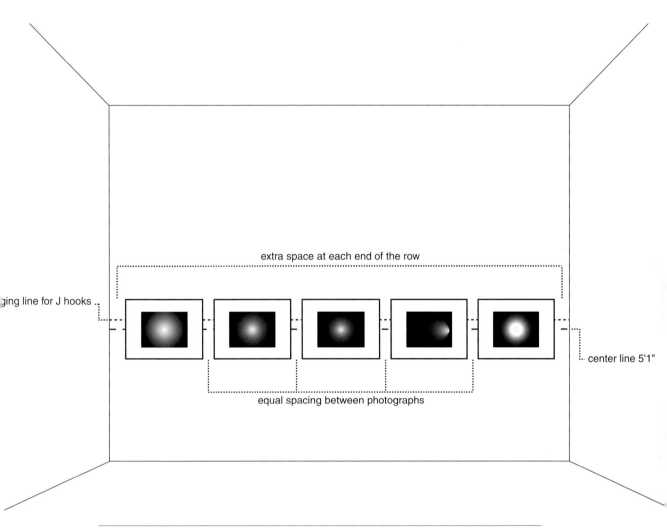

extra space at each end of the row

ging line for J hooks

equal spacing between photographs

center line 5'1"

Image © Nicole Polonsky.

The important thing is to check it visually when it is done and before starting to drill. It should be fairly obvious if the pencil marks on the wall are in the wrong places.

Let us take a hypothetical example. (This has been worked out using feet and inches but the method can be translated into any other measuring system.) Suppose we are to hang a line of five 30 × 40" framed landscape photographs on a wall that is twenty feet long. They are large images and will be hung quite close to each other in order to keep a tight sequence and to fit them all onto the same wall. I am using J-hooks (on the wall) and strap hangers (on the frame), two of each per frame. Each strap hanger eyehole is ten inches from the top of the frame. Each J-hook is two inches deep and has two screw holes, one directly above the other (I will calculate measurements from the top hole of the J-hook).

I start by placing the frames by eye before I work out the exact measurements, and move them around until I decide that they look best with a gap of about six inches between each

frame and a very slightly larger space at each end of the wall (most hangs center the work on each wall and 'lose' inconvenient small amounts of space at the sides).

Then I do the math to establish where to drill holes for the J-hooks. I do this either on graph paper or write it out clearly, step by step as I do it, in order to keep track in case I need to check it, revise it or adapt it for another wall. I need to work out three things:

1. the accurate placing of the frames across the wall and the size of the spaces between them

2. the height from the floor of the horizontal line where the J-hooks are to be fixed

3. the exact position of each of the ten J-hooks on that horizontal line

To work out the spacing of the frames across the wall, I first make an exact measurement of the width of the wall. Even if I have a floor plan I need to check it because a small error on the plan will wreck the design, so it is worth re-measuring the wall to be certain. It measures 240 inches. Then I measure the width of each picture frame and total these measurements (5 frames × 40" = 200"). Having already determined that the amount of space between each image should be 6", I total that (4 frames × 6" = 24") and add the two totals together (200" + 24" = 224"). Next I subtract this total from the overall width of the wall, which leaves me with the amount of additional space between the edge of the images and the end of each wall (240" – 224" = 16"). Assuming you want the images centered on the wall, you divide this measurement equally, which allows 8" at each end of the wall. (i.e., you have added the total width of all the frames and all the spaces between them together and subtracted this from the width of the wall, which leaves you with the amount of space on either side of your installation).

My next calculation is to decide the right height for the horizontal line of J-hooks I am going to use to hang the work. I want the center of the images (which are 30" high) to be at the standard height of 5"1" from the floor. The strap hanger eyeholes and J-hooks are the crucial part of this equation. The eyehooks are ten inches from the top of the frame—that is, five inches above the centre of the image. So the line for them would be at 5'6" above the floor. However, the two-inch-deep J-hook means that the actual line to drill the holes will add 2" to this, so the J-hooks will be 5'8" from the floor. (i.e., by deciding at what height you want the center of the image to be and working out how far above this the J-hooks will be fixed you establish the height at which you will draw your pencil hanging line).

The next step is to work out where to mark the drill holes for the J-hooks on the horizontal line. Each frame is 40" wide, and the two eyeholes are 10" in from each end. So the space between J-hooks inside the frame is 20" (40" – 10" – 10" = 20"). The space between the J-hook on the right of one frame and the one on the left of the next frame is 26" (10" + 10" + the space of 6" between the two frames). So the pencil line for the J-hooks is marked with a small X for each drill hole at the following intervals from left edge of the wall to right edge: 18," 20," 26," 20," 26," 20," 26," 20," 26," 20," and 18"= 240." (i.e., you work out the space between the edge of the wall and the first J-hook, then the space between every J-hook from then on—which will be a regular pattern!).

Once all of this has been worked out and double-checked by eye and with a measuring tape, I draw my pencil line right across the wall at the height of 5'8" as decided at step 2 above. I have a 1 × 2" piece of wood that is about 6' long and has a completely even end

which I use to do this. I put a small mark on the wall at the height of my line, and use it to make a series of marks along the wall which I then join up with the help of a metal ruler or spirit level. Other people may use a plumber's line or measure up from the floor at regular intervals to do this.

Once I have my pencil line, it is straightforward to mark the screw holes along it at the intervals already worked out. Still, I need to double-check it all visually before drilling the screw holes and attaching the J-hooks. Once all of the J-hooks are up, the images are hung from them.

This sounds complicated and harder than it is in practice. However, I find it easier to work it all out in one long series of sums rather than to do it piecemeal and make each calculation as the hang progresses. The great pleasure of this method is that you can check visually that you are about to do it right before you start to drill holes then all the images go up in one short burst of activity, and you should feel a warm glow of achievement.

Putting captions and text up

Captions should be easy to add once the exhibition has been hung, as long as space has been left for them. The important thing to remember is that they should be uniform in their type and placement. They are best positioned immediately underneath the images and lined up either with the left-hand side of the frame or the right. The aim is to make them as unobtrusive as possible. Stacking them to one side is not a good option, as to read them the viewer moves away from the image and breaks concentration.

Both text and captions, when mounted on card, can be attached with the various types of strong sticky pad available from art suppliers and stationers. Blu-Tack should be avoided as it is not very secure, leaves a mark on the wall, and can deteriorate under gallery lighting. The other option is to make captions on clear sticky-backed acetate, which will adhere directly to the wall (you can make these yourself by photocopying onto the acetate or format your captions and get a copy shop to do this for you).

This is also the time to install any large vinyl lettering you may have ordered to spell out the title of the show or the names of the artists and which goes directly onto the wall. This is usually straightforward to do and is similar to the old-fashioned Letraset. This type of lettering can be ordered from specialty sign-makers, with size, color, font, and spacing specified. To use this carefully position the top sheet in the right place, mark up the leading corners first and then transfer the letters to the wall by rubbing them lightly. The result should be carefully checked from a distance before being firmly rubbed down, since they can be repositioned once, if handled very carefully.

Checking the lights

Lighting in galleries is crucial to the exhibition hang. Photographs should usually be evenly and uniformly lit without hot spots, reflected glare, or shadows. The aim is to use the lighting

to draw the audience's attention to the images and to leave dead space less well lit or in shadow. Lighting can be used to create an atmosphere or mood for the exhibition and, although the convention is usually to aim for an unobtrusive overall effect, it will occasionally be used theatrically, as in *Twilight* at the Victoria and Albert Museum where the lighting duplicated the lilac glow of evening. It will also need to be subdued for some exhibitions where the photographs are vulnerable to light, such as vintage or nineteenth-century works.

Most galleries use a combination of spotlights and floods that can be positioned along tracks. These may be tungsten or halogen, and their angle can be altered by hand. In most galleries this means rearranging the lights with each new show, since the installation is likely to differ every time. Each photograph needs individual attention, and a walk around the gallery to check the lighting will soon tell you if each image is evenly lit. Working on the lighting takes time and can only be done when the installation is complete. You will probably need long ladders to reach the lights, and the efforts of two people, one of whom stands by the image and checks that moving a light onto one image works and, for example, will not cause the next to suffer from reflected glare as a result. The person handling the lights needs to wear thick cotton gloves or use a cloth to alter their position, as the bulbs get very hot.

When photographs that generate their own light (such as slide projections, light boxes, or LCD panels) are displayed along with framed photographic prints in group shows, the exhibition space will need to be carefully considered to show both kinds of photography to advantage. This may necessitate using screens to shield some images from light spill or turning one area into a darkened space in which to view these works.

Cleaning up and documenting the show

The final task is to clean up. It may be necessary to erase pencil lines and marks, refill any drill holes made in the wrong places, and to use a small paintbrush and white paint to retouch any marks that cannot be removed with an eraser. Then, once the paint is dry, it is important to sweep or vacuum to get rid of the dust. The last task is to dust and then clean the outside of any glass picture frames, which will, almost inevitably, have acquired a few fingerprints during the hang.

This may well also be the best moment to document the exhibition both as a record and for future publicity material.

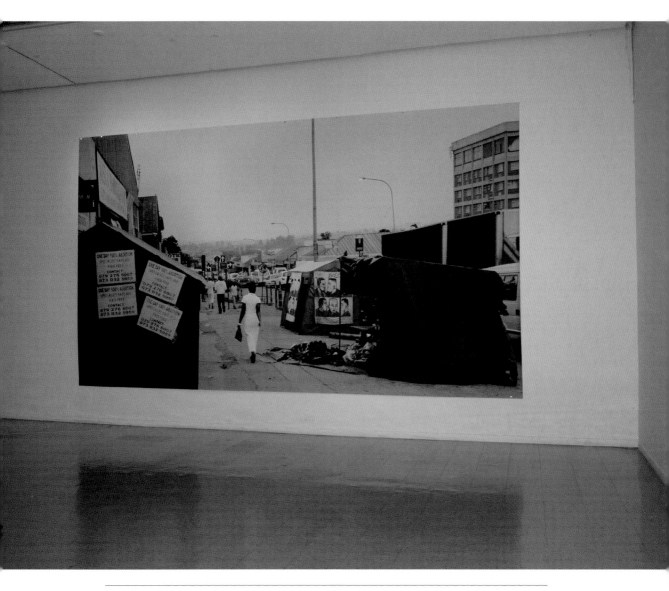

Making a record: Hannah Collin's *Walking Umthata*, installed at the Museo National de la Universidad de Colombia; image courtesy Hannah Collins.

The Private View

Image © Georgina McNamara

The private view is usually held the afternoon or evening before the exhibition opens to the public. This event has different names in different countries, and is also known as the opening, the artist's reception, or the vernissage in French. Vernissage comes from the word vernis, which is a clear varnish that was applied to a painting a day or so before the exhibition opened to the public in France. Press, critics, curators, collectors, sponsors and friends, colleagues, and family of the artist and gallery are invited for a preview of the work. In major galleries, which can expect substantial press coverage and huge audiences, the convention will be to hold more than one private view—these may be spread over two days or may be a series of two or three events on the same day. In this case each event will have a designated group invited—from sponsors and collectors to press—and specialist members of the gallery staff will be there to discuss the work with them. Some smaller galleries also have separate events for press and members and friends. The private view or opening is the moment at which the work goes public, and it is possible that more people will see the work on that evening than during the whole of the rest of the exhibition period.

This is usually one of the most important moments in the whole exhibition schedule. It is the evening when the work is made fully visible to the public for the first time, photographs may be sold, the artist may make important contacts, may be offered an opportunity for publication or future exhibition, and may receive useful positive or negative feedback. A gallery can usually predict, to a degree, who will attend a private view, and they should take responsibility for introducing the artist to collectors, curators, and other artists and gallerists. For the artist, it is potentially the most important and most stressful event of the whole process of exhibiting. It should also be the most rewarding.

However, a private view can be unpredictable, and it is also possible that none of these things will happen. The artist may spend an enjoyable evening talking to friends and colleagues about the work and receive some thoughtful and positive comments—and nothing more. But an apparent absence of response can be misleading: the artist should be aware that opportunities from a private view may be very slow in coming or, when they are offered, may not seem to be linked with the exhibition. This is because, for example, a curator may be considering the work for an exhibition being planned but may well hold off from saying anything until he or she has had time to think further about it. Equally, a curator may only remember the work much later, when planning a new exhibition. An ex-student of mine once told me he had been disappointed that nothing had developed from his private view and, in trying to respond positively, I mentioned that a colleague had said to me that his was the only work she found really interesting in the group exhibition. Two months later she offered him some lecturing work.

At a private view it needs to be clear who the gallery staff and artist are so that visitors can talk to them. This is important but it is very often forgotten. A 'meeter and greeter' at the entrance can be helpful here, so that there is clearly someone hosting the event. Bar staff should be able to offer to make introductions if necessary. It can be difficult to achieve visibility elegantly. Labels or lapel badges are a simple answer, although it can be difficult to make them look smart and professional. Lapel pins or flowers look good. It is quite useful to differentiate between gallery staff and artist, so labels for staff (the bureaucrats) and a flower for the artist (the creative one) is one way of doing this.

Many galleries use their own staff to work the bar at private views. Although this is economical, it also means taking the staff away from what they should be there to do—which is to network, make introductions, and promote the work. It is worth considering hiring special staff for the occasion. One gallery I know regularly uses the same small team of young actors. They are not expensive, they are charming, experienced enough to be fast and efficient, and they know the gallery visitors and can talk to them about the work; they also clear up during the evening and wash up before they leave. This not only frees up gallery staff to circulate but means they don't have to face the washing up the next morning. Crucially too, the bar staff are very good at creating a relaxed atmosphere, breaking the ice when visitors arrive and making introductions when necessary.

The private view is also an occasion on which there may be speeches or at least a few words of introduction, explanation, or thanks. These can be difficult because galleries often have poor acoustics; the audience is moving around, is in mid-conversation, at the bar, or in the process of arriving when speeches start. Although it may be necessary to say a few words of introduction or thank you, as a general rule talks at a private view should be kept brief and light-hearted. An in-depth artist's talk is better planned for another occasion when, even though it may be less well attended, the audience is comprised of people who are seriously interested in the work.

The gallery staff should also be ready to spend time talking to or briefing anyone who will promote or review the exhibition. I have, for example, walked around the gallery with a celebrity who opened the exhibition to the public. She had a short radio slot to talk about the exhibition the next day, but I knew that she would not have the time to do further preparation, so our conversation would be a dress rehearsal for her talk. I prepared by selecting a short list of key images I knew could be talked about on the radio without elaborate description; we discussed these and I gave her photocopies of both the images and the additional information I had about them. The next day on the radio she talked about the overall exhibition theme and then gave examples drawn from our discussion and notes of the previous evening. It was short but to the point, and it drew visitors to the gallery because she had something specific and interesting to say.

For a curator, a great deal rests on making good relationships with artists, and meeting them at a private view is a very good way of informally gauging this. This is not simply about the work on show but about the artist's other work and their approach as a whole. I have been at an exhibition where I wanted to talk to one of the artists, not because I had any very definite exhibition in mind but because I could see how an exhibition could be developed that would include the piece of work on show, and wanted to find out if the artist had other work on the same theme. I couldn't find anyone who was obviously the curator or artist, and in the end I went away clutching my catalogue with its contact address in it. In fact, I never used it because it needed that conversation to spark my interest. The artist never knew about it, but she had missed an opportunity.

Private views are usually timed to catch people in the arts at the end of their workday so that critics and curators drop in on the exhibition before they go home and still have time to go on somewhere else. Most private views are over by about 9:00 p.m., so it is a good idea to plan the rest of the evening in advance and make an arrangement for drinks or a meal somewhere near the gallery when it closes. Some galleries regularly book a table for a meal after the private view and, if they don't do this, the artist is well advised to arrange something themself.

The artist's task is to be prepared for the evening and ready to promote the work. This is a celebration of an artist's work, not a party being thrown for the artist at which he or she can relax, drink too much, or catch up with old friends. (If you do want to have a celebratory party the way to do this is to hold an end-of-exhibition party when you will know what there is to celebrate.) Instead, it's something between a job interview, being an actor at the first night of the play, and playing host at a dinner party. It is a curious thing that artists at a private view are expected to be positive, light-hearted, and rather urbane, showing nothing of the difficulty, raw emotion, or soul searching that may have gone into the creation of the work. I have twice now stood in front of images that very nearly cost the photographers their lives and listened to them recount their experience for my entertainment while marvelling at their detachment. As I see it, there are two reasons for this expectation. One is very practical and simply that a private view is a busy promotional event so artists cannot risk becoming too emotional about their work, even with friends, or they will not adjust to talking to collectors or critics about the same work. The other is that this is the point that the work is being launched into the world, so the maker needs to be able to step back and detach from it.

For the artist, a private view is often when you find out who is seriously interested in the work. If anyone shows real interest in your work, ask for a card or address, or ask if they would like to be put on your mailing list and receive an invitation to your next exhibition. Make sure that the staff know that you would like to be able to contact anyone who shows an interest in your work.

Here are some things one can do to prepare for the private view:

- Make sure you leave yourself enough time to be relaxed and looking and feeling good at your own private view. If you have hung the exhibition in good time, you should have the day of the private view free. Treat it as a holiday and arrange to do something else that day, preferably something enjoyable and relaxing that has nothing to do with work.

- Talk to the gallery beforehand about their plans for the evening and the timing. It can be a long evening, but they may insist that you are there early or, conversely, may be happy for you to be a little late.

- Find out whether the gallery has a plan for after the opening. Some galleries will arrange a post-event dinner while others will not. If nothing is planned, then make your own arrangements to spend the rest of the evening with friends: either book a table at a local restaurant or wine bar or find somewhere nearby where you can sit and have another drink or coffee. Of course, you won't know in advance how many to expect in your party, so you should check that there will be plenty of room at the time for which your reservation is made, because the wine bar that is empty at 6:00 p.m. may not have room for a group at 9:00 p.m. Tell everyone in advance, arrange a time, and draw a map if necessary.

- Eat beforehand if possible, because one of the difficulties for most people is the temptation to drink too much and, since you are likely to be there longer than anyone else, this can be a disaster. If you can avoid drinking anything alcoholic for the first hour or so, it will help. Having a glass of something that looks alcoholic but is not, such as mineral water with a slice of lime, stops enthusiastic bar staff from filling your glass time and again.

- If you are nervous, get yourself some support. You may find that there is a sympathetic member of the gallery staff who will look after you well during the evening, make useful introductions, and whisk you away from the people who are determined to monopolize you for the whole evening. If you think this is not a possibility, then brief a friend. Ask him or her to be 'on duty' and prepared to talk to you when you are left alone but then leave you when a potential client of the gallery wants to talk to you privately. If you think you need to, also warn your friends that you may be preoccupied and distracted! You do need to make sure that you are available for new people to talk to you, rather than locked into conversation with old friends.

- Be prepared to stand near your work and hover if necessary, especially in a group show. Visitors will talk to you about the work if you are there but may well not want to search you out if you are not.

- If you are the sort of person who finds it difficult to talk about your work, make sure you have prepared some specific things to say about it. People at a private view may well not have seen a press release or other text and will ask a range of both obvious and subtle questions, so do not forget basic information about places and circumstances, an interpretation, and some technical comments. If you have a couple of humorous anecdotes about the taking of the photographs or stories about particular images, so much the better. Most people ask straightforward questions and do not expect deeply complex or soul-searching replies, although some may go straight to the heart of the work.

- If you are part of a group show, you will also be asked about the work of the other artists and should be able to speak briefly about it and make an introduction when necessary.

- Be prepared to ask what visitors think of the work and listen to what they say in response. If people are really showing serious interest but you keep getting interrupted, consider suggesting that they come back for a chat on a specific day when you'll be there.

- Always thank people for coming to the exhibition.

- Make sure you have follow-up materials sorted out and accessible. You need a list of works/price list, a visitors' book (good comments can be really useful), and some cards or address labels and some way of getting other people's addresses/phone numbers to add them to your mailing list for future shows if you think they are seriously interested in the work.

Sales at the private view

Conventions about selling at a private view vary. Some galleries expect this to be the point at which the work starts to sell or an initial interest is expressed which will subsequently lead to a sale. However, the private view is not the time or place for a hard sell and major collectors

are more likely to want to look at the work more privately. As a rule, people know which images interest them and they need support and possibly encouragement in making a choice rather than to be pushed into buying work. The gallery's priority is likely to be to create an ongoing relationship with people who buy work, in the hope that they will stay interested in the gallery's artists and continue to buy. The artist's role is to support the gallery in this and to be ready to talk to possible clients about the work.

A member of the gallery staff should be responsible for sales at a private view, and that person should be very aware of this role and on the lookout for possible openings for sales. Conventions around this vary but, in my view, it looks more professional if the artist does not do the actual selling. Most people are not good at selling their own work, and some are too prone to giving work away or dropping the price under pressure.

If you are putting on your own group show outside the gallery system, there are several ways you can deal with sales, and it is important to sort this out in advance of the private view. A member of the group may have a flair for selling and enjoy the challenge, in which case my preferred option would be to ask them to handle all sales during the private view and relieve them of all bar duty in return. If no one volunteers, this is probably a task best shared by two people who can support each other during the process.

This does not mean that the artist has no role in selling the work. Most people buy work because they like it but may feel unsure of their taste and the whole area of the investment value of contemporary photography. Talking to the artist about the work, about the circumstances in which it was made, and about its meaning for the artist will provide reassurance for the buyer. Buyers like to be able to say that they have met the artist and to quote them directly. A good anecdote about the circumstance in which the image was made is useful, and this sort of conversation can lead to a sale. If this happens, the artist should be ready to hand the prospective buyer over to a member of staff who will deal with the mechanics of the transaction. Someone who has bought work once from an artist may also continue to follow that artist's career and buy work again, especially if they have met the artist.

An awkward issue that can come up at the private view is that people who have seen and liked some of the work may try to cut out the gallery by arranging a studio visit and buying directly from the artist and so save themselves the gallery part of the costs. This is absolutely not done, and the artist's reputation will suffer badly if they agree to such a request. They may also lose the support of their gallery.

The gallery will have red dots to indicate when a work is sold and a receipt and/or sales agreement system. Usually a gallery will want a deposit or payment for a work then and there, unless they know the would-be purchaser well—although some galleries do offer various payment options for impoverished but enthusiastic buyers. A receipt or sales agreement will include name, address, and contact details of the gallery or person selling the work, along with the price, title, print type, and edition number of the image. It should be dated and signed. It is a good idea to include arrangements for collection or delivery of the image to prevent later confusion.

After the Private View

Anne McNeill and Joy Gregory and guests at the launch of Joy's book *Translating Place* during her exhibition *Lost Languages and Other Voices* at Impressions Gallery. Images © Colin Davison and Impressions Gallery.

What is the artist's role while their exhibition is open to the public? All the preparation has been geared to that moment and most people have a sense that after the opening night their work is done. The exhibition is safely installed and there seems little to do. The attention of the gallery staff may well move on to the next exhibition, and the artist may want some time to recover from all the preparations. In fact, there is still a lot to do and this is a good time to do it.

Once the excitement of the private view is over, this can also be a curious period of limbo for the artist waiting to see how the work will be received. For some, it may be tempting to hang around the gallery, engaging visitors in conversation, while others may want to walk away and start work on a new project. It is worth talking to the gallery beforehand about this. Galleries differ in their attitude to having their artist around during the show, and while some encourage it, others do not. The answer is usually to arrange regular times to be in the gallery and available to talk with visitors.

This can also be a period of creative exhaustion for artists, and they should be prepared for it. The long build-up to an exhibition is over, the rewards may not yet be visible, and suddenly the world seems flat and dull. Artists may feel a lack of interest in their own work and need to remotivate themselves to follow through the opportunity that an exhibition represents. A student was expressing feelings that are all too common when he said to me, 'I've been a bit down and thinking it's all a lot of hard work with little chance of getting anywhere.' Sometimes, too, artists experience feelings of loss when the work, which was private to them, is suddenly out in the public domain or experience other emotions that are difficult to resolve.

It is important to recognize that these feelings are temporary, that this is about being tired rather than blocked, and that the desire to make work will return. In *The Artist's Way* (1992), her useful book on creativity, writer and filmmaker Julia Cameron talks of the 'recognizable ebb and flow' of the artistic process. She points out that, 'In a creative life, droughts are necessary' and speaks of a time 'between dreams' when 'we feel we have nothing to say, and we are tempted to say nothing.' For many people, this will be true of this moment between finishing or exhibiting one piece of work and waiting for the impetus that will lead to the next.

Whatever the artist feels, this is not the time to be absent from the gallery and the work but to remain in touch and see through the follow-up to the exhibition launch. In fact, there is quite a lot of exhibition-related work still to do, and this may be the perfect time for a kind of creative housekeeping. All of this should have been planned in advance. For those who do feel that they are in a creative limbo—and by no means will everyone feel this—it may be a positive way of keeping engaged with the working process.

Ongoing tasks at this stage include the following:

- continuing to promote the exhibition with follow-up phone calls and using social media
- giving an artist's talk and undertaking educational work with local schools and colleges, if that has been planned
- updating mailing lists with new contacts
- collecting financial records and completing the actual expenditure budget

- saying thank you
- documenting the exhibition
- compiling a record and possibly an evaluation report
- making a detailed plan to take the exhibition down, transport it, and store it

Many critics and reviewers dislike private views and want to look at the work without distraction. Reminder phone calls about an exhibition can be made in the days immediately after the exhibition has opened and may be very productive, especially if the artist can be present in the gallery to talk to visitors.

In the same way, this may be a good moment to get in touch with local schools and colleges and remind them that the gallery is open and that the artist will be available to talk to students by arrangement or at particular times.

This is the time to add new contacts to mailing lists. The budget will also need to be balanced. This means collecting all receipts and drawing up an actual budget. At the end of this, the artist should have both an estimated and actual budget for comparison. This will prove invaluable for estimates for future exhibitions.

This is a good time to write or phone to thank people, and it is a useful way to spend time in the gallery if there are few visitors. If sponsorship has been raised, it is a particularly good idea to phone the sponsor a day or so after the private view to thank them personally and also to give some appropriate feedback. This could be, for example, about visitor figures or the way in which their sponsorship was used or appreciated. An anecdote will make it more personal, and it may be a good idea to invite the sponsors to drop in to the gallery for a drink and tour of the show if they did not attend the private view. Sponsors appreciate being appreciated, and this sort of response from an artist may ensure future support and the development of a valuable working relationship.

It's also the time to deal with sales and plans to take down the exhibition. Dealing with sales may require sending a formal receipt of purchase and making or confirming arrangements for the buyer to collect the work or for it to be delivered once the show has been taken down. A gallery will handle this on behalf of the artists but you do it yourself in an independent exhibition. The original packing materials may well have disappeared or been damaged and need to be replaced. Taking the exhibition down may need little planning or may need careful arranging if another show is to be hung on the day this one comes down. You should plan to leave the gallery clean and tidy, and you may be required to fill and paint the holes you made when hanging your work.

Documentation and evaluation

The documentation and evaluation of an exhibition are important for several reasons:

- You need to keep a record for your own reference and c.v./résumé. As unbelievable as it seems at the time, you may well have forgotten basic details of the exhibition (such as dates and names of co-exhibitors) by the time you need to quote them.

- You need to keep a record to show to galleries, critics, curators, or publishers and to use when giving a talk or lecture about the work in the future.

- It will be useful when looking for promotion, sponsorship, or funding in future.

- It will be useful as a visual record of work that is on tour, on loan, sold, or in storage.

- It will be useful to keep track of work sold.

- It may be useful for insurance purposes.

- Galleries are sometimes fairly short-lived, and many galleries are poor record keepers. Do not assume that you will be able to ask them for information in a few years' time.

- An evaluation should provide you with concrete evidence of what works and what does not. It will be a useful reference for every exhibition in future and help you analyze and use the experience you have gained.

Documentation and evaluation are two different, though related, processes. Documentation involves keeping a fairly detailed record of the whole exhibition as it is presented to the public. Evaluation is a summary and analysis of every stage of the exhibition process. It is more complex to compile and involves assessing each element of the process, reviewing what worked and what did not, so that exhibition's lessons become the basis from which the artist can determine what steps to take and what to avoid in the next exhibition plan. Although every exhibition situation is likely to vary considerably, keeping track of them will give the exhibitor enough information to work from in planning further shows.

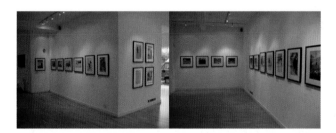

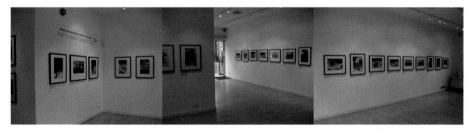

Documentation of *The Everest Generation* (from the collection of the Royal Geographical Society) an exhibition at Hoopers Gallery, London. Hoopers Gallery has a variety of options when hanging a show because the walls range from ones that will take only one or two images to walls that allow for a long row of photographs. So it is particularly crucial to document the various ways in which the space can be used, as well as documenting the sequence of images if the exhibition is to travel and be installed in what might be a very different gallery space. Images © David Scull and courtesy Hoopers Gallery.

Crucially, the documentation is made to be shown to other people, whereas the evaluation is made for the artist's personal use, so the two should not be confused. However, it is worth compiling them at the same time and keeping them together, simply because it will be easier to make both records simultaneously.

Many students will have compiled and written reports of this sort in school or college and perhaps not appreciated how useful it is to continue this process into their professional practice. However, this is the time to adapt student work. For example, records can be kept in note form rather than as continuous prose, as long as the notes are so not terse as to be impossible to understand in future.

Documentation of an exhibition could consist of the following:

- the invitation, press release, and any catalogue or brochure

- images of the installed exhibition and of individual photographs

- a copy of the artist's statement (if this does not exist, then make brief factual and personal notes about the photographs)

- a list of the works with print sizes and complete caption information

- a price list and list of works sold

- copies of press response and reviews, a reference to media coverage such as a mention on a particular TV or radio program

- audience responses, either a copy of the visitors' book or perceptive remarks taken from it and any thoughtful comments made to you directly by visitors or reported by gallery staff

- visitor numbers, if available

Copies of printed materials should be collected together at an early stage. These can disappear at great speed once the exhibition is open, especially if it is a successful exhibition. Additional copies of anything with a printed image of yours on it will be very useful when approaching curators and galleries in future, so make sure you have thirty or more of these. The artist's statement will be useful both as an aide memoire and as text for future applications for exhibition or sponsorship.

Documentation of the exhibition should be completed as soon after the exhibition opens as is possible, when the gallery and work look at their best and also as a record, just in case of accidental damage to, or theft of, any of the work during the exhibition. When photographing the exhibition for documentation, it is important to photograph the whole space in a long shot and then move closer and, rather than just photographing each image individually, photograph groups of images. A photograph of an entire wall or set of images will provide a useful reminder of how the images worked together. If an exhibition is to tour or be shown in another venue, this will also be a better way of demonstrating a possible hang than sending a list.

Good reviews will always be useful support for future exhibition applications. However, your work may not get reviewed, and in this situation you can use comments made by visitors. These can be taken from a visitors' book or written down when made to you or reported

to you by staff. The private view may also bring insightful or positive comments. This may seem a poor substitute for a glowing press review, but on a personal level it can be just as rewarding, since it will tell you how your work is reaching your intended audience. It is also valuable feedback to pass on to funders or sponsors, since it reassures them that their input is appreciated by the people on whose behalf they fund exhibitions, rather than just by an elite of critics and curators. Any input is good and worth your careful attention.

Most, but not all, galleries keep count of visitor numbers. This can be a good statistic to obtain simply because it is the sort of information funders and sponsors like. If the gallery does not keep a record, you can do this yourself by making a count while you are there and producing an estimate for the whole exhibition period from this. If you do this, you may well need to be able to substantiate the figure, so be ready to explain how you arrived at it and do not be tempted to inflate it.

An evaluation report should include:

- an evaluation of the practical workings of the exhibition, using estimated and actual copies of the timetable, budget, sponsorship/funding applications (successful and failed), a list of press materials, pricing and sales, plans and decisions on the framing and presentation of work, notes on the hanging, resources needed or used, the private view, working relationships, timing, and any thoughts or observations on the processes that may not fit neatly into these categories

- an evaluation of the work itself, a summary of the concept, and realization of the exhibition, the way it was shown and how it was received. These two aspects of the exhibition are separated out here only because the first is practical and fact based and the second subjective and personal and may need a different sort of approach and analysis

The conventional way to write an evaluation report is to divide the information into three parts, organized chronologically:

1. an account of the aims and planning of the exhibition

2. an account of the implementation of these plans

3. an account of the outcomes, achievement (or not) of the exhibition aims, and of the lessons learned

To do this, the exhibitor needs to start keeping detailed notes of discussions and decisions at the beginning of the process. This is in itself a learning process and may help the artist to make good working decisions. The planning will include all the elements above and also any aims of the exhibition (to reach a wider audience than has been achieved by previous exhibitions of the artist's work, for example), which may well shift during the exhibition's development. Keeping track of these sorts of shift is invaluable, because it will help the exhibitor learn to become more realistic when making future exhibition plans.

However, if this hasn't been done or it doesn't suit the artist's way of working, it may be simpler to undertake the entire process once the exhibition is complete by considering items of the planning and implementation together and then adding a list of outcomes and lessons learned.

So, for example, the estimated and actual budget would be put together and notes made to the effect that, for example, the contingency fee was spent because the framing costs had been written in without tax, that extra help had to be hired because the workload was underestimated, or that additional print costs had been incurred because of a last-minute change in the size of prints. Note for future reference and budgets any of the items that were not adequately costed, perhaps because the initial estimates were not accurate, because the planning wasn't thorough enough to include them or because of unexpected decisions, events, or accidents.

It is also always revealing to evaluate the timetable, especially where small deadlines, when missed, have had a disastrous domino effect. Timetabling is always one of the hardest bits of pre-exhibition planning to get right, and lessons learned here are invaluable. The following examples happened during exhibitions I worked on; making a note of them during an evaluation procedure means that the time they took will be accounted for in my future timetabling. On one exhibition, a writing deadline slipped which meant that the printer's deadline was missed. The printer was unable to reschedule printing the brochure until just before the exhibition opening. This did not seem to be a big problem until it became clear that the brochure, intended as pre-exhibition publicity, could not be included in the mailing. Since sending it out separately would double the mailing costs, it was not sent out and huge piles of unused brochures haunt me to this day. On another, the turnaround on printing the invitations did not allow enough time to proofread the text. Inevitably a date was wrong and, because it was not noticed until after the invitation had been printed, it meant that the entire print run had to be redone at additional cost and the mailing cost more because it was late.

As part of this analysis, it is important to list the practical outcomes of the exhibition, such as a record of sales, further opportunities in the form of offers or contacts made which might lead to inclusion in a book or exhibition, reviews, offers of residencies or teaching or additional sales. All sorts of opportunities might result from an exhibition, and it is useful to take note of this at the time. As I know from my work as an interviewer for the *Oral History of British Photography* archive (part of the National Sound Archive held at the British Library), for instance, interest in interviewing a photographer is often triggered by a successful exhibition.

Along with the practical outcomes, the exhibitor will most probably want to know how the exhibition was received and gather a response to the work on a much more personal level. If the private view has been too busy for much reflection, the gallery doesn't have a visitors' book, and the gallery staff does not actively seek out comments from visitors, the exhibitor may feel he or she has received an inadequate amount of feedback. Did the audience like and understand the images? If there was a theme or concept, was it successfully conveyed? Does the work engage? These things can be difficult to assess, relying as they do on subjective criteria as well as informed opinion. People are often reluctant to offer comment, and the exhibitor may need to take an active role in seeking out feedback from colleagues and visitors. This can be difficult and painful to do, particularly if the result is adverse or unhelpful criticism, so asking for feedback can feel very risky. Ways of initiating feedback include arranging an informal viewing in the gallery for invited visitors, followed by a discussion or lunch locally. A more formal artist's talk can also achieve this, especially if it includes a chaired question-and-answer session.

From these the exhibitor can make notes about the sorts of comments given and, if necessary, postpone their consideration until the exhibition can be reviewed with more detachment than may be possible when the exhibition is still a recent event.

The temptation is probably to chuck all this material into a large box or folder, forget about it, and move on to the next project. However, it is worth setting up a good filing system with your first exhibition so that it can be added to every time the work is shown. This is probably something best not done electronically, because you are dealing with the actual documents. But neither do you want to use a scrapbook, because it looks unprofessional. A large concertina folder or section of a filing cabinet will be easy to access, to keep work in, and to add to as necessary.

CHAPTER 22

A Summary

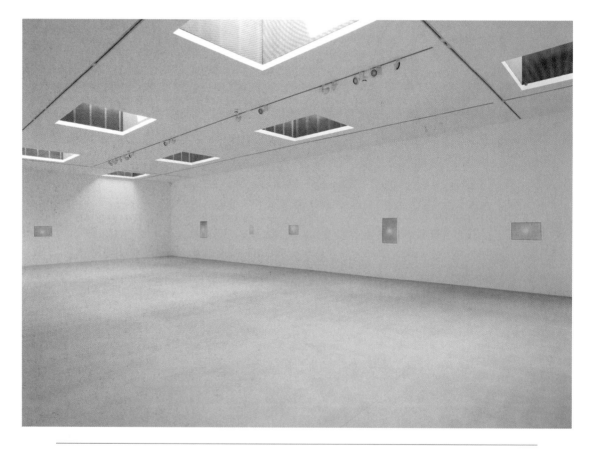

Installation view of Zoe Leonard, *Observation Point* 2012, Camden Arts Centre. Copyright: Zoe Leonard. Courtesy: Galerie Gisela Capitain. Photograph: Andy Keate.

This book has aimed to empower the reader by examining the processes that go into creating an exhibition so that you can make informed decisions about how you want to approach exhibiting. Much of it is common sense, much is learning by doing it, much is about understanding the conventions of exhibiting, and all of it is about allowing sufficient time in the process to plan ahead and not be rushed into decision making without time for consideration.

We live in a time when exhibition practice and exhibiting conventions are changing rapidly—with the booming interest in the arts, particularly photography, and the impact of digital photography and social media we can expect continuing change in these conventions. But, some things don't change and, as László Moholy-Nagy said in 1947, 'The enemy of photography is the convention, the fixed rules of "how to do." The salvation of photography comes from the experiment.' So, hopefully, knowing the 'rules' allows the serious artist to experiment and to take risks with the way they show as well as make work. In the end, the artist must acquire enough knowledge and experience to take control of the process, to find curators they can trust and enjoy working with, and find an exhibiting mode that suits them and suits the work.

Here is a summary of the things I believe to be important to taking control of your exhibiting career:

1. be aware that exhibiting, galleries, and the international art market are in the process of fairly constant change and this will affect what and how work is shown and received

2. plan for a long-term rather than a short-term exhibiting career

3. think through how exhibiting fits into your working methods and life and identify your exhibiting aims

4. identify how you will support the work (in terms of time and money) until it starts to pay for itself or if it never does pay

5. work on your support systems (an exhibiting group, for example)

6. work on your promotional systems (such as business card and website)

7. organize exhibiting opportunities for yourself and start small and local

8. build your exhibiting curriculum vitae

9. aim to learn all the tasks involved in putting on an exhibition for yourself including writing, timetabling, and budgeting and try to work with people whose skills complement yours while you do this

10. having learned as many skills as you can then be prepared to trust the curator to shape and place your work (this means accepting that you may be too close to the work to do this well and that they should know more than you about the world of exhibiting and audiences)

11. make sure that you caption, credit, and copyright every image you distribute and that your contact details are always part of any information you send out

12. collect together information about resources and suppliers in a resources file—make it relevant to your specific needs and keep it up to date

13. find out which galleries and suppliers you like working with and work well with, stay with them and build your own systems and support from there

14. keep up to date with conservation issues, particularly in regard to selling work

15. start to build your own personalized mailing list and update it regularly/with every exhibition

16. learn to speak and write about your work in straightforward terms

17. if you find it difficult to promote and market your own work find alternatives (a colleague may do it for you or you can employ a professional), but don't ignore this aspect of your work

18. spend time looking at the way that photographs are exhibited as a way of developing your understanding of the appropriate way to present your own work

19. spend time looking at how the space affects the way work is shown

20. learn to edit, sequence, and shape your work for exhibition

21. decide on a portfolio system that suits you and organize your prints in edited projects so that you have a completed piece of (exhibition-focused) work in a portfolio to show a curator or gallery at any time

22. do your networking, go to fairs, festivals, and events, and show your portfolio to as many curators as you can

23. keep your social networking, whatever outlet you choose (Facebook, Twitter, etc.), up to date at the same time

24. when an exhibition is booked, plan ahead and do as much as is possible early on to leave time for creative rethinking in the final stages

25. research possible galleries and keep in touch with the one(s) that are appropriate to your work and career stage

26. aim to find a gallery that will support you in the long term

27. when you are offered an exhibition ask a lot of questions about costs, responsibilities, sales, and so on so the whole process has been thoroughly discussed before you agree

28. always have a written contract even if it is the most basic of lists of what has been agreed

29. remember that a private view is not a party—you are working!

30. don't forget to do your follow-up work in documenting your exhibitions

31. don't forget to enjoy it!

Appendix Checklists

The resources file

A resources file could include:

- your mailing list (start with names of family, friends, and fellow photographers you know, and build from there)
- general graphic and photographic suppliers
- suppliers of conservation standard boxes and storage systems
- specialist printers who print to exhibition standard
- printers of catalogue or exhibition brochures (the criteria being that they reproduce images to a high standard)
- invitation or postcard printers
- mount cutters and dry mounters
- framers
- glass-cutting firms
- vinyl letter-cutting firms
- transportation—both hire firms and specialist art movers
- galleries to hire
- a list of galleries with relevant specialist interests or policies (such as all the galleries that regularly show young photographers or landscape photography, for instance)
- a list of the websites of specialist galleries internationally
- a list of sympathetic curators and writers (these could be specialists in the field or people who have shown interest in your work)
- if you show on a regular basis in one particular gallery a list of nearby bars or restaurants with contact details
- booklist

- sales and reproduction rates
- possible sponsors
- grants and funding information
- a list of photography festivals and contact addresses or websites
- a list of annual/regular photography competitions and contact addresses or websites
- samples of press materials, leaflets, and brochures to use for inspiration or as templates

Offering feedback

We have probably all been taught to be highly critical of creative projects, but in an independent photography group it is usually a good idea for members to be supportive rather than critical. Discussions of work should not be a competitive situation in which everyone demonstrates how much they know. If you have been to a college where crit sessions are tough, it may take time to adjust to the gentler pace of an independent photography group. It is useful to remember how hard it is to show work to other people, how vulnerable one feels when doing it and how awful it can be to discover that what one is doing is not well received. A group will usually get tougher as it gets established and members get to know each other better.

So when offering feedback to other photographers:

- don't feel you have to say something just for the sake of it

- aim for positive comment and to see what works rather than what doesn't and praise that—or at least start from that point

- technical advice and information can be very helpful but make it accessible, precise and brief—don't overwhelm the session or the photographer with it. Some people will hide behind technical issues and so avoid discussing the real issues in the work

- support what works by thinking about how it can be developed but, if the photographer doesn't seem interested in your ideas, don't push it—it's their work and the fact that if it were yours you'd take it in another direction isn't relevant to them

- never say 'I had that idea and/but…,' although if it is a technique or subject area you do know something about, look for ways you can share the information

- if the work reminds you of another artist or photographer's work say so—it may be difficult (there's nothing worse than hearing someone else is doing the same thing as you) but it'll probably be useful for the photographer to look at that work. Again, don't be surprised if they don't seem interested—some photographers just can't look at what anyone else is doing until they've completed their own project for fear of being distracted or influenced by someone else's handling of the same subject

An exhibiting c.v.: Alison Marchant

Installation Artist

REPRESENTED BY SARTORIAL CONTEMPORARY ART, LONDON WC1

Art Collections

2010	*Sartorial Contemporary Art, London*
2003	*The Michael Nyman Collection, London*
2000	*Casting Light, Leamington Spa Museum & Art Gallery*
1998	*Maureen Paley, Interim Art, London*
1997	*Private Collection, Cologne, Germany*
1994	*The Arts Council Collection, London*
1992	*The Third Eye Corporation, Tokyo*
1988	*Franklin Furnace, MOMA, New York*

Solo Shows

2010	*Mobile Allotments & Gardens Centre installation Vestry House Museum, London*
2009	*Dressing Room Small World, London*
	Relicta Fox Talbot Museum, Lacock
2008	*The Unconventional Plant Shop regeneration Small World, London*
	Flower Power Small World, London
	Charged Atmospheres ICIA, Bath University
2005	*Trace Sites specific installation, Neckinger*
	Mills Café Gallery Off-Site Projects, London/Micheal Nyman Ltd
	Resonance 104.4fm
	Charged Atmospheres Plymouth University Art Gallery
2004	*The Refusal Text piece Michael Nyman Ltd, London*
2001	*Bongainvillea Steffulla Studios, Meganisi, Greece*
1999	*East Londoners East London Gallery, London*
	100 Teasers on advert shells & 200 billboards
	across Newham, Hackney & Towerhamlets, London
	80 posters across Docklands Light Railway, London
	Casting Light Leamington Spa Museum & Art Gallery
1999	*Relicta (all that remains) Ffoto Gallery, Cardiff*
	Site/Insite Sites Specific Projections On
	Stratford Picture House, London
1998	*Relicta (all that remains) Cambridge Darkroom Gallery (touring)*
1993	*Charged Atmospheres Camden Arts Centre, London; Southampton Art Gallery; Cambridge Darkroom*

Group Shows

2011 *Extra-Ordinary. Alternative Perspectives on the Everyday*
 Arts Council Collection exhibition, artsdepot, London

2010 *9 Sheds Sartorial Contemporary Art, London*

2007 *Mainly Unclassified London College of Communication*
 University of the Arts

2006 *Re-Considered Contemporary Projects, London*

2005 *On The Verge Fourcorners, London*
 There Is Always An Alternative Curated by Dave Beech & Mark Hutchinson
 temporarycontemporary, London
 International 3, Manchester

2004 *Speglinger Kulturhuset, Stockholm*
 Soprimaverdada Area 10, Eagle Wharf, London

2002 *Bursary Exhibition Royal Society of British Sculptors, London*

Publications/Reviews/Television/Radio

2011 *Broadcasting House' BBC Radio 4 'Small World, reGeneration'*

2010 *Trace, in 'Exploring Site–Specific Art: Issues of Space and Internationalism'*
 Dr Judith Rugg Pub: I.B Tauris ISBN: 978-1-84885-064-6

2009 *Relicta featured on Womans Hours, interviewed by Judi Herman*
 BBC Radio World Service Relicta featured in The Daily Telegraph
 Small World website reviewed in Newham in Focus October
 Dressing Room reviewed in Sewing World June

2008 *Living Room an interventionist book featured in 'The Every Day'*
 Documents of Contemporary Art Series Edited by Iwona Blazwick
 published by the Whitechapel Art Gallery and MIT Press
 ISBN: 978-0-85488
 Exhibiting Photography Focal Point Press, USA & London
 reGeneration: The Unconventional Plant Shop
 Time Out, September
 reGeneration: The Unconventional Plant Shop
 Interviewed by Jim Weable BBC Radio 94.5fm

2007 *Mainly Unclassified Fieldstudy magazine no 9*
 London College of Communication
 Material Loss, Transitional Space & the Uncanny
 Alison Marchant's Kingsland Road, London-East
 P120-9 by Judith Rugg in Textile: The Journal of Cloth & Culture Edited by Janis
 Jefferies, vol 3 No 2, Summer
 Jerwood: Fashion, Film & Fiction. The Wapping Project
 Interviewed by Judy Herman, Womans Hour Radio 4,

2003 *Class, Gender Invisiblity and the Autograph*
 Alison Marchant's Oppositional Encounters with Space
 By Judith Rugg in Cultures & Settlements Edited by Malcolm Miles & Nicola
 Kirkham. Published by Intellect Press
 Living Room p26, Private Musings: Public Projections Navigating Places, Artists
 Newsletter, September
 Close To Home p5 & 43, City Racing: The Life & Times of an Artists-Run Gallery.
 Edited by John Burgess, Matt Hale, Keith Coventry, Pete Owen & Paul Noble
 Black Publishing ISBN: 1-901033-47-3
 Alison Marchant interviewed on Robert Elms Show
 London Live 10.30am 7 April

Gallery Lectures/Conferences

2008 *Artist Initiatives*
 Commissioned by the Arts Council of England, London
 E17 Art Trail, Walthamstow Library, London
2008 *Summoning The Past*
 Institute of Interdisciplinary Art, Bath University
2006 *Fashion Lives Artist Lecture*
 London School of Fashion
2005 *On The Sites Specific Artist Lecture*
 University Of East London
 On The Verge Artist Lecture
 Fourcorners Gallery, London
 Visual Archive: History, Evidence & Make Believe
 Invited Speaker, Tate Modern, London
 Fast Forward & Rewind Artist Lecture
 Kulturhuset, Stockholm, Sweden
2003 *Speculative Strategies: Pleasure & Fear in Interdisciplinary*
 Practice Institute of Contemporary Interdisciplinary Arts University of Bath
 Sites & Signs invited artist debating alongside
 John Roberts & Ann Tallentire
 Camden Arts Centre, London

Lectureships

2007–2011 *Visiting Lecturer to UK wide Art Schools*
2006–7 *Post Doctoral Research Fellow*
 Photography & the Archive Research Centre
 London School of Communication
 University of the Arts

1997–2003	*Head of PhotoVisual, and Full-Time Senior Lecturer Fine Art BA*
	Cardiff School of Fine Art, University of Wales
1994–1997	*Full-Time Lecturer in Visual Art, Contemporary Arts BA*
	Nottingham Trent University

Workshops

2008	*Sewing Circles*
	Small World at Katherine Road Community Centre, London
	Flower Power
	Small World, London
	Mobile Badge Making Workshops
	Small World, London
2006	*Memory Bank Morpeth School &HS Projects/Insight Investments, London*
2004–5	*Image Factory, St James Primary School & Café Gallery, London*
	Memory Factory, Beormund Community Centre
	Multi-track recordings on Resonasence FM Radio
	Café Gallery off-site projects

http://www.london-se1.co.uk/news/view/1669

www.smallworldstratfordvillage.co.uk

http://www.bbc.co.uk/radio4/womanshour/02/2009_23_wed.shtml

http://www.worldcat.org/identities/viaf-DNB%7C120952505

http://www.cornerhouse.org/bookstore/product/alison-marchant

http://www.iniva.org/dare/themes/space/marchant.html

The timetable

This list is a guideline only. You need to adapt it to your own specific circumstances and add items in to it as necessary—there may be all sorts of additional tasks and your timescale may be over a year or less than two months. Publicity in particular will have a set of deadlines but it also will need to be dealt with as an ongoing task because magazines will have a wide range of deadlines.

When drawing up a timetable work backward from the date of the opening evening view. This is the absolute deadline. You do need to allow time for emergencies and for unexpected delays. You may need to amend the timetable slightly as the exhibition preparation progresses.

• look at showing space & make some initial design plans	when you start
• set up website	when you start
• phone publications to find out copy deadlines	when you start
• look for sponsorship if you need it	when you start
• book in tasks such as printing, framing, mounting, or anything that relies on an external supplier	when you start
• draw up budget	when you start
• draw up timetable and circulate to everyone	when you start
• prepare listings information and press release	when you start
• select press prints	when you start
• send listings information to magazines	ongoing approximately three to four months in advance and as necessary to meet publication deadlines
• book equipment hire if necessary (e.g., projectors)	two to three months in advance
• book/confirm speaker for private view if necessary	two months in advance
• prepare artwork for invitation cards and other printed material	allow two weeks to do and do two months in advance (include time to proofread)
• send artwork to printers	two months in advance
• arrange insurance if necessary	two months in advance

- do initial exhibition plan, decide number of images & text and approx placings — at least two months in advance

- start mounting, matting, framing — at least one month in advance

- send out press and media invites — three to four weeks in advance

- organize transportation of work to and from gallery — approx one month in advance

- organize all texts in exhibition (e.g., captions) — one month in advance

- draw up price list — as soon as captions are complete

- organize opening, book staff — at least one month in advance

- post invitations (second class) — between two and three weeks in advance

- plan invigilation rota (if necessary) — at least three weeks in advance

- do local publicity by word of mouth — one week in advance

- phone/e-mail press reminder — one week in advance

- phone/e-mail reminder to speakers, key guests — one week in advance

- clean and paint gallery — before starting the hang

- check and replenish toolkit — before starting the hang

- hanging — as long before it opens as possible

- preparation for private view — one to two days before

- (tables, glasses, flowers, etc.) — opening

- private view — the day before it opens to the public

- document the exhibition — just before or after it opens

- take down exhibition — the day after it closes

The budget

Expenses could include:

1. Staff/personnel costs and fees and additional costs for:

 additional staff such as a curator or publicist

 temporary help, for example, with mailing, hanging, painting the gallery, staff for opening party

 fees for designer of artwork and/or the exhibition

 fee for speaker at opening event

 invigilation costs

2. Gallery costs: could be any or all of

 hire fee/rent

 electricity, lighting and heating

 insurance

3. Administration and miscellaneous general costs:

 phone calls, photocopying and stationery, travel, petty cash, etc

4. Publicity: could be any or all of

 press release

 invitation

 poster

 catalogue; gallery leaflets and handouts

 press prints and CDs

 paying for listings or advertisements in magazines and newspapers

 postage

5. Producing and presenting the work—framing/mounting to exhibition standard.

6. Hanging and presentation of work:

 Captions and text production and mounting

 Large vinyl letters to go on the entrance or similar

 Tools—you may need to buy velcro strip, screws, plugs, Blu-Tack, mirror plates, paint, brushes, cleaning materials, and so on

7. Transportation and packaging of work including van hire, insurance, and material such as crates or roll bubble wrap

8. Opening event or private view:

 wine/beer/spirits

 juice and water

 food or small snacks

 glasses hire/breakage

9. documentation of the show

10. contingency at 5 or 10 percent (always allow for contingency on principal)

Income could includes:

1. Sales of work

2. Sales of anything else: catalogues, postcards, picture frames, etc

3. Sales of drinks at the opening event

4. Funds raised through: sponsorship, grants, fund-raising events, support 'in kind'

The press release

This should include the following information:

- the artist's or artists' name/s
- the exhibition title
- the curator's credit
- the date and time of the opening view (unless this is for invited guests only)
- the start and end dates of the exhibition and opening hours of the gallery
- information about the content, theme or idea of the exhibition
- practical information such as the number of images, when the work was made, whether it has been seen before or collected, accompanying tour or publication, information that the work is for sale
- some biographical information on the artist including previous exhibiting career, their background, prizes, and so on
- a quote if desired and appropriate
- information about the gallery if useful or necessary (for instance that it is a new gallery, or has a particular exhibiting policy)
- a website address
- travel or access information as necessary
- the gallery address
- a contact e-mail or phone number
- any logos and credits
- information about any accompanying educational program of talks and workshops

Invitation card

One of the most important things about an invitation to an opening or private view is that it should be easy to read so information is usually kept to a minimum. It is also one of the most attractive pieces of publicity material and likely to be put on display so the information on it should also cover the whole period of the exhibition rather than just the opening night.

Even if you are sending all your invitations out by e-mail many galleries and groups still use the traditional format of an exhibition invitation and attach a personal note. When doing this I would make sure that the title of the exhibition, the artist's name and the dates are all in the e-mail itself or in the subject line of the e-mail—busy people don't always open attachments.

Invitation cards should include all of the following information:

- the artist's or artists' name/s
- the exhibition title
- photograph/s with credit
- the curator's credit
- the date and time of the private view
- the start and end dates of the exhibition and opening hours of the gallery
- the gallery address
- a contact e-mail or phone number and website address
- any logos and credits

Possible additional information:

- a one- or two-sentence subtitle or explanation of the exhibition
- the time of any talk to be given at the private view or during the exhibition run and the title or job of the guest speaker
- travel or access information if necessary (if it's a new space or hard to find)
- RSVP (only if entrance is to be restricted—do not use this otherwise, as sorting out replies and queries will take up an enormous amount of time)
- 'admits one' or 'admits two' if appropriate (only relevant if invites are checked on the door)
- admission charges if these are made

European paper sizes in millimeters and inches

Size designation	Size in millimetres	Size in inches
A0	841 × 1189 mm	33.11 × 46.86 inches
A1	594 × 841	23.39 × 33.11
A2	420 × 594	16.54 × 23.39
A3	297 × 420	11.69 × 16.54
A4	210 × 297	8.27 × 11.69
A5	148 × 210	5.83 × 8.27
A6	105 × 148	4.13 × 5.83
A7	74 × 105	2.91 × 4.13
A8	52 × 74	2.05 × 2.91
A9	37 × 52	1.46 × 2.05
A10	26 × 37	1.02 × 1.46

The tool kit

When hanging an exhibition you may need an extraordinary number of quite varied tools, so get together your own tool kit and/or a shared one. Check what the gallery already has about a week before the hang. It is crucial to organize this in advance because you won't have time to shop for things as you need them. But only take what you need plus extra supplies of small things such as screws, nails, pencils, Blu-Tack, and so on.

If you are part of a group show, remember that you will need more than one of many of the things on this list or you will lose time trying to find out who is using something you need and waiting for them to finish using it! Put your name on all your tools.

It's worth buying good tools when you can afford it—a two foot long spirit level is very useful and can double up as a ruler. A good metal tape measure will stay extended if you need it to instead of snapping back and trapping your fingers.

A tool kit should include some or all of the below:

- hammer, screwdriver (ordinary and cross head), electric or battery operated drill (with spare batteries), tape measure, scalpel and cutting tools, staple gun, pliers, bradawl, large spirit level (or laser level), a set square, steel rule

- nails, screws, rawlplugs, extra mirror plates—string is useful for measuring

- extension lead if you are not using battery operated tools—if you need to drill its unlikely the drill will have yards of lead

- notebook, pencils, cardboard, Blu-Tack or sticky pads, masking tape, and soft rubber (you will need to be able to remove pencil marks you've made to mark where you're hanging the work). A soft brush is useful for controlling dust particles and keeping the workspace clean.

- paint and brushes (for retouching the wall where you've put a screw in the wrong place and have to move it) filler and filling knife, sandpaper

- cleaning things—to clean the floor, broom, dustpan and brush, and to clean glass, lighter fuel for lifting off sticky labels

- spares—light bulbs, for example

- find out in advance if you will need to bring a ladder (a short ladder will be useful for hanging the work but you may need a long one for lights or painting the space)

- anything you may need to repair your own work if it gets damaged in transport or while hanging

- also you may need to take food and drink if you're putting up work somewhere where the only cafes are miles away, closed at the weekend or in the evening or you don't have time for a proper break—a thermos of coffee will be an enormous treat if you'll there very early or late

- basic first aid kit (all galleries should have one but check it and take band-aids, cotton wool, and antiseptic anyway)

Hanging an exhibition: the sequence

- pre-plan: look at the work very thoroughly
- pre-plan: look at the space (and/or floor plans)
- pre-plan: decide on the amount of work to fit the space
- pre-plan: group or sequence the work
- pre-plan: decide on frames and presentation methods
- pre-plan: check possible hanging methods and state of gallery walls and decide how to hang the work
- pre-plan: plan a hypothetical hang on paper
- early preparation: print, mat, mount, frame, or otherwise prepare the work in good time
- final preparation: check lighting is fully functioning and replace bulbs as necessary
- final preparation: clean and paint the gallery as necessary
- final preparation: collect everything together (the artwork, texts, tools, hanging plans)
- final preparation: frame all the work if it is not already framed
- actual hang: place it by propping frames up against the wall according to the hypothetical hanging plan, check it works in practice, and rearrange as necessary
- actual hang: hang the work on the walls
- actual hang: put text and captions up
- actual hang: arrange lights
- actual hang: clean frames and glass (if work is under glass) and clean the gallery and gallery windows
- before opening: check that price lists, catalogues, books, visitors book, etc are in place

Possible teams to organize a group exhibition

THE PUBLICITY TEAM: tasks:

- looking at sponsorship (to be done at the start of the exhibition process as logos will need to go on flyers, posters, website, etc.)
- compiling a mailing list (by getting names and e-mail addresses from all artists)
- coordinating the mailing of invitation to everyone on the mailing list and/or e-mailing PDF versions well in advance of opening night and working to the budgets set
- writing, or enlisting someone to write, a press release
- coordinating opening night (ordering drinks, collecting them, and organizing a rota to serve at the bar)
- liaising with the gallery to put publicity on their website
- liaising with other local arts organizations and delivering invitations, postcards, posters, and so on to them

THE DESIGN TEAM: tasks:

- design postcards and PDFs to send out and liaise with publicity team re dates, deadlines, etc
- work with website team so design is consistent with website
- coordinate all artists' statements and ensure that they are printed in the correct size and in the same font/style, etc
- arrange printing of postcards/posters etc with printer
- design logo for exhibition and liaise with publicity team re logos of any sponsors
- coordinate design of exhibition

THE WEBSITE TEAM:

- arrange for all artists to supply their selected publicity images at appropriate size
- liaise with design team so that design is consistent
- liaise with publicity team to ensure they can send out website details in good time
- ensure all logos are used on website

THE BUILDING TEAM: tasks:

- be available for at least two days before the hang to coordinate building of wall and frames
- arranging materials needed for painting gallery, building wall, building frames for the film, and projection—liaising with the gallery technician as to what tools and equipment they already have

- coordinating all artists for the painting of the gallery at the latest the day before the hang, ensuring that there are enough people to paint
- sourcing tables for opening night
- coordinating the building of any temporary walls
- arranging transport of building materials if needed, ensuring everything arrives on time
- be available on de-hang day to supervise uninstalling and leaving the gallery as it was found

THE HANGING TEAM

- if necessary coordinate framing
- plan/carry out any necessary pre-hang cleaning and decorating
- be available on consecutive days for hanging
- coordinate all artists to arrive with their work plus hanging material early on the first day of the hang. If any are not able to stay and hang, make sure that they have nominated someone else to hang their work and are aware that decisions may be made regarding their work without them
- liaise with technicians re the tools needed for hanging
- oversee hanging and ensure that it remains consistent
- liaise with design team re artists' statements and captions
- be available to take down work
- coordinate all artists to take down their work when agreed
- work with building team to ensure that the gallery is left as foun

In addition, it may be useful to have a management team (these people can be in another team as well so that they do more than just manage others)

MANAGEMENT TEAM (two to three people)

- draw up and keep an eye on the budget
- oversee fund-raising and sponsorship
- draw up timetable and ensure that deadlines are met
- ensure that all teams are running smoothly
- organize and oversee invigilation of the gallery

Photo festivals

Photography festivals and fairs can be local, national, or international. They can be hectic, inspiring, and informative, and offer a wide range of opportunities. They vary a great deal in size, scope, and content but all of them offer the individual photographer a useful and heartening reminder that their work is part of a larger world of photography.

Festivals usually focus on exhibitions and events. The events include conferences and symposium, talks, lectures and discussions, workshops, portfolio reviews, photo competitions, film screenings and multimedia shows, auctions and sales opportunities, as well as a range of other educational events. No two are the same and most have quite specific identities. Some are focused on selling, others on providing showing and networking opportunities. Big international events like Paris Photo offer a unique opportunity to see what is being exhibited in galleries across the world, while Rhubarb-Rhubarb offers photographers the chance to show their work to international curators and a smaller local festival will be just as useful in making contacts for someone starting out on an exhibiting career.

It's worth being aware that some festivals may last for a month or two, but that the best time to visit if you want to network with photographers and curators is likely to be during the initial week or so of launch events.

It is also well worth doing your research in advance rather than when you arrive—both in case you are completely overwhelmed by the number of events on offer and so miss the one exhibition you would most like to have seen and because you may need to book some events.

This list is a starting point only: the month given is current but times and venues and what is on offer will change from year to year.

Canada

Exposure Calgary Banff Canmore Photography Festival

Annual: February www.exposurephotofestival.com

Toronto Photography Festival

Annual: May www.scotiabankcontactphoto.com

Czech Republic

Funke's Kolin Photography Festival, Kolin

Biannual

www.funkehokolin.com

Denmark

FotoTriennale, Odense

Triannual

www.oftfyn.dk

Eire

PhotoIreland, Dublin

Annual: July www.photoireland.org

Finland

Helsinki Photography Festival, Helsinki

Held irregularly every three or four years, March-April

www.hpf.fi

Backlight, Tampere

Triannual

www.backlight.fi

France

Rencontres d'Arles, Arles

July–September (kicks off with the professional week, which is the time to be there)

www.rencontres-arles.com

Nature & Paysage Photo Festival, La Gacilly

June–September

www.festivalphoto-lagacilly.com

Transphotographiques, Lille

May–June

www.transphotographiques.com

Paris Photo

Annually, usually mid-November

www.parisphoto.fr

Month of Photography, Paris

Biannual in November

www.mep-fr.org

Visa pour l'image, Perpignan

Annual: August–September

www.visapourlimage.com

Germany

Europaischer Monat der Fotografie, Berlin

Biannual

www.mdf-berlin.de

Darmstadt Days of Photography, Darmstadt

March-May

www.dtdf.de

Triennial of Photography, Hamburg

April

www.phototriennale.de

Lumix Festival for young photojournalism, Hanover

Biannual

www.fotofestival-hannover.de

Fotobook Festival, Kassel

June

Internationale Photoszene Koln, Cologne

Biannual in September

www.photoszene.de

Internationales Fotografiefestival f stop, Leipzig

September–October

www.f-stop-leipzig.de

FotoFestival, Mannheim

Biannual

www.fotofestival.info

Greece

Athens Photo Festival, Athens

www.hcp.gr

Photobiennale, Thessalonica

Biannual

www.photobiennale.gr

Guatemala

GuatePhoto, Museum of Modern Art Carlos Merida, Guatemala City

A biannual festival

Hungary

Hungarian Month of Photography, Budapest

Biannual

www.fotohonap.hu

Italy

Foto & Photo, Cesano Maderno

Biannual

www.cesanofotoephoto.it

Toscana Film Festival, Toscana

July

www.toscanafotofestival.net

FotoGrafia, Rome

September–October

www.fotografiafestival.it

Mali

Bamako

Biennal

November–January

www.recontres-bamako.com

The Netherlands

Breda Foto, Breda

Biannual

www.bredaphoto.nl

Noorderlicht (Northern Light), Groningen

Usually late summer, September–October

www.noorderlicht.com

Epson, Fotofestival, Naarden

May

www.fotofestival.com

Norway

Nordic Light Festival of Photography,
Kristiansund

www.nle.no/en/

Poland

Photomonth, Krakow

May–June

www.photomonth.com

Portugal

Encontros da Imagem (Meetings of the Image) Braga

Usually late summer or September

www.encontrosdaimagem

Russia

International month of Photography, Moscow

Biannual

www.mdf.ru/english

Slovakia

Month of Photography, Bratislava

www.sedf.sk

Slovenia

Fotopub, Novo Mesto

July–August

Spain

PhotoEspana, Madrid

June–July

www.phedigital.com or www.phe.es

FotoNoviembre, Tenerife

Biannual

www.fotonoviembre.org

Sweden

xpoSeptember, Stockholm

Biannual

www.xposeptember.se

U.K.

Brighton Photo Biennal, Brighton

Biannual usually October

www.bpb.org.uk

Format International photography Festival, Derby

Biannual in March–April

www.formatfestival.com

Guernsey photography festival

June

www.guernseyphotographyfestival.com

Hereford Photography Festival, Hereford

October–November

www.photofest.org

Margate Photo Festival

Mid-August weekend

http://www.margatephotofest.co.uk/

Rhubarb Rhubarb, Birmingham

www.rhubarb-rhubarb.net

East London Photography Festival

www.photomonth.org

U.S.A.

Atlanta Celebrates Photography, Atlanta

October

www.acpinfo.org

AIPAD (Association of International Photography Art Dealers) Photography Show, New York

March

www.aipad.com

Fotofest, Houston

March–April

www.fotofest.org/calendar.htm

Fotoseptiembre USA-Safoto, San Antonio,

September

www.safofestival.com/

Look3, Charlottesville, Virginia

June

http://look3.org

Review, Santa Fe

June

www.visitcenter.org

Photo LA, Santa Monica

January

www.photola.com/

Palm Springs Photo Festival, Palm Springs

March–April

2012.palmspringsphotofestival.com/

New York Photo Festival

May

www.newyorkphotofestival.com/site/

Denver, Colorado

www.coloradophotographyfestival.com

Possible pitfalls of exhibiting

Professional:

1. Exhibiting can be a huge financial drain and the cost disproportionate to the reward.

2. Unexpected essential costs can arise late in the process when there is no choice but to go over budget.

3. Galleries sometimes push for high-end presentation, which may be beyond your means.

4. The time scale of an exhibition may seriously disrupt your working life.

5. You may be powerless to control the way your work is presented, promoted, or understood.

6. Your professional reputation could be damaged if the work is shown badly, the curation is poor, or your fellow exhibitors show weak work.

7. Your work could get damaged, lost, or stolen if security is poor.

8. The work might have no audience because the exhibition is inadequately promoted or the gallery unknown or inaccessible.

9. The pressure of exhibition deadlines can cause all sorts of misunderstanding and be destructive to professional relationships.

10. Your aim should be to have a long-term relationship with a supportive gallery and helpful colleagues, but sometimes you can only find out whether a gallery is right for you by showing with them.

11. Not all galleries have high standards or are entirely trustworthy.

12. An exhibition brings together many different elements (the work, curation, presentation, publicity, audience) and sometimes the failure of one small element can cause the failure of the entire exhibition.

13. Chance can play a part in the success or failure of exhibitions (e.g., freak weather or transportation failure may close the gallery).

Personal:

14. You may feel you have worked hard but achieved very little.

15. The exhibition process may be so demanding that it takes all your time and energy and your ongoing work suffers or stops as a result.

16. The process may leave you exhausted and drained.

17. The stress of exhibiting can be destructive to personal relationships.

Some ways to avoid pitfalls

Unfortunately the only way to deal with some of these pitfalls is not to exhibit with a particular gallery, group, or curator, but you will cause serious problems all around if you pull out of an exhibition once the publicity is under way; therefore, the key is to recognize situations in advance:

1. A careful and detailed budget that has been agreed by all involved is an essential. Allow a realistic contingency on it. If you are in a position to have a fund for exhibiting emergencies, then it can be reassuring but your aim should be not to touch it!

2. It is always going to be useful to have some extra funds available for the completely unpredictable emergency but if this happens more than once you need to review your ability to budget.

3. Research presentation thoroughly, find good reliable suppliers, find out what suits your work and budget and stick with it unless the gallery can give you financial support or an irrefutable case for high end presentation.

4. Good timetabling should enable you to stay in control of your working life; don't work twice with people who disrupt this.

5. If you have understood the exhibition process and your work and are well prepared for an exhibition then you have a sound basis for negotiation with anyone regarding showing or writing about your work. One or two close colleagues who know your work well may help with this. Building up long-term working relationships will help you to avoid taking risks with unknown situations.

6. Don't accept every invitation to exhibit, however flattering. Check who your fellow exhibitors are and see what you think of a curator before accepting.

7. Be aware of security issues; ask about them, especially invigilation arrangements and overnight safety. Back up digital work and/or remove it at night and over weekends if it seems at risk.

8. Take an active role in promoting your own exhibitions and make sure information gets out there even if you have to do some of the work yourself.

9. Making sure that the timetable is realistic and has a little bit of flexibility in it will go a long way to giving everyone time to sort out disagreements. Make sure you keep a good record of agreements and rearrangements as they are made and do what you can to keep agreeable and sort out disagreements as they happen.

10. You need to be able to take a chance on a gallery and assess what they do and don't offer you at the end of the exhibition process.

11. It can be very flattering to be taken up by a gallery or curator but you should check them out as thoroughly as possible before committing yourself.

12. Good timetabling and experience will help you keep a close eye on every single aspect of an exhibition so starting out by exhibiting as much as you can in a range of different situations will be helpful experience as your career progresses.

13. Sometimes when chance intervenes there is nothing to be done but keeping some creative energy going may help you deal with it. A snowstorm closes the gallery on the opening night? Arrange an end-of-show party. Public transportation failure makes the gallery inaccessible? Use your extra emergency fund to hire a coach to bring people in once a day over the final week.

14. Good and realistic forward planning and working with reliable colleagues should allow you to avoid stress and exhaustion.

Bibliography

a-n newsletter www.a-n.co.uk (publishers of useful "Fact Packs")

Badger, Gerry. (2003). *Collecting Photography*. UK & USA: Mitchell Beazley.

Barker, Emma (ed.). (1999). *Contemporary Cultures of Display*. UK & USA: The Open University Press with Yale University Press.

Barrett, Terry. (1996). *Criticizing Photographs: An Introduction to Understanding Images*. London and Toronto: Mayfield Publishing.

Barthes, Roland. (1977). 'Rhetoric of the Image' in *Image Music Text*. London: Fontana Press.

Buck, Louisa. (2000). *Moving Targets 2: A Users Guide to British Art Now*. London: Tate Publishing.

Buck, Louisa, and Judith Greer. (2006). *Owning Art: The Contemporary Art Collector's Handbook*. London: Cultureshock Media Ltd.

Bunnell, Peter C. (2006). *Inside the Photograph: Writing on Twentieth Century Photography*. New York: Aperture.

Burgin, Victor. (1982). 'Looking at Photographs' in *Thinking Photography*. London & Basingstoke: The Macmillan Press.

Cameron, Julia. (1992). *The Artist's Way: A Course in Discovering & Recovering Your Creative Self*. London and Basingstoke: Macmillan and Pan Books.

Cotton, Charlotte. (2004). *The Photograph as Contemporary Art*. London and New York: Thames & Hudson.

Crimp, Douglas. (1993). 'The Photographic Activity of Postmodernism' in *On The Museum's Ruins*. Cambridge, MA, and London: The MIT Press.

Duffin, Debbie. (1991). *Organising Your Own Exhibition: The Self Help Guide*. Sunderland: AN Publications.

Edwards, Steve. (2006). *Photography, A Very Short Introduction*. Oxford and New York: Oxford University Press.

Fogle, Douglas. (2003). *The Last Picture Show*. Minneapolis: Walker Art Center.

Fox, Anna. (2012). *Basics Creative Photography: Behind the Image*. UK: AVA

Goldberg, Vicki. (2005). *Light Matters: Writings on Photography*. New York: Aperture Foundation.

Goodman, Calvin J. (1978). *Art Marketing Handbook*. Los Angeles: Gee Tee Bee.

Graham, Beryl, and Sarah Cook. (2010). *Rethinking Curating: Art after New Media*. Cambridge, MA: MIT Press.

Hall, Stuart (ed.). (1997), *Representation: Cultural Representation and Signifying Practices*. London and New Delhi: Sage Publications.

Haworth Booth, Mark. (1997). *Photography: An Independent Art.* London: V & A Publications.

Janus, Elizabeth (ed.). (1998). *Veronica's Revenge: Contemporary Perspectives on Photography.* Zurich, Berlin, and New York: Scalo.

Jaeger, Anne-Celine. (2007). *Image Makers, Image Takers.* London: Thames & Hudson.

Karp, I., and S. D. Levine (eds.). (1991). *Exhibiting Cultures: The Poetics and Politics of Museum Display.* Washington, DC: Smithsonian Institution Press.

Marien, Mary Warner. (2002). *Photography: A Cultural History.* London: Laurence King Publishing.

Marincola, Paula. (2006). *What Makes a Great Exhibition?* Philadelphia: Philadelphia Exhibitions Initiative.

Miller, Russell. (1997). *Magnum: Fifty Years at the Front Line of History—the Story of the Legendary Photo Agency.* London: Secker & Warburg & Random House.

Noble, Laura. (2006). *The Art of Collecting Photography.* London: Ava Publishing.

Obrist, Hans Ulrich. (2011). *A Brief History of Curating.* Zurich: JRP/Ringier; Dijon: Les Presses du reel.

Sandeen, Eric J. (1995). *Picturing an Exhibition: The Family of Man and 1950s America.* Albuquerque: University of New Mexico Press.

Solomon-Godeau, Abigail. (1991). *Photography at the Dock.* Minneapolis: University of Minnesota Press.

Volk, Larry, and Danielle Currier. (2010). *No Plastic Sleeves: The Complete Portfolio Guide for Photographers and Designers.* Burlington, MA, and Oxford, UK: Focal Press.

Wilson, Rhonda. (1993). *Seeing the Light: A Photographer's Guide to Enterprise.* Nottingham: Nottingham Trent University.

Index